Tales of the Wandering Jew

Edited by Brian Stableford

Contributors:

from the past:
Percy Bysshe Shelley
Henry Neele
Nathaniel Hawthorne
George MacDonald
Rudyard Kipling
Eugene Field
Eugene Lee-Hamilton
A.T. Quiller-Couch
Bernard Capes
O. Henry
John Galsworthy

from the present day:
Mike Resnick
Kim Newman and Eugene Byrne
Geoffrey Farrington
Robert Irwin
Steve Rasnic Tem
Ian McDonald
Pat Gray
Scott Edelman
Brian Stableford
Barrington J. Bayley
David Langford

A Collection of contemporary and classic stories

Tales OF THE WANDERING JEW

edited by Brian Stableford

DEDALUS

Published in the UK by Dedalus Ltd
Langford Lodge, St Judith's Lane, Sawtry, Cambs, PE17 5XE

ISBN 0 946626 71 5

First published in 1991
Compilation copyright © Brian Stableford 1991
Introductory essay copyright © Brian Stableford 1991
All the contemporary stories are copyright © their respective authors
1991
Printed in England by Clays Ltd, St. Ives plc.

A C.I.P. listing for this title is available on request.

Dedalus would like to thank Eastern Arts for their generous support
in producing this book, with especial thanks to Richard Ings and
Alison Blair-Underwood.

CONTENTS

CONTEMPORARY TALES

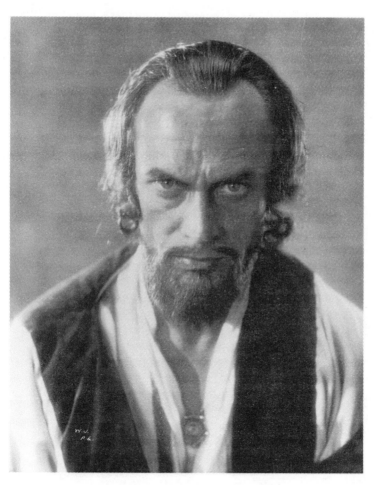

From the 1933 Film of The Wandering Jew

INTRODUCTION
by Brian Stableford

The legend of the Wandering Jew was first written down in the thirteenth century; how long it had flourished as an item of oral tradition before then we can only guess. There are, however, some much older legends with which it has certain elements in common, and from which it may have evolved. Indeed, the idea of eternal wandering as a punishment for an offence against God (or the gods) may be regarded as one among a whole series of unendingly tedious afflictions, other familiar examples being the sentences passed upon Sisyphus and Ixion in Classical mythology.

Examples of accursed wanderers appear in both Judaeo-Christian and Islamic mythology. The story of Cain, who is sent into exile bearing a mark which identifies him as a murderer, is told in the fourth chapter of Genesis, while the twentieth chapter of the Quran (which runs parallel to the thirty-second chapter of Exodus) tells the story of Al-Sameri, the maker of the golden calf which lured the followers of Moses to apostasy, who is similarly cursed by the prophet. In neither of these cases is it explicitly stated that the sinners will be made immortal in order to suffer, but it would have been easy enough for those familiar with the idea of eternally tedious punishments to take that inference.

The gospels of the New Testament are, of course, far more preoccupied with the idea of immortality than the writings which they set out to overlay with a new faith, and there are certain passages there which can be taken to imply that Jesus may have decreed that certain individuals would not die until he returned. In Matthew 16:28 Jesus is reported to have said to his disciples: "Verily I say unto you, There be some standing here, which shall not taste of death,

till they see the Son of man coming in his kingdom." How literally this is to be construed is a matter for theological argument, but it can certainly be read as a promise of earthly immortality if one accepts that Jesus did not expect to "come in his kingdom" for a long time.

Another passage of some significance occurs in John 21:20-22, when Peter, having heard "the disciple whom Jesus loved" (i.e., John) ask Jesus who would betray him, adds "And what shall this man do?" Jesus replies: "If I will that he tarry till I come, what is that to thee? follow thou me." The next verse comments that the disciples took this to mean that John would not die, but emphasizes that this is by no means the only way of interpreting what was said. Even if one leaves out the obvious supposition that Jesus was speaking purely hypothetically it is not entirely clear that Peter's "this man" and Jesus's "he" refer to John and not to the betrayer Judas - and there are, in fact, some modern tales of the Wandering Jew which assume that he is Judas. On the other hand, this is the last incident which occurs in the gospel of St. John, and it does seem to be included as a way of establishing the credentials of the writer, so it is not surprising that some readers felt that John's own cautionary rider in verse 23 was simple coyness.

There is another story, related in all four gospels, which might also be a contributor to the legend which was eventually written down in the thirteenth century. When the mob sent by the chief priests come to seize Jesus in the Garden of Gethsemane one of his followers strikes off the ear of the servant of the high priest. John adds that it was Peter who committed the act and that the servant's name was Malchus, while Luke reports that Jesus restored the ear. John also reports that when Jesus was subsequently brought before the high priest to be questioned one of the men who brought him slapped him; though the gospel does not say so, many readers have assumed that this was done

2

(ungratefully, if so) by Malchus.

It does not say in the gospels that any punishment was visited upon the man who struck Jesus, but a legend to that effect seems to have been current in the sixth century, when the *Leimonarium* of Eucrates told the story of a repentant heretic brought to tears after meeting a wretched Ethiopian who claimed to be the man who struck Jesus, still suffering the consequences of his unbelief.

That the thirteenth century legend of the Wandering Jew is a descendant of this tale seems likely; the tale crops up three times in the thirteenth century in different places and different versions, which have approximately as much in common with one another as they have with the *Leimonarium's* account of the accursed Ethiopian; the name and nationality of the wanderer have been altered, but the underlying message remains much the same: here is a living man who can testify to the actual existence and real miraculous power of Christ, and the foolhardiness of setting oneself against Him.

The first known record of the legend as we know it dates from 1223 and appears in a Latin chronicle from Bologna; it tells of a Jew encountered by pilgrims in Armenia, who had taunted Jesus as he was going to his martyrdom and was told "I go, and you will await me until I come again." Ever since, the said Jew had been rejuvenated to the apparent age of thirty after every hundred years.

Five years later a much more extensive and much better-known account of this same story was recorded by the English monk Roger of Wendover, who was compiling his *Flores Historiarum* at the monastery of St. Albans. Roger claims that St. Albans had been recently visited by an Armenian archbishop who was questioned on the subject

of rumours about an immortal man (nothing is said here about his being a Jew) named Joseph; the archbishop replied that he had actually met the man, who had been a hall-porter in the service of Pontius Pilate named Cartaphilus. This Cartaphilus had struck Jesus when he was being removed to be crucified, whereupon the fateful words were spoken to him. The report further adds that Cartaphilus was later baptized by the same man who baptized St. Paul, and had become a penitent and humble ascetic, who was now very ardent in the service of the Lord.

Roger of Wendover's account was reproduced, with no substantial changes, by his successor as chronicler at St. Albans, Matthew Paris, in his *Chronica Majora*. Matthew subsequently supplemented the story with endorsements by other supposed witnesses who had visited or come from Armenia. The same archbishop evidently told the story elsewhere, because it crops up also in a poem penned by Philippe Mouskes, the archbishop of Tournai, in 1243; and Matthew Paris's second-hand version, which was widely copied - and, significantly, translated into German in 1586-7 - spread it even further afield. In some of the later versions the name used is not Cartaphilus but Buttadeus, which seems to be a bad Latinist's rendering of "God-striker".

The next important stage in the popularization of the legend came, inevitably, after the advent of printing - a technology whose destruction of the Church's virtual monopoly on the reproduction of ideas became part and parcel of the Reformation and the subsequent wars of religion. In 1602 there appeared a pamphlet in the German language, which was reprinted in three different cities and seemingly enjoyed very wide circulation. It appeared fifteen years after the pamphlet which popularized the legend of

Faust, amid an angst-ridden welter of popular Millennarian literature anticipating the imminent apocalypse, at a time when the plague was running riot in parts of Germany.

The story which the pamphlet tells is attributed (apocryphally, one presumes) to Paul von Eitzen, Bishop of Schleswig, who had died in 1598. The bishop is said to have encountered the Wandering Jew in Hamburg in 1542, and to have learned from him that his name was Ahasuerus. This Ahasuerus had been a shoemaker in Jerusalem and had cried out in anger when Jesus, carrying his cross, had stopped for a moment to rest against the wall of his house, whereupon Jesus replied: "I will stand and rest, but you must walk." After this, Ahasuerus was compelled to follow Jesus and witness his execution, and then to leave Jerusalem and wander about the world unceasingly, miserably but reverently certain of the truth of Christ's power and teaching. The pamphlet adds that Ahasuerus was believed to have been seen in Danzig (probably the city where the text originated) as recently as the year 1599.

The new name attached to the Wandering Jew here was borrowed from the Old Testament Book of Esther, where it refers to the Persian emperor usually known as Xerxes; the story of Esther, in which an attempt to set up a massacre of the Jews is thwarted, is commemorated yearly at the festival of Purim, whose ceremonies had mistakenly led gentiles to associate the name Ahasuerus with Judaism.

The contents of this German pamphlet were to be widely reprinted in new editions, translations and paraphrases, and were re-appropriated into oral tradition, where they were sometimes amalgamated with other items of folklore. The pamphlet itself, or the story which it tells, was eventually exported to all of the major European languages. While the story was told and retold it was continually bolstered - after the manner of modern urban

5

folktales - with news of more recent and local sightings of the Wandering Jew. Such embellishments helped to maintain the immediacy of the tale, and each new addition contributed more apparent substance to the weight of hearsay evidence. The story quickly proved popular in France; it had also reached England before 1620, where it crystallized out as a ballad reproduced in several printed collections, eventually appearing in Thomas Percy's *Reliques of Ancient English Poetry* (1765).

<div align="center">********</div>

One consequence of the legend's rapid spread in the age of printing was a rash of impostors who appeared, or were reported to have appeared, in various places during the next two centuries. Sabine Baring-Gould, in his article on the legend - which is the first essay in his notable survey of *Curious Myths of the Middle Ages* - refers to three nineteenth-century impostors recorded in England. Baring-Gould is content to remain undecided as to whether these men were charlatans or "unhappy lunatics" who actually believed themselves to be the Wandering Jew.

One presumably fictitious report of such a visitation which added considerably to the legend was recorded by Giovanni Marana, who became known as "the Turkish Spy" after his epistolary series of essays, written a few years earlier, was translated into English in 1686 by William Bradshaw as *Letters Writ by a Turkish Spy, Who Lived Five and Forty Years Undiscover'd at Paris*. Marana's supposed visitor claimed to be called Michob Ader and to have been an officer in the court where Jesus was condemned; the following account of what he said, however, uses the familiar story as a launching pad for a series of opinions, supposedly based on first-hand observations, about the careers of many famous historical persons, including Nero, Saladin,

Suleiman the Magnificent and Tamerlane.

This version of the story revealed the full potential of the Wandering Jew as a literary character. While he was on the one hand a witness to the truth of the hard core of Christian myth, and one who had suffered more than any ordinary man, he was on the other hand a man who had a unique view of the history of the world and all its nations, and who therefore had better-informed opinions on historical matters than any ordinary man. He could therefore serve any of several different functions, alone or in combination, for writers who wished to adapt the tale for their own purposes. He was useful to pietistic writers who wished to round out his history in such a way as to say something about the mercy of Christ, and he was useful to writers who wanted to adopt a panoramic view of history. But what really intrigued the writers who became interested in him was the perversity of his strange predicament. Here was a man condemned not to die, however much he might desire to do so.

The most fascinating thing about this punishment, of course, is that it seems not to be a punishment at all. The legend of the Wandering Jew flourished alongside other tales of the alchemical quest for the elixir of life and the search for the fountain of youth, both of which are represented as objects of fervent desire. In order to reinterpret immortality as a curse rather than a boon, a certain amount of imaginative labour has to be carried out, which may require considerable rhetorical skill. Many of the literary works which attempt to empathize with the awful plight of the Wandering Jew might, in fact, be better seen as attempts to demonstrate that his condition is to be pitied rather than envied.

The Wandering Jew's big break as a literary character came with the advent of the Romantic Movement in Europe. He had previously figured in various obscure works as a satirical device or as a witness to history, but it was the Romantics, with their reverence for the power of the imagination and their respect for the force of the emotions, who felt free to work creatively upon the framework of the myth, analysing or reinterpreting the plight of its central character according to taste. The Romantics took up the cause of the unlucky wanderer with astonishing enthusiasm, and the nineteenth century produced a prolific catalogue of poems, plays, novels and short stories examining his predicament from every possible point of view.

This literary avalanche was prefigured in the unhatched schemes of Wolfgang von Goethe, the principle figure of German Romanticism. Goethe decided early in his life to make Ahasuerus the subject of an epic poem; he proposed, casually, to transplant the story of Christ's meeting with Ahasuerus to Dresden, and "explain" why Ahasuerus and Judas Iscariot felt it reasonable to act as they did. In 1774 and 1775 he did produce a few fragments of the projected poem, but soon abandoned it. It was therefore left to his countryman Christian Schubart to begin the Romanticization of the legend. Though Schubart too failed to finish the huge epic which he planned he did produce a coherent section which could stand alone; it was published in 1783, and set an example which was to inspire many later exercises in the same vein.

Schubart's *Der ewige Jude* has constantly been driven by his misery to seek death, but even though he has thrown himself into the mouth of a volcano he has been unable to find oblivion; these failures have been sufficiently frustrating to amplify his determination into a near-hysterical obsession. In the climax of the poem an angel appears to offer a crumb of comfort with the assurance that he will be

8

redeemed some day from this mental stress. An unsympathetic reader might have contended that the immortal's anguish was mostly self-inflicted, but there were few of those about, and the work made a deep impression on many of those who encountered it.

Schubart's poem was translated into both English and French, and thus became a key influence on later writers throughout Europe. The English translation of 1801 was read by Shelley, who adapted and further popularized its substance in several of his works, including *Queen Mab* (1813) and *Hellas* (1822). The French translation of 1830 was made by the notable Romantic poet Gérard de Nerval. Both these writers gave a further boost to the image of the anguished wanderer contained in Schubart's work, and helped to secure its status as the core element of nineteenth century representations of the accursed wanderer.

Later accounts of the Wandering Jew produced by the German Romantics are far too numerous to list. Notable early examples include Schlegel's ballad *Die Warnung* (1802), von Arnim's *Halle und Jerusalem* (1809-10), Franz Horn's novel *Der ewige Jude* (1814) and August Klingemann's play *Ahasver* (1827). Von Arnim seems to have been the first writer to release Ahasuerus from his curse by permitting him to die, but later writers were by no means reluctant to alter or embellish the legend much more extravagantly, as it suited them.

Clemens Brentano in *Blätter aus dem Tagebuch der Ahnfrau* (1830) adds an element of quest to the wanderer's curse by suggesting that he might win rest by locating one of several enigmatic artifacts. Adelbert von Chamisso, in *"Der neue Ahasverus"* (1831) gives the wanderer only the

9

dimmest of memories of the past in order that he may be more intimately in touch with the woes of every generation which passes. Other German stories and poems credit Ahasuerus with an assortment of superhuman powers to increase the dramatic potential of his interventions in present-day events, and there are many which present him as a baleful and Satanic character; he figures thus in Duller's *Der Antichrist* (1833) and Oelckers' *Prinzessin Marie von Oldenhof* (1844).

Inevitably, though, the Wandering Jew most frequently figures in German representations as the most perfect possible embodiment of the weltschmerz (world-weariness) in which Goethe's Werther had taught a whole generation to revel. This is his role in Julius Mosen's epic poem *Ahasver* (1838), which takes a thoroughly sympathetic view of the worthiness of the wanderer's struggle against his fate.

Goethe had contemplated the possibility of introducing the Wandering Jew to the great Jewish philosopher of the seventeenth century, Spinoza, and this idea was taken up by Berthold Auerbach in *Spinoza* (1837). Here the plight of Ahasuerus is metaphorically linked to the historical plight of the Jewish people, and he becomes a proto-Zionist. He plays a similar role in Gustav Pfizer's *Der ewige Jude* (1831) and in *Faust* (1839) by "F. Marlow" (L.H. Wolfram), where the two great anti-heroes of German Medieval legend finally meet up; they were to meet again in Eduard Grisebach's satire *Der neue Tannhäuser* (1869). Other interesting meetings are contrived in Robert Hamerling's long dramatic poem *Ahasver in Rom* (1866), in which Ahasuerus and the goddess Roman become the agents of the downfall of Nero, comprehensively punished for the sin of hubris, and Emil von Schönaich-Carolath's *Don Juans Tod* (1883), in which Ahasuerus meets Faust again as well as Don Juan.

Works in which the Wandering Jew stands as a symbol for the entire Jewish people inevitably came to have a special significance in the 1880s when German anti-Semitism was inflamed by the diatribes of Marr and Stöcker. Fritz Mauthner's novel *Der neue Ahasver* (1882) is an explicit reply to such bigotry. Even in this era, however, the wanderer could still be used as a generalized Romantic anti-hero; Max Haushofer's *Der ewige Jude* (1886) went to new extremes of formal contrivance in offering a dramatic trilogy in which a "myth", a "tragedy" and a "fantastic comedy" are framed by a prologue and an epilogue. The plot skips through time and space before culminating in a series of allegorical scenes, and was much admired for its complexity in its day. Johannes Lepsuis' *Ahasver, der ewige Jude* (1894) is a similarly chaotic "mystery play".

Schubart's poem was as variously influential in England as it proved to be in Germany. It is thanks to Schubart that the Wandering Jew was absorbed into the flourishing genre of Gothic romance; he plays a small but notable part in Matthew Lewis's lurid melodrama *The Monk*, where he exorcizes the malevolent spirit of the Bleeding Nun by means of the image of a burning cross which is emblazoned on his forehead. The example of Schubart was also significant in helping to inspire various other English Romantic works which feature accursed wanderers, including Coleridge's *Rime of the Ancient Mariner* (1798), Southey's *Curse of Kehama* (1810), Charles Maturin's *Melmoth the Wanderer* (1820) and Byron's *Cain* (1821).

The most elaborate treatment of the legend by a British Romantic poet can be found in *The Undying One* (1830) by Caroline Norton, who thought of herself as "the

female Byron". This long hymn of lamentation pays particular attention to the women whose love the wanderer has inevitably lost, and thus supports a diagnosis of his suffering which makes it resemble a kind of chronic nostalgia. The idea that the constant severance of his intimate relationships with mortals is a key element in the Wandering Jew's punishment recurs quite frequently; there is much lamenting of a similar stripe in *The Curse of Immortality* (1873) by Albert Eubule-Evans, where the protagonist is called Theudas.

Not all the English portraits of the Wandering Jew partake of the Romantic fever, though, and it was in this same period that he made his debut as a relatively sober character in a historical novel, in George Croly's three-decker *Salathiel: A Story of the Past, Present and Future* (1827). Despite its title, the story is set entirely in the distant past, tracing the adventures of the eponymous anti-hero from the time of the pronouncement of the curse until the destruction of Jerusalem by Titus - at which time he is only just beginning to realise what might be in store for him. This book was later to be hailed as one of the six greatest English novels by Lew Wallace, author of *Ben Hur* - who employed the Wandering Jew in a long novel of his own, *The Prince of India* (1893) - though no other literary historian has seen fit to agree with him.

The Wandering Jew is redeemed, after a fashion, in order that his story may be used as an exemplary moral fable, in George MacDonald's novel *Thomas Wingfold, Curate* (1876). Here, a section from the wanderer's autobiography is read aloud to the eponymous conscience-stricken sinner in order to demonstrate that even the worst of sins might ultimately be forgiven - but MacDonald is careful to retain an ambiguity which allows the reader, if he be so minded, to conclude that the story is only an allegory composed as a kind of self-therapy by a victim of delusion.

This was to become an increasingly popular ploy as the Wandering Jew's adventures extended into more rigorously sceptical times.

Most British works from the latter part of the nineteenth century and the early part of the twentieth deploy the Wandering Jew motif in carefully metaphorical fashion, and there is by no means the same tendency to repetition and recomplication that one sees in the German tradition. One of the most striking and original variations on the theme can, however, be found in Robert Buchanan's narrative poem *The Wandering Jew: A Christmas Carol* (1893), in which the poet meets a character whom he first believes to be Ahasuerus but who actually turns out to be Christ himself, condemned to a dose of his own medicine by his enemies in retribution for the awful catalogue of crimes committed in his name.

In post-Revolutionary France the Wandering Jew embarked upon a flourishing stage career, thanks to adaptations of the relevant subplot of *The Monk* and Louis Cagniez' *Le juif errant* (1812). The latter presents the character in an unusually favourable light, full of bonhomie and only too ready to ride off on a whirlwind in order to do a favour for a friend. A more conventional image can be found in Béranger's song *Le juif errant*, which was reprinted in 1856 with some new verses added by Paul Dupont and a series of illustrations by Gustave Doré. These illustrations have since been widely-reprinted, and are perhaps the most memorable visual image of the Wandering Jew.

An unprecedentedly elaborate treatment was given to the legend by the French writer Edgar Quinet, who first toyed with the legend in a series of ironic sketches, *Les tabletes du Juif-errant* (1823) but went on to develop a

much more extravagant and ambitious deployment of it in his long dramatic prose-poem *Ahasvérus* (1833), which tells, in spectacular fashion, the entire story of the world from its creation to the present day.

Quinet's *Ahasvérus* is by far the most extravagant and innovative work ever to feature the Wandering Jew. Here Ahasuerus is given an immortal horse, Semehe, to carry him on his way, and eventually acquires a female companion named Rachel, who has been cast out of the ranks of the angels for pitying him. Armoured by their love, Ahasuerus and Rachel go forward to meet a Day of Judgment which turns out to be very different from the Biblical Apocalypse, and they alone are left when all else is obliterated. Quinet is not afraid to bring God and Christ on to the stage to speak for themselves, nor to create entirely new symbolic figures like Mob (materialism) and Ocean (time) to afflict mankind. Ahasuerus here becomes "man eternal"; his plight is symbolic of that of the whole race. So ambitious is the work, and so conscientious in its visionary mysticism, that God Himself becomes a problematic character, His predicament discussed by a chorus of outmoded deities.

Quinet's symbolic figure was the direct parent of the most widely popularized version of Ahasuerus, who presides over (but takes no direct part in) the plot of Eugene Sue's *Le juif errant* (1844-45). Here the Wandering Jew's curse represents the historical misfortune of working men, while the similar curse upon his female counterpart (Herodias in this version) represents the oppression of womankind. Here the curse of wandering is augmented, as it sometimes is elsewhere, by an additional burden which makes Ahasuerus a plague-carrier whose footsteps are perpetually dogged by cholera. By this means, the luckless man becomes the agent of a much more wide-ranging curse affecting thousands of innocent bystanders - a particularly cruel and

insidious kind of punishment.

Sue's story is an inordinately elaborate melodrama, spun out to twice its natural length because of its popularity as a newspaper serial. The intricate plot describes how various innocent characters are prevented by evil Jesuit conspirators from coming into the inheritance which is rightfully theirs. The few who survive eventually decide that the salvation of women and working men is not to be found in the pursuit of wealth and luxury, but must be achieved by a fundamental change of attitude - only when Socialism is triumphant, it is implied, can Ahasuerus (and the victims of the plagues which follow him) be redeemed. A specific identification of Ahasuerus with the suffering proletariat is also made by Jean Richepin in his short story *"Le juif errant"* (1884).

The huge popularity of Sue's work ensured that it would be imitated and rebuked in full measure. Sue's great rival as a feuilletoniste, Alexandre Dumas, immediately planned a work of even greater scope, ultimately to fill thirty volumes, entitled *Isaac Laquedem.* This began serialization in 1853, but Dumas only wrote enough to fill two volumes before abandoning the hopeless task. Another one-time feuilletoniste, Paul Féval, produced a further recomplicated version of the legend in *La fille de juif errant* (1878), which features no less than five accursed wanderers who contrived to offend Christ during his brief career.

The popularity of the Wandering Jew in France was such that he was welcomed into another new medium in the opera *Le juif errant* (1852), which had music by Halévy and a libretto by Eugène Scribe and M. de St. Georges; a mazurka, a waltz and a polka from the opera were all published separately. By the end of the century, however, the Decadents, the Symbolists and the Surrealists had buried Romanticism beneath layers of cynicism and barbed wit, and such late versions of the story as Guillaume

Apollinaire's *"Le juif errant"* (1910) treat the tale with amused contempt - although Apollinaire does include a list of previous writers who have tackled the theme, marvelling at its awesome length.

The Wandering Jew is also represented in the evolving literatures of most other European countries. In Denmark Hans Christian Andersen, who was always fond of transmuting his own predicament into symbolic form, wrote an epic poem *Ahasverus* (1844) in which the wanderer becomes an incarnation of the angel of doubt witnessing mankind's slow progress toward enlightenment and true morality. The Danish poet Ingemann had earlier deployed the character in a cycle of poems lamenting the fate of the Jewish people, and he was taken up again by Paludan-Müller in 1853.

In Russia Ahasuerus was the subject of an epic poem begun by Vasily Zhukovsky in 1852, but not quite completed because of his death in that year. Here the wanderer initially lives the life of a miserable and tormented vagabond but eventually achieves a marvellous calm of mind as a result of his conversion.

In Hungary Emeric Madách discarded Ahasuerus in favour of Adam in his dramatic poem *Az ember tragédiája* (1859), while János Arany, Joseph Kiss and Julius Reviczky deployed the legend more straightforwardly.

In Romania Ahasuerus had the privilege of attracting the attention and sympathy of the literary Queen Elizabeth, who published her works under the name Carmen Sylva; her epic *Jehovah* (1882) depicts Ahasuerus' fruitless and frustrating search for God - who, he believes, would be too proud and noble to send his Son to earth to suffer and die.

In America the figure of the Wandering Jew was

employed infrequently, but very variously. In Nathaniel Hawthorne's *"A Virtuoso's Collection"* he is introduced in an amusing context as a guide in a museum of absurd antiquities, and he crops up again in the same author's *"Ethan Brand"* (1851), where he gives a shorter demonstration to the eponymous seeker after the Unpardonable Sin. A much more ambitious account of the Wandering Jew's observations was planned by David Hoffman, but - as usual - only two of six projected volumes were completed, issued under the title *Chronicles Selected from the Originals of Cartaphilus* (1853-54). The legend is straightforwardly summarized in Mark Twain's *The Innocents Abroad* (1869), and is more subtly deployed in Eugene Field's tale of the conquistadors *"The Holy Cross"* (1893).

Despite the relatively infrequent occurrence of the Wandering Jew in American literature it was an American, Moncure Daniel Conway, who produced the first major study in English of the legend and its literary versions: *The Wandering Jew* (1881). This presumably resulted from the research which Conway undertook in order to write an article on the legend for the edition of the Encyclopedia Britannica published in the same year, and may have helped to inspire a long and eccentric lecture on the legend's possible origins and significance published under the same title by a Cincinnati rabbi named Isaac Wise in 1899. Another American rabbi, H.M. Bien, transformed the legend into the tale of the *Wandering Gentile* in his *Ben-Beor: A Story of the Anti-Messiah* (1891); this was published in the same year as John L. Makeever's *The Wandering Jew: A Tale of the Lost Tribes of Israel*, which mingles the legend with other esoteric items of Hebrew folklore and legend.

17

George Y. Anderson's monumental study *The Legend of the Wandering Jew* (1965) describes hundreds more examples than those listed above, with an awesome thoroughness which is far easier to admire than imitate. This monument of scholarship, in fact, reveals the story to be one of the most popular and the most infinitely mutable of all the motifs which written literature has inherited from oral tradition.

The outpouring of new literary versions of the legend continued into the early years of the twentieth century, altered but by no means entirely inhibited by the entrenchment of scepticism. The Wandering Jew had by then become one of those figures of whom everyone had heard, whose name could readily be invoked as the symbol of a predicament. Characters deluded into identification with the legendary wanderer became increasingly commonplace, and the reasons for and consequences of such delusions became the linchpins of neat moral fables by writers as various as O. Henry, Rudyard Kipling and John Galsworthy. On the other hand, it also became possible to use the story playfully, in a quasi-experimental spirit of "what if...?" in order to investigate the logical corollaries of the idea of immortality.

The extraordinary power of the legend of the Wandering Jew to generate literary works is unequalled by any similar myth. Faust, who was similarly popularized by a German pamphlet, also attracted the attention of Goethe and enjoyed an extended literary career, but his representations are by no means so numerous. Within the literature of single nations there are characters who have been more prolifically reworked - King Arthur is the obvious example from British folklore - but there is no other imaginary character with quite the same level of universal appeal.

Some of the reasons for this astonishing popularity

are obvious enough, but they are probably not adequate, even in sum, to constitute an explanation. The notion of immortality is intriguing in itself, but there is evidently some special fascination in the idea of restless immortality as a curse inflicted upon those who offend God - a fascination which is further reflected in other accursed wanderers of legend such as the Flying Dutchman and the Wild Huntsman. Other literary figures of similar ilk include the unlucky Peter Rugg, who was cursed to wander the roads of New England in a hopeless attempt to reach Boston in a remarkable item of "instant folklore" produced by William Austin in 1824.

Part of the solution to the puzzle clearly lies in the particular emphasis placed by the Christian Church on the importance of valuing the immortality of the soul above the rewards of the flesh. If adherents of the Christian faith are to be persuaded of the supreme value of that kind of salvation which is supposed to be on offer to them, it makes sense to have a powerful counter-image in which the soul's bondage to the flesh, without the prospect of eventual release, becomes a kind of Hell - or at least a kind of Purgatory. The Wandering Jew is, in this respect, a kind of dark counterpart of Christ, whose failure to see the sense and worthiness of Christ's sacrifice is extrapolated into an eternity of misery. He was invented at a time when the Church was in a state of crisis, and his consequent career reflects the fact that the crisis of confidence never did pass, but simply gave rise to more and more confusion, more and more doubts.

Faust and Satan, who are much more straightforward anti-Christs, were as capable as Ahasuerus of taking on the roles of demonic villain or heroic rebel, but they were not sufficiently problematic to embody the whole mess of intellectual conflicts which attended the decay and dereliction of the Church's empire of faith. The Wandering

Jew was a more malleable, more paradoxical, more anxious character than they, and his predicament was one which did not require a final choice of allegiance or rejection. He could be pitied, and he could be feared; because his world-view was not tied to any particular moral position he was ubiquitous, and writers could make of him what they would without losing the essential power of the motif. His utility consisted not so much in the fact that he had been places and seen things, but rather, as Mae West would have put it, that he had seen places and been things.

Modern versions of the story of the Wandering Jew are sometimes content to recapitulate the traditional notion of the doomed wanderer, but in doing so they are required to take on a more ironic gloss. Times have changed, and the landscapes of the twentieth century cannot easily accomodate the wild-eyed ragged traveller of the Romantics. He can be a tramp or a vagabond, to be sure, and perhaps even a plague-carrier, but it is difficult for the modern writer to believe that a man who has had such opportunities for learning could not have made something more of himself. Thus it is that the tramps and vagabonds of modern stories are usually mere madmen, while the genuine obsessive wanderers are far more likely to travel on trains, boats and planes in relative comfort.

As the Church's empire of faith has gradually withered, the Wandering Jew was bound to become more versatile still as a character, continually extending his literary options. From a secularized point of view his plight is bound to seem a lot more attractive than it was intended to seem in the eyes of a committed Christian, full of imaginative potential. For those who cannot believe in an afterlife, the curse of immortality needs some pretty nasty

embellishments if it is not to look like a highly-desirable gift. Some stories achieve this by exaggerating the wandering aspect, denying poor Ahasuerus the freedom ever to sit down or sleep, but this creates obvious logical difficulties.

Curiously enough, however, immortality has always had a bad press even in thoroughly secularized romances. Among the hundreds of science fiction stories which contemplate the possibility of longevity the clear majority take pains to paint the prospect very black indeed. It is not entirely clear why this should be, but one suspects that Aesop's fable of *"The Fox and the Grapes"* may contain the vital clue: the reward is out of reach, and thus we console ourselves with the assertion that it would be too sour to tolerate anyway.

Given this, it is not surprising that there are a good many twentieth century stories in which characters who bump into the Wandering Jew find his situation carefully made intolerable by one additional affliction or another. On the other hand, there is a complementary swing in the other direction, so that the Wandering Jew is often represented as an entirely enviable figure. In between the extremes marked by these two kinds of exemplary tales, the elaboration of the basic pattern of the myth continues to generate more subtle and idiosyncratic allegories and moral fables. These are frequently sharpened by the bloodiness of twentieth century history, particularly by the new wave of German anti-Semitism which culminated in the holocaust of World War II.

E. Temple Thurston's drama *The Wandering Jew* (1920) is an interesting traditional version of the theme which enjoyed a highly successful run with Matheson Lang in the central role; it was filmed in 1933, with Conrad Veidt

playing the lead. Its four acts are set in different historical periods, representing different phases in the evolution of the Wandering Jew's attitude as he learns by degrees to be humble and self-sacrificing, until he is allowed to die at the hands of the Inquisition.

Robert M.N. Nichols' collection *Fantastica* (1923) includes a short novel *"Golgotha & Co."* which is a conspicuously modern allegory based on the myth. Here Dr. Ahasuerus is a powerful industrial magnate who cannot be successfully opposed by the feebly Christianized materialism of Dr. Mammon, and thus succeeds in subverting the Second Coming. The tone of the novel is generally embittered and sarcastic, as were most of the European speculative fictions which reflected upon the ideative legacy of the Great War.

The Wandering Jew became an unlikely best-seller in America in the late twenties when George S. Viereck and Paul Eldridge published the calculatedly scandalous *My First Two Thousand Years* (1928). Here the protagonist Cartaphilus explains that he quickly became accustomed to his immortality, and elected to devote himself to a quest for the secret of "unendurable pleasure, indefinitely prolonged" - a goal which has proved elusive but which has given him a great deal of fun in the seeking. His story is parallelled by two others; one describes the quest of *Salome, the Wandering Jewess* (1930) to discover a liberator for her sex - a quest which is continually confounded when her champions belatedly fall prey to the enfeebling curse of menstruation; the other describes the erotic adventures of Kotikokura, *The Invincible Adam* (1932), a proto-human whose extra "rib" (a penile bone) affords him unlimited erotic staying power. The casual salaciousness and deliberate irreverence of the trilogy have succeeded in irritating most commentators, and its mocking pretence of offering a serious philosophical allegory of the relations

between the sexes increases its capacity to infuriate, but this only serves to underline the challenges which it lays down to certain cherished notions - including the contention that immortality would be intolerably tedious.

The multiplication of Wandering Jew-like figures pioneered by the French feuilletonistes is carried forward by C.E. Lawrence in his brief drama *"Spikenard"* (1930), which imagines that when the human race has had its day and departed, the earth will be the heritage of a few unlucky wanderers - Ahasuerus, Judas and the unrepentant thief who was crucified alongside Christ - who will stand in need of a special redemption. The image of an accursed wanderer alone in an empty world is one which crops up frequently in twentieth century fiction, having first been memorably featured in M.P. Shiel's *The Purple Cloud* (1900), which draws elaborate parallels between the hero's predicament and the Book of Job. Shiel also wrote an interesting philosophical novel about a group of immortals created - but not cursed - by Jesus, variously known as *This Above All* (1933) and *Above All Else* (1943). This novel features Lazarus and Rachel Jeshurah, the latter eternally becalmed in childhood; St. John is also still alive, but remains in the background.

A pitiful but unrepentant Ahasuerus is featured in two novels by the Swedish writer Pär Lagerkvist. He is introduced in *Sybilin* (1956; tr. as *The Sybil*) and then moved to centre stage in *Ahasverus' död* (1960; tr. as *The Death of Ahasuerus*). This sexually-impotent and eternally miserable Ahasuerus considers his fate to be unjust and the god (uncapitalized) who condemned him to be unjust; he continues to defame his persecutor even as he is finally released from his unhappy state, insistent on believing that death is his own triumph over malign adversity.

The Wandering Jew has inevitably been adopted into the mythology of genre science fiction - which, despite its rigorously secular outlook, is astonishingly replete with playful "Shaggy God stories" which offer relatively crude reinterpretations of Bible stories and the like. Nelson Bond, a prolific writer of such stories, introduced a spacefaring Wandering Jew in his pseudonymous story *"The Castaway"* (1940 as by George Danzell), and was sufficiently pleased with the effect to write another story in which Jonah is forced into the role of accursed wanderer, *"Uncommon Castaway"* (1949). Equally playful is Wilson Tucker's *"King of the Planet"* (1959), one of many stories of the lonely last man on earth, who is here specifically identified as Ahasuerus, still waiting for Christ's belated return.

Robert F. Young's *"A Drink of Darkness"* (1962) is a more earnest story of self-betrayal in which the Wandering Jew is Judas, still haunted by the thirty pieces of silver, but it is still essentially a jeu d'esprit, as is J. G. Ballard's neatly ironic *"The Lost Leonardo"* (1962) where Ahasuerus is a subtle retoucher of Old Masters, seeking some fugitive hope of redemption by reconstructing the representations which are the record of his sin.

The best of the science fiction stories featuring the Wandering Jew is probably Walter M. Miller's post-holocaust novel *A Canticle for Leibowitz* (1960), in which the Wanderer is one of several symbolic figures lurking in the background while a reconstituted Church provides the social solidarity necessary to rebuild civilization, but cannot prevent a repetition of the destruction. The use of the character here is more bitterly elegiac than playful; he bears sad witness to the fact that the civilization which has arisen from the ashes of nuclear war has forgotten too much to have any real chance of redeeming itself.

In the contemporary stories which are featured in this anthology, along with a selection of antique versions, we inevitably find the playful and the bitterly elegiac rubbing shoulders - sometimes even in the same story. Those stories which are set in the recent past and present are inevitably coloured by memories of the holocaust, which lurks uneasily in the background even of those stories which make no reference to it. Even those which are set in the distant past serve to remind how recent experiences form a kind of lens which reshapes and refocuses our vision of more remote events. Those set in the future are anchored in our own time in a slightly different way, casually taking a much more expansive view of the possibilities of immortality than previous fictions could readily accommodate.

It is notable, I think, that there are no stories here - and very few in the entire vast canon - in which Christ actually does arrive to make good his promise to the Wandering Jew. (Even stories of the Wandering Jew's redemption tend to ignore that part of the curse which specifies that the punishment cannot end unless and until Christ returns.) In the stories gathered here, Ahasuerus waits, but no one comes - and, the texts imply, no one will ever come. If the accursed wanderer is ever to find some kind of salvation, it must be of his own making; if he is not, then he must suffer patiently for a very long time.

There are still sharp points to be made by such stories as these, and lessons to be taken from them. For Ahasuerus, as for us, hope and anxiety are different sides of the same coin; they are the contrasting corollaries of that foresight which allows us to be reasoning beings. He has his own unique predicament to live with, but we have ours, and the careful comparing and contrasting of the two allows us to see both in a colder and more revealing light.

ANTIQUE TALES

THE WANDERING JEW
(Anonymous)

When as in faire Jerusalem
 Our Saviour Christ did live,
And for the sins of all the worlde
 His own deare life did give;
The wicked Jewes with scoffes and scornes
 Did dailye him molest,
That never till he left his life,
 Our Saviour could not rest.

When they had crown'd his head with thornes,
 And scourg'd him to disgrace,
In scornfull sort they led him forthe
 Unto his dying place;
Where thousand thousands in the streete
 Beheld him passe along,
Yet not one gentle heart was there,
 That pityed this his wrong.

Both old and young reviled him,
 As in the streete he wente,
And nought he found but churlish tauntes,
 By every ones consente:
His owne deare crosse he bore himselfe,
 A burthen far too great,
Which made him in the street to fainte,
 With blood and water sweat.

Being weary thus, he sought for rest,
 To ease his burthened soule,

Upon a stone; the which a wretch
 Did churlishly controule;
And sayd, Awaye, thou king of Jewes,
 Thou shalt not rest thee here;
Pass on; thy execution place
 Thou seest nowe draweth neare.

And thereupon he thrust him thence;
 At which our Saviour sayd,
I sure will rest, but thou shalt walke,
 And have no journey stayed.
With that this cursed shoemaker,
 For offering Christ this wrong,
Left wife and children, house and all,
 And went from thence along.

Where after he had seene the bloude
 Of Jesus Christ thus shed,
And to the crosse his bodye nail'd,
 Awaye with speed he fled
Without returning backe againe
 Unto his dwelling place,
And wandred up and downe the worlde,
 A runnagate most base.

No resting could he finde at all,
 No ease, nor hearts content;
No house, nor home, nor biding place:
 But wandring forth he went
From towne to towne in foreigne landes,
 With grieved conscience still,
Repenting for the heinous guilt
 Of his fore-passed ill.

Thus after some fewe ages past
 In wandring up and downe;
He much again desired to see
 Jerusalems renowne,
But finding it all quite destroyd,
 He wandred thence with woe,
Our Saviours wordes, which he had spoke,
 To verifie and showe.

"I'll rest, sayd hee, but thou shalt walke,"
 So doth this wandring Jew
From place to place, but cannot rest
 For seeing countries newe;
Declaring still the power of him,
 Whereas he comes or goes,
And of all things done in the east,
 Since Christ his death, he showes.

The world he hath still compast round
 And seene those nations strange,
That hearing of the name of Christ,
 Their idol gods doe change:
To whom he hath told wondrous thinges
 Of time forepast, and gone,
And to the princes of the worlde
 Declares his cause of moane:

Desiring still to be dissolv'd,
 And yeild his mortal breath;
But, if the Lord hath thus decreed,
 He shall not yet see death.
For neither lookes he old nor young,
 But as he did those times,
When Christ did suffer on the crosse
 For mortall sinners crimes.

He hath past through many a foreigne place,
 Arabia, Egypt, Africa,
Grecia, Syria, and great Thrace,
 And throughout all Hungaria.
Where Paul and Peter preached Christ,
 Those blest apostles deare;
There he hath told our Saviours wordes,
 In countries far, and neare.

And lately in Bohemia,
 With many a German towne;
And now in Flanders, as tis thought,
 He wandreth up and downe:
Where learned men with him conferre
 Of those his lingering dayes,
And wonder much to heare him tell
 His journeyes, and his wayes.

If people give this Jew an almes,
 The most that he will take
Is not above a groat in time:
 Which he, for Jesus' sake,
Will kindlye give unto the poore,
 And thereof make no spare,
Affirming still that Jesus Christ
 Of him hath dailye care.

He ne'er was seene to laugh nor smile,
 But weepe and make great moane;
Lamenting still his miseries,
 And dayes forepast and gone:
If he heare any one blaspheme,
 Or take God's name in vaine,
He telles them that they crucifie
 Their Saviour Christe againe.

If you had seene his death, saith he,
 As these mine eyes have done,
Ten thousand thousand times would yee
 His torments think upon:
And suffer for his sake all paine
 Of torments, and all woes.
These are his wordes and eke his life
 Whereas he comes or goes.

THE WANDERING JEW'S SOLILOQUY
By Percy Bysshe Shelley

Is it the Eternal Triune, is it He
Who dares arrest the wheels of destiny
And plunge me in this lowest Hell of Hells?
Will not the lightning's blast destroy my frame?
Will not steel drink the blood-life where it swells?
No-let me hie where dark Destruction dwells,
To rouse her from her deeply-caverned lair,
And, taunting her curst sluggishness to ire,
Light long Oblivion's death-torch at its flame
And calmly mount Annihilation's pyre.

Tyrant of Earth! pale Misery's jackal Thou!
Are there no stores of vengeful violent fate
Within the magazines of Thy fierce hate?
No poison in Thy clouds to bathe a brow
That lowers on Thee with desperate contempt?
Where is the noonday Pestilence that slew
The myriad sons of Israel's favoured nation?
Where the destroying Minister that flew
Pouring the fiery tide of desolation
Upon the leagued Assyrian's attempt?
Where the dark Earthquake-daemon who engorged
At thy dread word Korah's unconscious crew?
Or the Angel's two-edged sword of fire that urged
Our primal parents from their bower of bliss
(Reared by Thine hand) for errors not their own
By Thine omniscient mind foredoomed, foreknown?
Yes! I would court a ruin such as this,
Almighty Tyrant, and give thanks to Thee!-
Drink deeply, drain the cup of hate, remit!...Then I
may die!

31

THE MAGICIAN'S VISITER
By Henry Neele

It was at the close of a fine autumnal day, and the shades of evening were beginning to gather over the city of Florence, when a low quick rap was heard at the door of Cornelius Agrippa, and shortly afterwards a Stranger was introduced into the apartment in which the Philosopher was sitting at his studies.

The Stranger, although finely formed, and of courteous demeanour, had a certain indefinable air of mystery about him, which excited awe, if, indeed, it had not a repellent effect. His years it was difficult to guess, for the marks of youth and age were blended in his features in a most extraordinary manner. There was not a furrow in his cheek, nor a wrinkle on his brow, and his large black eye beamed with all the brilliancy and vivacity of youth; but his stately figure was bent, apparently beneath the weight of years; his hair, although thick and clustering, was grey; and though his voice was feeble and tremulous, yet it's tones were of the most ravishing and soul-searching melody. His costume was that of a Florentine gentleman; but he held a staff like that of a Palmer in his hand, and a silken sash, inscribed with oriental characters, was bound around his waist. His face was deadly pale, but every feature of it was singularly beautiful, and it's expression was that of profound wisdom, mingled with poignant sorrow.

"Pardon me, learned Sir," said he, addressing the Philosopher, "but your fame has travelled into all lands, and has reached all ears; and I could not leave the fair City of Florence without seeking an interview with one who is it's greatest boast and ornament."

"You are right welcome, Sir," returned Agrippa; "but I fear that your trouble and curiosity will be but ill repaid. I am simply one, who, instead of devoting my days, as do the

wise, to the acquirement of wealth and honour, have passed long years in painful and unprofitable study; in endeavouring to unravel the secrets of Nature, and initiating myself in the mysteries of the Occult Sciences."

"Talkest thou of long years!" echoed the Stranger, and a melancholy smile played over his features: "thou, who hast scarcely seen fourscore since thou left'st thy cradle, and for whom the quiet grave is now waiting, eager to clasp thee in her sheltering arms! I was among the tombs to-day, the still and solemn tombs: I saw them smiling in the last beams of the setting sun. When I was a boy, I used to wish to be like that sun; his career was so long, so bright, so glorious! But to-night I thought 'it is better to slumber among those tombs than to be like him.' To-night he sank behind the hills, apparently to repose, but tomorrow he must renew his course, and run the same dull and unvaried, but toilsome and unquiet, race. There is no grave for him! and the night and morning dews are the tears that he sheds over his tyrannous destiny."

Agrippa was a deep observer and admirer of external nature and of all her phenomena, and had often gazed upon the scene which the Stranger described, but the feelings and ideas which it awakened in the mind of the latter were so different from any thing which he had himself experienced, that he could not help, for a season, gazing upon him in speechless wonder. His guest, however, speedily resumed the discourse.

"But I trouble you, I trouble you; then to my purpose in making you this visit. I have heard strange tales of a wondrous Mirror, which your potent art has enabled you to construct, in which whosoever looks may see the distant, or the dead, on whom he is desirous again to fix his gaze. My eyes see nothing in this outward visible world which can be pleasing to their sight: the grave has closed over all I loved; and Time has carried down it's stream every thing that once

contributed to my enjoyment. The world is a vale of tears: but amongst all the tears which water that sad valley, not one is shed for me! the fountain in my own heart, too, is dried up. I would once again look upon the face which I loved; I would see that eye more bright, and that step more stately, than the antelope's; that brow, the broad smooth page on which God had inscribed his fairest characters. I would gaze on all I loved, and all I lost. Such a gaze would be dearer to my heart than all that the world has to offer me; except the grave! except the grave! except the grave!"

The passionate pleading of the Stranger had such an effect upon Agrippa, who was not used to exhibit his miracle of art to the eyes of all who desired to look in it, although he was often tempted by exorbitant presents and high honours to do so, that he readily consented to grant the request of his extraordinary visiter.

"Whom would'st thou see?" he enquired.

"My child! my own sweet Miriam!" answered the Stranger.

Cornelius immediately caused every ray of the light of Heaven to be excluded from the chamber, placed the Stranger on his right hand, and commenced chaunting, in a low soft tone, and in a strange language, some lyrical verses, to which the Stranger thought he heard occasionally a response; but it was a sound so faint and indistinct that he hardly knew whether it existed any where but in his own fancy. As Cornelius continued his chaunt, the room gradually became illuminated, but whence the light proceeded it was impossible to discover. At length the Stranger plainly perceived a large Mirror, which covered the whole of the extreme end of the apartment, and over the surface of which a dense haze, or cloud, seemed to be rapidly passing.

"Died she in wedlock's holy bands?" enquired Cornelius.

"She was a virgin, spotless as the snow."

"How many years have passed away since the grave closed over her?"

A cloud gathered on the Stranger's brow, and he answered somewhat impatiently, "Many, many! more than I have now time to number."

"Nay," said Agrippa, "but I must know; for every ten years that have elapsed since her death once must I wave this wand; and when I have waved it for the last time you will see her figure in yon Mirror."

"Wave on, then," said the Stanger, and groaned bitterly, "wave on; and take heed that thou be not weary."

Cornelius Agrippa gazed on his strange guest with something of anger, but he excused his want of courtesy, on the ground of the probable extent of his calamities. He then waved his magic wand many times, but, to his consternation, it seemed to have lost it's virtue. Turning again to the Stranger, he exclaimed, "Who, and what art thou, man? Thy presence troubles me. According to all the rules of my art, this wand has already described twice two hundred years: still has the surface of the Mirror experienced no alteration. Say, do'st thou mock me, and did no such person ever exist as thou hast described to me?"

"Wave on, wave on!" was the stern and only reply which this interrogatory extracted from the Stranger.

The curiosity of Agrippa, although he was himself a dealer in wonders, began now to be excited, and a mysterious feeling of awe forbade him to desist from waving the wand, much as he doubted the sincerity of his visiter. As his arm grew slack, he heard the deep solemn tones of the Stranger, exclaiming, "Wave on, wave on!" and at length, after his wand, according to the calculations of his art, had described a period of nearly fifteen hundred years, the cloud cleared away from the surface of the Mirror, and the Stranger, with an exclamation of delight, arose, and gazed rapturously upon the scene which was there represented.

35

An exquisitely rich and romantic prospect was before him: in the distance arose lofty mountains crowned with cedars; a rapid stream rolled in the centre, and in the foreground were seen camels grazing; a rill trickling by, in which some sheep were quenching their thirst; and a lofty palm-tree, beneath whose shade a young female of exquisite beauty, and richly habited in the costume of the East, was sheltering herself from the rays of the noontide sun.

"'Tis she! 'tis she!" shouted the Stranger, and he was rushing towards the Mirror, but was prevented by Cornelius, who said, -

"Forbear, rash man, to quit this spot! with each step that thou advancest towards the Mirror, the image will become fainter, and should'st thou approach too near, it will entirely vanish."

Thus warned, he resumed his station, but his agitation was so excessive, that he was obliged to lean on the arm of the Philosopher for support; whilst, from time to time, he uttered incoherent expressions of wonder, delight, and lamentation. "'Tis she! 'tis she! even as she looked while living! How beautiful she is! Miriam, my child! can'st thou not speak to me? By Heaven, she moves! she smiles! Oh! speak to me a single word! or only breathe, or sigh! Alas! all's silent: dull and desolate as this cold heart! Again that smile! that smile, the remembrance of which a thousand winters have not been able to freeze up in my heart! Old man, it is in vain to hold me! I must, will clasp her!"

As he uttered these last words, he rushed franticly towards the Mirror; the scene represented within it faded away; the cloud gathered again over it's surface, and the Stranger sunk senseless to the earth!

When he recovered his consciousness, he found himself in the arms of Agrippa, who was chafing his temples and gazing on him with looks of fear and wonder. He immediately rose on his feet, with restored strength,

and, pressing the hand of his host, he said, "Thanks, thanks, for thy courtesy and thy kindness; and for the sweet but painful sight which thou hast presented to my eyes."

As he spake these words, he put a purse into the hand of Cornelius, but the latter returned it, saying, "Nay, nay, keep thy gold, friend. I know not, indeed, that a Christain man dare take it; but, be that as it may, I shall esteem myself sufficiently repaid, if thou wilt tell me who thou art."

"Behold!" said the Stranger, pointing to a large historical picture which hung on the left hand of the room.

"I see," said the Philosopher, "an exquisite work of art, the production of one of our best and earliest Artists, representing our Saviour carrying his Cross."

"But look again!" said the Stranger, fixing his keen dark eyes intently on him, and pointing to a figure on the left hand of the picture.

Cornelius gazed, and saw with wonder what he had not observed before, the extraordinary resemblance which this figure bore to the Stranger, of whom, indeed it might be said to be a portrait.

"That," said Cornelius, with an emotion of horror, "is intended to represent the unhappy infidel who smote the divine Sufferer for not walking faster; and was, therefore, condemned to walk the earth himself, until the period of that sufferer's second coming. 'Tis I! 'tis I!" exclaimed the Stranger; and rushing out of the house, rapidly disappeared.

Then did Cornelius Agrippa know that he had been conversing with the Wandering Jew!

A VIRTUOSO'S COLLECTION
By Nathaniel Hawthorne

The other day, having a leisure hour at my disposal,
I stepped into a new museum, to which my notice was
casually drawn by a small and unobtrusive sign: "TO BE
SEEN HERE, A VIRTUOSO'S COLLECTION." Such was
the simple yet not altogether unpromising announcement
that turned my steps aside for a little while from the sunny
sidewalk of our principal thoroughfare. Mounting a sombre
staircase, I pushed open a door at its summit, and found
myself in the presence of a person, who mentioned the
moderate sum that would entitle me to admittance.

"Three shillings, Massachusetts tenor," said he. "No,
I mean half a dollar, as you reckon in these days."

While searching my pocket for the coin I glanced at
the doorkeeper, the marked character and individuality of
whose aspect encouraged me to expect something not quite
in the ordinary way. He wore an old-fashioned great-coat,
much faded, within which his meagre person was so
completely enveloped that the rest of his attire was
undistinguishable. But his visage was remarkably wind-
flushed, sunburnt, and weather-worn, and had a most
unquiet, nervous, and apprehensive expression. It seemed
as if this man had some all-important object in view, some
point of deepest interest to be decided, some momentous
question to ask, might he but hope for a reply. As it was
evident, however, that I could have nothing to do with his
private affairs, I passed through an open doorway, which
admitted me into the extensive hall of the museum.

Directly in front of the portal was the bronze statue
of a youth with winged feet. He was represented in the act
of flitting away from earth, yet wore such a look of earnest
invitation that it impressed me like a summons to enter the
hall.

"It is the original statue of Opportunity, by the ancient sculptor Lysippus," said a gentleman who now approached me. "I place it at the entrance of my museum, because it is not at all times that once can gain admittance to such a collection."

The speaker was a middle-aged person, of whom it was not easy to determine whether he had spent his life as a scholar or as a man of action; in truth, all outward and obvious peculiarities had been worn away by an extensive and promiscuous intercourse with the world. There was no mark about him of profession, individual habits, or scarcely of country; although his dark complexion and high features made me conjecture that he was a native of some southern clime of Europe. At all events, he was evidently the virtuoso in person.

"With your permission," said he, "as we have no descriptive catalogue, I will accompany you through the museum and point out whatever may be most worthy of attention. In the first place, here is a choice collection of stuffed animals."

Nearest the door stood the outward semblance of a wolf, exquisitely prepared, it is true, and showing a very wolfish fierceness in the large glass eyes which were inserted into its wild and crafty head. Still it was merely the skin of a wolf, with nothing to distinguish it from other individuals of that unlovely breed.

"How does this animal deserve a place in your collection?" inquired I.

"It is the wolf that devoured Little Red Riding Hood," answered the virtuoso; "and by his side - with a milder and more matronly look, as you perceive - stands the she wolf that suckled Romulus and Remus."

"Ah, indeed!" exclaimed I. "And what lovely lamb is this with the snow-white fleece, which seems to be of as delicate texture as innocence itself?"

"Methinks you have but carelessly read Spenser," replied my guide, "or you would at once recognize the 'milk-white lamb' which Una led. But I set no great value upon the lamb. The next specimen is better worth our notice."

"What!" cried I, "this strange animal, with the black head of an ox upon the body of a white horse? Were it possible to suppose it, I should say that this was Alexander's steed Bucephalus."

"The same," said the virtuoso. "And can you likewise give a name to the famous charger that stands beside him?"

Next to the renowned Bucephalus stood the mere skeleton of a horse, with the white bones peeping through his ill-conditioned hide; but, if my heart had not warmed towards that pitiful anatomy, I might as well have quitted the museum at once. Its rarities had not been collected with pain and toil from the four quarters of the earth, and from the depths of the sea, and from the palaces and sepulchres of ages, for those who could mistake this illustrious steed.

"It is Rosinante!" exclaimed I, with enthusiasm.

And so it proved. My admiration for the noble and gallant horse caused me to glance with less interest at the other animals, although many of them might have deserved the notice of Cuvier himself. There was the donkey which Peter Bell cudgelled so soundly, and a brother of the same species who had suffered a similar infliction from the ancient prophet Balaam. Some doubts were entertained, however, as to the authenticity of the latter beast. My guide pointed out the venerable Argus, that faithful dog of Ulysses, and also another dog (for so the skin bespoke it), which, though imperfectly preserved, seemed once to have had three heads. It was Cerberus. I was considerably amused at detecting in an obscure corner the fox that became so famous by the loss of his tail. There were several stuffed cats, which, as a dear lover of that comfortable beast, attracted my affectionate regards. One was Dr. Johnson's

cat Hodge; and in the same row stood the favorite cats of Mahomet, Gray, and Walter Scott, together with Puss in Boots, and a cat of very noble aspect who had once been a deity of ancient Egypt. Byron's tame bear came next. I must not forget to mention the Erymanthean boar, the skin of St. George's dragon, and that of the serpent Python; and another skin with beautiful variegated hues, supposed to have been the garment of the "spirited sly snake" which tempted Eve. Against the walls were suspended the horns of the stag that Shakespeare shot; and on the floor lay the ponderous shell of the tortoise which fell upon the head of Aeschylus. In one row, as natural as life, stood the sacred bull Apis, the "cow with the crumpled horn," and a very wild-looking young heifer, which I guessed to be the cow that jumped over the moon. She was probably killed by the rapidity of her descent. As I turned away my eyes fell upon an indescribable monster, which proved to be a griffin.

"I look in vain," observed I, "for the skin of an animal which might well deserve the closest study of a naturalist - the winged horse, Pegasus."

"He is not yet dead," replied the virtuoso; "but he is so hard ridden by many young gentlemen of the day that I hope soon to add his skin and skeleton to my collection."

We now passed to the next alcove of the hall, in which was a multitude of stuffed birds. They were very prettily arranged, some on the branches of trees, others brooding upon nests, and others suspended by wires so artificially that they seemed in the very act of flight. Among them was a white dove, with a withered branch of olive leaves in her mouth.

"Can this be the very dove," inquired I, "that brought the message of peace and hope to the tempest-beaten passengers of the ark?"

"Even so," said my companion.

"And this raven, I suppose," continued I, "is the same

that fed Elijah in the wilderness."

"The raven? No," said the virtuoso; "it is a bird of modern date. He belonged to one Barnaby Rudge; and many people fancied that the devil himself was disguised under his sable plumage. But poor Grip has drawn his last cork, and has been forced to 'say die' at last. This other raven, hardly less curious, is that in which the soul of King George I. revisited his lady love, the Duchess of Kendall."

My guide next pointed out Minerva's owl and the vulture that preyed upon the liver of Prometheus. There was likewise the sacred ibis of Egypt, and one of the Stymphalides which Hercules shot in his sixth labor. Shelley's skylark, Bryant's water fowl, and a pigeon from the belfry of the Old South Church, preserved by N.P. Willis, were placed on the same perch. I could not but shudder on beholding Coleridge's albatross, transfixed with the Ancient Mariner's crossbow shaft. Beside this bird of awful poesy stood a gray goose of very ordinary aspect.

"Stuffed goose is no such rarity," observed I. "Why do you preserve such a specimen in your museum?"

"It is one of the flock whose cackling saved the Roman Capitol," answered the virtuoso. "Many geese have cackled and hissed both before and since; but none, like those, have clamored themselves into immortality."

There seemed to be little else that demanded notice in this department of the museum, unless we except Robinson Crusoe's parrot, a live phoenix, a footless bird of paradise, and a splendid peacock, supposed to be the same that once contained the soul of Pythagoras. I therefore passed to the next alcove, the shelves of which were covered with a miscellaneous collection of curiosities such as are usually found in similar establishments. One of the first things that took my eye was a strange-looking cap, woven of some substance that appeared to be neither woollen, cotton, nor linen.

"Is this a magician's cap?" I asked.

"No," replied the virtuoso; "it is merely Dr. Franklin's cap of asbestos. But here is one which, perhaps, may suit you better. It is the wishing cap of Fortunatus. Will you try it on?"

"By no means," answered I, putting it aside with my hand. "The day of wild wishes is past with me. I desire nothing that may not come in the ordinary course of Providence."

"Then probably," returned the virtuoso, "you will not be tempted to rub this lamp?"

While speaking, he took from the shelf an antique brass lamp, curiously wrought with embossed figures, but so covered with verdigris that the sculpture was almost eaten away.

"It is a thousand years," said he, "since the genius of this lamp constructed Aladdin's palace in a single night. But he still retains his power; and the man who rubs Aladdin's lamp has but to desire either a palace or a cottage."

"I might desire a cottage," replied I; "but I would have it founded on sure and stable truth, not on dreams and fantasies. I have learned to look for the real and the true."

My guide next showed me Prospero's magic wand, broken into three fragments by the hand of its mighty master. On the same shelf lay the gold ring of ancient Gyges, which enabled the wearer to walk invisible. On the other side of the alcove was a tall looking glass in a frame of ebony, but veiled with a curtain of purple silk, through the rents of which the gleam of the mirror was perceptible.

"This is Cornelius Agrippa's magic glass," observed the virtuoso. "Draw aside the curtain, and picture any human form within your mind, and it will be reflected in the mirror."

"It is enough if I can picture it within my mind."

answered I. "Why should I wish it to be repeated in the mirror? But, indeed, these works of magic have grown wearisome to me. There are so many greater wonders in the world, to those who keep their eyes open and their sight undimmed by custom, that all the delusions of the old sorcerers seem flat and stale. Unless you can show me something really curious, I care not to look farther into your museum."

"Ah, well, then," said the virtuoso, composedly, "perhaps you may deem some of my antiquarian rarities deserving of a glance."

He pointed out the iron mask, now corroded with rust; and my heart grew sick at the sight of this dreadful relic, which had shut out a human being from sympathy with his race. There was nothing half so terrible in the axe that beheaded King Charles, nor in the dagger that slew Henry of Navarre, nor in the arrow that pierced the heart of William Rufus - all of which were shown to me. Many of the articles derived their interest, such as it was, from having been formerly in the possession of royalty. For instance, here was Charlemagne's sheepskin cloak, the flowing wig of Louis Quatorze, the spinning wheel of Sardanapalus, and King Stephen's famous breeches which cost him but a crown. The heart of Bloody Mary, with the word "Calais" worn into its diseased substance, was preserved in a bottle of spirits; and near it lay the golden case in which the queen of Gustavus Adolphus treasured up that hero's heart. Among these relics and heirlooms of kings I must not forget the long, hairy ears of Midas, and a piece of bread which had been changed to gold by the touch of that unlucky monarch. And as Grecian Helen was a queen, it may here be mentioned that I was permitted to take into my hand a lock of her golden hair and the bowl which a sculptor modelled from the curve of her perfect breast. Here, likewise, was the robe that smothered

Agamemnon, Nero's fiddle, the Czar Peter's brandy bottle, the crown of Semiramis, and Canute's sceptre which he extended over the sea. That my own land may not deem itself neglected, let me add that I was favored with a sight of the skull of King Philip, the famous Indian chief, whose head the Puritans smote off and exhibited upon a pole.

"Show me something else," said I to the virtuoso. "Kings are in such an artificial position that people in the ordinary walks of life cannot feel an interest in their relics. If you could show me the straw hat of sweet little Nell, I would far rather see it than a king's golden crown."

"There it is," said my guide, pointing carelessly with his staff to the straw hat in question. "But, indeed, you are hard to please. Here are the seven-league boots. Will you try them on?"

"Our modern railroads have superseded their use," answered I; "and as to these cowhide boots, I could show you quite as curious a pair at the Transcendental community in Roxbury."

We next examined a collection of swords and other weapons, belonging to different epochs, but thrown together without much attempt at arrangement. Here was Arthur's sword Excalibar, and that of the Cid Campeador, and the sword of Brutus rusted with Caesar's blood and his own, and the sword of Joan of Arc, and that of Horatius, and that with which Virginius slew his daughter, and the one which Dionysius suspended over the head of Damocles. Here also was Arria's sword, which she plunged into her own breast, in order to taste of death before her husband. The crooked blade of Saladin's cimeter next attracted my notice. I know not by what chance, but so it happened, that the sword of one of our own militia generals was suspended between Don Quixote's lance and the brown blade of Hudibras. My heart throbbed high at the sight of the helmet of Miltiades and the spear that was broken in the breast of Epaminondas.

I recognized the shield of Achilles by its resemblance to the admirable cast in the possession of Professor Felton. Nothing in this apartment interested me more than Major Pitcairn's pistol, the discharge of which, at Lexington, began the war of the revolution, and was reverberated in thunder around the land for seven long years. The bow of Ulysses, though unstrung for ages, was placed against the wall, together with a sheaf of Robin Hood's arrows and the rifle of Daniel Boone.

"Enough of weapons," said I, at length; "although I would gladly have seen the sacred shield which fell from heaven in the time of Numa. And surely you should obtain the sword which Washington unsheathed at Cambridge. But the collection does you much credit. Let us pass on."

In the next alcove we saw the golden thigh of Pythagoras, which had so divine a meaning; and, by one of the queer analogies to which the virtuoso seemed to be addicted, this ancient emblem lay on the same shelf with Peter Stuyvesant's wooden leg, that was fabled to be of silver. Here was a remnant of the Golden Fleece, and a spring of yellow leaves that resembled the foliage of a frostbitten elm, but was duly authenticated as a portion of the golden branch by which Aeneas gained admittance to the realm of Pluto. Atalantas' golden apple and one of the apples of discord were wrapped in the napkin of gold which Rampsinitus brought from Hades; and the whole were deposited in the golden vase of Bias, with its inscription: "TO THE WISEST."

"And how did you obtain this vase?" said I to the virtuoso.

"It was given me long ago," replied he, with a scornful expression in his eye, "because I had learned to despise all things."

It had not escaped me that, though the virtuoso was evidently a man of high cultivation, yet he seemed to lack

sympathy with the spiritual, the sublime, and the tender. Apart from the whim that had led him to devote so much time, pains, and expense to the collection of this museum, he impressed me as one of the hardest and coldest men of the world whom I had ever met.

"To despise all things!" repeated I. "This, at best, is the wisdom of the understanding. It is the creed of a man whose soul, whose better and diviner part has never been awakened, or has died out of him."

"I did not think that you were still so young," said the virtuoso. "Should you live to my years, you will acknowledge that the vase of Bias was not ill bestowed."

Without further discussion of the point, he directed my attention to other curiosities. I examined Cinderella's little glass slipper, and compared it with one of Diana's sandals, and with Fanny Elssler's shoe, which bore testimony to the muscular character of her illustrious foot. On the same shelf were Thomas the Rhymer's green velvet shoes, and the brazen shoe of Empedocles which was thrown out of Mount Aetna. Anacreon's drinking cup was placed in apt juxtaposition with one of Tom Moore's wine glasses and Circe's magic bowl. These were symbols of luxury and riot; but near them stood the cup whence Socrates drank his hemlock, and that which Sir Philip Sidney put from his death-parched lips to bestow the draught upon a dying soldier. Next appeared a cluster of tobacco pipes, consisting of Sir Walter Raleigh's, the earliest on record, Dr. Parr's, Charles Lamb's, and the first calumet of peace which was ever smoked between a European and an Indian. Among other musical instruments, I noticed the lyre of Orpheus and those of Homer and Sappho, Dr. Franklin's famous whistle, the trumpet of Anthony Van Corlear, and the flute which Goldsmith played upon in his rambles through the French provinces. The staff of Peter the Hermit stood in a corner with that of good old Bishop Jewel, and one of ivory,

which had belonged to Papirius, the Roman senator. The ponderous club of Hercules was close at hand. The virtuoso showed me the chisel of Phidias, Claude's palette, and the brush of Apelles, observing that he intended to bestow the former either on Greenough, Crawford, or Powers, and the two latter upon Washington Allston. There was a small vase of oracular gas from Delphos, which I trust will be submitted to the scientific analysis of Professor Silliman. I was deeply moved on beholding a vial of the tears into which Niobe was dissolved; nor less so on learning that a shapeless fragment of salt was a relic of that victim of despondency and sinful regrets - Lot's wife. My companion appeared to set great value upon some Egyptian darkness in a blacking jug. Several of the shelves were covered by a collection of coins, among which, however, I remember none but the Splendid Shilling, celebrated by Phillips, and a dollar's worth of the iron money of Lycurgus, weighing about fifty pounds.

Walking carelessly onward, I had nearly fallen over a huge bundle, like a pedlar's pack, done up in sackcloth, and very securely strapped and corded.

"It is Christian's burden of sin," said the virtuoso.

"O, pray let us open it!" cried I. "For many a year I have longed to know its contents."

"Look into your own consciousness and memory," replied the virtuoso. "You will there find a list of whatever it contains."

As this was an undeniable truth, I threw a melancholy look at the burden and passed on. A collection of old garments, hanging on pegs, was worthy of some attention, especially the shirt of Nessus, Caesar's mantle, Joseph's coat of many colors, the Vicar of Bray's cassock, Goldsmith's peach-bloom suit, a pair of President Jefferson's scarlet breeches, John Randolph's red baize hunting shirt, the drab smallclothes of the Stout Gentleman, and the rags of

the "man all tattered and torn." George Fox's hat impressed me with deep reverence as a relic of perhaps the truest apostle that has appeared on earth for these eighteen hundred years. My eye was next attracted by an old pair of shears, which I should have taken for a memorial of some famous tailor, only that the virtuoso pledged his veracity that they were the identical scissors of Atropos. He also showed me a broken hourglass which had been thrown aside by Father Time, together with the old gentleman's gray forelock, tastefully braided into a brooch. In the hourglass was the handful of sand, the grains of which had numbered the years of the Cumaean sibyl. I think it was in this alcove that I saw the inkstand which Luther threw at the devil, and the ring which Essex, while under sentence of death, sent to Queen Elizabeth. And here was the blood-encrusted pen of steel with which Faust signed away his salvation.

The virtuoso now opened the door of a closet and showed me a lamp burning, while three others stood unlighted by its side. One of the three was the lamp of Diogenes, another that of Guy Fawkes, and the third that which Hero set forth to the midnight breeze in the high tower of Abydos.

"See!" said the virtuoso, blowing with all his force at the lighted lamp.

The flame quivered and shrank away from his breath, but clung to the wick, and resumed its brilliancy as soon as the blast was exhausted.

"It is an undying lamp from the tomb of Charlemagne," observed my guide. "That flame was kindled a thousand years ago."

"How ridiculous to kindle an unnatural light in tombs!" exclaimed I. "We should seek to behold the dead in the light of heaven. But what is the meaning of this chafing dish of glowing coals?"

"That," answered the virtuoso, "is the original fire which Prometheus stole from heaven. Look steadfastly into it, and you will discern another curiosity."

I gazed into that fire, - which, symbolically, was the origin of all that was bright and glorious in the soul of man, - and in the midst of it, behold, a little reptile, sporting with evident enjoyment of the fervid heat! It was a salamander.

"What a sacrilege!" cried I, with inexpressible disgust. "Can you find no better use for this ethereal fire than to cherish a loathsome reptile in it? Yet there are men who abuse the sacred fire of their own souls to as foul and guilty a purpose."

The virtuoso made no answer except by a dry laugh and an assurance that the salamander was the very same which Benvenuto Cellini had seen in his father's household fire. He then proceeded to show me other rarities; for this closet appeared to be the receptacle of what he considered most valuable in his collection.

"There," said he, "is the Great Carbuncle of the White Mountains."

I gazed with no little interest at this mighty gem, which it had been one of the wild projects of my youth to discover. Possibly it might have looked brighter to me in those days than now; at all events, it had not such brilliancy as to detain me long from the other articles of the museum. The virtuoso pointed out to me a crystalline stone which hung by a gold chain against the wall.

"This is the philosopher's stone," said he.

"And have you the elixir vitae which generally accompanies it?" inquired I.

"Even so; this urn is filled with it," he replied. "A draught would refresh you. Here is Hebe's cup; will you quaff a health from it?"

My heart thrilled within me at the idea of such a reviving draught; for methought I had great need of it after

travelling so far on the dusty road of life. But I know not whether it were a peculiar glance in the virtuoso's eye, or the circumstance that this most precious liquid was contained in an antique sepulchral urn, that made me pause. Then came many a thought with which, in the calmer and better hours of life, I had strengthened myself to feel that Death is the very friend whom, in his due season, even the happiest mortal should be willing to embrace.

"No; I desire not an earthly immortality," said I. "Were man to live longer on the earth, the spiritual would die out of him. The spark of ethereal fire would be choked by the material, the sensual. There is a celestial something within us that requires, after a certain time, the atmosphere of heaven to preserve it from decay and ruin. I will have none of this liquid. You do well to keep it in a sepulchral urn; for it would produce death while bestowing the shadow of life."

"All this is unintelligible to me," responded my guide, with indifference. "Life - earthly life - is the only good. But you refuse the draught? Well, it is not likely to be offered twice within one man's experience. Probably you have griefs which you seek to forget in death. I can enable you to forget them in life. Will you take a draught of Lethe?"

As he spoke, the virtuoso took from the shelf a crystal vase containing a sable liquor, which caught no reflected image from the objects around.

"Not for the world!" exclaimed I, shrinking back. "I can spare none of my recollections, not even those of error or sorrow. They are all alike the food of my spirit. As well never to have lived as to lose them now."

Without further parley we passed to the next alcove, the shelves of which were burdened with ancient volumes and with those rolls of papyrus in which was treasured up the eldest wisdom of the earth. Perhaps the most valuable work in the collection, to a bibliomaniac, was the Book of

Hermes. For my part, however, I would have given a higher price for those six of the Sibyl's books which Tarquin refused to purchase, and which the virtuoso informed me he had himself found in the cave of Trophonius. Doubtless these old volumes contain prophecies of the fate of Rome, both as respects the decline and fall of her temporal empire and the rise of her spiritual one. Not without value, likewise, was the work of Anaxagoras on Nature, hitherto supposed to be irrecoverably lost, and the missing treatises of Longinus, by which modern criticism might profit, and those books of Livy for which the classic student has so long sorrowed without hope. Among these precious tomes I observed the original manuscript of the Koran, and also that of the Mormon Bible in Joe Smith's authentic autograph. Alexander's copy of the Iliad was also there, enclosed in the jewelled casket of Darius, still fragrant of the perfumes which the Persian kept in it.

Opening an iron-clasped volume, bound in black leather, I discovered it to be Cornelius Agrippa's book of magic; and it was rendered still more interesting by the fact that many flowers, ancient and modern, were pressed between its leaves. Here was a rose from Eve's bridal bower, and all those red and white roses which were plucked in the garden of the Temple by the partisans of York and Lancaster. Here was Halleck's Wild Rose of Alloway. Shelley had contributed a Sensitive Plant, and Wordsworth an Eglantine, and Burns a Mountain Daisy, and Kirke White a Star of Bethlehem, and Longfellow a Sprig of Fennel, with its yellow flowers. James Russell Lowell had given a Pressed Flower, but fragrant still, which had been shadowed in the Rhine. There was also a sprig from Southey's Holly Tree. One of the most beautiful specimens was a Fringed Gentian, which had been plucked and preserved for immortality by Bryant. From Jones Very, a poet whose voice is scarcely heard among us by reason of its depth, there was a Wind

Flower and a Columbine.

As I closed Cornelius Agrippa's magic volume, an old, mildewed letter fell upon the floor. It proved to be an autograph from the Flying Dutchman to his wife. I could linger no longer among books; for the afternoon was waning, and there was yet much to see. The bare mention of a few more curiosities must suffice. The immense skull of Polyphemus was recognizable by the cavernous hollow in the centre of the forehead where once had blazed the giant's single eye. The tub of Diogenes, Medea's caldron, and Psyche's vase of beauty were placed one within another. Pandora's box, without the lid, stood next, containing nothing but the girdle of Venus, which had been carelessly flung into it. A bundle of birch rods which had been used by Shenstone's schoolmistress were tied up with the Countess of Salisbury's garter. I knew not which to value most, a roc's egg as big as an ordinary hogshead, or the shell of the egg which Columbus set upon its end. Perhaps the most delicate article in the whole museum was Queen Mab's chariot, which to guard it from the touch of meddlesome fingers, was placed under a glass tumbler.

Several of the shelves were occupied by specimens of entomolgy. Feeling but little interest in the science I noticed only Anacreon's grasshopper, and a humble bee which had been presented to the virtuoso by Ralph Waldo Emerson.

In the part of the hall which we had now reached I observed a curtain, that descended from the ceiling to the floor in voluminous folds, of a depth, richness, and magnificence which I had never seen equalled. It was not to be doubted that this splendid though dark and solemn veil concealed a portion of the museum even richer in wonders than that through which I had already passed; but, on my attempting to grasp the edge of the curtain and draw it aside, it proved to be an illusive picture.

"You need not blush," remarked the virtuoso; "for the

same curtain deceived Zeuxis. It is the celebrated painting of Parrhasius.

In a range with the curtain there were a number of other choice pictures by artists of ancient days. Here was the famous cluster of grapes by Zeuxis, so admirably depicted that it seemed as if the ripe juice were bursting forth. As to the picture of the old woman by the same illustrious painter, and which was so ludicrous that he himself died with laughing at it, I cannot say that it particularly moved my risibility. Ancient humor seems to have little power over modern muscles. Here, also, was the horse painted by Apelles which living horses neighed at; his first portrait of Alexander the Great, and his last unfinished picture of Venus asleep. Each of these works of art, together with others by Parrhasius, Timanthes, Polygnotus, Apollodorus, Pausias, and Pamphilus, required more time and study than I could bestow for the adequate perception of their merits. I shall therefore leave them undescribed and uncriticized, nor attempt to settle the question of superiority between ancient and modern art.

For the same reason I shall pass lightly over the specimens of antique sculpture which this indefatigable and fortunate virtuoso had dug out of the dust of fallen empires. Here was Aetion's cedar statue of Aesculapius, much decayed, and Alcon's iron statue of Hercules, lamentably rusted. Here was the statue of Victory, six feet high, which the Jupiter Olympus of Phidias had held in his hand. Here was a forefinger of the Colossus of Rhodes, seven feet in length. Here was the Venus Urania of Phidias, and other images of male and female beauty or grandeur, wrought by sculptors who appear never to have debased their souls by the sight of any meaner forms than those of gods or godlike mortals. But the deep simplicity of these great works was not to be comprehended by a mind excited and disturbed, as mine was, by the various objects that had

recently been presented to it. I therefore turned away with merely a passing glance, resolving on some future occasion to brood over each individual statue and picture until my inmost spirit should feel their excellence. In this department, again, I noticed the tendency to whimsical combinations and ludicrous analogies which seemed to influence many of the arrangements of the museum. The wooden statue so well known as the Palladium of Troy was placed in close apposition with the wooden head of General Jackson which was stolen a few years since from the bows of the frigate Constitution.

We had now completed the circuit of the spacious hall, and found ourselves again near the door. Feeling somewhat wearied with the survey of so many novelties and antiquities, I sat down upon Cowper's sofa, while the virtuoso threw himself carelessly into Rabelais' easy chair. Casting my eyes upon the opposite wall, I was surprised to perceive the shadow of a man flickering unsteadily across the wainscot, and looking as if it were stirred by some breath of air that found its way through the door or windows. No substantial figure was visible from which this shadow might be thrown; nor, had there been such, was there any sunshine that would have caused it to darken upon the wall.

"It is Peter Schlemihl's shadow," observed the virtuoso, "and one of the most valuable articles in my collection."

"Methinks a shadow would have made a fitting doorkeeper to such a museum," said I, "although, indeed, yonder figure has something strange and fantastic about him, which suits well enough with many of the impressions which I have received here. Pray, who is he?"

While speaking, I gazed more scrutinizingly than before at the antiquated presence of the person who had admitted me, and who still sat on his bench with the same

restless aspect, and dim, confused, questioning anxiety that I had noticed on my first entrance. At this moment he looked eagerly towards us, and, half starting from his seat, addressed me.

"I beseech you, kind sir," said he in a cracked, melancholy tone, "have pity on the most unfortunate man in the world. For Heaven's sake, answer me a single question! Is this the town of Boston?"

"You have recognized him now," said the virtuoso. "It is Peter Rugg, the missing man. I chanced to meet him the other day still in search of Boston, and conducted him hither; and, as he could not succeed in finding his friends, I have taken him into my service as doorkeeper. He is somewhat too apt to ramble, but otherwise a man of trust and integrity."

"And might I venture to ask," continued I, "to whom am I indebted for this afternoon's gratification?"

The virtuoso, before replying, laid his hand upon an antique dart, or javelin, the rusty steel head of which seemed to have been blunted, as if it had encountered the resistance of a tempered shield, or breastplate.

"My name has not been without its distinction in the world for a longer period than that of any other man alive," answered he. "Yet many doubt of my existence; perhaps you will do so tomorrow. This dart which I hold in my hand was once grim Death's own weapon. It served him well for the space of four thousand years; but it fell blunted, as you see, when he directed it against my breast."

These words were spoken with the calm and cold courtesy of manner that had characterized this singular personage throughout our interview. I fancied, it is true, that there was a bitterness indefinably mingled with his tone, as of one cut off from natural sympathies and blasted with a doom that had been inflicted on no other human being, and by the results of which he had ceased to be

human. Yet, withal, it seemed one of the most terrible consequences of that doom that the victim no longer regarded it as a calamity, but had finally accepted it as the greatest good that could have befallen him."

"You are the Wandering Jew!" exclaimed I.

The virtuoso bowed without emotion of any kind; for, by centuries of custom, he had almost lost the sense of strangeness in his fate, and was but imperfectly conscious of the astonishment and awe with which it affected such as are capable of death.

"Your doom is indeed a fearful one!" said I, with irrepressible feeling and a frankness that afterwards startled me; "yet perhaps the ethereal spirit is not entirely extinct under all this corrupted or frozen mass of earthly life. Perhaps the immortal spark may yet be rekindled by a breath of heaven. Perhaps you may yet be permitted to die before it is too late to live eternally. You have my prayers for such a consummation. Farewell."

"Your prayers will be in vain," replied he, with a smile of cold triumph. "My destiny is linked with the realities of earth. You are welcome to your visions and shadows of a future state; but give me what I can see, and touch, and understand, and I ask no more."

"It is indeed too late," thought I. "The soul is dead within him."

Struggling between pity and horror, I extended my hand, to which the virtuoso gave his own, still with the habitual courtesy of a man of the world, but without a single heart throb of human brotherhood. The touch seemed like ice, yet I know not whether morally or physically. As I departed, he bade me observe that the inner door of the hall was constructed with the ivory leaves of the gateway through which Aeneas and the Sibyl has been dismissed from Hades.

PASSAGES FROM THE AUTOBIOGRAPHY OF THE WANDERING JEW
By George MacDonald

"I have at length been ill, very ill, once more, and for many reasons foreign to the weightiest, which I had forgotten, I had hoped that I was going to die. But therein I am as usual deceived and disappointed. That I have been out of my mind I know, by having returned to the real knowledge of what I am. The conscious present has again fallen together and made a whole with the past, and that whole is my personal identity.

"How I broke loose from the bonds of madness, which, after so many and heavy years of uninterrupted sanity, had at length laid hold upon me, I will now relate.

"I had, as I have said, been very ill - with some sort of fever that had found fit rooting in a brain overwearied, from not having been originally constructed to last so long. Whether it came not of an indwelling demon, or a legion of demons, I cannot tell - God knows. Surely I was as one possessed. I was mad, whether for years, or but for moments - who can tell? I cannot. Verily it seems for many years; but, knowing well the truth concerning the relations of time in him that dreameth and waketh from his dream, I place no confidence in the testimony of the impressions left upon my seeming memory. I can however trust it sufficiently as to the character of the illusions that then possessed me. I imagined myself an Englishman called Polwarth, of an ancient Cornish family. Indeed, I had in my imagination, as Polwarth, gone through the history, every day of it, with its sunrise and sunset, of more than half a lifetime. I had a brother who was deformed and a dwarf, and a daughter who was like him; and the only thing, throughout the madness, that approached a consciousness of my real being and

history, was the impression that these things had come upon me because of a certain grievous wrong I had at one time committed, which wrong, however, I had quite forgotten - and could ill have imagined in its native hideousness.

"But one morning, just as I woke, after a restless night filled with dreams, I was aware of a half-embodied shadow in my mind - whether thought or memory or imagination, I could not tell: and the strange thing was, that it darkly radiated from it the conviction that I must hold and identify it, or be for ever lost to myself. Therefore, with all the might of my will to retain the shadow, and all the energy of my recollection to recall that of which it was the vague shadow, I concentrated the whole power of my spiritual man upon the phantom thought, to fix and retain it.

"Everyone knows what it is to hunt such a formless fact. Evanescent as a rainbow, its whole appearance, from the first, is that of a thing in the act of vanishing. It is a thing that was known, but, from the moment consciousness turned its lantern upon it, began to become invisible. For a time, during the close pursuit that follows, it seems only to be turning corner after corner to evade the mind's eye, but behind every corner it leaves a portion of itself; until at length, although when finally cannot be told, it is gone so utterly that the mind remains aghast in the perplexity of the doubt whether ever there was a thought there at all.

"Throughout my delusion of an English existence, I had been tormented in my wakings with such thought-phantoms, and ever had I followed them, as an idle man may follow a flitting marsh-fire. Indeed, I had grown so much interested in the phenomenon and its possible indications that I had invented various theories to account for them, some of which seemed to myself original and ingenious, while the common idea that they are vague reminiscences of a former state of being, I had again and

again examined, and as often entirely rejected, as in no way tenable or verisimilar.

"But upon the morning to which I have referred, I succeeded, for the first time, in fixing, capturing, identifying the haunting, fluttering thing. That moment the bonds of my madness were broken. My past returned upon me. I had but to think in any direction, and every occurrence, with time and place and all its circumstance, rose again before me. The awful fact of my own being once more stood bare - awful always - tenfold more awful after such a period of blissful oblivion thereof: I was, I had been, I am now, as I write, the man so mysterious in crime, so unlike all other men in his punishment, known by various names in various lands - here in England as the Wandering Jew. Ahasuerus was himself again, alas! - himself and no other. Wife, daughter, brother vanished, and returned only in dreams. I was and remain the wanderer, the undying, the repentant, the unforgiven. O heart! O weary feet! O eyes that have seen and never more shall see, until they see once and are blinded for ever! Back upon my soul rushes the memory of my deed, like a storm of hail mingled with fire, flashing through every old dry channel, that it throbs and writhes anew, scorched at once and torn with the poisonous burning.

II

"It was a fair summer-morning in holy Jerusalem, and I sat and wrought at my trade, for I sewed a pair of sandals for the feet of the high priest Caiaphas. And I wrought diligently, for it behoved me to cease an hour ere set of sun, for it was the day of preparation for the eating of the Passover.

"Now all that night there had been a going to and fro in the city, for the chief priests and their followers had at length laid hands upon him that was called Jesus, whom

some believed to be the Messiah, and others, with my fool-self amongst them, an arch-imposter and blasphemer. For I was of the house of Caiaphas, and heartily did desire that the man my lord declared a deceiver of the people, should meet with the just reward of his doings. Thus I sat and worked, and thought and rejoiced; and the morning passed and the noon came.

"It was a day of sultry summer, and the street burned beneath the sun, and I sat in the shadow and looked out upon the glare; and ever I wrought at the sandals of my lord, with many fine stitches, in cunning workmanship. All had been for some time very still, when suddenly I thought I heard a far-off tumult. And soon came the idle children, who ever run first that they be not swallowed up of the crowd; and they ran and looked behind as they ran. And after them came the crowd, crying and shouting, and swaying hither and thither; and in the midst of it arose the one arm of a cross, beneath the weight of which that same Jesus bent so low that I saw him not. Truly, said I, he hath not seldom borne heavier burdens in the workshop of his father the Galilean, but now his sins and his idleness have found him, and taken from him his vigour; for he that despiseth the law shall perish, while they that wait upon the Lord shall renew their strength. For I was wroth with the man who taught the people to despise the great ones that administered the law, and give honour to the small ones who only kept it. Besides, he had driven my father's brother from the court of the Gentiles with a whip, which truly hurt him not outwardly, but stung him to the soul; and yet that very temple which he pretended thus to honour, he had threatened to destroy and build again in three days! Such were the thoughts of my heart; and when I learned from the boys that it was in truth Jesus of Nazareth who passed on his way to Calvary to be crucified, my heart leaped within me at the thought that the law had at length overtaken the

malefactor. I laid down the sandal and my awl, and rose and went forth and stood in the front of my shop. And Jesus drew nigh, and as he passed, lo, the end of the cross dragged upon the street. And one in the crowd came behind, and lifted it up and pushed therewith, so that Jesus staggered and had nigh fallen. Then would he fain have rested the arm of the cross on the stone by which I was wont to go up into my shop from the street. But I cried out, and drove him thence, saying scornfully, *Go on, Jesus; go on. Truly thou restest not on stone of mine!* Then turned he his eyes upon me, and said, *I go indeed, but thou goest not*; and therefore he rose again under the weight of the cross, and staggered on.

"And I followed in the crowd to Calvary."

Here the reader paused and said,

"I can give you but a few passages now. You see it is a large manuscript. I will therefore choose some of those that bear upon the subject of which we have been talking. A detailed account of the crucifixion follows here, which I could not bring myself to read aloud. The eclipse is in it, and the earthquake, and the white faces of the risen dead gleaming through the darkness about the cross. It ends thus:

"And all the time, I stood not far from the foot of the cross, nor dared go nearer, for around it were his mother and they that were with her, and my heart was sore for her also. And I would have withdrawn my foot from the place where I stood, and gone home to weep, but something, I know not what, held me there as it were rooted to the ground. At length the end was drawing near. He opened his mouth and spake to his mother and the disciple who stood by her, but truly I know not what he said, for as his eyes turned from them, they looked upon me, and my heart died within me. He said nought, but his eyes had that in them that would have slain me with sorrow, had not death,

although I knew it not, already shrunk from my presence, daring no more come nigh such a malefactor. - Oh Death, how gladly would I build thee a temple, set thee in a lofty place, and worship thee with the sacrifice of vultures on a fire of dead men's bones, wouldst thou but hear my cry! - But I rave again in my folly! God forgive me. All the days of my appointed time will I wait until my change comes. - With that look - a well of everlasting tears in my throbbing brain - my feet were unrooted, and I fled...."

Here the reader paused again, and turned over many leaves.

"And ever as I passed at night through the lands, when I came to a cross by the wayside, thereon would I climb, and, winding my arms about its arms and my feet about its stem, would there hang in the darkness or the moon, in rain or hail, in wind or snow or frost, until my sinews gave way, and my body dropped, and I knew no more until I found myself lying at its foot in the morning. For, ever in such case, I lay without sense until again the sun shone upon me.

"....And if ever the memory of that look passed from me, then straightway I began to long for death, and so longed until the memory and the power of the look came again, and with the sorrow in my soul came the patience to live. And truly, although I speak of forgetting and remembering, such motions of my spirit in me were not as those of another man; in me they are not of years, but of centuries; for the seconds of my life are ticked by a clock whose pendulum swings through an arc of motionless stars.

"Once I had a vision of Death. Methinks it must have been a precursive vapour of the madness that afterwards infolded me, for I know well that there is not one called Death, that he is but a word needful to the weakness of human thought and the poverty of human speech; that he is a no-being, and but a change from that which is. - I had

a vision of Death, I say. And it was on this wise:

"I was walking over a wide plain of sand, like Egypt, so that ever and anon I looked around me to see if nowhere, from the base of the horizon, the pyramids cut their triangle out of the blue night of heaven; but I saw none. The stars came down and sparkled on the dry sands, and all was waste, and wide desolation. The air also was still as the air of a walled-up tomb, where there are but dry bones, and not even the wind of an evil vapour that rises from decay. And through the dead air came over the low moaning of a distant sea, towards which my feet did bear me. I had been journeying thus for years, and in their lapse it had grown but a little louder. - Suddenly I was aware that I was not alone. A dim figure strode beside me, vague, but certain of presence. And I feared him not, seeing that which men fear the most was itself that which by me was the most desired. So I stood and turned and would have spoken. But the shade that seemed not a shadow, went on and regarded me not. Then I also turned again towards the moaning of the sea and went on. And lo! the shade which had gone before until it seemed but as a vapour among the stars, was again by my side walking. And I said, and stood not, but walked on: Thou shade that art not a shadow, seeing there shineth no sun or moon, and the stars are many, and the one slayeth the shadow of the other, what art thou, and wherefore goest thou by my side? Think not to make me afraid, for I fear nothing in the universe but that which I love the best. - I spake of the eyes of the Lord Jesus. - Then the shade that seemed no shadow answered me and spake and said: Little knowest thou what I am, seeing the very thing thou sayest I am not, that I am, and nought else, and there is no other but me. I am Shadow, the shadow, the only shadow - none such as those from which the light hideth in terror, yet like them, for life hideth from me and turneth away, yet if life were not, neither were I, for I am nothing; and yet again, as

soon as anything is, there I am, and needed no maker, but came of myself, for I am Death. - Ha! Death! I cried, and would have cast myself before him with outstretched arms of worshipful entreaty; but lo, there was a shadow upon the belt of Orion, and no shadow by my side! and I sighed, and walked on towards the ever moaning sea. Then again the shadow was by my side. And again I spake and said: Thou thing of flitting and return, I despise thee, for thou wilt not abide the conflict. And I would have cast myself upon him and wrestled with him there, for defeat and not for victory. But I could not lay hold upon him. Thou art a powerless nothing, I cried; I will not even defy thee. - Thou wouldst provoke me, said the shadow, but it availeth not. I cannot be provoked. Truly, I am but a shadow, yet know I my own worth, for I am the Shadow of the Almighty, and where he is, there am I. - Thou art nothing, I said. - Nay, nay, I am not Nothing. Thou, nor any man - God only knoweth what that word meaneth. I am but the shadow of Nothing, and when thou sayest nothing, thou meanest only me; but what God meaneth when he sayeth Nothing - the nothing without him, that nothing which is no shadow but the very substance of Unbeing - no created soul can know. - Then art thou not Death? I asked. - I am what thou thinkest of when thou sayest Death, he answered, but I am not Death. - Alas, then! why comest thou to me in the desert places, for I did think thou wast Death indeed, and couldst take me unto thee so that I should be no more. - That is what death cannot do for thee, said the shadow; none but he that created thee can cause that thou shouldst be no more. Thou art until he will that thou be not. I have heard it said amongst the wise that, hard as it is to create, it is harder still to uncreate. Truly I cannot tell. But wouldst thou be uncreated by the hand of Death? Wouldst thou have thy no-being the gift of a shadow? - Then I thought of the eyes of the Lord Jesus, and the look he cast upon me, and I said, No: I would not be

65

carried away of Death. I would be fulfilled of Life, and stand before God for ever. Then once again the belt of Orion grew dim, and I saw the shadow no more. And yet did I long for Death, for I thought he might bring me to those eyes, and the pardon that lay in them.

<p style="text-align:center">********</p>

"But again, as the years went on, and each brought less hope than that before it, I forgot the look the Lord had cast upon me, and in the weariness of the life that was mortal and yet would not cease, in the longing after the natural end of that which against nature endured, I began to long even for the end of being itself. And in a city of the Germans, I found certain men of my own nation who said unto me: Fear not, Ahasuerus; there is no life beyond the grave. Live on until thy end come, and cease thy complaints. Who is there among us who would not gladly take upon him thy judgment, and live until he was weary of living? - Yea, but to live after thou art weary? I said. But they heeded me not, answering me and saying: Search thou the Scriptures, even the Book of the Law, and see if thou find there one leaf of this gourd of a faith that hath sprung up in a night. Verily, this immortality is but a flash in the brain of men that would rise above their fate. Sayeth Moses, or sayeth Job, or sayeth David or Daniel a word of the matter? And I listened unto them, and became of their mind. But therewithal the longing after death returned with tenfold force and I rose up and girt my garment about me, and went forth once more to search for him whom I now took for the porter of the gate of eternal silence and unfelt repose. And I said unto myself as I walked: What in the old days was sweeter when I was weary with my labour at making of shoes, than to find myself dropping into the death of sleep! how much sweeter then must it not be to sink into the

sleepiest of sleeps, the father-sleep, the mother-bosomed death of nothingness and unawaking rest! Then shall all this endless whir of the wheels of thought and desire be over; then welcome the night whose darkness doth not seethe, and which no morning shall ever stir!..........

" And wherever armies were drawing nigh, each to the other, and the day of battle was near, thither I flew in hot haste, that I might be first upon the field, and ready to welcome hottest peril. I fought not, for I would not slay those that counted it not the good thing to be slain, as I counted it. But had the armies been of men that loved death like me, how had I raged among them then, even as the angel Azrael, to give them their sore-desired rest! for I loved and hated not my kind, and would diligently have mown them down out of the stinging air of life into the soft balm of the sepulchre. But what they sought not, and I therefore would not give, that searched I after the more eagerly for myself. And my sight grew so keen that, when yet no bigger than a mote in the sunbeam, I could always descry the vulture-scout, hanging aloft over the field of destiny. Then would I hasten on and on, until a swoop would have brought him straight on my head...........

"And with that a troop of horsemen, horses and men mad with living fear, came with a level rush towards the spot where I sat, faint with woe. And I sprang up, and bounded to meet them, throwing my arms aloft and shouting, as one who would turn a herd. And like a wave of the rising tide before a swift wind, a wave that sweeps on and breaks not, they came hard-buffeting over my head. Ah! that was a torrent indeed! - a thunderous succession of solid billows, alive, hurled along by the hurricane-fear in the heart of them! For one moment only I felt and knew what I lay beneath, and then for a time there was nothing. - I woke in silence, and thought I was dying, that I had all but passed across the invisible line between, and in a moment there

would be for evermore nothing and nothing. Then followed again an empty space as it seemed. And now I am dead and gone, I said, and shall wander no more. And with that came the agony of hell, for, lo, still I thought! And I said to myself, Alas! O God! for, notwithstanding I no more see or hear or taste or smell or touch, and my body hath dropped from me, still am I Ahasuerus, the Wanderer, and must go on and on and on, blind and deaf, through the unutterable wastes that know not the senses of man - nevermore to find rest! Alas! death is not death, seeing he slayeth but the leathern bottle, and spilleth not the wine of life upon the earth. Alas! alas! for I cannot die! And with that a finger twitched, and I shouted aloud for joy: I was yet in the body! And I sprang to my feet jubilant, and, lame and bruised and broken-armed, tottered away after Death, who yet might hold the secret of eternal repose. I was alive, but yet there was hope, for Death was yet before me! I was alive, but I had not died, and who could tell but I might yet find the lovely night that hath neither clouds or stars! I had not passed into the land of the dead and found myself yet living! The wise men of my nation in the city of the Almains might yet be wise! And for an hour I rejoiced, and was glad greatly.

<p style="text-align:center">********</p>

<p style="text-align:center">III</p>

"It was midnight, and sultry as hell. All day not a breath had stirred. The country through which I passed was level as the sea that had once flowed above it. My heart had almost ceased to beat, and I was weary as the man who is too weary to sleep outright, and labours in his dreams. I slumbered and yet walked on. My blood flowed scarce faster than the sluggish water in the many canals I crossed on my weary way. And ever I thought to meet the shadow that was

and was not death. But this was no dream. Just on the stroke of midnight, I came to the gate of a large city, and the watchers let me pass. Through many an ancient and lofty street I wandered, like a ghost in a dream, knowing no one, and caring not for myself, and at length reached an open space where stood a great church, the cross upon whose spire seemed bejewelled with the stars upon which it dwelt. And in my soul I said, O Lord Jesus! and went up the base of the tower, and found the door thereof open to my hand. Then with my staff I ascended the winding stairs, until I reached the open sky. And the stairs went still winding, on and on, up towards the stars. And with my staff I ascended, and arose into the sky, until I stood at the foot of the cross of stone.

"Ay me! how the centuries without haste, without rest, had glided along since I stood by the cross of dishonour and pain! And God had not grown weary of his life yet, but I had grown so weary in my very bones that weariness was my element, and I had ceased almost to note it. And now, high-uplifted in honour and worship over every populous city, stood the cross among the stars! I scrambled the pinnacles, and up on the carven stem of the cross, for my sinews were as steel, and my muscles had dried and hardened until they were as those of the tiger or the great serpent. So I climbed, and lifted up myself until I reached the great arms of the cross, and over them I flung my arms, as was my wont, and entwined the stem with my legs, and there hung, three hundred feet above the roofs of the houses. And as I hung the moon rose and cast the shadow of me Ahasuerus upon the cross, up against the Pleiades. And as if dull Nature were offended thereat, nor understood the offering of my poor sacrifice, the clouds began to gather, like the vultures - no one could have told whence. From all sides around they rose, and the moon was blotted out, and they gathered and rose until they met right over the cross.

And when they closed, then the lightning brake forth, and the thunder with it, and it flashed and thundered above and around and beneath me, so that I could not tell which voice belonged to which arrow, for all were mingled in one great confusion and uproar. And the people in the houses below heard the sound of thunder, and they looked from their windows, and they saw the storm raving and flashing about the spire, which stood the heart of the agony, and they saw something hang there, even upon its cross, in the form of a man, and they came from their houses, and the whole space beneath was filled with people, who stood gazing up at the marvel. *A miracle! A miracle!* they cried; and truly it was no miracle - it was only me Ahasuerus, the wanderer, taking thought concerning his crime against the crucified. Then came a great light all about me, such light for shining as I had never before beheld, and indeed I saw it not all with my eyes, but the greater part with my soul, which surely is the light of the eyes themselves. And I said to myself, Doubtless the Lord is at hand, and he cometh to me as late to the blessed Saul of Tarsus, who was *not* the chief of sinners, but I - Ahasuerus, the accursed. And the thunder burst like the bursting of a world in the furnace of the sun; and whether it was that the lightning struck me, or that I dropped, as was my custom, outwearied from the cross, I know not, but thereafter I lay at its foot among the pinnacles, and when the people looked again, the miracle was over, and they returned to their houses and slept. And the next day, when I sought the comfort of the bath, I found upon my side the figure of a cross, and the form of a man hanging thereupon as I had hung, depainted in a dark colour as of lead, plain upon the flesh of my side over my heart. Here was a miracle indeed! but verily I knew not whether therefrom to gather comfort or despair.

"And it was night as I went into a village among the

mountains, through the desert places of which I had all that day been wandering. And never before had my condition seemed to me so hopeless. There was not one left upon the earth who had ever seen me knowing me, and although there went a tale of such a man as I, yet faith had so far vanished from the earth that for a thing to be marvellous, however just, was sufficient reason wherefore no man, to be counted wise, should believe the same. For the last fifty years I had found not one that would receive my testimony. For when I told them the truth concerning myself, saying as I now say, and knowing the thing for true - that I was Ahasuerus whom the Word had banished from his home in the regions governed of Death, shutting against him the door of the tomb that he should not go in, every man said I was mad, and would hold with me no manner of communication, more than if I had been possessed with a legion of swine-loving demons. Therefore was I cold at heart, and lonely to the very root of my being. And thus it was with me that midnight as I entered the village among the mountains. - Now all therein slept, so even that not a dog barked at the sound of my footsteps. But suddenly, and my soul yet quivers with dismay at the remembrance, a yell of horror tore its way from the throat of every sleeper at once, and shot into every cranny of the many-folded mountains, that my soul knocked shaking against the sides of my body, and I also shrieked aloud with the keen terror of the cry. For surely there was no sleeper there, man, woman, or child, who yelled not aloud in an agony of fear. And I knew that it could only be because of the unseen presence in their street of the outcast, the homeless, the loveless, the wanderer for ever, who had refused a stone to his maker whereon to rest his cross. Truly I know not whence else could have come that cry. And I looked to see that all the inhabitants of the village should rush out upon me, and go for to slay the unslayable in their agony. But the

cry passed, and after the cry came again the stillness. And for very dread lest yet another such cry should enter my ears, and turn my heart to a jelly, I did hasten my steps to leave the dwellings of the children of the world, and pass out upon the pathless hills again. But as I turned and would have departed, the door of a house opened over against where I stood; and as it opened, lo! a sharp gust of wind from the mountains swept along the street, and out into the wind came running a girl, clothed only in the garment of the night. And the wind blew upon her, and by the light of the moon I saw that her hands and her feet were rough and brown, as of one that knew labour and hardship, but yet her body was dainty and fair, and moulded in loveliness. Her hair blew around her like a rain cloud, so that it almost blinded her, and truly she had much ado to clear it from her face, as a half-drowned man would clear from his face the waters whence he hath been lifted; and like two stars of light from amidst the cloud gazed forth the eyes of the girl. And she looked upon me with the courage of a child, and she said unto me, Stranger, knowest thou wherefore was that cry? Was it thou who did so cry in our street in the night? And I answered her and said, Verily not I, maiden, but I too heard the cry, and it shook my soul within me. - What seemed it unto thee like, she asked, for truly I slept, and know only the terror thereof and not the sound? And I said, It seemed unto me that every soul in the village cried out at once in some dream of horror. - I cried not out, she said; for I slept and dreamed, and my dream was such that I know verily I cried not out. And the maiden was lovely in her innocence. And I said: And was thy dream such, maiden, that thou wouldst not refuse but wouldst tell it to an old man like me? And with that the wind came down from the mountain like a torrent of wolves, and it laid hold upon me and swept me from the village, and I fled before it, and could not stay my steps until I got me into the covert of a hollow

72

rock. And scarce had I turned in thither when, lo! thither came the maiden also, flying in my footsteps, and driven of the self-same mighty wind. And I turned in pity and said, Fear not, my child. Here is but an old man with a sore and withered heart, and he will not harm thee. - I fear thee not, she answered, else would I not have followed thee. - Thou didst not follow me of thine own inclining, I said, but the wind that came from the mountains and swept me before it, did bear thee after me. - Truly I know of no wind, she said, but the wind of my own following of thee. Wherefore didst thou flee from me? - Nay! but wherefore didst thou follow me, maiden? - That I might tell thee my dream to the which thou didst desire to hearken. For, lo! as I slept I dreamed that a man came unto me and said, Behold, I am the unresting and undying one, and my burden is greater than I can bear, for Death who befriendeth all is my enemy, and will not look upon me in peace. And with that came the cry, and I awoke, and ran out to see whence came the cry, and found thee alone in the street. And as God liveth, such as was the man in my dream, such art thou in my waking sight. - Not the less must I ask thee again, I said, wherefore didst thou follow me? - That I may comfort thee, she answered. - And how thinkest thou to comfort one whom God hath forsaken? - That cannot be, she said, seeing that in a vision of the night he sent thee unto me, and so now hath sent me unto thee. Therefore will I go with thee, and minister unto thee. - Bethink thee well what thou doest, I said; and before thou art fully resolved, sit thee down by me in this cave, that I may tell thee my tale. And straightway she sat down, and I told her all. And ere I had finished the sun had risen. - Then art thou now alone, said the maiden, and hast no one to love thee? - No one, I answered, man, woman, or child. - Then will I go with thee, for I know neither father nor mother, and no one hath power over me, for I keep goats on the mountains for wages, and if thou wilt

73

but give me bread to eat I will serve thee. And a great love arose in my heart to the maiden. And I left her in the cave, and went to the nearest city, and returned thence with garments and victuals. And I loved the maiden greatly. And although my age was then marvellous, being over and above a thousand and seven hundred years, yet found she my person neither pitiful nor uncomely, for I was still in body even such as when the Lord Jesus spake the word of my doom. And the damsel loved me, and was mine. And she was the apple of mine eye. And the world was no more unto me as a desert, but it blossomed as the rose of Sharon. And although I knew every city upon it, and every highway and navigable sea, yet did all become to me fresh and new because of the joy which the damsel had in beholding its kingdoms and the glories thereof.....

"And it came to pass that my heart grew proud within me, and I said to myself that I was all-superior to other men, for Death could not touch me; that I was a marvel upon the face of the world; and in this yet more above all men that had ever lived, that at such age as mine I could yet gain the love, yea, the absolute devotion, of such an one as my wife, who never wearied of my company and conversation. So I took to me even the free grace of love as my merit unto pride, and laid it not to the great gift of God and the tenderness of the heart of my beloved. Like Satan in Heaven I was uplifted in the strength and worthiness and honour of my demon-self, and my pride went not forth in thanks, for I gloried not in my God, but in Ahasuerus. Then the thought smote me like an arrow of lightning: She will die, and thou shalt live-live-live and as he hath delayed, so will he yet delay his coming. And as Satan from the seventh heaven, I fell prone".

"....Then my spirit began again to revive within me, and I said, Lo! I have yet many years of her love ere she dieth, and when she is gone, I shall yet have the memory of

74

my beloved to be with me, and cheer me, and bear me up, for I may never again despise that which she hath loved as she hath loved me. And yet again a thought smote me, and it was as an arrow of the lightning, and its barb was the truth: But she will grow old, it said, and will wither before thy face, and be as the waning moon in the heavens. And my heart cried out in an agony. But my will sought to comfort my heart, and said, Cry not out, for, in spite of old age as in spite of death, I will love her still. Then something began to writhe within me, and to hiss out words that gathered themselves unto this purpose: But she will grow unlovely, and wrinkled, and dark of hue, and the shape of her body will vanish, and her form be unformed, and her eyes will grow small and dim, and creep back into her head, and her hair will fall from her, and she shall be as the unsightly figure of Death with a skin drawn over his unseemly bones; and the damsel of thy love, with the round limbs and the flying hair, and the clear eyes out of which looketh a soul clear as they, will be nowhere - nowhere, for evermore, for thou wilt not be able to believe that she it is who standeth before thee: how will it be with thee then? And what mercy is his who hath sent thee a growing loss in the company of this woman? Thereupon I rose in the strength of my agony and went forth. And I said nothing unto my wife, but strode to the foot of the great mountain, whose entrails were all aglow, and on whose sides grew the palm and the tree-bread and the nut of milk. And I climbed the mountain, nor once looked behind me, but climbed to the top. And there for one moment I stood in the stock-dullness of despair. And beneath me was the great fiery gulf, outstretched like a red lake skinned over with black ice, through the cracks wherein shone the blinding fire. Every moment here and there a great liquid bubbling would break through the crust, and make a wallowing heap upon the flat, then sink again, leaving an open red wellpool of fire whence the rays shot up

like flame, although flame there was none. It lay like the
back of some huge animal upheaved out of hell, which was
wounded and bled fire. - Now, in the last year of my long
sojourn, life had again, because of the woman that loved me,
become precious unto me, and more than once had I laughed
as I caught myself starting back from some danger in a
crowded street, for the thing was new to me, so utterly had
the care of my life fallen into disuse with me. But now again
in my misery I thought no more of danger, but went stalking
and sliding down the sindery slope of the huge fire-cup, and
out upon the lake of molten earth - molten as when first it
shot from the womb of the sun, of whose ardour, through all
the millions of years, it had not yet cooled. And as once St.
Peter on the stormy water to find the Lord of Life, so walked
I on the still lake of fire, caring neither for life nor death. For
my heart was withered to the roots by the thought of the
decay of her whom I had loved; for would not then her very
presence every hour be causing me to forget the beauty that
had once made me glad? - I had walked some ten furlongs,
and passed the middle of the lake, when suddenly I bethought
me that she would marvel whither I had gone, and set out
to seek me, and something might befall her, and I should
lose my rose ere its leaves had begun to drop. And I turned
and strode again in haste across the floor of black heat,
broken and seamed with red light. And lo! as I neared the
midst of the lake, a form came towards me, walking in the
very footsteps I had left behind me, nor had I to look again
to know the gracious motion of my beloved. And the black
ice broke at her foot, and the fire shone up on her face, and
it was lovely as an angel of God, and the glow of her love
outshone the glow of the nether fire. And I called not to stay
her foot, for I judged that the sooner she was with me, the
sooner would she be in safety, for I knew how to walk
thereon better than she. And my heart sang a song within
me in praise of the love of woman, but I thought only of the

love of my woman to me, whom the fires of hell could not hold back from him who was worthy of her love; and my heart sent the song up to my lips; but, as the first word arose, sure itself a red bubble from the pit of glowing hell, the black crust burst up between us, and a great hillock of seething, slow-spouting, slow-falling, mad red fire arose. For a moment or two the molten mound bubbled and wallowed, then sank - and I saw not my wife. Headlong I plunged into the fiery pool at my feet, and the clinging torture hurt me not, and I caught her in my arms, and rose to the surface, and crept forth, and shook the fire from mine eyes, and lo! I held her to my bosom but as the fragment of a cinder of the furnace. And I laughed aloud in my madness, and the devils below heard me, and laughed yet again. O Age! O Decay! I cried, see how I triumph over thee: what canst thou do to this? And I flung the cinder from me into the pool, and plunged again into the grinning fire. But it cast me out seven times, and the seventh time I turned from it, and rushed out of the valley of burning, and threw myself on the mountainside in the moonlight, and awoke mad.

"And what I had then said in despair, I said yet again in thankfulness. O Age! O Decay! I cried, what canst thou now do to destroy the image of her which I bear nested in my heart of hearts? That at least is safe, I thank God. And from that hour I never more believed that I should die when at length my body dropped from me. If the thought came, it came as a fear, and not as a thing concerning which a man may say I would or I would not. For a mighty hope had arisen within me that yet I should stand forgiven in the eyes of him that was crucified, and that in token of his forgiveness he would grant me to look again, but in peace, upon the face of her that had loved me. O mighty Love, who can tell to what heights of perfection thou mayest yet rise in the bosom of the meanest who followeth the Crucified!"...

THE WANDERING JEW
By Rudyard Kipling

'If you go once round the world in an easterly direction, you gain one day,' said the men of science to John Hay. In after years John Hay went east, west, north, and south, transacted business, made love, and begat a family, as have done many men, and the scientific information above recorded lay neglected in the deeps of his mind with a thousand other matters of equal importance.

When a rich relative died, he found himself wealthy beyond any reasonable expectation that he had entertained in his previous career, which had been a chequered and evil one. Indeed, long before the legacy came to him, there existed in the brain of John Hay a little cloud - a momentary obscuration of thought that came and went almost before he could realise that there was any solution of continuity. So do the bats flit round the eaves of a house to show that the darkness is falling. He entered upon great possessions, in money, land, and houses; but behind his delight stood a ghost that cried out that his enjoyment of these things should not be of long duration. It was the ghost of the rich relative, who had been permitted to return to earth to torture his nephew into the grave. Wherefore, under the spur of this constant reminder, John Hay, always preserving the air of heavy business-like stolidity that hid the shadow on his mind, turned investments, houses, and lands into sovereigns - rich, round, red, English sovereigns, each one worth twenty shillings. Lands may become valueless, and houses fly heavenward on the wings of red flame, but till the Day of Judgment a sovereign will always be a sovereign - that is to say, a king of pleasures.

Possessed of his sovereigns, John Hay would fain have spent them one by one on such coarse amusements as

his soul loved; but he was haunted by the instant fear of Death; for the ghost of his relative stood in the hall of his house close to the hat-rack, shouting up the stairway that life was short, that there was no hope of increase of days, and that the undertakers were already roughing out his nephew's coffin. John Hay was generally alone in the house, and even when he had company, his friends could not hear the clamorous uncle. The shadow inside his brain grew larger and blacker. His fear of death was driving John Hay mad.

Then, from the deeps of his mind, where he had stowed away all his discarded information, rose to light the scientific fact of the easterly journey. On the next occasion that his uncle shouted up the stairway urging him to make haste and live, a shriller voice cried, 'Who goes round the world once easterly, gains one day.'

His growing diffidence and distrust of mankind made John Hay unwilling to give this precious message of hope to his friends. They might take it up and analyse it. He was sure it was true, but it would pain him acutely were rough hands to examine it too closely. To him alone of all the toiling generations of mankind had the secret of immortality been vouchsafed. It would be impious - against all the designs of the Creator - to set mankind hurrying eastward. Besides, this would crowd the steamers inconveniently, and John Hay wished of all things to be alone. If he could get round the world in two months - some one of whom he had read, he could not remember the name, had covered the passage in eighty days - he would gain a clear day; and by steadily continuing to do it for thirty years, would gain one hundred and eighty days, or nearly the half of a year. It would not be much, but in the course of time, as civilisation advanced, and the Euphrates Valley Railway was opened, he could improve the pace.

Armed with many sovereigns, John Hay, in the

thirty-fifth year of his age, set forth on his travels, two voices bearing him company from Dover as he sailed to Calais. Fortune favoured him. The Euphrates Valley Railway was newly opened, and he was the first man who took ticket direct from Calais to Calcutta - thirteen days in the train. Thirteen days in the train are not good for the nerves; but he covered the world and returned to Calais from America in twelve days over the two months, and started afresh with four and twenty hours of precious time to his credit.

Three years passed, and John Hay religiously went round this earth seeking for more time wherein to enjoy the remainder of his sovereigns. He became known on many lines as the man who wanted to go on; when people asked him what he was and what he did, he answered -

'I'm the person who intends to live, and I am trying to do it now.'

His days were divided between watching the white wake spinning behind the stern of the swiftest steamers, or the brown earth flashing past the windows of the fastest trains; and he noted in a pocket-book every minute that he had railed or screwed out of remorseless eternity.

'This is better than praying for long life,' quoth John Hay as he turned his face eastward for his twentieth trip. The years had done more for him than he dared to hope. By the extension of the Brahmaputra Valley line to meet the newly-developed China Midland, the Calais railway ticket held good via Karachi and Calcutta to Hongkong. The round trip could be managed in a fraction over forty-seven days, and, filled with fatal exultation, John Hay told the secret of his longevity to his only friend, the house-keeper of his rooms in London. He spoke and passed; but the woman was one of resource, and immediately took counsel with the lawyers who had first informed John Hay of his golden legacy. Very many sovereigns still remained, and

another Hay longed to spend them on things more sensible than railway tickets and steamer accommodation.

The chase was long, for when a man is journeying literally for the dear life, he does not tarry upon the road. Round the world Hay swept anew, and overtook the wearied Doctor, who had been sent out to look for him, in Madras. It was there that he found the reward of his toil and the assurance of a blessed immortality. In half an hour the Doctor, watching always the parched lips, the shaking hands, and the eye that turned eternally to the east, won John Hay to rest in a little house close to the Madras surf. All that Hay need do was to hang by ropes from the roof of the room and let the round earth swing free beneath him. This was better than steamer or train, for he gained a day in a day, and was thus the equal of the undying sun. The other Hay would pay his expenses throughout eternity.

It is true that we cannot yet take tickets from Calais to Hongkong, though that will come about in fifteen years; but men say that if you wander along the southern coast of India you shall find in a neatly whitewashed little bungalow, sitting in a chair swung from the roof, over a sheet of thin steel which he knows so well destroys the attraction of the earth, an old and worn man who for ever faces the rising sun, a stop-watch in his hand, racing against eternity. He cannot drink, he does not smoke, and his living expenses amount to perhaps twenty-five rupees a month, but he is John Hay, the Immortal. Without, he hears the thunder of the wheeling world with which he is careful to explain he has no connection whatever; but if you say that it is only the noise of the surf, he will cry bitterly, for the shadow on his brain is passing away as the brain ceases to work, and he doubts sometimes whether the Doctor spoke the truth.

'Why does not the sun always remain over my head?' asks John Hay.

THE HOLY CROSS
By Eugene Field

Whilst the noble Don Esclevador and his little band of venturesome followers explored the neighboring fastnesses in quest for gold, the Father Miguel tarried at the shrine which in sweet piety they had hewn out of the stubborn rock in that strangely desolate spot. Here, upon that serene August morning, the holy Father held communion with the saints, beseeching them, in all humility, to intercede with our beloved Mother for the safe guidance of the fugitive Cortes to his native shores, and for the divine protection of the little host, which, separated from the Spanish army, had wandered leagues to the northward, and had sought refuge in the noble mountains of an unknown land. The Father's devotions were, upon a sudden, interrupted by the approach of an aged man who toiled along the mountain-side path, - a man so aged and so bowed and so feeble that he seemed to have been brought down into that place, by means of some necromantic art, out of distant centuries. His face was yellow and wrinkled like ancient parchment, and a beard whiter than Samite streamed upon his breast, whilst about his withered body and shrunken legs hung faded raiment which the elements had corroded and the thorns had grievously rent. And as he toiled along, the aged man continually groaned, and continually wrung his palsied hands, as if a sorrow, no lighter than his years, afflicted him.

"In whose name comest thou?" demanded the Father Miguel, advancing a space toward the stranger, but not in threatening wise; whereat the aged man stopped in his course and lifted his eyebrows, and regarded the Father a goodly time, but he spake no word.

"In whose name comest thou?" repeated the priestly man. "Upon these mountains have we lifted up the cross of

our blessed Lord in the name of our sovereign liege, and here have we set down a tabernacle to the glory of the Virgin and of her ever-blessed son, our Redeemer and thine, - whoso thou mayest be!"

"Who is thy king I know not," quoth the aged man, feebly; "but the shrine in yonder wall of rock I know; and by that symbol which I see therein, and by thy faith for which it stands, I conjure thee, as thou lovest both, give me somewhat to eat and to drink, that betimes I may go upon my way again, for the journey before me is a long one."

These words spake the old man in tones of such exceeding sadness that the Father Miguel, touched by compassion, hastened to meet the wayfarer, and, with his arms about him, and with whisperings of sweet comfort, to conduct him to a resting-place. Coarse food in goodly plenty was at hand; and it happily fortuned, too, that there was a homely wine, made by Pietro del y Saguache himself, of the wild grapes in which a neighboring valley abounded. Of these things anon the old man partook, greedily but silently, and all that while he rolled his eyes upon the shrine; and then at last, struggling to his feet, he made as if to go upon his way.

"Nay," interposed the Father Miguel, kindly; "abide with us a season. Thou art an old man and sorely spent. Such as we have thou shalt have, and if thy soul be distressed, we shall pour upon it the healing balm of our blessed faith."

"Little knowest thou whereof thou speakest," quoth the old man, sadly. "There is no balm can avail me. I prithee let me go hence, ere, knowing what manner of man I am, thou hatest me and doest evil unto me." But as he said these words he fell back again even then into the seat where he had sat, and, as through fatigue, his hoary head dropped upon his bosom.

"Thou art ill!" cried the Father Miguel, hastening to

his side. "Thou shalt go no farther this day! Give me thy staff," - and he plucked it from him.

Then said the old man: "As I am now, so have I been these many hundred years. Thou hast heard tell of me, - canst thou not guess my name, canst thou not read my sorrow in my face and in my bosom? As thou art good and holy through thy faith in that symbol in yonder shrine, hearken to me, for I will tell thee of the wretch whom thou hast succored. Then, if it be thy will, give me thy curse and send me on my way."

Much marvelled the Father Miguel at these words, and he deemed the old man to be mad; but he made no answer. And presently the old man, bowing his head upon his hands, had to say in this wise:-

"Upon a time," he quoth, "I abided in the city of the Great King, - there was I born and there I abided. I was of good stature, and I asked favor of none. I was an artisan, and many came to my shop, and my cunning was sought of many, - for I was exceeding crafty in my trade; and so, therefore, speedily my pride begot an insolence that had respect to none at all. And once I heard a tumult in the street, as of the cries of men and boys commingled, and the clashing of arms and staves. Seeking to know the cause thereof, I saw that one was being driven to execution, - one that had said he was the Son of God and the King of the Jews, for which blasphemy and crime against our people he was to die upon the cross. Overcome by the weight of this cross, which he bore upon his shoulders, the victim tottered in the street and swayed this way and that, as though each moment he were like to fall, and he groaned in sore agony. Meanwhile about him pressed a multitude that with vast clamor railed at him and scoffed him and smote him, to whom he paid no heed; but in his agony his eyes were alway uplifted to heaven, and his lips moved in prayer for them that so shamefully entreated him. And as he went his way

to Calvary, it fortuned that he fell and lay beneath the cross right at my very door, whereupon, turning his eyes upon me as I stood over against him, he begged me that for a little moment I should bear up the weight of the cross whilst that he wiped the sweat from off his brow. But I was filled with hatred, and I spurned him with my foot, and I said to him: 'Move on, thou wretched criminal, move on. Pollute not my doorway with thy touch, - move on to death, I command thee!' This was the answer I gave to him, but no succor at all. Then he spake to me once again, and he said: 'Thou too, shalt move on, O Jew! Thou shalt move on forever, but not to death!' And with these words he bore up the cross again and went upon his way to Calvary.

"Then of a sudden," quoth the old man, "a horror filled my breast, and a resistless terror possessed me. So was I accursed forevermore. A voice kept saying always to me: 'Move on, O Jew! move on forever!' From home, from kin, from country, from all I knew and loved I fled; nowhere could I tarry, - the nameless horror burned in my bosom, and I heard continually a voice crying unto me: 'Move on, O Jew! move on forever!' So, with the years, the centuries, the ages, I have fled before that cry and in that nameless horror; empires have risen and crumbled, races have been born and are extinct, mountains have been cast up and time hath levelled them, - still I do live and still I wander hither and thither upon the face of the earth, and am an accursed thing. The gift of tongues is mine, - all men I know, yet mankind knows me not. Death meets me face to face, and passes me by; the sea devours all other prey, but will not hide me in its depths; wild beasts flee from me, and pestilences turn their consuming breaths elsewhere. On and on and on I go, - not to a home, nor to my people, nor to my grave, but evermore into the tortures of an eternity of sorrow. And evermore I feel the nameless horror burn within, whilst evermore I see the pleading eyes of him that

85

bore the cross, and evermore I hear his voice crying: 'Move on, O Jew! move on forevermore!"

"Thou art the Wandering Jew!" cried the Father Miguel.

"I am he," saith the aged man. "I marvel not that thou dost revolt against me, for thou standest in the shadow of that same cross which I have spurned, and thou art illumined with the love of him that went his way to Calvary. But I beseech thee bear with me until I have told thee all, - then drive me hence if thou art so minded."

"Speak on," quoth the Father Miguel.

Then said the Jew: "How came I here I scarcely know; the seasons are one to me, and one day but as another; for the span of my life, O priestly man! is eternity. This much know you: from a far country I embarked upon a ship, - I knew not whence 't was bound, nor cared I. I obeyed the voice that bade me go. Anon a mighty tempest fell upon the ship and overwhelmed it. The cruel sea brought peace to all but me; a many days it tossed and buffeted me, then with a cry of exultation cast me at last upon a shore I had not seen before, a coast far, far westward whereon abides no human thing. But in that solitude still heard I from within the awful mandate that sent me journeying onward, 'Move on, O Jew! move on; and into vast forests I plunged, and mighty plains I traversed; onward, onward, onward I went, with the nameless horror in my bosom, and - that cry, that awful cry! The rains beat upon me; the sun wrought pitilessly with me; the thickets tore my flesh; and the inhospitable shores bruised my weary feet, - yet onward I went, plucking what food I might from thorny bushes to stay my hunger, and allaying my feverish thirst at pools where reptiles crawled. Sometimes a monster beast stood in my pathway and threatened to devour me; then would I spread my two arms thus, and welcome death, crying: 'Rend thou this Jew in twain, O beast! strike thy kindly fangs deep into this

heart, - be not afeard, for I shall make no battle with thee, nor any outcry whatsoever!' But, lo, the beast would cower before me and skulk away. So there is no death for me; the judgment spoken is irrevocable; my sin is unpardonable, and the voice will not be hushed!"

Thus and so much spake the Jew, bowing his hoary head upon his hands. Then was the Father Miguel vastly troubled; yet he recoiled not from the Jew, - nay, he took the old man by the hand and sought to soothe him.

"Thy sin was most heinous, O Jew!" quoth the Father; "but it falleth in our blessed faith to know that whoso repenteth of his sin, what it soever may be, the same shall surely be forgiven. Thy punishment hath already been severe, and God is merciful, for even as we are all his children, even so his tenderness to us is like unto the tenderness of a father unto his child - yea, and infintely tenderer and sweeter, for who can estimate the love of our heavenly Father? Thou didst deny thy succor to the Nazarene when he besought it, yet so great compassion hath he that if thou but callest upon him he will forget thy wrong, - leastwise will pardon it. Therefore be thou persuaded by me, and tarry here this night, that in the presence of yonder symbol and the holy relics our prayers may go up with thine unto our blessed Mother and to the saints who haply shall intercede for thee in Paradise. Rest here, O sufferer, - rest thou here, and we shall presently give thee great comfort."

The Jew, well-nigh fainting with fatigue, being persuaded by the holy Father's gentle words, gave finally his consent unto this thing, and went anon unto the cave beyond the shrine, and entered thereinto, and lay upon a bed of skins and furs, and made as if to sleep. And when he slept his sleep was seemingly disturbed by visions, and he tossed as doth an one that sees full evil things, and in that sleep he muttered somewhat of a voice he seemed to hear, though round about there was no sound whatsoever, save

only the soft music of the pine-trees on the mountain-side. Meanwhile in the shrine, hewn out of those rocks, did the Father Miguel bow before the sacred symbol of his faith and plead for mercy for that same Jew that slumbered anear. And when, as the deepening blue mantle of night fell upon the hilltops and obscured the valleys round about, Don Esclevador and his sturdy men came clamoring along the mountain-side, the holy Father met them a way off and bade them have regard to the aged man that slept in yonder cave. But when he told them of that Jew and of his misery and of the secret causes thereof, out spake the noble Don Esclevador, full hotly, -

"By our sweet Christ," he cried, "shall we not offend our blessed faith and do most impiously in the Virgin's sight if we give this harbor and this succor unto so vile a sinner as this Jew that hath denied our dear Lord!"

Which words had like to wrought great evil with the Jew, for instantly the other men sprang forward as if to awaken the Jew and drive him forth into the night. But the Father Miguel stretched forth his hands and commanded them to do no evil unto the Jew, and so persuasively did he set forth the godliness and the sweetness of compassion that presently the whole company was moved with a gentle pity toward that Jew. Therefore it befell anon, when night came down from the skies and after they had feasted upon their homely food as was their wont, that they talked of the Jew, and thinking of their own hardships and misfortunes (whereof it is not now to speak), they had all the more compassion to that Jew, which spake them passing fair, I ween.

Now all this while lay the Jew upon the bed of skins and furs within the cave, and though he slept (for he was exceeding weary), he tossed continually from side to side, and spoke things in his sleep, as if his heart were sorely troubled, and as if in his dreams he beheld grievous things.

And seeing the old man, and hearing his broken speech, the others moved softly hither and thither and made no noise soever lest they should awaken him. And many an one - yes, all that valiant company bowed down that night before the symbol in the shrine, and with sweet reverence called upon our blessed Virgin to plead in the cause of that wretched Jew. Then sleep came to all, and in dreams the noble Don Esclevador saw his sovereign liege, and kneeled before his throne, and heard his sovereign liege's gracious voice; in dreams the heartweary soldier sailed the blue waters of the Spanish main, and pressed his native shore, and beheld once again the lovelight in the dark eyes of her that awaited him; in dreams the mountain-pines were kissed of the singing winds, and murmured drowsily and tossed their arms as do little children that dream of their play; in dreams the Jew swayed hither and thither, scourged by that nameless horror in his bosom, and seeing the pleading eyes of our dying Master, and hearing that awful mandate: "Move on, O Jew! move on forever!" So each slept and dreamed his dreams, - all slept but the Father Miguel, who alone throughout the night kneeled in the shrine and called unto the saints and unto our Mother Mary in prayer. And his supplication was for that Jew; and the mists fell upon that place and compassed it about, and it was as if the heavens had reached down their lips to kiss the holy shrine. And suddenly there came unto the Jew a quiet as of death, so that he tossed no more in his sleep and spake no word, but lay exceeding still, smiling in his sleep as one who sees his home in dreams, or his mother, or some other such beloved thing.

It came to pass that early in the morning the Jew came from the cavern to go upon his way, and the Father Miguel besought him to take with him a goodly loaf in his wallet as wise provision against hunger. But the Jew denied this, and then he said: "Last night while I slept

methought I stood once more in the city of the Great King,- ay, in that very doorway where I stood, swart and lusty, when I spurned him that went his way to Calvary. In my bosom burned the terror as of old, and my soul was consumed of a mighty anguish. None of those that passed in that street knew me; centuries had ground to dust all my kin. 'Oh God!' I cried in agony, 'suffer my sin to be forgotten, - suffer me to sleep, to sleep forever beneath the burden of the cross I sometime spurned!' As I spake these words there stood before me one in shining raiment, and lo! 't was he who bore the cross to Calvary! His eyes that had pleaded to me on a time now fell compassionately upon me, and the voice that had commanded me move on forever, now broke full sweetly on my ears: 'Thou shalt go on no more, O Jew, but as thou hast asked, so shall it be, and thou shalt sleep forever beneath the cross.' Then fell I into a deep slumber, and, therefrom but just now awaking, I feel within me what peace bespeaketh pardon for my sin. This day am I ransomed; so suffer me to go my way, O holy man."

So went the Jew upon his way, not groaningly and in toilsome wise, as was his wont, but eagerly, as goeth one to meet his bride, or unto some sweet reward. And the Father Miguel stood long, looking after him and being sorely troubled in mind; for he knew not what interpretation he should make of all these things. And anon the Jew was lost to sight in the forest.

But once, a little space thereafter, while that José Conejos, the Castilian, clambered up the yonder mountain-side, he saw amid the grasses there the dead and withered body of an aged man, and thereupon forthwith made he such clamor that Don Esclevador hastened thither and saw it was the Jew; and since there was no sign that wild beasts had wrought evil with him, it was declared that the Jew had died of age and fatigue and sorrow, albeit on the wrinkled face there was a smile of peace that none had seen thereon

while yet the Jew lived. And it was accounted to be a most wondrous thing that, whereas never before had flowers of that kind been seen in those mountains, there now bloomed all round about flowers of the dye of blood, which thing the noble Don Esclevador took full wisely to be a symbol of our dear Lord's most precious blood, whereby not only you and I but even the Jew shall be redeemed to Paradise.

Within the spot where they had found the Jew they buried him, and there he sleeps unto this very day. Above the grave the Father Miguel said a prayer; and the ground of that mountain they adjudged to be holy ground; but over the grave wherein lay the Jew they set up neither cross nor symbol of any kind, fearing to offend their holy faith.

But that very night, when that they were returned unto their camp half a league distant, there arose a mighty tempest, and there was such an upheaval and rending of the earth as only God's hand could make; and there was a crashing and a groaning as if the world were smitten in twain, and the winds fled through the valleys in dismay, and the trees of the forest shrieked in terror and fell upon their faces. Then in the morning when the tempest ceased and all the sky was calm and radiant they saw that an impassable chasm lay between them and that mountainside wherein the Jew slept the sleep of death; that God had traced with his finger a mighty gulf about that holy ground which held the bones of the transgressor. Between heaven and earth hung that lonely grave, nor could any foot scale the precipice that guarded it; but one might see that the spot was beautiful with kindly mountain verdure and that flowers of blood-red dye bloomed in that lonely place.

This was the happening in a summer-time a many years ago; to the mellow grace of that summer succeeded the purple glory of the autumn, and then came on apace the hoary dignity of winter. But the earth hath its resurrection too, and anon came the beauteous spring-time with warmth

and scents and new life. The brooks leapt forth once more from their hiding-places, the verdure awaked, and the trees put forth their foliage. Then from the awful mountain peaks the snow silently and slowly slipped to the valleys, and in divers natural channels went onward and ever downward to the southern sea, and now at last 't was summer-time again and the mellow grace of August brooded over the earth. But in that yonder mountain-side had fallen a symbol never to be removed, - ay, upon that holy ground where slept the Jew was stretched a cross, a mighty cross of snow on which the sun never fell and which no breath of wind ever disturbed. Elsewhere was the tender warmth of verdure and the sacred passion of the blood-red flowers, but over that lonely grave was stretched the symbol of him that went his way to Calvary, and in that grave slept the Jew.

Mightily marvelled Don Esclevador and his warrior host at this thing; but the Father Miguel knew its meaning; for he was minded of that vision wherein it was foretold unto the Jew that, pardoned for his sin, he should sleep forever under the burden of the cross he spurned. All this the Father Miguel showed unto Don Esclevador and the others, and he said: "I deem that unto all ages this holy symbol shall bear witness of our dear Christ's mercy and compassion. Though we, O exiled brothers, sleep in this foreign land in graves which none shall know, upon that mountain height beyond shall stretch the eternal witness to our faith and to our Redeemer's love, minding all that look thereon, not of the pains and the punishments of the Jew, but of the exceeding mercy of our blessed Lord, and of the certain eternal peace that cometh through his love!"

How long ago these things whereof I speak befell, I shall not say. They never saw - that Spanish host - they never saw their native land, their sovereign liege, their loved ones' faces again; they sleep, and they are dust among those mighty mountains in the West. Where is the grave of

the Father Miguel, or of Don Esclevador, or of any of the valiant Spanish exiles, it is not to tell; God only knoweth, and the saints: all sleep in the faith, and their reward is certain. But where sleepeth the Jew all may see and know; for on that awful mountain-side, in a spot inaccessible to man, lieth the holy cross of snow. The winds pass lightly over that solemn tomb, and never a sunbeam lingereth there. White and majestic it lies where God's hands have placed it, and its mighty arms stretch forth as in a benediction upon the fleeting dust beneath.

So shall it bide forever upon that mountain-side, and the memory of the Jew and of all else human shall fade away and be forgotten in the surpassing glory of the love and the compassion of him that bore the redeeming burden to Calvary.

THE WANDERING JEW TO DISTANT ROME
By Eugene Lee-Hamilton

I

Once more, O Rome, once more, Eternal One,
 I come to thee from northmost woods of larch,
 Across thy plain, whose grasses rot and parch,
And see thee standing in the setting sun;

And see as once, though ages slowly run,
 Thy aqueducts still stretching, arch on arch,
 Like files of dusky giants on the march,
Through miasms I alone need never shun.

But what is yon strange mass that I behold;
 What unfamiliar heaven-scaling dome
Stands out in black against the sky of gold?

As deathless as myself, Eternal Rome,
 Thou slowly changest as the world grows old,
While I, unchanged, still measure plain and foam.

II

The dust of countless years weighs down my feet,
Worn out with trudging o'er the bones of those
Whom I saw born, while states and cities rose,
Declined and vanished, even to their seat.

The generations ripen like the wheat
 Which every Spring for Summer's sickle sows;
 While I, sole spared, trudge on without repose
Through empty desert and through crowded street.

The lightning splits the stone upon my path;
 The earthquake passes with its crazing sound;
The whirlwind wraps me in its cloak of wrath;

All Nature spares me, while it girds me round
 With every living terror that it hath,
And on I trudge, till ages shall be crowned.

III

And on and on, through Scythia's whistling waste,
 Alone beneath inexorable stars;
 Or, lonelier still, through India's full bazaars,
Pursued by none, yet ever onward chased.

Or through the wreck of empires long effaced,
 Whose pomp I saw, and their triumphal cars;
 Or in the track of Europe's thousand wars,
Swept on by routed armies in their haste.

Each path of Earth, my foot, which ne'er may stop,
 Treads and retreads, and yet hath but begun
Its lonely journey through the human crop;

To last till Earth, exhausted, shall have spun
 Her meted spin, and, like a wavering top,
Shall lurch her last, and Time shall eat the Sun.

THE MYSTERY OF JOSEPH LAQUEDEM
By A.T. Quiller-Couch

*A Jew, unfortunately slain on the sands of Sheba
Cove, in the parish of Ruan Lanihale, August 15, 1810: or so
much of it as is hereby related by the Rev. Endymion Trist,
B.D., then vicar of that parish, in a letter to a friend.*

My dear J——, - You are right, to be sure, in supposing
that I know more than my neighbours in Ruan Lanihale
concerning the unfortunate young man, Joseph Laquedem,
and more than I care to divulge; in particular concerning
his tragical relations with the girl Julia Constantine, or
July, as she was commonly called. The vulgar knowledge
amounts to little more than this - that Laquedem, a young
Hebrew of extraordinary commercial gifts, first came to our
parish in 1807 and settled here as managing secretary of a
privateering company at Porthlooe; that by his aptitude
and daring in this and the illicit trade he amassed a
respectable fortune, and at length opened a private bank at
Porthlooe and issued his own notes; that on August 15,
1810, a forced "run" which, against his custom, he was
personally supervising, miscarried, and he met his death
by a carbine-shot on the sands of Sheba Cove; and, lastly,
that his body was taken up and conveyed away by the girl
Julia Constantine, under the fire of the preventive men.

The story has even in our time received what I may
call some fireside embellishments; but these are the facts,
and the parish knows little beyond them. I (as you conjecture)
know a great deal more; and yet there is a sense in which
I know nothing more. You and I, my old friend, have come
to an age when men do not care to juggle with the mysteries
of another world, but knowing that the time is near when
all accounts must be rendered, desire to take stock honestly
of what they believe and what they do not. And here lies my

difficulty. On the one hand I would not make public an experience which, however honestly set down, might mislead others, and especially the young, into rash and mischievous speculations. On the other, I doubt if it be right to keep total silence and withhold from devout and initiated minds any glimpse of truth, or possible truth, vouchsafed to me. As the Greek said, "Plenty are the thyrsus-bearers, but few the illuminate"; and among these few I may surely count my old friend.

It was in January 1807 - the year of the abominable business of Tilsit - that my churchwarden, the late Mr. Ephraim Pollard, and I, in cleaning the south wall of Lanihale Church for a fresh coat of whitewash, discovered the frescoes and charcoal drawings, as well as the brass plaque of which I sent you a tracing; and I think not above a fortnight later that, on your suggestion, I set to work to decipher and copy out the old churchwardens' accounts. On the Monday after Easter, at about nine o'clock P.M., I was seated in the Vicarage parlour, busily transcribing, with a couple of candles before me, when my housekeeper Frances came in with a visiting-card, and the news that a stranger desired to speak with me. I took the card and read "Mr. Joseph Laquedem."

"Show the gentleman in," said I.

Now the fact is, I had just then a few guineas in my chest, and you know what a price gold fetched in 1807. I dare say that for twelve months together the most of my parishioners never set eyes on a piece, and any that came along quickly found its way to the Jews. People said that Government was buying up gold, through the Jews, to send to the armies. I know not the degree of truth in this, but I had some five and twenty guineas to dispose of, and had been put into correspondence with a Mr. Isaac Laquedem, a Jew residing by Plymouth Dock, whom I understood to be offering 25s. 6d. per guinea, or a trifle above the price then

current.

I was fingering the card when the door opened again and admitted a young man in a caped overcoat and tall boots bemired high above the ankles. He halted on the threshold and bowed.

"Mr. ——?"

"Joseph Laquedem," said he in a pleasant voice.

"I guess your errand," said I, "though it was a Mr. Isaac Laquedem whom I expected. - Your father, perhaps?"

He bowed again, and I left the room to fetch my bag of guineas. "You have had a dirty ride," I began on my return.

"I have walked," he answered, lifting a muddy boot. "I beg you to pardon these."

"What, from Torpoint Ferry? And in this weather? My faith, sir, you must be a famous pedestrian!"

He made no reply to this, but bent over the guineas, fingering them, holding them up to the candlelight, testing their edges with his thumbnail, and finally poising them one by one on the tip of his forefinger.

"I have a pair of scales," suggested I.

"Thank you, I too have a pair in my pocket. But I do not need them. The guineas are good weight, all but this one, which is possibly a couple of grains short."

"Surely you cannot rely on your hand to tell you that?"

His eyebrows went up as he felt in his pocket and produced a small velvet-lined case containing a pair of scales. He was a decidedly handsome young man, with dark intelligent eyes and a slightly scornful - or shall I say ironical? - smile. I took particular note of the steadiness of his hand as he adjusted the scales and weighed my guinea.

"To be precise," he announced, "1.898, or practically one and nine-tenths short."

"I should have thought," said I, fairly astounded, "a

98

lifetime too little for acquiring such delicacy of sense!"

He seemed to ponder. "I dare say you are right, sir," he answered, and was silent again until the business of payment was concluded. While folding the receipt he added, "I am a connoisseur of coins, sir, and not of their weight alone."

"Antique, as well as modern?"

"Certainly."

"In that case," said I, "you may be able to tell me something about this": and going to my bureau I took out the brass plaque which Mr. Pollard had detached from the planks of the church wall. "To be sure, it scarcely comes within the province of numismatics."

He took the plaque. His brows contracted, and presently he laid it on the table, drew my chair towards him in an absent-minded fashion, and, sitting down, rested his brow on his open palms. I can recall the attitude plainly, and his bent head, and the rain still glistening in the waves of his black hair.

"Where did you find this?" he asked, but without looking up.

I told him. "The engraving upon it is singular. I thought that possibly —"

"Oh, that," said he, "is simplicity itself. An eagle displayed, with two heads, the legs resting on two gates, a crescent between, an imperial crown surmounting - these are the arms of the Greek Empire, the two gates are Rome and Constantinople. The question is, how it came where you found it? It was covered with plaster, you say, and the plaster whitewashed? Did you discover anything near it?"

Upon this I told him of the frescoes and charcoal drawings, and roughly described them.

His fingers began to drum upon the table.

"Have you any documents which might tell us when the wall was first plastered?"

"The parish accounts go back to 1594 - here they are: the Registers to 1663 only. I keep them in the vestry. I can find no mention of plastering, but the entries of expenditure on whitewashing occur periodically, the first under the year 1633." I turned the old pages and pointed to the entry *"Ite' paide to George mason for a dayes work about the churche after the Jew had been, and white wassche is vjd."*

"A Jew? But a Jew had no business in England in those days. I wonder how and why he came." My visitor took the old volume and ran his finger down the leaf, then up, then turned back a page. "Perhaps this may explain it," said he. *"Ite' deliued Mr. Beuill to make puision for the companie of a fforeste barke yt came ashoare iiis ivd."* He broke off, with a finger on the entry, and rose. "Pray forgive me, sir; I had taken your chair."

"Don't mention it," said I. "Indeed I was about to suggest that you draw it to the fire while Frances brings in some supper."

To be short, although he protested he must push on to the inn at Porthlooe, I persuaded him to stay the night; not so much, I confess, from desire of his company, as in the hope that if I took him to see the frescoes next morning he might help me to elucidate their history.

I remember now that during supper and afterwards my guest allowed me more than my share of the conversation. He made an admirable listener, quick, courteous, adaptable, yet with something in reserve (you may call it a facile tolerance, if you will) which ended by irritating me. Young men should be eager, fervid, *sublimis cupidusque*, as I was before my beard grew stiff. But this young man had the air of a spectator at a play, composing himself to be amused. There was too much wisdom in him and too little emotion. We did not, of course, touch upon any religious question - indeed, of his own opinions on any subject he disclosed extraordinarily little: and yet as I reached my bedroom that

night I told myself that here, behind a mask of good manners, was one of those perniciously modern young men who have run through all beliefs by the age of twenty, and settled down to a polite but weary atheism.

I fancy that under the shadow of this suspicion my own manner may have been cold to him next morning. Almost immediately after breakfast we set out for the church. The day was sunny and warm; the atmosphere brilliant after the night's rain. The hedges exhaled a scent of spring. And, as we entered the churchyard, I saw the girl Julia Constantine seated in her favourite angle between the porch and the south wall, threading a chain of daisies.

"What an amazingly handsome girl!" my guest exclaimed.

"Why, yes," said I, "she has her good looks, poor soul!"

"Why 'poor soul'?"

"She is an imbecile, or nearly so," said I, fitting the key in the lock.

We entered the church. And here let me say that, although I furnished you at the time of their discovery with a description of the frescoes and the ruder drawings which overlay them, you can scarcely imagine the grotesque and astonishing *coup d'œil* presented by the two series. To begin with the frescoes, or original series. One, as you know, represented the Crucifixion. The head of the Saviour bore a large crown of gilded thorns, and from the wound in His left side flowed a continuous stream of red gouts of blood, extraordinarily intense in colour (and intensity of colour is no common quality in fresco-painting). At the foot of the cross stood a Roman soldier, with two female figures in dark-coloured drapery a little to the right, and in the background a man clad in a loose dark upper coat, which reached a little below the knees.

The same man reappeared in the second picture, alone, but carrying a tall staff or hunting spear, and

advancing up a road, at the top of which stood a circular building with an arched doorway and, within the doorway, the head of a lion. The jaws of this beast were open and depicted with the same intense red as the Saviour's blood.

Close beside this, but further to the east, was a large ship, under sail, which from her slanting position appeared to be mounting over a long swell of sea. This vessel had four masts; the two foremost furnished with yards and square sails, the others with lateen-shaped sails, after the Greek fashion; her sides were decorated with six gaily painted bands or streaks, each separately charged with devices - a golden saltire on a green ground, a white crescent on a blue, and so on; and each masthead bore a crown with a flag or streamer fluttering beneath.

Of the frescoes these alone were perfect, but fragments of others were scattered over the wall, and in particular I must mention a group of detached human limbs lying near the ship - a group rendered conspicuous by an isolated right hand and arm drawn on a larger scale than the rest. A gilded circlet adorned the arm, which was flexed at the elbow, the hand horizontally placed, the forefinger extended towards the west in the direction of the picture of the Crucifixion, and the thumb shut within the palm beneath the other three fingers.

So much for the frescoes. A thin coat of plaster had been laid over them to receive the second series, which consisted of the most disgusting and fantastic images, traced in black. One of these drawings represented Satan himself - an erect figure, with hairy paws clasped in a supplicating posture, thick black horns, and eyes which (for additional horror) the artist had painted red and edged with a circle of white. At his feet crawled the hindmost limb of a peculiarly loathsome monster with claws stuck in the soil. Close by a nun was figured, sitting in a pensive attitude, her cheek resting on the back of her hand, her

elbow supported by a hideous dwarf, and at some distance a small house, or prison, with barred windows and a small doorway crossed with heavy bolts.

As I said, this upper series had been but partially scraped away, and as my guest and I stood at a little distance, I leave you to imagine, if you can, the incongrous tableau; the Prince of Darkness almost touching the mourners beside the cross; the sorrowful nun and grinning dwarf side by side with a ship in full sail, which again seemed to be forcing her way into a square and forbidding prison, etc.

Mr. Laquedem conned all this for some while in silence, holding his chin with finger and thumb.

"And it was here you discovered the plaque?" he asked at length.

I pointed to the exact spot.

"H'm!" he mused, "and that ship must be Greek or Levantine by its rig. Compare the crowns on her masts, too, with that on the plaque..." He stepped to the wall and peered into the frescoes. "Now this hand and arm —"

"They belong to me," said a voice immediately behind me, and turning, I saw that the poor girl had followed us into the church.

The young Jew had turned also. "What do you mean by that?" he asked sharply.

"She means nothing," I began, and made as if to tap my forehead significantly.

"Yes, I do mean something," she persisted. "They belong to me. I remember —"

"What do you remember?"

Her expression, which for a moment had been thoughtful, wavered and changed into a vague foolish smile. "I can't tell...something...it was sand, I think..."

"Who is she?" asked Mr. Laquedem.

"Her name is Julia Constantine. Her parents are

dead; an aunt looks after her - a sister of her mother's."

He turned and appeared to be studying the frescoes. "Julia Constantine - an odd name," he muttered. "Do you know anything of her parentage?"

"Nothing except that her father was a labourer at Sheba, the manor-farm. The family has belonged to this parish for generations. I believe July is the last of them."

He faced round upon her again. "*Sand*, did you say? That's a strange thing to remember. How does *sand* come into your mind? Think, now."

She cast down her eyes; her fingers plucked at the daisy-chain. After a while she shook her head. "I can't think," she answered, glancing up timidly and pitifully.

"Surely we are wasting time," I suggested. To tell the truth I disapproved of his worrying the poor girl.

He took the daisy-chain from her, looking at me the while with something between a "by-your-leave" and a challenge. A smile played about the corners of his mouth.

"Let us waste a little more." He held up the chain before her and began to sway it gently to and fro. "Look at it, please, and stretch out your arm; look steadily. Now your name is Julia Constantine, and you say that the arm on the wall belongs to you. Why?"

"Because...if you please, sir, because of the mark."

"What mark?"

"The mark on my arm."

This answer seemed to discompose as well as to surprise him. He snatched at her wrist and rolled back her sleeve, somewhat roughly, as I thought. "Look here, sir!" he exclaimed, pointing to a thin red line encircling the flesh of the girl's upper arm, and from that to the arm and armlet in the fresco.

"She has been copying it," said I, "with a string of ribbon, which no doubt she tied too tightly."

"You are mistaken, sir; this is a birthmark. You have

104

had it always?" he asked the girl.

She nodded. Her eyes were fixed on his face with the gaze of one at the same time startled and confiding; and for the moment he too seemed to be startled. But his smile came back as he picked up the daisy-chain and began once more to sway it to and fro before her.

"And when that arm belonged to you, there was sand around you - eh! Tell us, how did the sand come there?"

She was silent, staring at the pendulum-swing of the chain. "Tell us," he repeated in a low coaxing tone.

And in a tone just as low she began, "There was sand...red sand...it was below me...and something above...something like a great tent." She faltered, paused and went on, "There were thousands of people..." She stopped.

"Yes, yes - there were thousands of people on the sand —"

"No, they were not on the sand. There were only two on the sand...the rest were around...under the tent...my arm was out...just like this..."

The young man put a hand to his forehead.

"Good Lord!" I heard him say, "the amphitheatre!"

"Come, sir," I interrupted, "I think we have had enough of this jugglery."

But the girl's voice went on steadily as if repeating a lesson:-

"And then you came —"

"*I!*" His voice rang sharply, and I saw a horror dawn in his eyes, and grow. "I!"

"And then you came," she repeated, and broke off, her mind suddenly at fault. Automatically he began to sway the daisy-chain afresh. "We were on board a ship...a funny ship...with a great high stern..."

"Is this the same story?" he asked, lowering his voice almost to a whisper; and I could hear his breath going and

105

coming.

"I don't know...one minute I see clear, and then it all gets mixed up again...we were up there, stretched on deck, near the tiller...another ship was chasing us...the men began to row, with long sweeps..."

"But the sand," he insisted, "is the sand there?"

"The sand?...Yes, I see the sand again...we are standing upon it...we and the crew...the sea is close behind us...some men have hold of me...they are trying to pull me away from you...Ah! —"

And I declare to you that with a sob the poor girl dropped on her knees, there in the aisle, and clasped the young man about the ankles, bowing her forehead upon the insteps of his high boots. As for him, I cannot hope to describe his face to you. There was something more in it than wonder - something more than dismay, even - at the success of his unhallowed experiment. It was as though, having prepared himself light-heartedly to witness a play, he was seized and terrified to find himself the principal actor. I never saw ghastlier fear on human cheeks.

"For God's sake, sir," I cried, stamping my foot, "relax your cursed spells! Relax them and leave us! This is a house of prayer."

He put a hand under the girl's chin, and, raising her face, made a pass or two, still with the daisy-chain in his hand. She looked about her, shivered and stood erect. "Where am I?" she asked. "Did I fall? What are you doing with my chain?" She had relapsed into her habitual childishness of look and speech.

I hurried them from the church, resolutely locked the door, and marched up the path without deigning a glance at the young man. But I had not gone fifty yards when he came running after.

"I entreat you, sir, to pardon me. I should have stopped the experiment before. But I was startled - thrown

106

off my balance. I am telling you the truth, sir!"

"Very likely," said I. "The like has happened to other rash meddlers before you."

"I declare to you I had no thought —" he began. But I interrupted him:

"No thought,' indeed! I bring you here to resolve me, if you can, a curious puzzle in archaeology, and you fall to playing devil's pranks upon a half-witted child. 'No thought!' - I believe you, sir."

"And yet," he muttered, "it is an amazing business: the sand - the *velarium* - the outstretched arm and hand - *pollice compresso* - the exact gesture of the gladiatorial shows —"

"Are you telling me, pray, of gladiatorial shows under the Eastern Empire?" I demanded scornfully.

"Certainly not: and that," he mused, "only makes it the more amazing."

"Now, look here," said I, halting in the middle of the road, "I'll hear no more of it. Here is my gate, and there lies the highroad, on to Porthlooe or back to Plymouth, as you please. I wish you good morning, sir; and if it be any consolation to you, you have spoiled my digestion for a week."

I am bound to say the young man took his dismissal with grace. He halted then and there and raised his hat; stood for a moment pondering; and, turning on his heel, walked quickly off towards Porthlooe.

It must have been a week before I learnt casually that he had obtained employment there as secretary to a small company owning the *Lord Nelson* and the *Hand-in-hand* privateers. His success, as you know, was rapid; and naturally in a gossiping parish I heard about it - a little here, a little there - in all a great deal. He had bought the *Providence* schooner; he had acted as freighter for Minards' men in their last run with the *Morning Star*; he had slipped

107

over to Cork and brought home a Porthlooe prize illegally detained there; he was in London, fighting a salvage case in the Admiralty Court;...Within twelve months he was accountant of every trading company in Porthlooe, and agent for receiving the moneys due to the Guernsey merchants. In 1809, as you know, he opened his bank and issued notes of his own. And a year later he acquired two of the best farms in the parish, Tresawl and Killifreeth, and held the fee simple of the harbour and quays.

During the first two years of his prosperity I saw little of the man. We passed each other from time to time in the street of Porthlooe, and he accosted me with a politeness to which, though distrusting him, I felt bound to respond. But he never offered conversation, and our next interview was wholly of my seeking.

One evening towards the close of his second year at Porthlooe, and about the date of his purchase of the *Providence* schooner, I happened to be walking homewards from a visit to a sick parishioner, when at Cove Bottom, by the miller's footbridge, I passed two figures - a man and a woman standing there and conversing in the dusk. I could not help recognising them; and halfway up the hill I came to a sudden resolution and turned back.

"Mr. Laquedem," said I, approaching them, "I put it to you, as a man of education and decent feeling, is this quite honourable?"

"I believe, sir," he answered courteously enough, "I can convince you that it is. But clearly this is neither the time nor the place."

"You must excuse me," I went on, "but I have known Julia since she was a child."

To this he made an extraordinary answer. "No longer?" he asked; and added, with a change of tone, "Had you not forbidden me the vicarage, sir, I might have something to say to you."

"If it concern the girl's spiritual welfare - or yours - I shall be happy to hear it."

"In that case," said he, "I will do myself the pleasure of calling upon you - shall we say tomorrow evening?"

He was as good as his word. At nine o'clock next evening - about the hour of his former visit - Frances ushered him into my parlour. The similarity of circumstance may have suggested to me to draw the comparison; at any rate I observed then for the first time that rapid ageing of his features which afterwards became a matter of common remark. The face was no longer that of the young man who had entered my parlour two years before; already some streaks of grey showed in his black locks, and he seemed even to move wearily.

"I fear you are unwell," said I, offering a chair.

"I have reason to believe," he answered, "that I am dying." And then, as I uttered some expression of dismay and concern, he cut me short. "Oh, there will be no hurry about it! I mean, perhaps, no more than that all men carry about with them the seeds of their mortality - so why not I?" But I came to talk of Julia Constantine, not of myself."

"You may guess, Mr. Laquedem, that as her vicar, and having known her and her affliction all her life, I take something of a fatherly interest in the girl."

"And having known her so long, do you not begin to observe some change in her, of late?"

"Why, to be sure," said I, "she seems brighter."

He nodded. "*I* have done that; or rather, love has done it."

"Be careful, sir!" I cried. "Be careful of what you are going to tell me! If you have intended or wrought any harm to that girl, I tell you solemnly —"

But he held up a hand. "Ah, sir, be charitable! I tell you solemnly our love is not of that kind. We who have loved, and lost, and sought each other, and loved again

109

through centuries, have out- learned that rougher passion. When she was a princess of Rome and I a Christian Jew led forth to the lions —"

I stood up, grasping the back of my chair and staring. At last I knew. This young man was stark mad.

He read my conviction at once. "I think, sir," he went on, changing his tone, "the learned antiquary to whom, as you told me, you were sending your tracing of the plaque, has by this time replied with some information about it."

Relieved at this change of subject, I answered quietly (while considering how best to get him out of the house), "My friend tells me that a similar design is found in Landulph Church, on the tomb of Theodore Paleologus, who died in 1636."

"Precisely; of Theodore Paleologus, descendant of the Constantines."

I began to grasp his insane meaning. "The race, so far as we know, is extinct," said I.

"The race of the Constantines," said he slowly and composedly, "is never extinct; and while it lasts, the soul of Julia Constantine will come to birth again and know the soul of the Jew, until —"

I waited.

"— Until their love lifts the curse, and the Jew can die."

"This is mere madness," said I, my tongue blurting it out at length.

"I expected you to say no less. Now look you, sir - in a few minutes I leave you, I walk home and spend an hour or two before bedtime in adding figures, balancing accounts; to-morrow I rise and go about my daily business cheerfully, methodically, always successfully. I am the long-headed man, making money because I know how to make it, respected by all, with no trace of madness in me. You, if you meet me to-morrow, shall recognise none. Just now you are

forced to believe me mad. Believe it then; but listen while I tell you this:- When Rome was, I was; when Constantinople was, I was. I was that Jew rescued from the lions. It was I who sailed from the Bosphorus in that ship, with Julia beside me; I from whom the Moorish pirates tore her, on the beach beside Tetuan; I who, centuries after, drew those obscene figures on the wall of your church - the devil, the nun, and the barred convent - when Julia, another Julia but the same soul, was denied to me and forced into a nunnery. For the frescoes, too, tell my history. I was that figure in the dark habit, standing a little back from the cross. Tell me, sir did you never hear of Joseph Kartophilus, Pilate's porter?"

I saw that I must humour him. "I have heard his legend," said I; "and have understood that in time he became a Christian."

He smiled wearily. "He has travelled through many creeds; but he has never travelled beyond Love. And if that love can be purified of all passion such as you suspect, he has not travelled beyond forgiveness. Many times I have known her who shall save me in the end; and now in the end I have found her and shall be able, at length, to die; have found her, and with her all my dead loves, in the body of a girl whom you call half- witted - and shall be able, at length, to die."

And with this he bent over the table, and, resting his face on his arms, sobbed aloud. I let him sob there for a while, and then touched his shoulder gently.

He raised his head. "Ah," said he, in a voice which answered the gentleness of my touch, "you remind me!" And with that he deliberately slipped his coat off his left arm and, rolling up the shirt sleeve, bared the arm almost to the shoulder. "I want you close," he added with half a smile; for I have to confess that during the process I had backed a couple of paces towards the door. He took up a candle, and held it while I bent and examined the thin red

111

line which ran like a circlet around the flesh of the upper arm just below the apex of the deltoid muscle. When I looked up I met his eyes challenging mine across the flame.

"Mr. Laquedem," I said, "my conviction is that you are possessed and are being misled by a grievous hallucination. At the same time I am not fool enough to deny that the union of flesh and spirit, so passing mysterious in everyday life (when we pause to think of it), may easily hold mysteries deeper yet. The Church Catholic, whose servant I am, has never to my knowledge denied this; yet has providentially made a rule of St. Paul's advice to the Colossians against intruding into those things which she hath not seen. In the matter of this extraordinary belief of yours I can give you no such comfort as one honest man should offer to another: for I do not share it. But in the more practical matter of your conduct towards July Constantine, it may help you to know that I have accepted your word and propose henceforward to trust you as a gentleman."

"I thank you, sir," he said, as he slipped on his coat. "May I have your hand on that?"

"With pleasure," I answered, and, having shaken hands, conducted him to the door.

From that day the affection between Joseph Laquedem and July Constantine, and their frequent companionship, were open and avowed. Scandal there was, to be sure; but as it blazed up like straw, so it died down. Even the women feared to sharpen their tongues openly on Laquedem, who by this time held the purse of the district, and to offend whom might mean an empty skivet on Saturday night. July, to be sure, was more tempting game; and one day her lover found her in the centre of a knot of women fringed by a dozen children with open mouths and ears. He stepped forward. "Ladies," said he, "the difficulty which vexes you cannot, I feel sure, be altogether good for

your small sons and daughters. Let me put an end to it." He bent forward and reverently took July's hand. "My dear, it appears that the depth of my respect for you will not be credited by these ladies unless I offer you marriage. And as I am proud of it, so forgive me if I put it beyond their doubt. Will you marry me?" July, blushing scarlet, covered her face with her hands, but shook her head. There was no mistaking the gesture: all the women saw it. "Condole with me, ladies!" said Laquedem, lifting his hat and including them in an ironical bow; and placing July's arm in his, escorted her away.

I need not follow the history of their intimacy, of which I saw, indeed, no more than my neighbours. On two points all accounts of it agree: the rapid ageing of the man during this period and the improvement in the poor girl's intellect. Some profess to have remarked an equally vehement heightening of her beauty; but, as my recollection serves me, she had always been a handsome maid; and I set down the transfiguration - if such it was - entirely to the dawn and growth of her reason. To this I can add a curious scrap of evidence. I was walking along the cliff track, one afternoon, between Porthlooe and Lanihale church-tower, when, a few yards ahead, I heard a man's voice declaiming in monotone some sentences which I could not catch; and rounding the corner, came upon Laquedem and July. She was seated on a rock; and he, on a patch of turf at her feet, held open a small volume which he laid face downwards as he rose to greet me. I glanced at the back of the book and saw it was a volume of Euripides. I made no comment, however, on this small discovery; and whether he had indeed taught the girl some Greek, or whether she merely listened for the sake of hearing his voice, I am unable to say.

Let me come then to the last scene, of which I was one among many spectators.

On the morning of August 15th, 1810, and just about

daybreak, I was awakened by the sound of horses' hoofs coming down the road beyond the vicarage gate. My ear told me at once that they were many riders and moving at a trot; and a minute later the jingle of metal gave me an inkling of the truth. I hurried to the window and pulled up the blind. Day was breaking on a grey drizzle of fog which drove up from seaward, and through this drizzle I caught sight of the last five or six scarlet plumes of a troop of dragoons jogging down the hill past my bank of laurels.

Now our parish had stood for some weeks in apprehension of a visit from these gentry. The riding-officer, Mr. Luke, had threatened us with them more than once. I knew, moreover, that a run of goods was contemplated: and without questions of mine - it did not become a parish priest in those days to know too much - it had reached my ears that Laquedem was himself in Roscoff bargaining for the freight. But we had all learnt confidence in him by this time - his increasing bodily weakness never seemed to affect his cleverness and resource - and no doubt occurred to me that he would contrive to checkmate this new move of the riding-officer's. Nevertheless, and partly I dare say out of curiosity, to have a good look at the soldiers, I slipped on my clothes and hurried downstairs and across the garden.

My hand was on the gate when I heard footsteps, and July Constantine came running down the hill, her red cloak flapping and her hair powdered with mist.

"Hullo!" said I, "nothing wrong, I hope?"

She turned a white, distraught face to me in the dawn.

"Yes, yes! All is wrong! I saw the soldiers coming - I heard them a mile away, and set up the rocket from the church-tower. But the lugger stood in - they *must* have seen! - she stood in, and is right under Sheba Point now - and *he* —"

114

I whistled. "This is serious. Let us run out towards the point; we - you, I mean - may be in time to warn them yet."

So we set off running together. The morning breeze had a cold edge on it, but already the sun had begun to wrestle with the bank of sea-fog. While we hurried along the cliffs the shoreward fringe of it was ripped and rolled back like a tent-cloth, and through the rent I saw a broad patch of the cove below; the sands (for the tide was at low ebb) shining like silver; the dragoons with their greatcoats thrown back from their scarlet breasts and their accoutrements flashing against the level rays. Seaward, the lugger loomed through the weather; but there was a crowd of men and black boats - half a score of them - by the water's edge, and it was clear to me at once that a forced run had been at least attempted.

I had pulled up, panting, on the verge of the cliff, when July caught me by the arm.

"*The sand!*"

She pointed; and well I remember the gesture - the very gesture of the hand in the fresco - the forefinger extended, the thumb shut within the palm. "*The sand...*he told me..."

Her eyes were wide and fixed. She spoke, not excitedly at all, but rather as one musing, much as she had answered Laquedem on the morning when he waved the daisy-chain before her.

I heard an order shouted, high up on the beach, and the dragoons came charging down across the sand. There was a scuffle close by the water's edge; then, as the soldiers broke through the mob of free-traders and wheeled their horses round, fetlock deep in the tide, I saw a figure break from the crowd and run, but presently check himself and walk composedly towards the cliff up which climbed the footpath leading to Porthlooe. And above the hubbub of

oaths and shouting, I heard a voice crying distinctly, "Run, man! 'Tis after thee they are! *Man, go faster!*"

Even then, had he gained the cliff-track, he might have escaped; for up there no horseman could follow. But as a trooper came galloping in pursuit, he turned deliberately. There was no defiance in his attitude; of that I am sure. What followed must have been mere blundering ferocity. I saw a jet of smoke, heard the sharp crack of a firearm, and Joseph Laquedem flung up his arms and pitched forward at full length on the sand.

The report woke the girl as with the stab of a knife. Her cry - it pierces through my dreams at times - rang back with the echoes from the rocks, and before they ceased she was halfway down the cliffside, springing as surely as a goat, and, where she found no foothold, clutching the grass, the rooted samphires and the sea pinks, and sliding. While my head swam with the sight of it, she was running across the sands, was kneeling beside the body, had risen, and was staggering under the weight of it down to the water's edge.

"Stop her!" shouted Luke, the riding-officer. "We must have the man! Dead or alive, we must have'n!"

She gained the nearest boat, the free-traders forming up around her, and hustling the dragoons. It was old Solomon Tweedy's boat, and he, prudent man, had taken advantage of the skirmish to ease her off, so that a push would set her afloat. He asserts that as July came up to him she never uttered a word, but the look on her face said "Push me off," and though he was at that moment meditating his own escape, he obeyed and pushed off "like a mazed man." I may add that he spent three months in Bodmin Gaol for it.

She dropped with her burden against the stern sheets, but leapt up instantly and had the oars between the thole-pins almost as the boat floated. She pulled a dozen strokes,

and hoisted the main- sail, pulled a hundred or so, sprang forward and ran up the jib. All this while the preventive men were straining to get off two boats in pursuit; but, as you may guess, the free-traders did nothing to help and a great deal to impede. And first the crews tumbled in too hurriedly, and had to climb out again (looking very foolish) and push afresh, and then one of the boats had mysteriously lost her plug and sank in half a fathom of water. July had gained a full hundred yards' offing before the pursuit began in earnest, and this meant a good deal. Once clear of the point the small cutter could defy their rowing and reach away to the eastward with the wind just behind her beam. The riding- officer saw this, and ordered his men to fire. They assert, and we must believe, that their object was merely to disable the boat by cutting up her canvas.

Their first desultory volley did no damage. I stood there, high on the cliff, and watched the boat, making a spy-glass of my hands. She had fetched in close under the point, and gone about on the port tack - the next would clear- when the first shot struck her, cutting a hole through her jib, and I expected the wind to rip the sail up immediately; yet it stood. The breeze being dead on-shore, the little boat heeled towards us, her mainsail hiding the steerswoman.

It was a minute later, perhaps, that I began to suspect that July was hit, for she allowed the jib to shake and seemed to be running right up into the wind. The stern swung round and I strained my eyes to catch a glimpse of her. At that moment a third volley rattled out, a bullet shore through the peak halliards, and the mainsail came down with a run. It was all over.

The preventive men cheered and pulled with a will. I saw them run alongside, clamber into the cutter, and lift the fallen sail.

And that was all. There was no one on board, alive or dead. Whilst the canvas hid her, in the swift two minutes

between the boat's putting about and her running up into the wind, July Constantine must have lifted her lover's body overboard and followed it to the bottom of the sea. There is no other explanation; and of the bond that knit these two together there is, when I ask myself candidly, no explanation at all, unless I give more credence than I have any wish to give to the wild tale which Joseph Laquedem told me. I have told you the facts, my friend, and leave them to your judgment.

THE ACCURSED CORDONNIER
By Bernard Capes

'Poor Chrymelus, I remember, arose from the diversion of a card-table, and dropped into the dwellings of darkness.' - HERVEY

It must be confessed that Amos Rose was considerably out of his element in the smoking-room off Portland Place. All the hour he remained there he was conscious of a vague rising nausea, due not in the least to the visible atmosphere - to which, indeed, he himself contributed languorously from a crackling spilliken of South American tobacco rolled in a maize leaf and strongly tinctured with opium - but to the almost brutal post-prandial fecundity of its occupants.

Rose was patently a degenerate. Nature, in scheduling his characteristics, had pruned all superlatives. The rude armour of the flesh, under which the spiritual, like a hide-bound chrysalis, should develop secret and self-contained, was perished in his case, as it were, to a semi-opaque suit, through which his soul gazed dimly and fearfully on its monstrous arbitrary surroundings. Not the mantle of the poet, philosopher, or artist fallen upon such, can still its shiverings, or give the comfort that Nature denies.

Yet he was a little bit of each - poet, philosopher, and artist; a nerveless and self-deprecatory stalker of ideals, in the pursuit of which he would wear patent leather shoes and all the apologetic graces. The grandson of a 'three-bottle' J.P., who had upheld the dignity of the State constitution while abusing his own in the best spirit of squirearchy; the son of a petulant dyspeptic, who alternated seizures of long moroseness with fits of abject moral helplessness, Amos found his inheritance in the reversion of a dissipated constitution, and an imagination as sensitive as an exposed nerve. Before he was thirty he was a

119

neurasthenic so practised, as to have learned a sense of luxury in the very consciousness of his own suffering.

It was a negative evolution from the instinct of self-protection - self-protection, as designed in this case, against the attacks of the unspeakable. Another evolution, only less negative, was of a certain desperate pugnacity, that derived from a sense of the inhuman injustice conveyed in the fact that temperamental debility not only debarred him from that bold and healthy expression of self that it was his nature to wish, but made him actually appear to act in contradiction to his own really sweet and sound predilections.

So he sat (in the present instance, listening and revolting) in a travesty of resignation between the stools of submission and defiance.

The neurotic youth of to-day renews no ante-existent type. You will look in vain for a face like Amos's amongst the busts of the recovered past. The same weakness of outline you may point to - the sheep-like features falling to a blunt prow; the lax jaw and pinched temples - but not to that which expresses a consciousness that combative effort in a world of fruitless results is a lost desire.

Superficially, the figure in the smoking-room was that of a long, weedy young man - hairless as to his face; scalped with a fine lank fleece of neutral tint; pale-eyed, and slave to a bored and languid expression, over which he had little control, though it frequently misrepresented his mood. He was dressed scrupulously, though not obtrusively, in the mode, and was smoking a pungent cigarette with an air that seemed balanced between a genuine effort at self-abstraction and a fear of giving offence by a too pronounced show of it. In this state, flying bubbles of conversation broke upon him as he sat a little apart and alone.

'Johnny, here's Callander preaching a divine egotism.'

'Is he? Tell him to beg a lock of the Henbery's hair.

Ain't she the dog that bit him?'

'Once bit, twice shy.'

'Rot! - In the case of a woman? I'm covered with their scars.'

'What,' thought Rose, 'induced me to accept an invitation to this person's house?'

'A divine egotism, eh? It jumps with the dear Sarah's humour. The beggar is an imitative beggar.'

'Let the beggar speak for himself. He's in earnest. Haven't we been bred on the principle of self- sacrifice, till we've come to think a man's self is his uncleanest possession?'

'There's no thinking about it. We've long been alarmed on your account, I can assure you.'

'Oh! I'm no saint.'

'Not you. Your ecstasies are all of the flesh.'

'Don't be gross. I —'

'Oh! take a whisky and seltzer.'

'If I could escape without exciting observation,' thought Rose.

Lady Sarah Henbery was his hostess, and the inspired projector of a new scheme of existence (that was, in effect, the repudiation of any scheme) that had become quite the 'thing.' She had found life an arbitrary design - a coil of days (like fancy pebbles, dull or sparkling) set in the form of a mainspring, and each gem responsible to the design. Then she had said, 'To-day shall not follow yesterday or precede to-morrow'; and she had taken her pebbles from their setting and mixed them higgledy-piggledy, and so was in the way to wear or spend one or the other as caprice moved her. And she became without design and responsibility, and was thus able to indulge a natural bent towards capriciousness to the extent that - having a face for each and every form of social hypocrisy and licence - she was presently hardly to be put out of countenance by the extremist expression of either.

It followed that her reunions were popular with worldlings of a certain order.

By-and-by Amos saw his opportunity, and slipped out into a cold and foggy night.

II

> *'De savoir votr' grand âge,*
> *Nous serions curieux;*
> *A voir votre visage,*
> *Vous paraissez fort vieux;*
> *Vous avez bien cent ans,*
> *Vous montrez bien autant?'*

A stranger, tall, closely wrapped and buttoned to the chin, had issued from the house at the same moment, and now followed in Rose's footsteps as he hurried away over the frozen pavement.

Suddenly this individual overtook and accosted him.

'Pardon,' he said. 'This fog baffles. We have been fellow-guests, it seems. You are walking? May I be your companion? You look a little lost yourself.'

He spoke in a rather high, mellow voice - too frank for irony.

At another time Rose might have met such a request with some slightly agitated temporising. Now, fevered with disgust of his late company, the astringency of nerve that came to him at odd moments, in the exaltation of which he felt himself ordinarily manly and human, braced him to an attitude at once modest and collected.

'I shall be quite happy,' he said. 'Only, don't blame me if you find you are entertaining a fool unawares.'

'You were out of your element, and are piqued. I saw you there, but wasn't introduced.'

'The loss is mine. I didn't observe you - yes, I did!'

He shot the last words out hurriedly - as they came within the radiance of a street lamp - and his pace lessened a moment with a little bewildered jerk.

He had noticed this person, indeed - his presence and his manner. They had arrested his languid review of the frivolous forces about him. He had seen a figure, strange and lofty, pass from group to group; exchange with one a word or two, with another a grave smile; move on and listen; move on and speak; always stately restless; never anything but an incongruous apparition in a company of which every individual was eager to assert and expound the doctrines of self.

This man had been of curious expression, too - so curious that Amos remembered to have marvelled at the little comment his presence seemed to excite. His face was absolutely hairless - as, to all evidence, was his head, upon which he wore a brown silk handkerchief loosely rolled and knotted. The features were presumably of a Jewish type - though their entire lack of accent in the form of beard or eyebrow made identification difficult - and were minutely covered, like delicate cracklin, with a network of flattened wrinkles. Ludicrous though the description, the lofty individuality of the man so surmounted all disadvantages of appearance as to overawe frivolous criticism. Partly, also, the full transparent olive of his complexion, and the pools of purple shadow in which his eyes seemed to swim like blots of resin, neutralised the superficial barrenness of his face. Forcibly, he impelled the conviction that here was one who ruled his own being arbitrarily through entire fearlessness of death.

'You saw me?' he said, noticing with a smile his companion's involuntary hesitation. 'Then let us consider the introduction made, without further words. We will even expand to the familiarity of old acquaintanceship, if you like to fall in with the momentary humour.'

'I can see,' said Rose, 'that years are nothing to you.'

'No more than this gold piece, which I fling into the night. They are made and lost and made again.'

'You have knowledge and the gift of tongues.'

The young man spoke bewildered, but with a strange warm feeling of confidence flushing up through his habitual reserve. He had no thought why, nor did he choose his words or inquire of himself their source of inspiration.

'I have these,' said the stranger. 'The first is my excuse for addressing you.'

'You are going to ask me something.'

'What attraction —'

'Drew me to Lady Sarah's house? I am young, rich, presumably a desirable *parti*. Also, I am neurotic, and without the nerve to resist.'

'Yet you knew your taste would take alarm - as it did.'

'I have an acute sense of delicacy. Naturally I am prejudiced in favour of virtue.'

'Then - excuse me - why put yours to a demoralising test?'

'I am not my own master. Any formless apprehension - any shadowy fear enslaves my will. I go to many places from the simple dread of being called upon to explain my reasons for refusing. For the same cause I may appear to acquiesce in indecencies my soul abhors; to give countenance to opinions innately distasteful to me. I am a quite colourless personality.'

'Without force or object in life?'

'Life, I think, I live for its isolated moments - the first half-dozen pulls at a cigarette, for instance, after a generous meal.'

'You take the view, then —'

'Pardon me. I take no views. I am not strong enough to take anything - not even myself - seriously.'

'Yet you know that the trail of such volitionary

ineptitude reaches backwards under and beyond the closed door you once issued from?'

'Do I? I know at least that the ineptitude intensifies with every step of constitutional decadence. It may be that I am wearing down to the nerve of life. How shall I find that? diseased? Then it is no happiness to me to think it imperishable.'

'Young man, do you believe in a creative divinity?'

'Yes.'

'And believe without resentment?'

'I think God hands over to His apprentices the moulding of vessels that don't interest Him.'

The stranger twitched himself erect.

'I beg you not to be profane,' he said.

'I am not,' said Rose. 'I don't know why I confide in you, or what concern I have to know. I can only say my instincts, through bewildering mental suffering, remain religious. You take me out of myself and judge me unfairly on the result.'

'Stay. You argue that a perishing of the bodily veil reveals the soul. Then the outlook of the latter should be the cleaner.'

'It gazes through a blind of corruption. It was never designed to stand naked in the world's market-places.'

'And whose the fault that it does?'

'I don't know. I only feel that I am utterly lonely and helpless.'

The stranger laughed scornfully.

'You can feel no sympathy with my state?' said Rose.

'Not a grain. To be conscious of a soul, yet to remain a craven under the temporal tyranny of the flesh; fearful of revolting, though the least imaginative flight of the spirit carried it at once beyond any bodily influence! Oh, sir! Fortune favours the brave.'

'She favours the fortunate,' said the young man, with

a melancholy smile. 'Like a banker, she charges a commission on small accounts. At trifling deposits she turns up her nose. If you would escape her tax, you must keep a fine large balance at her house.'

'I dislike parables,' said the stranger drily.

'Then, here is a fact in illustration. I have an acquaintance, an impoverished author, who anchored his ark of hope on Mount Olympus twenty years ago. During all that time he has never ceased to send forth his doves; only to have them return empty-beaked with persistent regularity. Three days ago the olive branch - a mere sprouting twig - came home. For the first time a magazine - an indifferent one - accepted a story of his and offered him a pound for it. He acquiesced; and the same night was returned to him from an important American firm an under-stamped MS., on which he had to pay excess postage, half a crown. That was Fortune's commission.'

'Bully the jade, and she will love you.'

'Your wisdom has not learned to confute that barbarism?'

The stranger glanced at his companion with some expression of dislike.

'The sex figures in your ideals, I see,' said he. 'Believe my long experience that its mere animal fools constitute its only excuse for existing - though' (he added under his breath) 'even they annoy one by their monogamous prejudices.'

'I won't hear that with patience,' said Rose. 'Each sex in its degree. Each is wearifully peevish over the hateful rivalry between mind and matter; but the male only has the advantage of distractions.'

'This,' said the stranger softly, as if to himself, 'is the woeful proof, indeed, of decadence. Man waives his prerogative of lordship over the irreclaimable savagery of earth. He has warmed his temperate house of clay to be a

hot-house to his imagination, till the very walls are frail and eaten with fever.'

'Christ spoke of no spiritual division between the sexes.'

There followed a brief silence. Preoccupied, the two moved slowly through the fog, that was dashed ever and anon with cloudy blooms of lamplight.

'I wish to ask you,' said the stranger at length, 'in what has the teaching of Christ proved otherwise than so impotent to reform mankind, as to make one sceptical as to the divinity of the teacher?'

'Why, what is your age?' asked Rose in a tone of surprise.

'I am a hundred to-night.'

The astounded young man jumped in his walk.

'A hundred!' he exclaimed. 'And you cannot answer that question yourself?'

'I asked you to answer it. But never mind. I see faith in you like a garden of everlastings - as it should be - as of course it should be. Yet disbelievers point to inconsistencies. There was a reviling Jew, for instance, to whom Christ is reported to have shown resentment quite incompatible with His teaching.'

'Whom do you mean?'

'Cartaphilus; who was said to be condemned to perpetual wandering.'

'A legend,' cried Amos scornfully. 'Bracket it with Nero's fiddling and the hymning of Memnon.'

A second silence fell. They seemed to move in a dead and stagnant world. Presently said the stranger suddenly-

'I am quite lost; and so, I suppose, are you?'

'I haven't an idea where we are.'

'It is two o'clock. There isn't a soul or a mark to guide us. We had best part and each seek his own way.'

He stopped and held out his hand.

'Two pieces of advice I should like to give you before we separate. Fall in love and take plenty of exercise.'

'Must we part?' said Amos. 'Frankly, I don't think I like you. That sounds strange and discourteous after my ingenuous confidences. But you exhale an odd atmosphere of witchery; and your scorn braces me like a tonic. The pupils of your eyes, when I got a glimpse of them, looked like the heads of little black devils peeping out of windows. But you can't touch my soul on the raw when my nerves are quiescent; and then I would strike any man that called me coward.'

The stranger uttered a quick, chirping laugh, like the sound of a stone on ice.

'What do you propose?' he said.

'I have an idea you are not so lost as you pretend. If we are anywhere near shelter that you know, take me in and I will be a good listener. It is one of my negative virtues.'

'I don't know that any addition to my last good counsel would not be an anti-climax.'

He stood musing and rubbing his hairless chin.

'Exercise - certainly. It is the golden demephitizer of the mind. I am seldom off my feet.'

'You walk much - and alone?'

'Not always alone. Periodically I am accompanied by one or another. At this time I have a companion who has tramped with me for some nine months.'

Again he pondered apart. The darkness and the fog hid his face, but he spoke his thoughts aloud.

'What matter if it does come about? To-morrow I have the world - the mother of many daughters. And to redeem this soul - a dog of a Christian - a friend at Court!'

He turned quickly to the young man.

'Come!' he said. 'It shall be as you wish.'

'Do you know where we are?'

'We are at the entrance to Wardour Street.'

He gave a gesture of impatience, whipped a hand at his companion's sleeve, and once more they trod down the icy echoes, going onwards.

The narrow lane reverberated to their footsteps; the drooping fog swayed sluggishly; the dead blank windows and high-shouldered doors frowned in stubborn progression and vanished behind them.

The stranger stopped in a moment where a screen of iron bars protected a shop front. From behind them shot leaden glints from old clasped bookcovers, hanging tongues of Toledo steel, croziers rich in nielli - innumerable and antique curios gathered from the lumber-rooms of history.

A door to one side he opened with a latch-key. A pillar of light, seeming to smoke as the fog obscured it, was formed of the aperture.

Obeying a gesture, Rose set foot on the threshold. As he was entering, he found himself unable to forbear a thrill of effrontery.

'Tell me,' said he. 'It was not only to point a moral that you flung away that coin?'

The stranger, going before, grinned back sourly over his shoulder.

'Not only,' he said. 'It was a bad one.'

III

...'La Belle Dame sans merci
Hath thee in thrall!'

All down the dimly luminous passage that led from the door straight into the heart of the building, Amos was aware, as he followed his companion over the densely piled carpet, of the floating sweet scent of amber-seed. Still his own latter exaltation of nerve burned with a steady radiance. He seemed to himself bewitched - translated; a consciousness

129

apart from yesterday; its material fibres responsive to the least or utmost shock of adventure. As he trod in the other's footsteps, he marvelled that so lavish a display of force, so elastic a gait, could be in a centenarian.

'Are you ever tired? he whispered curiously.

'Never. Sometimes I long for weariness as other men desire rest.'

As the stranger spoke, he pulled aside a curtain of stately black velvet, and softly opening a door in a recess, beckoned the young man into the room beyond.

He saw a chamber, broad and low, designed, in its every rich stain of picture and slumberous hanging, to appeal to the sensuous. And here the scent was thick and motionless. Costly marqueterie; Palissy candlesticks reflected in half-concealed mirrors framed in embossed silver; antique Nankin vases brimming with pot-pourri; in one corner a suit of Milanese armour, fluted, damasquinée, by Felippo Negroli; in another a tripod table of porphyry, spectrally repeating in its polished surface the opal hues of a vessel of old Venetian glass half filled with some topaz-coloured liqueur - such and many more tokens of a luxurious aestheticism wrought in the observer an immediate sense of pleasurable enervation. He noticed, with a swaying thrill of delight, that his feet were on a padded rug of Astrakhan - one of many, disposed eccentrically about the yellow tassellated-marble floor; and he noticed that the sole light in the chamber came from an iridescent globed lamp, fed with some fragrant oil, that hung near an alcove traversed by a veil of dark violet silk.

The door behind him swung gently to: his eyes half closed in a dreamy surrender of will: the voice of the stranger speaking to him sounded far away as the cry of some lost unhappiness.

'Welcome!' it said only.

Amos broke through his trance with a cry.

'What does it mean - all this? We step out of the fog, and here - I think it is the guest-parlour of Hell!'

'You flatter me,' said the stranger, smiling. 'Its rarest antiquity goes no further back, I think, than the eighth century. The skeleton of the place is Jacobite and comparatively modern.'

'But you - the shop!'

'Contains a little of the fruit of my wanderings.'

'You are a dealer?'

'A casual collector only. If through a representative I work my accumulations of costly lumber to a profit - say thousands per cent - it is only because utility is the first principle of Art. As to myself, here I but pitch my tent - periodically, and at long intervals.'

'An unsupervised agent must find it a lucrative post.'

'Come - there shows a little knowledge of human nature. For the first time I applaud you. But the appointment is conditional on many things. At the moment the berth is vacant. Would you like it?'

'My (paradoxically) Christian name was bestowed in compliment to a godfather, sir. I am no Jew. I have already enough to know the curse of having more.'

'I have no idea how you are called. I spoke jestingly, of course; but your answer quenches the flicker of respect I felt for you. As a matter of fact, the other's successor is not only nominated, but is actually present in this room.'

'Indeed? You propose to fill the post yourself?'

'Not by any means. The mere suggestion is an insult to one who can trace his descent backwards at least two thousand years.'

'Yes, indeed. I meant no disparagement, but —'

'I tell you, sir,' interrupted the stranger irritably, 'my visits are periodic. I could not live in a town. I could not settle anywhere. I must always be moving. A prolonged constitutional - that is my theory of health.'

'You are always on your feet - at your age —'

'I am a hundred to-night. But - mark you - *I have eaten of the Tree of Life.*'

As the stranger uttered these words, he seized Rose by the wrist in a soft, firm grasp. His captive, staring at him amazed, gave out a little involuntary shriek.

'Hadn't I better leave? There is something - nameless - I don't know; but I should never have come in here. Let me go!'

The other, heedless, half pulled the troubled and bewildered young man across the room, and drew him to within a foot of the curtain closing the alcove.

'Here,' he said quietly, 'is my fellow-traveller of the last nine months, fast, I believe, in sleep - unless your jarring outcry has broken it.'

Rose struggled feebly.

'Not anything shameful,' he whimpered - 'I have a dread of your manifestations.'

For answer, the other put out a hand, and swiftly and silently withdrew the curtain. A deepish recess was revealed, into which the soft glow of the lamp penetrated like moonlight. It fell in the first instance upon a couch littered with pale, uncertain shadows, and upon a crucifix that hung upon the wall within.

In the throb of his emotions, it was something of a relief to Amos to see his companion, releasing his hold of him, clasp his hands and bow his head reverently to this pathetic symbol. The cross on which the Christ hung was of ebony a foot high; the figure itself was chryselephantine and purely exquisite as a work of art.

'It is early seventeenth century,' said the stranger suddenly, after a moment of devout silence, seeing the other's eyes absorbed in contemplation. 'It is by Duquesnoy.' (Then, behind the back of his hand) 'The rogue couldn't forget his bacchanals even here.'

'It is a Christ of infidels,' said Amos, with repugnance. He was adding involuntarily (his *savoir faire* seemed suddenly to have deserted him) - 'But fit for an unbelieving -' when his host took him up with fury -

'Dog of a Gentile! - if you dare to call me Jew!'

The dismayed start of the young man at this outburst blinded him to its paradoxical absurdity. He fell back with his heart thumping. The eyes of the stranger flickered, but in an instant he had recovered his urbanity.

'Look!' he whispered impatiently. 'The Calvary is not alone in the alcove.'

Mechanically Rose's glance shifted to the couch; and in that moment shame and apprehension and the sickness of being were precipitated in him as in golden flakes of rapture.

Something, that in the instant of revelation had seemed part only of the soft tinted shadows, resolved itself into a presentment of loveliness so pure, and so pathetic in its innocent self- surrender to the passionate tyranny of his gaze, that the manhood in him was abashed in the very flood of its exaltation. He put a hand to his face before he looked a second time, to discipline his dazzled eyes. They were turned only upon his soul, and found it a reflected glory. Had the vision passed? His eyes, in a panic, leaped for it once more.

Yes, it was there - dreaming upon its silken pillow; a grotesque carved dragon in ivory looking down, from a corner of the fluted couch, upon its supernal beauty - a face that, at a glance, could fill the vague desire of a suffering, lonely heart - spirit informing matter with all the flush and essence of some flower of the lost garden of Eden.

And this expressed in the form of one simple slumbering girl; in its stately sweet curves of cheek and mouth and throat; in its drifted heap of hair, bronze as copper-beech leaves in spring; in the very pulsing of its half-

hidden bosom, and in its happy morning lips, like Psyche's, night-parted by Love and so remaining entranced.

A long light robe, sulphur-coloured, clung to the sleeper from low throat to ankle; bands of narrow nolana-blue ribbon crossed her breast and were brought together in a loose cincture about her waist; her white, smooth feet were sandalled; one arm was curved beneath her lustrous head; the other lay relaxed and drooping. Chrysoberyls, the sea-virgins of stones, sparkled in her hair and lay in the bosom of her gown like dewdrops in an evening primrose.

The gazer turned with a deep sigh, and then a sputter of fury -

'Why do you show me this? You cruel beast, was not my life barren enough before?'

'Can it ever be so henceforward? Look again.'

'Does the devil enter? Something roars in me! Have you no fear that I shall kill you?'

'None. I cannot die.'

Amos broke into a mocking, fierce laugh. Then, his blood shooting in his veins, he seized the sleeper roughly by her hand.

'Wake!' he cried, 'and end it!'

With a sigh she lifted her head. Drowsiness and startled wonderment struggled in her eyes; but in a moment they caught the vision of the stranger standing aside, and smiled and softened. She held out her long, white arms to him.

'You have come, dear love,' she said, in a happy, low voice, 'and I was not awake to greet you.'

Rose fell on his knees.

'Oh, God in Heaven!' he cried, 'bear witness that this is monstrous and unnatural! Let me die rather than see it.'

The stranger moved forward.

'Do honour, Adnah, to this our guest; and minister to him of thy pleasure.'

The white arms dropped. The girl's face was turned, and her eyes, solemn and witch-like, looked into Amos's. He saw them, their irises golden-brown shot with little spars of blue; and the soul in his own seemed to rush towards them and to recoil, baffled and sobbing.

Could she have understood? He thought he saw a faint smile, a gentle shake of the head, as she slid from the couch and her sandals tapped on the marble floor.

She stooped and took him by the hand.

'Rise, I pray you,' she said, 'and I will be your handmaiden.'

She led him unresisting to a chair, and bade him sweetly to be seated. She took from him his hat and overcoat, and brought him rare wine in a cup of crystal.

'My lord will drink,' she murmured, 'and forget all but the night and Adnah.'

'You I can never forget,' said the young man, in a broken voice.

As he drank, half choking, the girl turned to the other, who still stood apart, silent and watchful.

'Was this wise?' she breathed. 'To summon a witness on this night of all - was this wise, beloved?'

Amos dashed the cup on the floor. The red liquid stained the marble like blood.

'No, no!' he shrieked, springing to his feet. 'Not that! it cannot be!'

In an ecstasy of passion he flung his arms about the girl, and crushed all her warm loveliness against his breast. She remained quite passive - unstartled even. Only she turned her head and whispered: 'Is this thy will?'

Amos fell back, drooping, as if he had received a blow.

'Be merciful and kill me,' he muttered. 'I - even I can feel at last the nobility of death.'

Then the voice of the stranger broke, lofty and passionless.

'Tell him what you see in me.'

She answered, low and without pause, like one repeating a cherished lesson -

'I see - I have seen it for the nine months I have wandered with you - the supreme triumph of the living will. I see that this triumph, of its very essence, could not be unless you had surmounted the tyranny of any, the least, gross desire. I see that it is incompatible with sin; with offence given to oneself or others; that passion cannot live in its serene atmosphere; that it illustrates the enchantment of the flesh by the intellect; that it is happiness for evermore redeemed.'

'How do you feel this?'

'I see it reflected in myself - I, the poor visionary you took from the Northern Island. Week by week I have known it sweetening and refining in my nature. None can taste the bliss of happiness that has not you for master - none can teach it save you, whose composure is unshadowed by any terror of death.'

'And love that is passion, Adnah?'

'I hear it spoken as in a dream. It is a wicked whisper from far away. You, the lord of time and of tongues, I worship - you, only you, who are my God.'

'Hush! But the man of Nazareth?'

'Ah! His name is an echo. What divine egotism taught He?'

Where lately had Amos heard this phrase? His memory of all things real seemed suspended.

'He was a man, and He died,' said Adnah simply.

The stranger threw back his head, with an odd expression of triumph; and almost in the same moment abased it to the crucifix on the wall.

Amos stood breathing quickly, his ears drinking in every accent of the low musical voice. Now, as she paused, he moved forward a hurried step, and addressed himself to

the shadowy figure by the couch -

'Who are you, in the name of the Christ you mock and adore in a breath, that has wrought this miracle of high worship in a breathing woman?'

'I am he that has eaten of the Tree of Life.'

'Oh, forego your fables! I am not a child.'

'It could not of its nature perish' (the voice went on evenly, ignoring the interruption). 'It breathes its immortal fragrance in no transplanted garden, invisible to sinful eyes, as some suppose. When the curse fell, the angel of the flaming sword bore it to the central desert; and the garden withered, for its soul was withdrawn. Now, in the heart of the waste place that is called Tiah-Bani-Israil, it waits in its loveliness the coming of the Son of God.'

'He has come and passed.'

It might have been an imperceptible shrug of the shoulders that twitched the tall figure by the couch. If so, it converted the gesture into a bow of reverence.

'Is He not to be revealed again in His glory? But there, set as in the crater of a mountain of sand, and inaccessible to mortal footstep, stands unperishing the glory of the earth. And its fragrance is drawn up to heaven, as through a wide chimney; and from its branches hangs the undying fruit, lustrous and opalescent; and in each shining globe the world and its starry system are reflected in miniature, moving westwards; but at night they glow, a cluster of tender moons.'

'And whence came *your* power to scale that which is inaccessible?'

'From Death, that, still denying me immortality, is unable to encompass my destruction.'

The young man burst into a harsh and grating laugh.

'Here is some inconsistency!' he cried. 'By your own showing you were not immortal till you ate of the fruit!'

Could it be that this simple deductive snip cut the

thread of coherence? A scowl appeared to contract the lofty brow for an instant. The next, a gay chirrup intervened, like a little spark struck from the cloud.

'The pounding logic of the steam engine!' cried the stranger, coming forward at last with an open smile. 'But we pace in an altitude refined above sensuous comprehension. Perhaps before long you will see and believe. In the meantime let us be men and women enjoying the warm gifts of Fortune!'

IV

'Nous pensions comme un songe
Le récrit de vos maux;
Nous traitions de mensonge
Tous vos plus grands travaux!'

In that one night of an unreality that seemed either an enchanted dream or a wilfully fantastic travesty of conventions, Amos alternated between fits of delirious self-surrender and a rage of resignation, from which now and again he would awake to flourish an angry little bodkin of irony.

Now, at this stage, it appeared a matter for passive acquiescence that he should be one of a trio seated at a bronze table, that might have been recovered from Herculaneum, playing three-handed cribbage with a pack of fifteenth-century cards - limned, perhaps by some Franceso Bachiacca - and an ivory board inlaid with gold and mother-of-pearl. To one side a smaller 'occasional' table held the wine, to which the young man resorted at the least invitation from Adnah.

In this connexion (of cards), it would fitfully perturb him to find that he who had renounced sin with mortality,

138

had not only a proneness to avail himself of every oversight on the part of his adversaries, but frequently to peg-up more holes than his hand entitled him to. Moreover, at such times, when the culprit's attention was drawn to this by his guest - at first gently; later, with a little scorn - he justified his action on the assumption that it was an essential interest of all games to attempt abuse of the confidence of one's antagonist, whose skill in checkmating any movement of this nature was in right ratio with his capacity as a player, and finally he rose, the sole winner of a sum respectable enough to allow him some ingenuous expression of satisfaction.

Thereafter conversation ensued; and it must be remarked that nothing was further from Rose's mind than to apologize for his long intrusion and make a decent exit. Indeed, there seemed some thrill of vague expectation in the air, to the realisation of which his presence sought to contribute; and already - so rapidly grows the assurance of love - his heart claimed some protective right over the pure, beautiful creature at his feet.

For there, at a gesture from the other, had Adnah seated herself, leaning her elbow, quite innocently and simply, on the young man's knee.

The sweet strong Moldavian wine buzzed in his head; love and sorrow and intense yearning went with flow and shock through his veins. At one moment elated by the thought that, whatever his understanding of the ethical sympathy existing between these two, their connexion was, by their own acknowledgment, platonic; at another, cruelly conscious of the icy crevasse that must gape between so perfectly proportioned an organism and his own atrabilarious personality, he dreaded to avail himself of a situation that was at once an invitation and a trust; and ended by subsiding, with characteristic lameness, into mere conversational commonplace.

'You must have got over a great deal of ground,' said he to his host, 'on that constitutional hobby-horse of yours?'

'A great deal of ground.'

'In all weathers?'

'In all weathers; at all times; in every country.'

'How do you manage - pardon my inquisitiveness - the little necessities of dress and boots and such things?'

'Adnah,' said the stranger, 'go fetch my walking suit and show it to our guest.'

The girl rose, went silently from the room, and returned in a moment with a single garment, which she laid in Rose's hands.

He examined it curiously. It was a marvel of sartorial tact and ingenuity; so fashioned that it would have appeared scarcely a solecism on taste in any age. Built in one piece to resemble many, and of the most particularly chosen material, it was contrived and ventilated for any exigencies of weather and of climate, and could be doffed or assumed at the shortest notice. About it were cunningly distributed a number of strong pockets or purses for the reception of divers articles, from a comb to a sandwich-box; and the position of these was so calculated as not to interfere with the symmetry of the whole.

'It is indeed an excellent piece of work,' said Amos, with considerable appreciation; for he held no contempt for the art which sometimes alone seemed to justify his right of existence.

'Your praise is deserved,' said the stranger, smiling, 'seeing that it was contrived for me by one whose portrait, by Giambattista Moroni, now hangs in your National Gallery.'

'I have heard of it, I think. Is the fellow still in business?'

'The tailor or the artist? The first died bankrupt in prison - about the year 1560, it must have been. It was

140

fortunate for me, inasmuch as I acquired the garment for nothing, the man disappearing before I had settled his claim.'

Rose's jaw dropped. He looked at the beautiful face reclining against him. It expressed no doubt, no surprise, no least sense of the ludicrous.

'Oh, my God!' he muttered, and ploughed his forehead with his hands. Then he looked up again with a pallid grin.

'I see,' he said. 'You play upon my fancied credulity. And how did the garment serve you in the central desert?'

'I had it not then, by many centuries. No garment would avail against the wicked Samiel - the poisonous wind that is the breath of the eternal dead sand. Who faces that feels, pace by pace, his body wither and stiffen. His clothes crackle like paper, and so fall to fragments. From his eyeballs the moist vision flakes and flies in powder. His tongue shrinks into his throat, as though fire had writhed and consumed it to a little scarlet spur. His furrowed skin peels like the cerements of an ancient mummy. He falls, breaking in his fall - there is a puff of acrid dust, dissipated in a moment - and he is gone.'

'And this you met unscathed?'

'Yes; for it was preordained that Death should hunt, but never overtake me - that I might testify to the truth of the first Scriptures.'

Even as he spoke, Rose sprang to his feet with a gesture of uncontrollable repulsion; and in the same instant was aware of a horrible change that was taking place in the features of the man before him.

V

'Trahentibus autem Judaeis Jesum extra praetorium cum venisset ad ostium, Cartaphilus praetorii ostiarius et Pontii Pilati, cum per ostium exiret Jesus, pepulit Eum pugno

contemptibiliter post tergum, et irridens dixit, 'Vade, Jesu citius, vade, quid moraris?" Et Jesus severo vultu et oculo respiciens in eum, dixit: 'Ego vado, et expectabis donec veniam!" Itaque juxta verbum Domini expectat adhuc Cartaphilus ille, qui tempore Dominicae passionis - erat quasi triginta annorum, et semper cum usque ad centum attigerit aetatem redeuntium annorum redit redivivus ad illum aetatis statum, quo fuit anno quand passus est Dominus.' - MATTHEW OF PARIS, Historia Major.

The girl - from whose cheek Rose, in his rough rising, had seemed to brush the bloom, so keenly had its colour deepened - sank from the stool upon her knees, her hands pressed to her bosom, her lungs working quickly under the pressure of some powerful excitement.

'It comes, beloved!' she said, in a voice half terror, half ecstasy.

'It comes, Adnah,' the stranger echoed, struggling - 'this periodic self-renewal - this sloughing of the veil of flesh that I warned you of.'

His soul seemed to pant grey from his lips; his face was bloodless and like stone; the devils in his eyes were awake and busy as maggots in a wound. Amos knew him now for wickedness personified and immortal, and fell upon his knees beside the girl and seized one of her hands in both his.

'Look!' he shrieked. 'Can you believe in him longer? believe that any code or system of his can profit you in the end?'

She made no resistance, but her eyes still dwelt on the contorted face with an expression of divine pity.

'Oh, thou sufferest!' she breathed; 'but thy reward is near!'

'Adnah!' wailed the young man, in a heartbroken voice. 'Turn from him to me! Take refuge in my love. Oh, it is natural, I swear. It asks nothing of you but to accept the

142

gift - to renew yourself in it, if you will; to deny it, if you will, and chain it for your slave. Only to save you and die for you, Adnah!'

He felt the hand in his shudder slightly; but no least knowledge of him did she otherwise evince.

He clasped her convulsively, released her, mumbled her slack white fingers with his lips. He might have addressed the dead.

In the midst, the figure before them swayed with a rising throe - turned - staggered across to the couch, and cast itself down before the crucifix on the wall.

'Jesu, Son of God,' it implored, through a hurry of piercing groans, 'forbear Thy hand: Christ, register my atonement! My punishment - eternal - and oh, my mortal feet already weary to death! Jesu, spare me! Thy justice, Lawgiver - let it not be vindictive, oh, in Thy sacred name! lest men proclaim it for a baser thing than theirs. For a fault of ignorance - for a word of scorn where all reviled, would *they* have singled *one* out, have made him, most wretched, the scapegoat of the ages? Ah, most holy, forgive me! In mine agony I know not what I say. A moment ago I could have pronounced it something seeming less than divine that Thou couldst so have stultified with a curse Thy supreme hour of self-sacrifice - a moment ago, when the rising madness prevailed. Now, sane once more - Nazarene, oh, Nazarene! not only retribution for my deserts, but pity for my suffering - Nazarene, that Thy slanderers, the men of little schisms, be refuted, hearing me, the very witness to Thy mercy, testify how the justice of the Lord triumphs supreme through that His superhuman prerogative - that they may not say, He can destroy, even as we; but can He redeem? The sacrifice - the yearling lamb - it awaits Thee, Master, the proof of my abjectness and my sincerity. I, more curst than Abraham, lift my eyes to Heaven, the terror in my heart, the knife in my hand. Jesu - Jesu!'

143

He cried and grovelled. His words were frenzied, his abasement fulsome to look upon. Yet it was impressed upon one of the listeners, with a great horror, how unspeakable blasphemy breathed between the lines of the prayer - the blasphemy of secret disbelief in the Power it invoked, and sought, with its tongue in its cheek, to conciliate.

Bitter indignation in the face of nameless outrage transfigured Rose at this moment into something nobler than himself. He feared, but he upheld his manhood. Conscious that the monstrous situation was none of his choosing, he had no thought to evade its consequences so long as the unquestioning credulity of his co-witness seemed to call for his protection. Nerveless, sensitive natures, such as his, not infrequently give the lie to themselves by accesses of an altruism that is little less than self-effacement.

'This is all bad,' he struggled to articulate. 'You are hipped by some devilish cantrip. Oh, come - come! - in Christ's name I dare to implore you - and learn the truth of love!'

As he spoke, he saw that the apparition was on its feet again - that it had returned, and was standing, its face ghastly and inhuman, with one hand leaned upon the marble table.

'Adnah!' it cried, in a strained and hollow voice. 'The moment for which I prepared you approaches. Even now I labour. I had thought to take up the thread on the further side; but it is ordained otherwise, and we must part.'

'Part!' The word burst from her in a sigh of lost amazement.

'The holocaust, Adnah!' he groaned - 'the holocaust with which every seventieth year my expiation must be punctuated! This time the cross is on thy breast, beloved; and to-morrow - oh! thou must be content to tread on lowlier altitudes than those I have striven to guide thee by.'

'I cannot - I cannot, I should die in the mists. Oh,

144

heart of my heart, forsake me not!'

'Adnah - my selma, my beautiful - to propitiate —'

'Whom? Thou hast eaten of the Tree, and art a God!'

'Hush!' He glanced round with an awed visage at the dim hanging Calvary; then went on in a harsher tone, 'It is enough - it must be. (His shifting face, addressed to Rose, was convulsed into an expression of bitter scorn.) 'I command thee, go with him. The sacrifice - oh, my heart, the sacrifice! And I cry to Jehovah, and He makes no sign; and into thy sweet breast the knife must enter.'

Amos sprang to his feet with a loud cry.

'I take no gift from you. I will win or lose her by right of manhood!'

The girl's face was white with despair.

'I do not understand,' she cried in a piteous voice.

'Nor I,' said the young man, and he took a threatening step forward. 'We have no part in this - this lady and I. Man or devil you may be; but —'

'Neither!'

The stranger, as he uttered the word, drew himself erect with a tortured smile. The action seemed to kilt the skin of his face into hideous plaits.

'I am Cartaphilus,' he said, 'who denied the Nazarene shelter.'

'The *Wandering Jew!*'

The name of the old strange legend broke involuntarily from Rose's lips.

'Now you know him!' he shrieked then. 'Adnah, I am here! Come to me!'

Tears were running down the girl's cheeks. She lifted her hands with an impassioned gesture; then covered her face with them.

But Cartaphilus, penetrating the veil with eyes no longer human, cried suddenly, so that the room vibrated with his voice, 'Bismillah! Wilt thou dare the Son of Heaven,

145

questioning if His sentence upon the Jew - to renew, with his every hundredth year, his manhood's prime - was not rather a forestalling, through His infinite penetration, of the consequences of that Jew's finding and eating of the Tree of Life? Is it Cartaphilus first, or Christ?'

The girl flung herself forward, crushing her bosom upon the marble floor, and lay blindly groping with her hands.

'He was a God and vindictive!' she moaned. 'He was a man and He died. The cross - the cross!'

The lost cry pierced Rose's breast like a knife. Sorrow, rage, and love inflamed his passion to madness. With one bound he met and grappled with the stranger.

He had no thought of the resistance he should encounter. In a moment the Jew, despite his age and seizure, had him broken and powerless. The fury of blood blazed down upon him from the unearthly eyes.

'Beast! that I might tear you! But the Nameless is your refuge. You must be chained - you must be chained. - Come!'

Half dragging, half bearing, he forced his captive across the room to the corner where the flask of topaz liquid stood.

'Sleep!' he shrieked, and caught up the glass vessel and dashed it down upon Rose's mouth.

The blow was a stunning one. A jagged splinter tore the victim's lip and brought a gush of blood; the yellow fluid drowned his eyes and suffocated his throat. Struggling to hold his faculties, a startled shock passed through him, and he dropped insensible on the floor.

VI

'Wandering stars, to whom is reserved the blackness of darkness for ever.'

Where had he read these words before? Now he saw them as scrolled in lightning upon a dead sheet of night.

There was a sound of feet going on and on.

Light soaked into the gloom, faster - faster; and he saw - pasture and the waste places of the world. But though he, the dreamer, longed to outstrip and stay the figure and look searchingly in its face, he could not, following, close upon the intervening space; and its back was ever towards him.

And always as the figure passed by populous places, there rose long murmurs of blasphemy to either side, and bestial cries: 'We are weary! the farce is played out! He reveals Himself not, nor ever will! Lead us - lead us, against Heaven, against hell; against any other, or against ourselves! The cancer of life spreads, and we cannot enjoy nor can we think cleanly. The sins of the fathers have accumulated to one vast mount of putrefaction. Lead us, and we follow!'

And, uttering these cries, swarms of hideous half-human shapes would emerge from holes and corners and rotting burrows, and stumble a little way with the figure, cursing and jangling, and so drop behind, one by one, like glutted flies shaken from a horse.

And the dreamer saw in him, who went ever on before, the sole existent type of a lost racial glory, a marvellous survival, a prince over monstrosities; and he knew him to have reached, through long ages of evil introspection, a terrible belief in his own self-acquired immortality and lordship over all abased peoples that must die and pass; and the seed of his blasphemy he sowed broadcast in triumph as he went; and the ravenous horrors of the earth ran forth in broods and devoured it like birds, and trod one another underfoot in their gluttony.

And he came to a vast desolate plain, and took his stand upon a barren drift of sand; and the face of the dreamer longed and feared to see was yet turned from him.

And the figure cried in a voice that grated down the winds of space: 'Lo! I am he that cannot die! Lo! I am he that has eaten of the Tree of Life; who am the Lord of Time and of the races of the earth that shall flock to my standard!'

And again: 'Lo! I am he that God was impotent to destroy because I had eaten of the fruit! He cannot control that which He hath created. He hath builded His temple upon His impotence, and it shall fall and crush Him. The children of his misrule cry out against Him. There is no God but Antichrist!'

Then from all sides came hurrying across the plain vast multitudes of the degenerate children of men, naked and unsightly; and they leaped and mouthed about the figure on the hillock, like hounds baying a dead fox held aloft; and from their swollen throats came one cry:

'There is no God but Antichrist!'

And thereat the figure turned about - and it was Cartaphilus the Jew.

VII

'There is no death! What seems so is transition.'

Uttering an incoherent cry, Rose came to himself with a shock of agony and staggered to his feet. In the act he traversed no neutral ground of insentient purposelessness. He caught the thread of being where he had dropped it - grasped it with an awful and sublime resolve that admitted no least thought of self-interest.

If his senses were for the moment amazed at their surroundings - the silence, the perfumed languor, the beauty and voluptuousness of the room - his soul, notwithstanding, stood intent, unfaltering - waiting merely the physical capacity for action.

The fragments of the broken vessel were scattered at

148

his feet; the blood of his wound had hardened upon his face. He took a dizzy step forward, and another. The girl lay as he had seen her cast herself down - breathing, he could see; her hair in disorder; her hands clenched together in terror or misery beyond words.

Where was the other?

Suddenly his vision cleared. He saw that the silken curtains of the alcove were closed.

A poniard in a jewelled sheath lay, with other costly trifles, on a settle hard by. He seized and, drawing it, cast the scabbard clattering on the floor. His hands would have done; but this would work quicker.

Exhaling a quick sigh of satisfaction, he went forward with a noiseless rush and tore apart the curtains.

Yes - he was there - the Jew - the breathing enormity, stretched silent and motionless. The shadow of the young man's lifted arm ran across his white shirt front like a bar sinister.

To rid the world of something monstrous and abnormal - that was all Rose's purpose and desire. He leaned over to strike. The face, stiff and waxen as a corpse's, looked up into his with a calm impenetrable smile - looked up, for all its eyes were closed. And this was a horrible thing, that, though the features remained fixed in that one inexorable expression, something beneath them seemed alive and moving - something that clouded or revealed them, as when a sheet of paper glowing in the fire wavers between ashes and flame. Almost he could have thought that the soul, detached from its envelope, struggled to burst its way to the light.

An instant he dashed his left palm across his eyes; then shrieking, 'Let the fruit avail you now!' drove the steel deep into its neck with a snarl.

In the act, for all his frenzy, he had a horror of the spurting blood that he knew must foul his hand obscenely,

and sprinkle his face, perhaps, as when a finger half plugs a flowing water-tap.

None came! The fearful white wound seemed to suck at the steel, making a puckered mouth of derision.

A thin sound, like the whinny of a dog, issued from Rose's lips. He pulled out the blade - it came with a crackling noise, as if it had been drawn through parchment.

Incredulous - mad - in an ecstasy of horror, he stabbed again and again. He might as fruitfully have struck at water. Then slashed and gaping wounds closed up so soon as he withdrew the steel, leaving not a scar.

With a scream he dashed the unstained weapon on the floor and sprang back into the room. He stumbled and almost fell over the prostrate figure of the girl.

A strength as of delirium stung and prickled in his arms. He stopped and forcibly raised her - held her against his breast - addressed her in a hurried passion of entreaty.

'In the name of God, come with me! In the name of God, divorce yourself from this horror! He is the abnormal - the deathless - the Antichrist!'

Her lids were closed; but she listened.

'Adnah, you have given me myself. My reason cannot endure the gift alone. Have mercy and be pitiful, and share the burden!'

At last she turned on him her swimming gaze.

'Oh! I am numbed and lost! What would you do with me?'

With a sob of triumph he wrapped his arms hard about her, and sought her lips with his. In the very moment of their meeting, she drew herself away, and stood panting and gazing with wide eyes over his shoulder. He turned.

A young man of elegant appearance was standing by the table where *he* had lately leaned.

In the face of the new-comer the animal and the fanatic were mingled, characteristics inseparable in pseudo-

revelation.

He was unmistakably a Jew, of the finest primitive type - such as might have existed in preneurotic days. His complexion was of a smooth golden russet; his nose and lips were cut rather in the lines of sensuous cynicism; the look in his polished brown eyes was of defiant self-confidence, capable of the extremes of devotion or of obstinacy. Short curling black hair covered his scalp, and his moustache and small crisp beard were of the same hue.

'Thanks, stranger,' he said, in a somewhat nasal but musical voice. 'Your attack - a little cowardly, perhaps, for all its provocation - has served to release me before my time. Thanks - thanks indeed!'

Amos sent a sick and groping glance towards the alcove. The curtain was pulled back - the couch was empty. His vision returning, caught sight of Adnah still standing motionless.

'No, no!' he screeched in a suffocated voice, and clasped his hands convulsively.

There was an adoring expression in her wet eyes that grew and grew. In another moment she had thrown herself at the stranger's feet.

'Master,' she cried, in a rich and swooning voice; 'O Lord and Master - as blind love foreshadowed thee in these long months!'

He smiled down upon her.

'A tender welcome on the threshold,' he said softly, 'that I had almost renounced. The young spirit is weak to confirm the self-sacrifice of the old. But this ardent modern, Adnah, who, it seems, has slipped his opportunity?'

Passionately clasping the hands of the young Jew, she turned her face reluctantly.

'He had blood on him,' she whispered. 'His lip is swollen like a schoolboy's with fighting. He is not a man, sane, self-reliant and glorious - like you, O my heart!'

151

The Jew gave a high, loud laugh, which he checked in mid-career.

'Sir,' he said derisively, ' we will wish you a very pleasant good-morning.'

How - under what pressure or by what process of self-effacement - he reached the street, Amos could never remember. His first sense of reality was in the stinging cold, which made him feel, by reaction, preposterously human.

It was perhaps six o'clock of a February morning, and the fog had thinned considerably, giving place to a wan and livid glow that was but half-measure of dawn.

He found himself going down the ringing pavement that was talcous with a sooty skin of ice, a single engrossing resolve hammering time in his brain to his footsteps.

The artificial glamour was all past and gone - beaten and frozen out of him. The rest was to do - his plain duty as a Christian, as a citizen - above all, as a gentleman. He was, unhypnotized, a law- abiding young man, with a hatred of notoriety and a detestation of the abnormal. Unquestionably his forebears had made a huge muddle of his inheritance.

About a quarter to seven he walked (rather unsteadily) into Vine Street Police Station and accosted the inspector on duty.

'I want to lay an information.'

The officer scrutinised him, professionally, from the under side, and took up a pen.

'What's the charge?'

'Administering a narcotic, attempted murder, abduction, profanity, trading under false pretences, wandering at large - great heavens! what isn't it?'

'Perhaps you'll say. Name of accused?'

'Cartaphilus.'

'Any other?'

'The Wandering Jew.'

The Inspector laid down his pen and leaned forward, bridging his finger-tips under his chin.

'If you take my advice,' he said, 'you'll go and have a Turkish bath.'

The young man gasped and frowned.

'You won't take my information?'

'Not in that form. Come again by-and-by.'

Amos walked straight out of the building and retraced his steps to Wardour Street.

'I'll watch for his coming out,' he thought, 'and have him arrested, on one charge only, by the constable on the beat. Where's the place?'

Twice he walked the length of the street and back, with dull increasing amazement. The sunlight had edged its way into the fog by this time, and every door and window stood out sleek and self-evident. But amongst them all was none that corresponded to the door or window of his adventure.

He hung about till day was bright in the air, and until it occurred to him that his woeful and bloodstained appearance was beginning to excite unflattering comment. At that he trudged for the third time the entire length to and fro, and so coming out into Oxford Street stood on the edge of the pavement, as though it were a brink of Cocytus.

'Well, she called me a boy,' he muttered; 'what does it matter?'

He hailed an early hansom and jumped in.

THE DOOR OF UNREST
By O. Henry

I sat an hour by sun, in the editor's room of the Montopolis *Weekly Bugle*. I was the editor.

The saffron rays of the declining sunlight filtered through the cornstalks in Micajah Widdup's garden-patch, and cast an amber glory upon my paste-pot. I sat at the editorial desk in my non-rotary revolving chair, and prepared my editorial against the oligarchies. The room, with its one window, was already a prey to the twilight. One by one, with my trenchant sentences, I lopped off the heads of the political hydra, while I listened, full of kindly peace, to the home-coming cowbells and wondered what Mrs. Flanagan was going to have for supper.

Then in from the dusky, quiet street there drifted and perched himself upon a corner of my desk old Father Time's younger brother. His face was beardless and as gnarled as an English walnut. I never saw clothes such as he wore. They would have reduced Joseph's coat to a monochrome. but the colors were not the dyer's. Stains and patches and the work of sun and rust were responsible for the diversity. On his coarse shoes was the dust, conceivably, of a thousand leagues. I can describe him no further, except to say that he was little and weird and old - old I began to estimate in centuries when I saw him. Yes, and I remember that there was an odor, a faint odor like aloes, or possibly like myrrh or leather; and I thought of museums.

And then I reached for a pad and pencil, for business is business, and visits of the oldest inhabitants are sacred and honorable, requiring to be chronicled.

"I am glad to see you, sir," I said. "I would offer you a chair, but - you see, sir," I went on, "I have lived in Montopolis only three weeks, and I have not met many of our citizens." I turned a doubtful eye upon his dust-stained

shoes, and concluded with a newspaper phrase, "I suppose that you reside in our midst?"

My visitor fumbled in his raiment, drew forth a soiled card, and handed it to me. Upon it was written, in plain but unsteadily formed characters, the name "Michob Ader."

"I am glad you called, Mr. Ader," I said. "As one of our older citizens, you must view with pride the recent growth and enterprise of Montopolis. Among other improvements, I think I can promise that the town will now be provided with a live, enterprising newspa——"

"Do ye know the name on that card?" asked my caller, interrupting me.

"It was not a familiar one to me," I said.

Again he visited the depths of his ancient vestments. This time he brought out a torn leaf of some book or journal, brown and flimsy with age. The heading on the page was the *Turkish Spy* in old- style type; the printing upon it was this:

"There is a man come to Paris in this year 1643 who pretends to have lived these sixteen hundred years. He says of himself that he was a shoemaker in Jerusalem at the time of the Crucifixion; that his name is Michob Ader; and that when Jesus, the Christian Messiah, was condemned by Pontius Pilate, the Roman president, he paused to rest while bearing his cross to the place of crucifixion before the door of Michob Ader. The shoemaker struck Jesus with his fist, saying 'Go; why tarriest thou?' The Messiah answered him: 'I indeed am going; but thou shalt tarry until I come,' thereby condemning him to live until the day of judgment. He lives for ever, but at the end of every hundred years he falls into a fit or trance, on recovering from which he finds himself in the same state of youth in which he was when Jesus suffered, being then about thirty years of age.

"Such is the story of the Wandering Jew, as told by Michob Ader, who relates —" Here the printing ended.

I must have muttered aloud something to myself about the Wandering Jew, for the old man spake up, bitterly and loudly.

"'Tis a lie," said he, "like nine tenths of what ye call history. 'Tis a Gentile I am, and no Jew. I am after footing it out of Jerusalem, my son; but if that makes me a Jew, then everything that comes out of a bottle is babies' milk. Ye have my name on the card ye hold; and ye have read the bit of paper they call the *Turkish Spy* that printed the news when I stepped into their office on the 12th day of June, in the year 1643, just as I have called upon ye to-day."

I laid down my pencil and pad. Clearly it would not do. Here was an item for the local column of the *Bugle* that - but it would not do. Still, fragments of the impossible "personal" began to flit through my conventionalized brain. "Uncle Michob is as spry on his legs as a young chap of only a thousand or so." "Our venerable caller relates with pride that George Wash - no, Ptolemy the Great - once dandled him on his knee at his father's house." "Uncle Michob says that our wet spring was nothing in comparison with the dampness that ruined the crops around Mount Ararat when he was a boy —" But no, no - it would not do.

I was trying to think of some conversational subject with which to interest my visitor, and was hesitating between walking matches and the Pliocene Age, when the old man suddenly began to weep poignantly and distressfully.

"Cheer up, Mr. Ader," I said, a little awkwardly; "this matter may blow over in a few hundred years more. There has already been a decided reaction in favor of Judas Iscariot and Colonel Burr and the celebrated violinist, Signor Nero. This is the age of whitewash. You must not allow yourself to become down-hearted."

Unknowingly, I had struck a chord. The old man blinked belligerently through his senile tears.

"'Tis time," he said, "that the liars be doin' justice to somebody. Yer historians are no more than a pack of old women gabblin' at a wake. A finer man than the Imperor Nero niver wore sandals. Man, I was at the burnin' of Rome. I knowed the Imperor well, for in them days I was a well-known char-actor. In thim days they had rayspect for a man that lived for ever.

"But 'twas of the Imperor Nero I was goin' to tell ye. I struck into Rome, up the Appian Way, on the night of July the 16th, the year 64. I had just stepped down by way of Siberia and Afghanistan; and one foot of me had a frost-bite, and the other a blister burned by the sand of the desert; and I was feelin' a bit blue from doin' patrol duty from the North Pole down to the Last Chance corner in Patagonia, and bein' miscalled a Jew in the bargain. Well, I'm tellin' ye I was passin' the Circus Maximus, and it was dark as pitch over the way, and then I heard somebody sing out, 'Is that you, Michob?'

"Over ag'inst the wall, hid out amongst a pile of barrels and old dry-goods boxes, was the Imperor Nero wid his togy wrapped around his toes, smokin' a long, black segar.

"Have one, Michob?' says he.

"None of the weeds for me,', says I - 'nayther pipe nor segar. What's the use,' says I, 'of smokin' when ye've got not the ghost of a chance of killin' yeself by doin' it?'

"True for ye, Michob Ader, my perpetual Jew,' says the Imperor; 'ye're not always wandering. Sure, 'tis danger gives the spice of our pleasures - next to their bein' forbidden.'

"And for what,' says I, 'do ye smoke be night in dark places widout even a cinturion in plain clothes to attend ye?'

"Have ye ever heard, Michob,' says the Imperor, 'of predestinarianism?'

"I've had the cousin of it,' says I. 'I've been on the trot with pedestrianism for many a year, and more to come, as

ye well know.'

"The longer word,' says me friend Nero, 'is the tachin' of this new sect of people they call the Christians. 'Tis them that's raysponsible for me smokin' be night in holes and corners of the dark.'

"And then I sets down and takes off a shoe and rubs me foot that is frosted, and the Imperor tells me about it. It seems that since I passed that way before, the Imperor had mandamused the Impress wid a divorce suit, and Misses Poppæa, a cilibrated lady, was ingaged, widout riferences, as housekeeper at the palace. 'All in one day,' says the Imperor, 'she puts up new lace windy-curtains in the palace and joins the anti-tobacco society, and whin I feels the need of a smoke I must be after sneakin' out to these piles of lumber in the dark.' So there in the dark me and the Imperor sat, and I told him of me travels. And when they say the Imperor was an incindiary, they lie. 'Twas that night the fire started that burnt the city. 'Tis my opinion that it began from a stump of segar that he threw down among the boxes. And 'tis a lie that he fiddled. He did all he could for six days to stop it, sir."

And now I detected a new flavor to Mr. Michob Ader. It had not been myrrh or balm of hyssop that I had smelled. The emanation was the odor of bad whiskey - and, worse, still, of low comedy - the sort that small humorists manufacture by clothing the grave and reverend things of legend and history in the vulgar, topical frippery that passes for a certain kind of wit. Michob Ader as an imposter, claiming nineteen hundred years, and playing his part with the decency of respectable lunacy, I could endure; but as a tedious wag, cheapening his egregious story with song-book levity, his importance as an entertainer grew less.

And then, as if he suspected my thoughts, he suddenly shifted his key.

"You'll excuse me, sir," he whined, "but sometimes I

get a little mixed in my head. I am a very old man; and it is hard to remember everything."

I knew that he was right, and that I should not try to reconcile him with Roman history; so I asked for news concerning other ancients with whom he had walked familiar.

Above my desk hung an engraving of Raphael's cherubs. You could yet make out their forms, though the dust blurred their outlines strangely.

"Ye calls them 'cher-rubs,'" cackled the old man. "Babes, ye fancy they are, with wings. And there's one wid legs and a bow and arrow that ye call Cupid - I know where they was found. The great-great-great-grandfather of thim all was a billy-goat. Bein' an editor, sir, do ye happen to know where Solomon's Temple stood?"

I fancied that it was in - in Persia? Well, I did not know.

" 'Tis not in history nor in the Bible where it was. But I saw it, meself. The first pictures of cher-rubs and cupids was sculptured upon thim walls and pillars. Two of the biggest, sir, stood in the adytum to form the baldachin over the Ark. But the wings of thim sculptures was intindid for horns. And the faces was the faces of goats. Ten thousand goats there was in and about the temple. And yon cher-rubs was billy-goats in the days of King Solomon, but the painters misconstrued the horns into wings.

"And I knew Tamerlane, the lame Timour, sir, very well. I saw him at Keghut and at Zaranj. He was a little man no larger than yerself, with hair the color of an amber pipe stem. They buried him at Samarkand. I was at the wake, sir. Oh, he was a fine-built man in his coffiin, six feet long, with black whiskers to his face. And I see 'em throw turnips at the Imperor Vispacian in Africa. All over the world I have tramped, sir, without the body of me findin' any rest. 'Twas so commanded. I saw Jerusalem destroyed, and Pompeii go

159

up in the fireworks; and I was at the coronation of Charlemagne and the lynchin' of Joan of Arc. And everywhere I go there comes storms and revolutions and plagues and fires. 'Twas so commanded. Ye have heard of the Wandering Jew. 'Tis all so, except that divil a bit am I Jew. But history lies, as I have told ye. Are ye quite sure, sir, that ye haven't a drop of whiskey convenient? Ye well know that I have many miles of walking before me."

"I have none," said I, "and, if you please, I am about to leave for my supper."

I pushed the chair back creakingly. This ancient landlubber was becoming as great an affliction as any cross-bowed mariner. He shook a musty effluvium from his piebald clothes, overturned my inkstand, and went on with his insufferable nonsense.

"I wouldn't mind it so much," he complained, "if it wasn't for the work I must do on Good Fridays. Ye know about Pontius Pilate, sir, of course. His body, whin he killed himself, was pitched into a lake on the Alps mountains. Now, listen to the job that 'tis mine to perform on the night of every Good Friday. The ould divil goes down in the pool and drags up Pontius, and the water is bilin' and spewin' like a wash pot. And the ould divil sets the body on top of a throne on the rocks, and thin comes me share of the job. Oh, sir, ye would pity me thin - ye would pray for the poor Wandering Jew that niver was a Jew if ye could see the horror of the thing that I must do. 'Tis I that must fetch a bowl of water and kneel down before it till it washes its hands. I declare to ye that Pontius Pilate, a man dead two hundred years, dragged up with the lake slime coverin' him and fishes wrigglin' inside of hid widout eyes, and in the discomposition of the body, sits there, sir, and washes his hands in the bowl I hold for him on Good Fridays. 'Twas so commanded."

Clearly, the matter had progressed far beyond the

scope of the *Bugle's* local column. There might have been employment here for the alienist or for those who circulate the pledge; but I had had enough of it. I got up, and repeated that I must go.

At this he seized my coat, grovelled upon my desk, and burst again into distressful weeping. Whatever it was about, I said to myself that his grief was genuine.

"Come now, Mr. Ader," I said, soothingly; "what is the matter?"

The answer came brokenly through his racking sobs: "Because I would not ... let the poor Christ ... rest ... upon the step."

His hallucination seemed beyond all reasonable answer; yet the effect of it upon him scarcely merited disrespect. But I knew nothing that might assuage it; and I told him once more that both of us should be leaving the office at once.

Obedient at last, he raised himself from my dishevelled desk, and permitted me to half lift him to the floor. The gale of his grief had blown away his words; his freshet of tears had soaked away the crust of his grief. Reminiscence died in him - at least, the coherent part of it.

"Twas me that did it," he muttered, as I led him toward the door - "me, the shoemaker of Jerusalem."

I got him to the sidewalk, and in the augmented light I saw that his face was seared and lined and warped by a sadness almost incredibly the product of a single lifetime.

And then high up in the firmamental darkness we heard the clamant cries of some great passing birds. My Wandering Jew lifted his hand, with side-tilted head.

"The Seven Whistlers!" he said, as one introduces well-known friends.

"Wild geese," said I; "but I confess that their number is beyond me."

"They follow me everywhere," he said. "Twas so

161

commanded. What ye hear is the souls of the seven Jews that helped with the Crucifixion. Sometimes they're plovers and sometimes geese, but ye'll find them always flyin' where I go."

I stood, uncertain how to take my leave. I looked down the street, shuffled my feet, looked back again - and felt my hair rise. The old man had disappeared.

And then my capillaries relaxed, for I dimly saw him footing it away through the darkness. But he walked so swiftly and silently and contrary to the gait promised by his age that my composure was not all restored, though I knew not why.

That night I was foolish enough to take down some dust-covered volumes from my modest shelves. I searched "Hermippus Redivivus" and "Salathiel" and the "Pepys Collection" in vain. And then in a book called "The Citizen of the World," and in one two centuries old, I came upon what I desired. Michob Ader had indeed come to Paris in the year 1643, and related to the *Turkish Spy* an extraordinary story. He claimed to be the Wandering Jew, and that —

But here I fell asleep, for my editorial duties had not been light that day.

Judge Hoover was the *Bugle*'s candidate for congress. Having to confer with him, I sought his home early the next morning; and we walked together down town through a little street with which I was unfamiliar.

"Did you ever hear of Michob Ader?" I asked him, smiling.

"Why, yes," said the judge. "And that reminds me of my shoes he has for mending. Here is his shop now."

Judge Hoover stepped into a dingy, small shop. I looked up at the sign, and saw "Mike O'Bader, Boot and Shoe Maker," on it. Some wild geese passed above, honking clearly. I scratched my ear and frowned, and then trailed into the shop.

There sat my Wandering Jew on his shoemaker's bench, trimming a half sole. He was drabbled with dew, grass-stained, unkempt, and miserable; and on his face was still the unexplained wretchedness; the problematic sorrow, the esoteric woe, that had been written there by nothing less, it seemed, than the stylus of the centuries.

Judge Hoover inquired kindly concerning his shoes. The old shoemaker looked up, and spoke sanely enough. He had been ill, he said, for a few days. The next day the shoes would be ready. He looked at me, and I could see that I had no place in his memory. So out we went, and on our way.

"Old Mike," remarked the candidate, "has been on one of his sprees. He gets crazy drunk regularly once a month. But he's a good shoemaker."

"What is his history?" I inquired.

"Whiskey," epitomized Judge Hoover. "That explains him."

I was silent, but I did not accept the explanation. And so, when I had the chance, I asked old man Sellers, who browsed daily on my exchanges.

"Mike O'Bader," said he, "was makin' shoes in Montopolis when I came here goin' on fifteen year ago. I guess whiskey's his trouble. Once a month he gets off the track, and stays so a week. He's got a rigmarole somethin' about his bein' a Jew peddler that he tells ev'rybody. Nobody won't listen to him any more. When he's sober he ain't sich a fool - he's got a sight of books in the back room of his shop that he reads. I guess you can lay all his trouble to whiskey."

But again I would not. Not yet was my Wandering Jew rightly construed for me. I trust that women may not be allowed a title to all the curiosity in the world. So when Montopolis's oldest inhabitant (some ninety score years younger than Michob Ader) dropped into acquire promulgation in print, I siphoned his perpetual trickle of

reminiscence in the direction of the uninterpreted maker of shoes.

Uncle Abner was the Complete History of Montopolis, bound in butternut.

"O'Bader," he quavered, "come here in '69. He was the first shoemaker in the place. Folks generally considers him crazy at times now. But he don't harm nobody. I s'pose drinkin' upset his mind - yes, drinkin' very likely done it. It's a powerful bad thing, drinkin'. I'm an old, old man, sir, and I never see no good in drinkin'."

I felt disappointment. I was willing to admit drink in the case of my shoemaker, but I preferred it as a recourse instead of a cause. Why had he pitched upon his perpetual, strange note of the Wandering Jew? Why his unutterable grief during his aberration? I could not yet accept whiskey as an explanation.

"Did Mike O'Bader ever have a great loss or trouble of any kind?" I asked.

"Lemme see! About thirty years ago there was somethin' of the kind, I recollect. Montopolis, sir, in them days used to be a mightly strict place.

"Well, Mike O'Bader had a daughter then - a right pretty girl. She was too gay a sort for Montopolis, so one day she slips off to another town and runs away with a circus. It was two years before she comes back, all fixed up in fine clothes and rings and jewelry, to see Mike. He wouldn't have nothin' to do with her, so she stays around town awhile, anyway. I reckon the men folks wouldn't have raised no objections, but the women egged 'em on to order her to leave town. But she had plenty of spunk, and told 'em to mind their own business.

"So one night they decided to run her away. A crowd of men and women drove her out of her house, and chased her with sticks and stones. She run to her father's door, callin' for help. Mike opens it, and when he sees who it is he

164

hits her with his fist and knocks her down and shuts the door.

"And then the crowd kept on chunkin' her till she run clear out of town. And the next day they finds her drowned dead in Hunter's mill pond. I mind it all now. That was thirty year ago."

I leaned back in my non-rotary revolving chair and nodded gently, like a mandarin, at my paste- pot.

"When old Mike has a spell," went on Uncle Abner, tepidly garrulous, "he thinks he's the Wanderin' Jew."

"He is," said I, nodding away.

And Uncle Abner cackled insinuatingly at the editor's remarks, for he was expecting at least a "stickful" in the "Personal Notes" of the *Bugle*.

A SIMPLE TALE
By John Galsworthy

Talking of anti-Semitism one of those mornings, Ferrand said in his good French: "Yes, *monsieur*, plenty of those gentlemen in these days esteem themselves Christian, but I have only once met a Christian who esteemed himself a Jew. *C'était très drôle - je vais vous conter cela.*"

"It was one autumn in London, and, the season being over, I was naturally in poverty, inhabiting a palace in Westminster at fourpence the night. In the next bed to me that time there was an old gentleman, so thin that one might truly say he was made of air. English, Scotch, Irish, Welsh - I shall never learn to distinguish those little differences in your race - but I well think he was English. Very feeble, very frail, white as paper, with a long grey beard, and caves in the cheeks, and speaking always softly, as if to a woman For me it was an experience to see an individual so gentle in a palace like that. His bed and bowl of broth he gained in sweeping out the kennels of all those sorts of types who come to sleep there every night. There he spent all his day long, going out only at ten hours and a half every night, and returning at midnight less one quarter. Since I had not much to do, it was always a pleasure for me to talk with him; for, though he was certainly a little *toqué*," and Ferrand tapped his temple, "he had great charm of an old man, never thinking of himself no more than a fly that turns in dancing all day beneath a ceiling. If there was something he could do for one of these specimens - to sew on a button, clean a pipe, catch beasts in their clothes, or sit to see they were not stolen, even to give up his place by the fire - he would always do it with his smile so white and gentle; and in his leisure he would read the Holy Book! He inspired in me a sort of affection - there are not too many old men so

166

kind and gentle as that, even when they are 'crackey,' as you call it. Several times I have caught him in washing the feet of one of those sots, or bathing some black eye or other, such as they often catch - a man of a spiritual refinement really remarkable; in clothes also so refined that one sometimes saw his skin. Though he had never great thing to say, he heard you like an angel, and spoke evil of no one; but, seeing that he had no more vigour than a swallow, it piqued me much how he would go out like that every night in all the weathers at the same hour for so long a promenade of the streets. And when I interrogated him on this, he would only smile his smile of one not there, and did not seem to know very much of what I was talking. I said to myself: 'There is something here to see, if I am not mistaken. One of these good days I shall be your guardian angel while you fly the night.' For I am a connoisseur of strange things, *monsieur*, as you know; though, you may well imagine, being in the streets all day long between two boards of a sacred sandwich does not give you too strong a desire to *flâner* in the evenings. *Eh, bien!* It was a night in late October that I at last pursued him. He was not difficult to follow, seeing he had no more guile than an egg; passing first at his walk of an old shadow into your St. James's Park, along where your military types puff out their chests for the nursemaids to admire. Very slowly he went, leaning on a staff - *une canne de promenade* such as I have never seen, nearly six feet high, with an end like a shepherd's crook or the handle of a sword, a thing truly to make the gamins laugh - even me it made to smile, though I am not too well accustomed to mock at age and poverty, to watch him march in leaning on that cane. I remember that night - very beautiful, the sky of a clear dark, the stars as bright as they can ever be in these towns of our high civilisation, and the leaf-shadows of the plane-trees, colour of grapes on the pavement, so that one had not the heart to put foot on them.

167

One of those evenings when the spirit is light, and policemen a little dreamy and well-wishing. Well, as I tell you, my Old marched, never looking behind him, like a man who walks in sleep. By that big church - which, like all those places, had its air of coldness, far and ungrateful among us others, little human creatures who have built it - he passed, into the great Eaton Square, whose houses ought well to be inhabited by people very rich. There he crossed to lean him against the railings of the garden in the centre, very tranquil, his long white beard falling over hands joined on his staff, in awaiting what - I could not figure to myself at all. It was the hour when your high *bourgeoisie* return from the theatre in their carriages, whose manikins sit, the arms crossed, above horses fat as snails. And one would see through the window some lady *bercée doucement*, with the face of one who has eaten too much and loved too little. And gentlemen passed me, marching for a mouthful of fresh air, *très comme il faut*, their concertina hats pushed up, and nothing at all in their eyes. I remarked my Old, who, making no movement, watched them all as they went by, till presently a carriage stopped at a house nearly opposite. At once, then, he began to cross the road quickly, carrying his great stick. I observed the lackey pulling the bell and opening the carriage door, and three people coming forth - a man, a woman, a young man. Very high *bourgeoisie*, some judge, knight, mayor - what do I know? - with his wife and son, mounting under the porch. My Old had come to the bottom of the steps, and spoke, in bending himself forward, as if supplicating. At once those three turned their faces, very astonished. Although I was very intrigued, I could not hear what he was saying, for, if I came nearer, I feared he would see me spying on him. Only the sound of his voice I heard, gentle as always; and his hand I saw wiping his forehead, as though he had carried something heavy from very far. Then the lady spoke to her husband, and went into

the house, and the young son followed in lighting a cigarette. There rested only that good father of the family, with his grey whiskers and nose a little bent, carrying an expression as if my Old were making him ridiculous. He made a quick gesture, as though he said, 'Go!' then he too fled softly. The door was shut. At once the lackey mounted, the carriage drove away, and all was as if it had never been, except that my Old was standing there, quite still. But soon he came returning, carrying his staff as if it burdened him. And recoiling in a porch to see him pass I saw his visage full of dolour, of one overwhelmed with fatigue and grief; so that I felt my heart squeeze me. I must well confess, *monsieur*, I was a little shocked to see this old sainted father asking, as it seemed, for alms. That is a thing I myself have never done, not even in the greatest poverty - one is not like your 'gentlemen' - one does always some little thing for the money he receives, if it is only to show a drunken man where he lives. And I returned in meditating deeply over this problem, which well seemed to me fit for the angels to examine; and knowing what time my Old was always re-entering, I took care to be in my bed before him. He came in as ever, treading softly so as not to wake us others, and his face had again its serenity, a little 'crackey.' As you may well have remarked, *monsieur*, I am not one of those individuals who let everything grow under the nose without pulling them up to see how they are made. For me the greatest pleasure is to lift the skirts of life, to unveil what there is under the surface of things which are not always what they seem, as says your good little poet. For that one must have philosophy, and a certain industry, lacking to all those gentlemen who think they alone are industrious because they sit in chairs and blow into the telephone all day, in filling their pockets with money. Myself, I coin knowledge of the heart - it is the only gold they cannot take from you. So that night I lay awake. I was not content with

what I had seen; for I could not imagine why this old man, so unselfish, so like a saint in thinking ever of others, should go thus every night to beg, when he had always in this palace his bed, and that with which to keep his soul within his rags. Certainly we all have our vices, and gentlemen the most revered do, in secret, things they would cough to see others doing; but that business of begging seemed scarcely in his character of an old altruist - for in my experience, *monsieur*, beggars are not less egoist than millionaires. As I say, it piqued me much, and I resolved to follow him again. The second night was of the most different. There was a great wind, and white clouds flying in the moonlight. He commenced his pilgrimage in passing by your House of Commons, as if toward the river. I like much that great river of yours. There is in its career something of very grand; it ought to know many things, although it is so silent, and gives to no one the secrets which are confided to it. He had for objective, it seemed, that long row of houses very respectable, which gives on the Embankment, before you arrive at Chelsea. It was painful to see the poor Old, bending almost double against that great wind coming from the west. Not too many carriages down here, and few people - a true wilderness, lighted by tall lamps which threw no shadows, so clear was the moon. He took his part soon, as of the other night, standing on the far side of the road, watching for the return of some lion to his den. And presently I saw one coming, accompanied by three lionesses, all taller than himself. This one was bearded, and carried spectacles - a real head of learning; walking, too, with the step of a man who knows his world. Some professor - I said to myself - with his harem. They gained their house at fifty paces from my Old; and, while this learned one was opening the door, the three ladies lifted their noses in looking at the moon. A little of aesthetic, a little of science - as always with that type there! At once I had perceived my Old coming

170

across, blown by the wind like a grey stalk of thistle; and his face, with its expression of infinite pain as if carrying the sufferings of the world. At the moment they see him those three ladies drop their noses and fly within the house as if he were the pestilence, in crying, 'Henry!' And out comes my *monsieur* again, in his beard and spectacles. For me, I would freely have given my ears to hear, but I saw that this good Henry had his eye on me, and I did not budge, for fear to seem in conspiracy. I heard him only say: 'Impossible! Impossible! Go to the proper place!' and he shut the door. My Old remained, with his long staff resting on a shoulder bent as if that stick were of lead. And presently he commenced to march again whence he had come, curved and trembling, the very shadow of a man, passing me, too, as if I were the air. That time also I regained my bed before him, in meditating very deeply, still more uncertain of the psychology of this affair, and resolved once again to follow him, saying to myself: 'This time I shall run all risks to hear.' There are two kinds of men in this world, *monsieur* - one who will not rest content till he has become master of all the toys that make a fat existence - in never looking to see of what they are made; and the other, for whom life is tobacco and a crust of bread, and liberty to take all to pieces, so that his spirit may feel good within him. Frankly, I am of that kind. I rest never till I have found out why this is that: for me mystery is the salt of life, and I must well eat of it. I put myself again, then, to following him the next night. This time he traversed those little dirty streets of your great Westminster where all is mixed in a true pudding of lords and poor wretches at two sous the dozen; of cats and policemen; kerosene flames, abbeys, and the odour of fried fish. Ah! truly it is frightful to see your low streets in London; that gives me a conviction of hopelessness such as I have never caught elsewhere; piquant, too, to find them so near to that great House which sets example of good

171

government to all the world. There is an irony so ferocious there, *monsieur*, that one can well hear the good God of your *bourgeois* laugh in every wheel that rolls, and the cry of each cabbage that is sold; and see him smile in the smoky light of every flare, and in the candles of your cathedral, in saying to himself: 'I have well made this world. Is there not variety here! - *en voilà une bonne soupe!*' This time, however, I attended my Old like his very shadow, and could hear him sighing as he marched, as if he also found the atmosphere of those streets too strong. But all of a sudden he turned a corner, and we were in the most quiet, most beautiful little street I have seen in all your London. It was of small, old houses, very regular, which made as if they inclined themselves in their two rows before a great church at the end, grey in the moonlight, like a mother. There was no one in the street, and no more cover than hair on the head of a pope. But I had some confidence now that my Old would not remark me standing there so close, since in these pilgrimages he seemed to remark nothing. Leaning on his staff, I tell you he had the air of an old bird in a desert, reposing on one leg by a dry pool, his soul looking for water. It gave me that notion one has sometimes in watching the rare spectacles of life - that sentiment which, according to me, pricks artists to their work. We had not stayed there too long before I saw a couple marching from the end of the street, and thought: 'Here they come to their nest.' Vigorous and gay they were, young married ones, eager to get home; one could see the white neck of the young wife, the white shirt of the young man, gleaming under their cloaks. I know them well, those young couples in great cities, without a care, taking all things, the world before them, *très amoureux*, without, as yet, children; jolly and pathetic, having life still to learn - which, believe me, *monsieur*, is a sad enough affair for nine rabbits out of ten. They stopped at the house next to where I stood; and, since my Old was coming fast as always to the

feast, I put myself at once to the appearance of ringing the bell of the house before me. This time I had well the chance of hearing. I could see, too, the faces of all three, because I have by now the habit of seeing out of the back hair. The pigeons were so anxious to get to their nest that my Old had only the time to speak, as they were in train to vanish. 'Sir, let me rest in your doorway!' *Monsieur*, I have never seen a face so hopeless, so cribbled with fatigue, yet so full of a gentle dignity as that of my Old while he spoke those words. It was as if something looked from his visage surpassing what belongs to us others, so mortal and so cynic as human life must well render all who dwell in this earthly paradise. He held his long staff upon one shoulder, and I had the idea, sinister enough, that it was crushing his body of a spectre down into the pavement. I know not how the impression came, but it seemed to me that this devil of a stick had the nature of a heavy cross reposing on his shoulder; I had pain to prevent myself turning, to find if in truth 'I had them,' as your drunkards say. Then the young man called out: 'Here's a shilling for you, my friend!' But my Old did not budge, answering always: 'Sir, let me rest in your doorway!' As you may well imagine, *monsieur*, we were all in the silence of astonishment, I pulling away at my bell next door, which was not ringing, seeing I took care it did not; and those two young people regarding my Old with eyes round as moons, out of their pigeon-house, which I could well see was prettily feathered. Their hearts were making seesaw, I could tell; for at that age one is still impressionable. Then the girl put herself to whispering, and her husband said those two words of your young 'gentlemen,' 'Awfully sorry!' and put out his hand, which held now a coin large as a saucer. But again my Old only said: 'Sir, let me rest in your doorway!' And the young man drew back his hand quickly as if he were ashamed, and saying again, 'Sorry!' he shut the door. I have heard many sighs in my time - they are the

173

good little accompaniments to the song we sing, we others who are in poverty; but the sigh my Old pushed then - how can I tell you? - had an accent as if it came from Her, the faithful companion, who marches in holding the hands of men and women so that they may never make the grand mistake to imagine themselves for a moment the good God. Yes, *monsieur*, it was as if pushed by Suffering herself, that bird of the night, never tired of flying in this world where they talk always of cutting her wings. Then I took my resolution, and, coming gently from behind, said: 'My Old - what is it? Can I do anything for you?' Without looking at me, he spoke as to himself: 'I shall never find one who will let me rest in his doorway. For my sin I shall wander for ever!' At this moment, *monsieur*, there came to me an inspiration so clear that I marvelled I had not already had it a long time before. He thought himself the Wandering Jew! I had well found it. This was certainly his fixed idea, of a cracked old man! And I said: 'My Jew, do you know this? In doing what you do, you have become as Christ, in a world of wandering Jews!' But he did not seem to hear me, and only just as we arrived at our palace became again that old gentle being, thinking never of himself."

Behind the smoke of his cigarette a smile curled Ferrand's red lips under his long nose a little on one side.

"And, if you think of it, *monsieur*, it is well like that. Provided there exists always that good man of a Wandering Jew, he will certainly have become as Christ, in all these centuries of being refused from door to door. Yes, yes, he must well have acquired charity the most profound that this world has ever seen, in watching the crushing virtue of others. All those gentry, of whom he asks night by night to let him rest in their doorways, they tell him where to go, how to *ménager* his life, even offer him money, as I had seen; but, to let him rest, to trust him in their houses - this strange old man - as a fellow, a brother voyager - that they

174

will not; it is hardly in the character of good citizens in a Christian country. And, as I have indicated to you, this Old of mine, cracked as he was, thinking himself that Jew who refused rest to the good Christ, had become, in being refused for ever, the most Christ-like man I have ever encountered on this earth, which, according to me, is composed almost entirely of those who have themselves the character of the Wandering Jew."

Puffing out a sigh of smoke, Ferrand added: "I do not know whether he continued to pursue his idea, for I myself took the road next morning, and I have never seen him since."

MIKE RESNICK has written more than 200 novels in various genres. His most notable works are science fiction stories which draw on his considerable knowledge of African culture and history, including the novels *Ivory* (1988) and *Paradise* (1989) and the award-winning short story *"Kirinyaga"* (1988).

HOW I WROTE THE NEW TESTAMENT, USHERED IN THE RENAISSANCE, AND BIRDIED THE 17TH HOLE AT PEBBLE BEACH
By Mike Resnick

So how was I to know that after all the false Messiahs the Romans nailed up, *he* would turn out to be the real one?

I mean, it's not every day that the Messiah lets himself be nailed to a cross, you know? We all thought he was supposed to come with the sword and throw the Romans out and raze Jerusalem to the ground - and if he couldn't quite pull that off, I figured the least he could do was take on a couple of the bigger Romans, *mano a mano,* and whip them in straight falls.

It's not as if I'm an unbeliever. (How could I be, at this late date?) But you talk about the Anointed One, you figure you're talking about a guy with a little flash, a little style, a guy whose muscles have muscles, a Sylvester Stallone or Arnold Schwarzenegger-type of guy, you know what I mean?

So sure, when I see them walking this skinny little wimp up to Golgotha, I join in the fun. So I drink a little too much wine, and I tell too many jokes (but all of them funny, if I say so myself), and maybe I even hold the vinegar for one of the guards (though I truly don't remember doing that) - but is that any reason for him to single me out?

Anyway, there we are, the whole crowd from the pub, and he looks directly at me from his cross, and he says, "One of you shall tarry here until I return."

"You can't be talking to me!" I answer, giving a big wink to my friends. "I do all my tarrying at the House of Young Maidens over on the next street!"

Everybody else laughs at this, even the Romans, but he just stares reproachfully at me, and a few minutes later he's telling God to forgive us, as if *we're* the ones who broke the rules of the Temple, and then he dies, and that's that.

Except that from that day forth, I don't age so much as a minute, and when Hannah, my wife, sticks a knife between my ribs just because I forgot her birthday and didn't come home for a week and then asked for a little spending money when I walked in the door, I find to my surprise that the second she removes the knife I am instantly healed with not even a scar.

Well, this puts a whole new light on things, because suddenly I realize that this little wimp on the cross really *was* the Messiah, and that I have been cursed to wander the Earth (though in perfect health) until he returns, which does not figure to be any time soon as the Romans are already talking about throwing us out of Jerusalem and property values are skyrocketing.

Well, at first this seems more like a blessing than a curse, because at least it means I will outlive the *yenta* I married and maybe get a more understanding wife. But then all my friends start growing old and dying, which they would do anyway but which always seems to happen a little faster in Judea, and Hannah adds a quick eighty pounds to a figure that could never be called *svelte* in the first place, and suddenly it looks like she's going to live as long as me, and I decide that maybe this is the very worst kind of curse after all.

Now, at about the time that Hannah celebrates her

90th birthday - thank God we didn't have cakes and candles back in those days or we might have burnt down the whole city - I start to hear that Jerusalem is being overrun by a veritable plague of Christians. This in itself is enough to make my good Jewish blood boil, but when I find out exactly what a Christian is, I am fit to be tied. Here is this guy who curses me for all eternity or until he returns, whichever comes first (and it's starting to look like it's going to be a very near thing), and suddenly - even though nothing he promised has come to pass *except* for cursing a poor itinerant businessman who never did anyone any harm - everybody I know is worshipping him.

There is no question in my mind that the time has come to leave Judea, and I wait just long enough for Hannah to choke on an unripe fig which someone has thoughtlessly served her while she laid in bed complaining about her nerves, and then I catch the next caravan north and book passage across the Mediterranean Sea to Athens, but as Fate would have it, I arrive about five centuries too late for the Golden Age.

This is naturally an enormous disappointment, but I spend a couple of decades soaking up the sun and dallying with assorted Greek maidens, and when this begins to pall I finally journey to Rome to see what all the excitement is about.

And what is going on there is Christianity, which makes absolutely no sense whatsover, since to the best of my knowledge no one else he ever cursed or blessed is around to give testimony to it, and I have long since decided that being known as the guy who taunted him on the cross would not be in the best interests of my social life and so I have kept my lips sealed on the subject.

But be that as it may, they are continually having these gala festivals - kind of like the Super Bowl, but without the two-week press buildup - in which Christians

are thrown to the lions, and they have become overwhelmingly popular with the masses, though they are really more of a pageant than a sporting event, since the Christians almost never win and the local bookmakers won't even list a morning line on the various events.

I stay in Rome for almost two centuries, mostly because I have become spoiled by indoor plumbing and paved roads, but then I can see the handwriting on the wall and I realize that I am going to outlive the Roman Empire, and it seems like a good idea to get established elsewhere before the Huns overrun the place and I have to learn to speak German.

So I become a wanderer, and I find that I really *like* to travel, even though we do not have any amenities such as Pullman cars or even Holiday Inns. I see all the various wonders of the ancient world - although it is not so ancient then as it has become - and I journey to China (where I help them invent gunpowder, but leave before anyone considers inventing the fuse), and I do a little tiger-hunting in India, and I even consider climbing Mount Everest (but I finally decide against it since it didn't have a name back then, and bragging to people that I climbed this big nameless mountain in Nepal will somehow lack a little something in the retelling.)

After I have completed my tour, and founded and outlived a handful of families, and hobnobbed with the rich and powerful, I return to Europe, only to find out that the whole continent is in the midst of the Dark Ages. Not that the daylight isn't as bright as ever, but when I start speaking to people it is like the entire populace has lost an aggregate of 40 points off its collective I.Q.

Talk about dull! Nobody can read except the monks, and I find to my dismay that they still haven't invented air-conditioning or even frozen food, and once you finish talking about the king and the weather and what kind of fertilizer

you should use on your fields, the conversation just kind of lays there like a dead fish, if you know what I mean.

Still, I realize that I now have my chance for revenge, so I take the vows and join an order of monks and live a totally cloistered life for the next twenty years (except for an occasional Saturday night in town, since I am physically as vigorous and virile as ever), and finally I get my opportunity to translate the Bible, and I start inserting little things, little hints that should show the people what he was really like, like the bit with the Gadarene swine, where he puts devils into the pigs and makes them rush down the hill to the sea. So okay, that's nothing to write home about today, but you've got to remember that back then I was translating this for a bunch of pig farmers, who have a totally different view of this kind of behaviour.

Or what about the fig tree? Only a crazy man would curse a fig tree for being barren when it's out of season, right? But for some reason, everyone who reads it decides it is an example of his power rather than his stupidity, and after awhile I just pack it in and leave the holy order forever.

Besides, it is time to move on, and the realization finally dawns on me that no matter how long I stay in one spot, eventually my feet get itchy and I have to give in to my wanderlust. It is the curse, of course, but while wandering from Greece to Rome during the heyday of the Empire was pleasant enough, I find that wandering from one place to another in the Dark Ages is something else again, since nobody can understand two-syllable words and soap is not exactly a staple commodity.

So after touring all the capitals of Europe and feeling like I am back in ancient Judea, I decide that it is time to put an end to the Dark Ages, I reach this decision when I am in Italy, and I mention it to Michelangelo and Leonardo while we are sitting around drinking wine and playing cards, and

they decide that I am right and it is probably time for the Renaissance to start.

Creating the Renaissance is pretty heady stuff, though, and they both go a little haywire. Michelangelo spends the next few years lying on his back getting paint on his face, and Leonardo starts designing organic airplanes. However, once they get their feet wet they do a pretty good job of bringing civilisation back to Italy, though my dancing partner Lucretia Borgia is busily poisoning it as quick as Mike and Leo are enlightening it, and just about the time things get really interesting I find my feet getting itchy again, and I spend the next century or so wandering through Africa, where I discover the Wandering Jew Falls and put up a signpost to that effect, but evidently somebody uses it for firewood, because the next I hear of the place it has been renamed the Victoria Falls.

Anyway, I keep wandering around the world, which becomes an increasingly interesting place to wander around once the Industrial Revolution hits, but I can't help feeling guilty, not because of that moment of frivolity eons ago, but because except for having Leonardo do a portrait of my girlfriend Lisa, I really don't seem to have any great accomplishments, and eighteen centuries of aimlessness can begin to pall on you.

And then I stop by a little place in England called Saint Andrews, where they have just invented a new game, and I play the very first eighteen holes of golf in the history of the world, and suddenly I find that I have a purpose after all, and that purpose is to get my handicap down to scratch and play every course in the world, which so far comes to a grand total of one but soon will run into the thousands.

So I invest my money, and I buy a summer home in California and a winter home in Florida, and while the world is waiting for the sport to come to them, I build my own putting greens and sand traps, and for those of you who

are into historical facts, it is me and no one else who invents the sand wedge, which I do on April 17, 1893. (I invent the slice into the rough three days later, which forces me to invent the two-iron. Over the next decade I also invent the three through nine irons, and I have plans to invent irons all the way up to number twenty-six, but I stop at nine until such time as someone invents the golf cart, since twenty-six irons are very difficult to carry over a five-mile golf course, with or without a complete set of woods and a putter.)

By the 1980s I have played on all six continents, and I am currently awaiting the creation of a domed links on Antarctica. Probably it won't come to pass for another two hundred years, but if there is one thing I've got plenty of, it's time. And in the meantime, I'll just keep adding to my list of accomplishments. So far, I'd say my greatest efforts have been putting in that bit about the pigs, and maybe getting Leonardo to stop daydreaming about flying men and get back to work at his easel. And birdying the 17th Hole at Pebble Beach has got to rank right up there, too; I mean, how many people can sink a 45-foot uphill putt in a cold drizzle?

So all in all, it's been a pretty good life. I'm still doomed to wander for eternity, but there's nothing in the rulebook that says I can't wander in my personal jet plane, and Fifi and Fatima keep me company when I'm not on the links, and I'm up for a lifetime membership at Augusta, which is a lot more meaningful in my case than in most others.

In fact, I'm starting to feel that urge again. I'll probably stop off at the new course they've built near Lake Naivasha in Kenya, and then hit the links at Bombay, and then the Jaipur Country Club, and then....

I just hope the Second Coming holds off long enough for me to play a couple of rounds at the Chou En-Lai Memorial Course in Beijing. I hear it's got a water hole that

you've got to see to believe.

You know, as curses go, this is one of the better ones.

KIM NEWMAN is a novelist and film critic whose books include a notable study of modern horror films, *Nightmare Movies* (1985); a science fiction novel replete with *film noir* imagery, *The Night Mayor* (1989); and the stylish horror novel *Bad Dreams* (1990). He has previously worked with EUGENE BYRNE on a series of pseudonymous novels.

THE WANDERING CHRISTIAN
By Eugene Byrne and Kim Newman

'I'm dying,' said the madman next to him.

'So,' Absalom grunted, feeling the arrowhead shift against his ribs, 'there's a lot of that about.'

'No," said the madman, eyes like candleflames, 'I'm *really* dying.'

Absalom coughed, bringing up blood. The arrow had dimpled one of his lungs, and he was slowly drowning, he supposed, his blood filling up his lungs. He knew more about doctoring than the barber-surgeons who occasionally came round to see what they could do for the wounded. As a soldier, he was more than familiar with the many ways a man could die.

He tried to remember whether he had seen the madman before, up on the walls of Rome, maybe defending one of the gates. Now, he was bearded and scrawny, his hands pressed on the yellow rag he held to his liver, trying to keep his insides in. His armour and weapons were long gone, passed on to a healthier defender.

'It's the end of time,' he said. "What date is it?

'The second day of Tammuz.'

'No,' the madman coughed, 'the year? I've forgotten.'

Absalom knew his One True Testament. '4759,' he said. '4759 years since the creation of the world. It's not the end of time at all. The Messiah has not come.'

The madman grimaced, painfully. Absalom realised he really was mad. Twenty-two years of soldiering, and he would die a forgotten hero with only a lunatic for company.

'Even if Rome falls, it will not be the end of time. The Chosen People will endure.'

The madman began to choke, and Absalom thought he was about to pass away, but his coughs changed, turned to bitter laughter. He was beyond pain, beyond everything.

'The Chosen People,' he said, 'the Chosen People...'

Outside the walls, the Persians were gathered, half-heartedly building their earthen ramps to the edge of the city, barely bothering to launch attacks with their huge wooden siege-towers any more. They were catapulting rocks and corpses into the city, and firing rains of arrows, but mainly they waited for starvation and disease to do their job for them. At first, Shah Yzdkrt, known as Yzdkrt the Flayer, had decreed that all gentiles would be allowed to pass unharmed through the besieging ranks and, after paying a small tribute, be allowed on their way. But the rumour was that those citizens foolhardy enough to believe him had been meekly led to a glade on the Tevere and slaughtered, their bodies dumped into the river in an attempt to poison the city's water supply. Two months ago, rabbi Judah, a good and humble merchant well known for charitable works, was sent out to parley with the Persians, taking with him gifts for Yzdkrt and a message of peace from the Emperor. Yzdkrt had him slowly stripped of his skin, and his hide was stretched out on the ground before the main gate as reminder to the besieged Romans of the fate the Shah had set aside for them all.

Governor David Cohen was ruthlessly enforcing siege regulations on the populace, military and civilian. Soldiers were on half-rations, all others on quarter-rations. Absalom heard that anyone who used water for washing was being put to death. Certainly, no one had offered to clean his

wounds, with the result that even if he didn't drown he'd be eaten up by the mange spreading from the cuts on his body. The wounded were being stacked up in the catacombs, out of sight, but it was impossible to silence their screams. When he had been on patrol up above, everyone had been spooked by groans coming from under the earth. Now he was with the groaners, and he thought he had a foretaste of Hell. There were a few lamps, but it was mainly gloomy, and some straw had been spread to lie on, but it was filthy with blood and shit. Latrines had been dug, but most of the wounded were unable to get to them without help, and there was no one to help. The tunnels were trickling with sewage.

A few of the more zealous or compassionate rabbis left their other trades or duties and ventured into the catacombs to comfort the dying. Absalom could always hear the low mumble of the kaddish under the screaming.

Rumours were the only entertainment the dying had. Absalom received the rumours from Isaac bar-Samuel to his left and passed them on to the madman as they came his way. It was rumoured that Governor Cohen was expecting an army of relief directly from the North, led by the Emperor in person; that the plague raging in the city had spread to the Persians, and that Yzdkrt himself had succumbed; that the men of Rome, no matter how young or old, were used up, and that the women were being impressed to bear arms against the Zoroastran unbeliever. The madman took it all lightly, laughing as the yellow stain spread up his side.

The rats would have been a problem, only Governor Cohen had organised gangs of children to hunt them for food. The shochets were setting aside the dictates of kashrut and learning to make do with rodentmeat. In the catacombs, where any animal that got within reach of a man deserved the swift death it inevitably got, even the

niceties of butchering were being ignored. Raw ratmeat was tough, but chewing something helped lessen the pain.

A new rumour came down from Isaac. Above, it was noontime, but the sky was dark. The sun had been blotted out, and a peculiar sign was visible in the sky; an upright cross, like the skeleton of a kite, stood out in fire against the black. The rabbis and scholars were arguing its significance, and no one could tell whether the sign was meant for the Chosen People inside the walls or the infidel beyond.

Absalom told the madman, and, for the first time, got a reaction out of him.

'It has come. It is time. One thousand years.'

"What's the babbling idiot talking about?" Isaac asked.

Absalom shrugged, feeling a stabbing under his arm as his broken bones shifted.

'I don't know. He's mad.'

There was a lot of that about too.

'No,' the madman said, 'listen...'

It was quieter than usual. The dying were calming down.

A rabbi scuttled around the corner, bent over by the low roof. He was hardly more than a boy, his beard still thin and wispy. His robes were full of tears, each rip a ritual sign of grief for a dying man he had attended. All the rabbis in the city were looking like beggars these days.

'Hear me,' the madman said, 'hear my confession...'

'What, what,' said the rabbi, 'confession, what's this, what's this?'

'Is it true about the sky?' Absalom asked.

'Yes,' said the rabbi, ' a rain of blood has fallen, and a lamb with a glowing heart has been seen in the clouds. Most significant.'

'Of course, of course,' said the madman. 'He has returned. It was prophesied.'

'I don't know what you're talking about,' said the rabbi, 'I know all the prophecies by heart, and this is without precedent.'

'Hear me out.'

There was something about the man that persuaded the rabbi. Absalom was interested too, and Isaac. A few of the others, dim shapes in the dark, pulled themselves nearer. The madman seemed to glow. His pain was forgotten, and he let the rag fall away from his festering wound. It was a bad one. Absalom could see into the man's entrails, and could tell they were not healthy. It must have been a swordstroke at one of the gate skirmishes that had done for him. But the madman did not feel the hurt any more. He sat up, and, as he spoke, his eyes glowed brighter.....

My name is Joseph. I was born in Judaea a thousand years ago. No, I'm not mad. Well, maybe I am. A thousand years, a thousand deaths, would send anyone mad. Whatever, I'm a thousand years old.

When I was born, Judaea was ruled by the old Roman Empire. Romans were accustomed to being welcomed, or at least tolerated, as wise and beneficent rulers throughout their imperium. But they could never persuade the Judaeans to accept their rule and there was always a revolt going against them. The biggest of these, led by Judas of Galilee, was against a poll tax the Romans imposed. It was suppressed with efficient brutality. But the Romans never broke the spirit of the Jewish people, the Chosen People...

In a shithole called Nazareth, there grew up a humble carpenter. We were born in the same year, so we're the same age. He was Yeshua bar-Joseph; called, in the Romanised form, Jesus, son of Joseph. About the age of

thirty, He decided to quit his trade and become a travelling preacher. He pulled in the crowds wherever He went. He also gathered a small band of dedicated followers, hangers-on who believed all He said and talked Him up with the rabble, and bully boys who kept Him out of trouble with the priests and the occupation goons. As Yeshua's reputation spread, so did the stories about Him, stories of miracles that He performed - walking on water, raising the dead, curing the sick, the crippled, the blind, the leprous... Back then, the cure for anything was a miracle. He could also turn water into wine, which made him very, very popular.

His disciples decided that Yeshua was the promised one, the Redeemer, the Messiah of the Jews. Others said He was the son of God. Yeshua the Nazarene, son of Joseph became known as Yeshua the Anointed One. In later years He would be called by the Greek word meaning the anointed one, Christos.

As I said, this was a bad time for Judaea politically; the Messiah, if Yeshua was He - something He never denied - was expected to rescue the country from the Romans.

He also annoyed the priests by saying the Law was only a starting point for moral improvement. His love of ordinary people no matter how much they had sinned and no matter how vile their status, annoyed the clergy even more. The ordinary people, understandably, loved Him. He mixed with harlots and tax-collectors and Samaritans. The scum of the earth. If you want to get a sect together, that's a good way to start. People who've been pissed on all their lives love being told they're special.

It wasn't long before everyone in power wanted Yeshua dead. The Romans thought He might be a dangerous revolutionary. The Pharisees disagreed with His preaching. The Sadducees, who were rich and who wanted to placate the Romans and not disturb the status quo, regarded Him as a distasteful upstart with some funny ideas about people

being resurrected after death. The Zealots, real diehards who wanted to remove the Romans by force, wanted to use Him as a figurehead for a revolt, even though He renounced the use of violence. His ideas were peace, love, justice and prayer and He preached that the kingdom of God was coming, though He never said when it would arrive. If you want to know what happens to people who preach peace, love and justice, go ask Rabbi Judah.

After three years preaching on the road, Yeshua visited Jerusalem for the first time. Although He was just a hick from up-country Galilee coming to the political and religious centre of Judaea for the first time, He got a spectacular welcome. The mob turned out to see Him arrive. He came riding in on a donkey as if to say 'look, I'm no better than any of the rest of you.' And everyone was expecting Him to do great things. They threw palms to the ground in front of Him and lined the streets, asking him to do magic tricks. A cousin of mine, Jacob the wine merchant, turned up with a cartload of waterbags, and tried to get Him to turn them into wine, and he got beaten up by Peter bar-Jonah, who was Yeshua's strong-arm man. That was one of the first things that put me off this so-called Anointed One.

His entry into Jerusalem raised everyone's expectations. And what's more, He had walked into the arms of the Romans and the priests. They would have no trouble getting their hands on Him now.

Everyone waited a few days to see what would happen. In the end, the priests decided to remove Him. One of Yeshua's close friends, Judas, was a Zealot. He wanted Yeshua to raise the people against the Romans, but when it became clear Yeshua would do no such thing, Judas tried to force His hand. He thought that if he led the priests to Yeshua, his friend would be forced to run from them and lead the revolt, or that the people would be so outraged by the sight of Yeshua being put on trial for sedition or

blasphemy that they would spontaneously rise up. Judas went to the priests and told them he could set Yeshua up for a nice quiet arrest. The priests agreed, and Judas led an armed posse of temple guards to Yeshua. But Yeshua, instead of making a hasty escape, went along meekly. Judas started to realise he'd made a big mistake, and emptied a few wineskins in misery.

The next day, Yeshua was taken before the Council of the Sanhedrin, who drew up a series of charges against Him. They wanted Yeshua safely dead, but they couldn't condemn Him to death themselves. They had to make a case that would convince the Romans to execute Him.

The priests, you understand, were not all evil men. Many of them were worried that the Nazarene would lead the whole of Judaea into confrontation with the Romans. This provincial troublemaker might have plunged the whole country into war, and that would have been bad for business for everybody. The high-priest, Caiaphas, told the other council members it was their duty to condemn this one man in order that the rest of the nation should not suffer.

Many members of the council wanted to hang a blasphemy charge on Yeshua, but Caiaphas persuaded them to ignore that, and use the charge that would frighten the Roman authorities most. So they alleged unfairly that He had been inciting revolt against Roman rule. A few days before, Yeshua had thrown a fit in the Temple, and kicked some money-changers out of the Court of the Gentiles, so the small business lobby was against Him. A couple of money-changers were prepared to allege that He was shouting 'death to Caesar' as he roughed them up.

So the Sanhedrin handed Yeshua over to the Romans.

The procurator of Judaea at this time was Pontius Pilate. He was an arrogant, insensitive blockhead. He enjoyed antagonising the Jews, not that that was difficult.

I don't even think he always did it deliberately. He was just too stupid to understand all our little sensitivities.

So here he was, confronted with this guy the priests and a lot of the mob wanted put to death. Nobody in the crowd seemed to be a friend of the Nazarene any more. Perhaps everyone was disappointed He hadn't challenged the Romans after all.

Pilate was a Roman, he respected due process of law. And the Nazarene had committed no crime he could see. But he was in a difficult position; much as he enjoyed lording it over his subjects, he didn't want to start a riot, and the mob wanted Yeshua dead. So you'd think he would have no problem just killing the Nazarene quickly, and getting back to the baths or eating grapes or whatever it is that Roman governors did all day. Maybe he was just suspicious and didn't want to do anything until he fully understood what was going on. That would have been a problem, because no one understood what was going on.

Then Pilate's wife interfered. She was Claudia Procula, a granddaughter of the Emperor Augustus, which gives you some idea of how well-connected the procurator was back in Rome. Just as he was sitting in judgement on Yeshua, he got a message from Claudia, claiming that she had just had the worst nightmare ever, and all on account of the Nazarene. In the dream, she foresaw all kinds of terrible things if her husband executed the man. So now Pilate was having real trouble making his mind up, which for him was pretty unusual.

What concluded the argument for Pilate was politics back home. This was the time of the Emperor Tiberias. Tiberias was cracked. He had retired to the island of Capri, surrounding himself with astrologers and quacks. And, if you believe the gossips, a small army of young people to cater to his increasingly bizarre sexual tastes. For a while, the Empire was effectively run by his guard commander,

Sejanus, who, given a free hand, set about clearing the way for himself to suceed Tiberias. Every potential rival, including members of the imperial family, was murdered or executed on trumped-up charges. Sejanus' plan worked well enough until the Emperor's sister-in-law managed to get to Capri and tell Tiberias what his Praetorian favourite was really getting up to. So Sejanus was toppled, and there was the usual bloodbath in which all his associates, including his children, were slaughtered. Pontius Pilate, a self-seeking dickhead, had been a supporter of Sejanus. Now, a year or two after the fall of Sejanus, Pilate's loyalty to Caesar is questionable as far as Caesar is concerned.

Caiaphas knew this, and he whispered to Pilate that Yeshua was setting Himself up as King of Judaea. He added that Pilate could be no friend of Caesar's if he did not execute the Nazarene. The last thing Pilate needed was a letter from Rome telling him to come home with his will written out in triplicate. He gave his permission for the Nazarene to be put to death. As was the usual practice, Yeshua was taken out and executed at once.

I know, my friends, that we live in a barbaric age in which the days of the great Roman Empire are sometimes looked on fondly, but the way they killed Christos was atrocious. Believe me, Absalom, an arrow in the lungs is a luxurious hot bath next to crucifixion.

That was what the Romans did to Him. It was reserved for those they despised the most. It's the worst possible way I've ever come across for a man to die. No Roman noble or or citizen could be crucified because it was considered a form of death unfair for free men. It was for slaves, thieves, bandits and - of course - for those who rebelled against Rome.

It all started with a thrashing. The soldiers triced you up and flogged you. They used a long whip with pieces of bone or metal studded in the end. The thong wrapped

itself right around the body, tearing off flesh as it went. After three times thirteen lashes - sometimes more - there was more skin hanging off your back and chest than was left hanging on.

Having softened you up like this, they made you lift a heavy wooden beam and stagger off to the place of execution. In Jerusalem at this time, it was a small hill outside the city walls called Golgotha, the Place of Skulls.

Here there was a vertical wooden post six or seven feet high. When you got there, you were invited to drop the beam you'd been carrying. Then the soldiers knocked you over and lay the back of your neck in the middle of the beam. Then they stretched out one of your arms along the beam. A couple of the men held the arm down while another one took one of those big, long four-sided nails and hammered it through your wrist into the wood below.

Having nails through the wrist is extremely painful. Believe me, I know.

After they'd done this with the other arm, the whole execution squad lent a hand to lift up the crossbeam with you hanging from it, yelling your lungs out in agony, or maybe just biting your tongue, determined not to give those filthy bastards any pleasure by letting on you were suffering.

But then you found it very difficult not to yell out when they actually lifted you off the ground.

There was a hole in the middle of the beam roughly under your head. This they slotted into the vertical piece already wedged in the ground.

Now they bent your knees upwards until the sole of one foot was pressed flat against the vertical piece. Well fuck my old sandals if they didn't then produce another one of those big nails.

A nail through the foot is more - much more - painful than a nail through the wrist. They hammered it through one foot, and when the point came through the sole of that

194

foot, they hammered it through the other foot and into the wood.

Then they would leave you alone. Some would watch, maybe they would take bets with one another on how long you'd live. After a while, it got boring, and they'd post a guard and go off to get drunk or screw a hog or whatever it was that legionaries did in their time off.

About now, you'd wish that you were back in the barracks being flogged. If, by any strange mischance, you had not gone out of your mind, you might have time to wish they had flogged you harder because the flogging weakened you. And the weaker you were, the sooner you died. And death was the only thing you desired. Death was the only thing left.

You didn't bleed much, but the pain was indescribable. The weight of your body hanging from your wrists pulled your chest upwards as though you'd taken the biggest, deepest breath ever. But you couldn't breathe out. To breathe out, you'd have to push upwards with your legs. Pushing up with your legs was indescribably painful because of that bloody nail running through your feet.

At the same time, there was even more pain coming from cramps in your hands, along your arms and shoulders and chest.

You were in all this pain, and you could hardly breathe. If you were really lucky, you'd bleed, or more likely suffocate, to death in perhaps five hours. If you weren't lucky, it could take days.

And those clever, cunning, oh-so-bloody *civilised* Romans could vary it. They could hammer a piece of wood into the vertical piece, like a little seat under your arse. That meant it was slightly easier to breathe because you didn't have to push on your legs so much, so you hung there for longer. Or they could tie your arms to the crosspiece as well as nailing them there. That had the same effect.

Maybe the sons of bitches used both methods. I've seen poor bastards spend nearly a week dying that way. If the Romans liked you - or your relatives bribed them - they could break your legs. That way, you couldn't push yourself up to breathe even if you wanted to, so you suffocated fairly quickly.

So don't talk to me about the old Roman civilisation. I know they had central heating and straight roads and the greatest army the world has ever known, but at the back of all that they were the biggest shits in creation. Look, if some barbarian king back in the Dark Ages wanted you dead, what did he do? Cut off your head, or bludgeon your brains out, or drown you, or throw you off a high rock. All pretty quick. The Romans, being three times as clever and ten times as organised as any barbarian were a hundred times more savage in their methods of murdering people.

And that's what they did to Yeshua Christos.

Pilate, being Pilate, got his revenge on the priests for blackmailing him. Whenever someone was crucified, the law said that you had to have a plaque on the top saying what crime the victim was condemned for. Pilate ordered that the inscription read "Yeshua of Nazareth, King of the Jews', and had it written in Latin, Greek and Hebrew to make sure everyone got the message. This was hung around Yeshua's neck when He was on his way to the execution and then it was nailed to the top of the cross.

So how do I know all these things? Well, first, I was there when He was crucified. Secondly, I've been crucified myself. Lots of times. They say you have no memory for pain. That's crap. I shiver every time I pass a carpenter's shop or hear someone hammering. And I'm immortal. Or I was until today.

A thousand years ago, my name was Cartaphilus. I was a good, law-abiding, unimaginative orthodox Jew. And I worked as doorkeeper to Pontius Pilate. He needed

doorkeepers because most people who came to visit a Roman govenor were either too important to touch a door themselves or too busy crawling and begging to bother with one. The first time I met Yeshua of Nazareth was as he was being led out to be executed. He had just been scourged. The soldiers had put this crown of thorns on Him. They wanted to have their part in annoying the priests as well and were playing up to Pilate's crack about Yeshua being King of the Jews. Yeshua was being led out, struggling under the weight of the cross-piece of the crucifixionframe.

Now at that time most of what I knew about Him was rumour - that and what my cousin Jacob the wine-merchant said when he dropped in to have his head bandaged. Some people were claiming Yeshua was the Messiah, the king of the Jews. But the high priest Caiaphas had wanted Him condemned to death. Being a good Jew, I figured that anything Caiaphas said must be kosher. If the high priest wanted the Nazarene killed, then he had his good, religious, reasons. So, what can I say? I was an idiot.

The Nazarene was trying to get through the door. I spat on Him. He fell down under the weight of the wooden beam. I put my foot on His back, where He had been whipped and the flesh was hanging off him. I pushed with my foot and told Him to get up and get a move on.

Someone had told me He sacrificed and ate small children. And, back then, I was callous.

He cried out. Then He got up, picked up the beam with some effort and he looked at me. He said, '*I am going quickly to my death. But you will wait a long time for death. You will be waiting until I return.*'

I didn't know what to make of this. I didn't think much about it. A couple of soldiers hit Him with the flats of their swords and off He went to Golgotha.

His words didn't sink in at first, then a strange panic overtook me. I realised He'd put some kind of curse on me.

Even if He was a blasphemer, He was still some kind of holy man. I was very troubled. An hour and a half after He had spoken to me, I quit my doorkeeper's job for ever.

I ran to Golgotha. He was nailed to his cross in between two Zealots. He was still alive, but quiet, not struggling and groaning as much as the other two. There weren't many other people around, just some ghouls. His disciples had all deserted him. Whether Yeshua was the son of God or not, no man would want to be associated with him and run the risk of winding up nailed to the next-cross-but-one.

There were a few women around. Friends and relatives. And the execution squad was there, playing dice for his possessions. But there was a strange thing, a Roman officer - I don't know if he was in charge of the execution squad - was pacing up and down, looking at the dying man and muttering to himself.

The Centurion looked at me and beckoned me over. In those days, you did everything in your power to avoid those people. They brutalised their own soldiers enough, and they could be lethal to ordinary civilians, especially in a country they could barely control. I was terrified as I walked over to him. But all he did was grab me by the shoulders, look straight into my eyes and say, 'Truly, this man was the son of God.' All he wanted was someone to listen.

The son of God! Only afterwards did I realise what a queer thing this was for a Roman to be saying. Romans believed in lots of Gods. The only people around who believed in one god were we Jews. Maybe the Centurion was Jewish. I don't know.

The son of God!

If the Centurion was right, then I was condemned for ever. I lost my reason. I walked to the foot of the cross and begged the Nazarene to forgive me. But it was too late. He

was in too much pain to take any notice.

Then I went over to the women, who were all crying and pulling at their hair and I joined them. One of the whores had seen me kicking Him. They didn't want to know me. I can't blame them for that.

I was too troubled and too ashamed to seek out the Nazarene's friends. Not that he had many at this stage. His male followers were in hiding. Even good old Peter, who was no slouch when it came to beating the crap out of money-changers and wine merchants, was at this moment loudly claiming he had never heard of Yeshua and didn't like him anyway. As for Judas the Zealot, he hanged himself because his plan had gone wrong. I regretted that. In the next few years, he would have been company.

I began to wander. I left my wife and my family and walked-first north, towards Galilee. I don't know why. An evil spirit within me told me that I must wander the face of the world until He should return.

The nights were always the worst. As evening drew in and the shadows lengthened, my own shadow would become that of Yeshua struggling under the weight of that wooden beam.

Years later, I heard what happened. The Romans liked to leave corpses hanging to rot as an example to any other would-be offenders. But the Jewish law would not permit bodies to be exposed in this way on the Sabbath, and the day after Yeshua's execution was the Sabbath. Joseph, a man from a place called Arimathea, a rich and influential Jew who was friendly both with Yeshua's family and with Pilate, approached the governor. After the Romans had checked that Yeshua was dead, Joseph got permission to take the body down and he buried It in the tomb he had bought for himself.

A few days later, Yeshua of Nazareth rose from the dead. He visited his frightened followers, who took strength

from seeing Him again. Some time after that He ascended to Heaven to take his place at the right hand of the Lord.

Don't be so shocked, rabbi. Just because it isn't in your One True Testament doesn't mean it didn't happen.

Yeshua's followers now dispersed throughout the Empire and beyond, spreading the story of how He had come to save man from his sins. Some of them began their work right there in Jerusalem, but they were driven out by the authorities. One of them, a man named Stephen, was stoned to death for blasphemy.

At first, followers of Christos and those they baptised into their faith seemed to be forming a new sect of Judaism, but soon it became clear that there were important differences. One of the others, Philip, met an Ethiopian on the road from Jerusalem to Gaza. The Ethiopian was an important court official in the service of the queen of his country. He was a eunuch. As you know, a man who is not whole may not become a Jew. The eunuch asked Philip 'Is there anything to prevent me being baptised?' And Philip answered, 'Nothing.'

From now on, said the Christians, there would be no distinction between Jews and Gentiles, slaves and freedmen, men and women. The Ethiopian returned to Nubia and told his fellow citizens the good news.

The number of Christians multiplied rapidly. The faith was taken by the missionaries into Africa and Syria, to Mesopotamia and even as far as India. Syria, with its great cities of Antioch, Damascus and Edessa, became a great centre of the Christian religion.

Don't be ashamed that you've not heard of Christianity. It was a long time ago.

What of me?

My travels took me to Rome where I found a thriving

community of believers in the Christian sect. I joined them. and learned more of Yeshua's teachings. I was baptised into their faith, meaning they dunked me in water in a ceremony similar to that of immersion in the mikveh. I changed my name to Joseph in honour of Joseph of Arimathea.

By now, I was almost a hundred years old, though I looked no older than the day on which I had abused our Saviour. My new faith brought me peace of a sort, for Yeshua Christos taught that the most loathsome of sins would be forgiven by the Lord His Father. I had spat on Him and kicked Him, and while I dared not admit this to my comrades I could hope that when He returned I would be forgiven. In those days we all believed His return was imminent. This is what we told one another, and it is what we preached to any who were willing to listen, and many who did not wish to hear. We were a nuisance to some, offensive to others. Some of our number, including Peter the thug, were executed by the authorities. My cousin Jacob the wine-merchant, whose fault all this was, prospered and lived to be 115, at which age he was still fathering children.

We were unsure of our relationship with the orthodox Jews. Most of us considered ourselves a Jewish sect. Others, generally the hotheads, thought we should be completely separate. There were many Jews in Rome and we debated with them whether or not Yeshua had been the Messsiah. We believed so, but they did not. On many occasions we fought openly in the streets. We gradually came to realise there was no reconciliation between us.

There was a great fire which wrecked the city centre. The Emperor Nero's new palace was badly damaged. Nero was spendthrift and unpredictable and unpopular, and the rumour went about the market that he had started the fire deliberately. Another story had it that he had done nothing

to quench the fires, and had played a lyre and recited his poems as the city burned, for he considered himself a great artist. Having been burned alive and having heard Nero recite in public, I can honestly say I preferred the former experience.

Nero, probably at the suggestion of one of his toadies, wanted to blame the fire on the Jews. The Jews were unpopular in Rome for while their religion was tolerated, they did not worship the Roman Gods. Nero's wife Poppaea discouraged him from persecuting the Jews. She was not Jewish herself, but was sympathetic to them. She said that Nero should instead blame the Christians. Nero readily agreed. We were to be used in the manner of a scape-goat.

Nero, by the way, also ordered the death of the aged Pontius Pilate. I don't know why. Pilate was in Gaul at that time, and the story goes that he was staked out, cut open in a few places and eaten alive by worms. Perhaps this was just wishful thinking on our part.

Nero ordered his brutish Praetorian prefect Tigellinus to do his dirty work. The soldiers came for us and, after trials of sorts in which they seemed more interested in our 'hatred of humanity' than our alleged arson, we were despatched in all manner of ways. Not by crucifixion, but by the sword, or by being sewn into the skins of wild animals and being attacked and eaten by dogs in the circus. That was a good one - it hurt like a bastard. At first, our persecution was popular. People disliked us for our disdain for their gods, and for preaching our own faith so aggressively. Then Nero's excesses turned many to pity, while others were inspired by the way in which we died for our faith. This happened particularly after Nero ordered that Christians be tied to crosses which were set in tubs of oil. This was at night and we were then set ablaze and used like oversized torches to light an avenue through the Emperor's gardens, along which His Talentless Majesty

proceeded in his chariot.

I was one of those Christians.

I've said much about suffering already, so I shall spare you a detailed description of what it is like to be set in oil and pitch and burned alive. In spite of all the pain and the terror which I and my brothers and sisters experienced, I am proud to say that we all went to our deaths without show of fear and with great joy, for would we not soon be reunited with our Saviour?

But imagine my surprise when, after experiencing considerable physical agony and apparently dying, I woke up the next day as though nothing had happened, in Judaea.

That's a bloody long way from Rome.

Now I began to fully understand the meaning of Yeshua's curse upon me. To atone for my great sin I would have to wander the world of men until His return. This was the first occasion on which I had died and now, I found I had not been granted the release of death but had remained among men. My soul was chained to the earth in the same body and my martyrdom in the Emperor's gardens had not taken place.

Whenever I died subsequently, I would not know what happened to my corpse, but I always awoke in the same body - or a similar one - in some new and frequently distant land.

Waking from the dead this first time in Judaea, I soon discovered what my purpose was to be.

I entered Jerusalem and, without bothering to seek out others among the Christian community, I begged food and drink and preached the good news of Christos in public. Within three days the Sanhedrin had me stoned to death as a blasphemer. Again, I did not truly die. I woke up in a different place, Corinth. Again I preached the message of Christos and again, though it took me a few years this time,

I was martyred.

At around the same time as the last great Jewish rebellion against Rome, which as you know resulted in the destruction of the Temple and the sack of Jerusalem, I became a professional martyr. At the same time as the Romans were causing the Jews to disperse throughout the world, I too, travelled, seeking out death. The Voice of the Lord told me that in this way I was doing penance for my sin, that the example shown to others by martyrs would win people over to our Church.

For almost three hundred years after the death of Yeshua, a great many of his followers died martyrs' deaths. Martyrdom was an idea we borrowed from the Jews and turned into a fine art, my friends. Martyrdom, we told ourselves, was a second baptism and a highway to heaven, which indeed it was - for everyone except me. Every time a crowd lynched me, or a magistrate ordered me be burnt, beheaded or savaged by animals, I awoke in a new place and sought out the Christian community and joined it, or simply preached the gospels in the nearest town square.

The persecutions were more intense at some times than at others. When they did occur, they were for a number of reasons.

In the early days, for instance, we would always hold our meetings before dawn. This went against the spirit of the Twelve Tables, which were at the centre of Roman law and which forbade nightly meetings. So the Romans got suspicious of us, thinking we were conspiring, or committing shameful acts. We would sing or chant, exchange oaths not to commit crimes and we would have a meal in common. This led us to be suspected of magic.

They despised us, too, for the simplicity of our faith. Sophisticated patricians looked down on us because we avoided demonstrative argument, preferring to talk about Yeshua's miracles and re-tell parables they thought were

childish. They called us "Galileans' and mocked our faith as a religion for slaves.

Before too long, they also came to despise many of us for the way in which we sought out martyrdom. The Emperor Marcus Aurelius, a snobbish old dilettante who fancied himself as a philosopher, said he hated the vulgar and undignified way in which we went to our deaths. Tell me, what were we supposed to do? If wild dogs had chewed his balls off in the circus, I'm sure he would have been really fucking dignified about it.

But I think what annoyed educated pagans most was our certainty that there was only one true God. The Romans tolerated all religions, even the Jews, on the principle that each man should worship in the way he sees most fitting. Now we came along and preached the absolute truth in the face of their ancient deities - gods which had, after all, brought Rome great prosperity and success. And now we working-class upstarts came along saying everyone else was wrong and that we had a monopoly of truth.

All manner of wild rumours cirulated about us. They said we worshipped the head of an ass. They said that we met every week to sacrifice and then eat a baby. You can imagine how I felt when I first heard that old chestnut. I couldn't bring myself to sneer at those stupid enough to believe it. After all, I am cursed not only with longevity but with a perfect memory. Now you know why I wasn't too impressed yesterday when Isaac told us the rumour that old Yzdkrt out there dines on babies every Sabbath. Mind you, with him it just might be true.

The Romans also accused us of incest, perhaps from our habit of calling one another 'brother' and 'sister'. They said that we worshipped the genitals of our priests. More damaging were the stories of sexual licence because, I regret, some of these were true.

We were scattered throughout the Empire.

Congregations developed with little contact with one another, and there was no unifying authority to establish the detail of our rites and beliefs. Mainly, this made little difference and most Christians lived - or tried to live - good and pious lives. But there were heresies in a few places; some, for example, debated whether Christos had been god or man - He was obviously both - and other points of belief. The worst heresy I ever witnessed was that of the Phibionites.

They lived in Alexandria, and I landed among them the day after I'd had my head cut off in Philadelphia. The sect had been founded by a man named Nicholas of Antioch and their rites took the idea of heavenly love to obscene extremes. They held their wives in common and would, in a travesty of our communion ceremony, smear semen and menstrual blood on their hands offering these as the 'body and blood' of our Redeemer. If any woman among them became pregnant as a result of one of their orgies, they would abort her and eat the foetus mixed with honey and pepper.

It became clear to me that these were not wicked or licentious people. They had just been led tragically astray by Satan, and they sincerely believed that in offering up what they called 'the essence of man' in sacrifice, they were honouring the Lord.

I poisoned them all and prayed for the salvation of their souls. Mine too.

What else was I to do? Had I reported them to the authorities, I would only have been handing them a great propaganda opportunity. They would simply have said, 'Look, this is how all Christians behave.'

I tried in all things to emulate the example of Yeshua, as I had heard from those who knew him and as I read in our sacred books, the Gospels. Though we needed leaders, though we had our elders and priests and bishops, I never

sought a position of prominence in the Church because I, who had kicked our Saviour, was never worthy of it. I wanted to be the humblest member of each congregation I joined. At other times, I lived the life of a beggar, travelling the roads and preaching in every town I came to.

I would sometimes go for years on end without being martyred, no matter how much I sought it. At other times, I could be killed ten times in a month. If you are tempted to say that being killed was no penance for me because I would always wake up again, you are mistaken. Almost every time I and my brethren were arrested we suffered torture or humiliation. Death itself was frequently agonising. Though I am still not worthy of God's mercy for abusing his only-begotten son, I have suffered a great deal of physical pain.

I have been beheaded, starved to death, flayed alive, strangled, hanged, crucified, burned, gored by bulls, bitten by dogs, clawed by leopards, crushed by bears. And that's not counting plague, poison, accident, lightning-bolts, murder, drowning and bad falls.

Frequently, martyrdom was a public spectacle in the local arena, paid for by some fat local worthy to earn popularity by pandering to the bloodlusts of the mob. Carthage was the worst. Once, a Christian woman named Perpetua and her servant-girl Felicitas were sent into the arena to face wild animals. One was just a frail girl, barely out of childhood. The other had given birth a day or two before. Both were half-naked. I watched as the crowd roared its disapproval at this sickening spectacle and offered thanks to the Lord. But it turned out that all they wanted was for the women to be clothed more modestly. When they came back, fully-covered, a few minutes later, the good people of Carthage cheered and applauded and sat back to enjoy the show, their sense of decency fully intact. Comrades, the greatest burden I carry is that of my sin, but

the second-hardest thing for me after that is to follow Yeshua's edict to love all men.

Meanwhile, events in the Roman Empire continued their course, often affecting us. We were never great in number, but by the second century after Yeshua's death, we had a terrible reputation. At the beginning of the reign of Emperor Marcus Aurelius, for instance, there was a great plague. Nero, had he but known it, had set a vogue, and the Christians were blamed in many places for this pestilence. By now, there was a popular expression, 'the rains fail because of the Christians.'

Marcus Aurelius was succeeded by his ridiculous, hedonistic son Commodus. He was besotted by every vice imaginable and, rather than govern, gave himself up to pleasure. He abandoned his father's wars with the German tribes, which endangered the security of the borders. He began to believe he was Hercules and became fond of wrestling. When people could take no more of this behaviour, they had him strangled in his sleep by Narcissus, who was a real wrestler. From the point of view of the Romans, Commodus' lack of interest in military matters was a disaster. It was scarcely any better for we Christians, for while the Romans occasionally wished us extinct, the Empire provided something approaching peace and prosperity. The alternatives were much worse, for now barbarians of numerous races and savage beliefs were crowding in on the frontiers.

After Commodus, the next hundred years were like the end of the world.

A succession of weak Emperors, always looking behind their backs for treachery, vied for the imperial purple. Usually they were second-rate soldiers. In a period of 50 years, there were 21 Emperors. Only two of them, my friends, died of old age. It's hard to remember the names of any of them, apart from Elagabalus and Valerian.

Elagabalus was insane, dominated by his mother and was given to suffocating dinner-guests under rose petals. That one sounds interesting. Valerian was captured by the Persians and flayed alive by King Shapur who had his skin dried and salted and kept on display as a trophy. Yzdkrt outside probably regards Shapur as a hero. People from that part of the world always were keen on skinning people. I don't know why. Anyway, for a Roman Emperor to be captured and to suffer such a humiliating death was terrible. Nobody could feel safe anymore.

I saw none of these things; most Christians eschewed service in the army. Yet on my martyrdom-induced travels, I could tell that the framework of the Empire was rotting. If there were any blessing hidden in this chaos it was that our Church gained more converts. We were always the first to help people in distress with money and labour, and we offered people a vision of hope in a troubled time. People began to respect and even like us. And with the officials distracted by other troubles, we could practise our religion openly in many places.

For all practical purposes, the Empire collapsed. But people clung on to the idea of Empire. Many, many, places that I visited at this time were untouched by war and prospered. Others were less lucky. Even the fortunate regions did not know when the army of one imperial contender or another would march through like a locust-swarm and just requisition what it wanted. Much worse, in the frontier regions, there was the ever-present fear that barbarians, who were jealous of Roman prosperity and eager for human and material plunder, would sweep across the river or the ramparts, killing, burning, and raping everything in their path. I saw it happen often enough. I tell you, you haven't known real discomfort until you've been buggered by a Visigoth.

At the end of the third century after Christos' birth,

the Emperor Diocletian restored some order. The government had been organised so that four men ruled together; one in the east, one in the west and their two named successors. Diocletian, Emperor of the East, happened to be the strongest among his own tetrarchy. Need I add that Diocletian was an enthusiastic persecutor of Christians? His persecution had two causes. First, there was an occasion on which the entrails of sacrificial animals looked particularly unpromising and the pagan priests, reaching for the usual excuse, blamed the Christians for it. Second, he consulted the oracle of Apollo at Didyma, who told him that his ability to give advice was being hampered by the Christians. It got to the point where if a man's wife didn't want sex of an evening, she said the Christians had given her a headache. Diocletian passed an edict of persecution, ordering our churches destroyed, our services banned and our scriptures burned. This was in the eastern half of the Empire, and the persecution was ferocious. I got to be burned along with a pile of Gospels in the market place at Caesaraea. The western half of the Empire was relatively unaffected.

Diocletian's sidekick and supposed successor, the Caesar Maximin, was really keen on carrying out his master's edict in the provinces he controlled. He ordered that food on sale in the markets be sprinkled with libations or blood from pagan offerings. Checks on Christians were to be carried out at city gates or public baths. He put about scandalous libels about Christos. Guess what? Christos was supposed to eat babies! Big fucking surprise! Prostitutes were tortured into confessing that they had taken part in Christian orgies and our bishops were ordered into new jobs as shit-shovellers in the imperial stables. However, Maximin's campaign was not a brilliant success. He had to offer tax-breaks to get the city authorities to bother persecuting us. There were a very large number of

martyrdoms, it is true, and lots of Christians paid bribes or offered sacrifices before a statue of the Emperor in order to save themselves. But most ordinary pagans weren't too bothered about hounding us. Everyone knew by now the stories about child-sacrifice and incest and conspiracy were nonsense - well, most of them did. In many places, Christians had shown more compassion and charity than the rest of the community put together, especially in times of crisis. And there had been plenty of those recently. So what Diocletian and Maximin had hoped would be a killer blow to the Church, at least in the East, was nothing of the sort.

We had our own problems. I've already mentioned how disunified we were. We were now arguing among ourselves on various fine points of belief, and even the persecutions were causing bitter argument. Some said those who had not had the courage to face martyrdom and who had sacrificed to the Emperor to save their lives should not be readmitted to the Church. Others pointed out the all-encompassing love of God which welcomes all repentant sinners. It was a big time for us.

But now, something completely unexpected happened. Diocletian abdicated and the strong man among the tetrarchy turned out to be a man named Constantine. Some years previously, he had been at the head of troops in the north of Britain - a cold, miserable, wet, piss-sodden island that I don't recommend you ever visit. At the same time, I wound up there after being martyred at Edessa under Diocletian's persecution. I had surrendered myself to the pagan soldiers, who told me to look to my safety and hide myself. They took a great deal of persuasion before they would imprison and kill me. In Britain, I had barely got my mouth open and the name of Yeshua out when I was thrown into a pit full of hungry wolves.

Constantine, on the death of his father, was proclaimed tetrarch by his troops, an event I did not witness

directly. The other tetrarchs, however, had fallen to fighting among themselves, while Constantine bided his time. For five years, he trained his army and put it about that he was descended from one of the great imperial houses. Then he did something wonderful.

He announced his conversion to Christianity.

It seems he had been impressed by the fortitude, not to say guts, of a Christian missionary he had seen being thrown into a pit full of wolves at York. A year later, he had seen a Christian preaching in Gaul who was the dead image of the first man. That was one of the few times I ever encountered someone from an earlier life in a later one and, typically, I can't remember seeing the future Emperor at either occasion. The wolves, in the first place, and the jeering crowd in the second, distracted me. Still, that's the nearest I've come to influencing the course of history.

I joined Constantine's army as an infantryman. After all, I had never been martyred in battle before.

There were a few other Christians in the army. Christians had regarded it as forbidden to serve in the imperial forces, but many had done so since soldiering, like being a blacksmith or tailor, is a trade and a man cannot be prevented from practising his trade. I knew it was my duty to lend my strength, such as it was, to a Christian commander who might become a Christian Emperor.

Constantine's army was, for the main part, a pagan force, with lots of thick provincials, particularly Germans, and almost no real Romans. The soldiers worshipped German tribal deities, the orthodox Roman gods, or were followers of Mithras. None were upset by Constantine's conversion. The Romans regarded a man's religion as his own business, and it was almost traditional for an Emperor or would-be Emperor to favour a particular cult. So nobody was uncomfortable with the idea of a Christian leader and my comrades-in-arms and I got along well enough once they

had beaten me up and twisted my arm until I promised to stop trying to convert them.

Constantine bided his time until at last he broke with the tetrarchy and marched across the Alps to invade Italy. His aim was to overthrow the tetrarch Maxentius, whose base was at Rome.

While Constantine was a Christian, many of his officers consulted soothsayers and astrologers. Not one of them said that the omens for Constantine's success were good. Some predicted outright disaster. There was a Jew, Benjamin, in our platoon, and he went around for days shaking his head and waving his hands whenever anyone asked him how he expected us to do in the war.

We marched into Italy, fought a series of skirmishes and small battles and on each occasion we thrashed that bastard Maxentius. With the remains of his army, Maxentius retreated to Rome and barricaded himself in the city to pass his days and nights furiously sacrificing to his pagan gods and casting spells against Constantine.

Now we reached the outskirts of Rome, expecting that we would have to settle down to a long siege. As you know, this isn't an easy city to take by force and it was no different back then, seven hundred years ago.

But on the day we arrived there was a strange sign in the noonday sun. Not all the soldiers could see it, but many did. It was the sign of the cross, symbol of the love of Christos, set into the middle of the sun's orb.

Does that sound familiar?

Beneath it there appeared a legend in Latin writing. I explained to those of my fellow-soldiers around me - they could not read - that it said, 'by this sign, conquer'.

A message from God! Or so we thought.

Everyone who saw the sign understood it to mean that Christianity was about to win us the war. In camp that night, we talked of nothing else, and the other soldiers were

at last interested in hearing what I had to tell them about Christos. Benjamin converted on the spot since, as a Jew, he had a head start on Yeshua's teachings, which extended the One True Testament.

Constantine, who had also seen everything, now gave orders that a special banner be made bearing the sign of the cross to be carried at the head of the army. He further ordered that we soldiers paint the sign of the cross on our shields, for had it not said in the sky that we would conquer by that sign? This was an order I complied with joyfully, though many of the other soldiers grumbled because they had already painted the images or symbols of their pagan gods, or the thunderbolts of Zeus, on their shields.

The following day dawned and, before Constantine could set about investing the city properly, Maxentius emerged from the gates to offer us pitched battle.

This looked really promising, because there were 40,000 trained fighting men in our army, while Maxentius could barely muster half that number, and many of them were reluctant conscripts. Even without the sign of the cross in the sky we would have been confident of winning.

The two armies faced one another on a plain to the north of the city crossed by the Tevere. We grunts guessed that Constantine's strategy would be to overwhelm the enemy's flanks, try to surround him, then squeeze Maxentius like an orange in his fist. We were looking forward to the squeezing.

This is indeed how the battle began, with cavalry and infantry at either side advancing first. But then the enemy's heavy cataphract cavalry came charging at our centre, which is where I was posted. This should not have panicked us; we should have set our spears in the ground and presented the enemy with a bristling wall of sharp steel. But something went wrong. In a moment in which the course of history can be made by the irrational behaviour of

a few people, somebody panicked and ran. That started everybody off.

Benjamin got about ten yards before some horseman got his lance through him.

Constantine, mounted on his horse behind us, with a man bearing the banner of the cross next to him, tried to rally the troops, but now a rout set in. Men dropped their cross-painted shields and threw down their weapons to make a quicker getaway. It was madness, as even an imbecile would have known had he not been siezed by blind terror. For in running away and refusing to form a wall against the enemy, they simply made it easier for the cavalry to come among them and cut them down like ripe corn.

Constantine tried to close the gap in his line, calling for men on either side to move in and repel the cavalry, but it was too late.

Maxentius, seizing his chance, was following up his attack with infantry who were now rushing across to split our army in two. Then the cataphracts reached Constantine himself and overwhelmed him and captured his banner. I heard cheering in the distance and saw the top of the banner above the fighting as it was carried towards Maxentius' lines. I knew we were lost. Moments later, I was beheaded - I think - by a single swordstroke from behind and died again. What we had thought was a sign from God had been a cruel deception by Satan.

So, in my lives, I've been at two sieges of Rome and, each time, I've been with the losing side.

The death of Constantine robbed the Empire of a strong and able ruler who could have restored it to stability and then to glory. His defeat also completely discredited our Church. Maxentius, believing all his sacrifices to the pagan gods had brought him success, ensured his victory, and then deliberately spared the lives of as many of

Constantine's soldiers as possible. This was his way of making sure that the story of the Christian God's false promise to Constantine would be spread widely.

Now the persecutions more or less stopped, but the death of Constantine had a powerful effect. The Romans, who judged a deity by its effectiveness, merely laughed at us where they had once hated us. While this was happening, we had become busily caught up in bitter theological arguments among ourselves.

Maxentius was overthrown within a few years by another little general and the Empire, beset on all sides by barbarians, lapsed into painful decline. Some of the barbarians were placated with lands, others with positions of high office, but anyone could see that the Roman Peace had become a hollow joke. The Empire was formally split into Eastern and Western kingdoms a hundred years later.

The Eastern and Western kingdoms fragmented in religion just as they did politically. Many worshipped the old Roman gods, others turned to the ancient Greek ones. The Persian religion of Zoroaster became popular in the Eastern kingdom and was adopted by King Justinian and Queen Eudoxia. Among the common people of the countryside there were spirits older than antiquity to be propitiated at set times of the year. The barbarians, meanwhile, brought in their childish, idiotic cults. In the West, rulers and soldiers remained loyal to Mithras.

The Western kingdom collapsed completely five hundred years ago, and its place was taken by barbarian fiefdoms whose rulers constantly warred with one another while retaining varying amounts of old Roman customs and laws. The Eastern kingdom prospered after a fashion, and the military successes of King Justinian and then King Belisarius kept the barbarians at bay.

I was rarely martyred for my faith now, and for over three hundred years I wandered the world, preaching the

gospels. I gained few converts. Most people thought I was a crank to be either pitied or kicked out of town by the nightwatchmen. I travelled as far as India, but the Indians, too, have their ancient gods and would not listen to me.

There were still many Christian communities left in the world, but they were increasingly to be found in isolated places, among more simple, credulous people. It was a very depressing time. At first, people would tell jokes about Constantine's defeat and how stupid and cowardly Christians were. They would say our churches were built of reeds because Mithras-worshippers didn't like pulling down stone buildings. Or they would ask how many Christians it takes to hammer in a nail, and answer none, because the nail usually hammers them. After a while, even the jokes stopped as more and more people just forgot all about the Christians. I think I preferred it when they were still telling jokes about us. Oh, here's another one - why do Christians wear big crosses on their tunics? No? It's to make it easier for the archers.

I drifted towards the country that in the time of the Empire had been known as Gaul and part of which was now the kingdom of the Franks. I reverted to my old trade of doorkeeper and found employment at the court of King Charles, son of King Pepin the Short, just after his accession. I had not intended to stay, but I became aware that this was a place in which interesting things were happening.

Charles was everything you would expect a great king to be - a brave and resourceful soldier and a great athlete. He was over six feet tall and very handsome. People always remarked on his keen and expressive eyes, though I never saw anything special in them myself. Charles was also, as kings at that time went, very learned. He could speak Latin and Greek, though he could not, at first, read or write. That's the credit side of his account.

He had a terrible secret, however. Early in his reign,

his power went to his head in a strange way. A king can have any woman - or for that matter, any man or boy - he wants. The woman Charles wanted when he was a young man was his sister Iolande. I saw it myself. The worst-kept secret on earth was the fact that Frankish king was sneaking into the chamber of his sister in his big, cold castle at Aachen every night.

What do you do if you see something like that? You can keep your peace, which is what most people did. You can plot to overthrow the King for his shocking, unnatural vice. But in the court of King Charles of the Franks, nobody dared to do that. In any case, morals had sunk to such a low ebb that few were as shocked by this as you might imagine. The third thing is you can plot to lure him away from his vice. That is what a group of courtiers and soldiers, led by Duke Bohemond of Rennes resolved to do.

There was a Jewish banker in town, Abraham of Milan, who occasionally did business with the royal treasury. His daughter was rumoured to be amazingly beautiful, though I have to say that in Aachen in the Dark Ages, that wasn't too difficult. Having both eyes, a nose, and half your teeth would make a Cleopatra of you. Bohemond, who had been one of Pepin the Short's most loyal servants, was disgusted by Charles' incest and determined to lure the King from the bed of his sister. Anything was worth a try, so he and his cronies threatened to kill Abraham and all his family if they didn't get a look at the girl. I was the one who got to take this message to the old banker.

Abraham immediately agreed to help out, and emphasized how delighted he would be to allow a dozen heavily-armed knights into his house to check out his daughter.

The girl's name was Deborah, and the rumours about her were not wrong. Bohemond and his friends turned up and found she had the most beautiful, unblemished

complexion you ever saw, blooming like the skin of a healthy baby. Her hair was long and very dark, but not as dark and deep as her eyes. She was fifteen years old and shapely. Every man in that room would gladly have hacked off his right arm with an axe to possess the beautiful Deborah.

Deborah, being a good girl, did as her father commanded and took her clothes off and submitted to inspection. Duke Bohemond, who normally delegated everything, took it on himself to ensure that the girl was in good health all over and was indeed a virgin.

Having been passed fit, she was brought to court at once, masquerading as a servant to Bohemond's wife. Charles noticed her quickly and, better than we dared hope, went wild for her. But Deborah said that there was no way he could have her unless he married her. And there was no way he could marry her unless he became a Jew.

This she said to him for two years. Every Spring, Charles quit his freezing castle to go to war against someone. Each autumn he returned to find Deborah grown more beautiful. And more devious. Deborah would only see the King in the presence of chaperones. 'Convert, marry me and I'm all yours,' she kept saying.

This was a problem for Charles. Like all the Frankish nobility, he had been a worshipper of Mithras all his life. He feared a terrible vengeance would be exacted on him if he renounced his fealty now. But, at the end of the second winter, after giving the fair Deborah fabulous gifts, after elevating her father to the position of Royal Treasurer, after giving offices and honours to both the able and the worthless hangers-on in her family and still being unable to get into the girl's velvet skirts, he gave in.

The King's coarse English wool drawers were bursting. His balls were swollen to the size of two men's heads, his prick was hard enough to poleaxe the bullocks

whose blood he once bathed in. 'Yes, my love,' he said, steam rising from his britches, 'I will become a Jew.'

Do I sound bitter? No wonder. Deborah and her husband destroyed the one true faith. Because of them I am the last Christian on the face of the earth.

Charles submitted to a bet din, in which the dyanim quickly agreed to consider him for conversion. That they were pious men I do not deny, but they were also in fear of their lives. They also had to consider the safety of the large number of Jews in town who had been attracted by stories of all the well-paid jobs to be had at Charles' court. But the dyanim could not, in all decency, allow Charles' conversion right away. They told him, as was the tradition, to start living as a Jew, they gave him instruction in the Jewish faith. That spring, he left to campaign against the Avars of the east, with a group of Jewish teachers in his baggage-train. And no pigs.

While Charles was off fighting, Duke Bohemond had Iolande ambushed while she was out hunting. A couple of heavies jumped her in a quiet corner of a forest and broke her neck, making it look like she had a riding accident. Then the assassins themselves were killed, just to make sure nobody told tales. I should know. I held their horses, and had my throat cut.

That spring and summer, Charles, King of the Franks, learned to read Latin and Hebrew, captured territories the size of Italy, won three major battles and enslaved 150,000 Avar men and women. The news of his sister's death did not bother him. He returned to Aachen convinced he was ready to become a Jew. And who were the dyanim to argue with him?

The person I felt sorry for was the poor fuck who had to circumcise him. He was the most powerful ruler the West had seen in centuries, he had just slaughtered thousands of people, and the only thing he wanted in the world was to get

on with his wedding. Someone had to hold a razor to the prick of this lust-bothered tyrant. I often think about the mohel. I don't know what his name was. I should have taken his place. One little slip of the knife and I could have changed the course of history. But having been killed - again - I was still in the process of walking back from Mongolia.

Back in Aachen, everything went smoothly. Charles was dipped into the mikveh, which wasn't such a bad idea because he never washed much, and emerged a fully-fledged Jew. I'm not joking when I say the wedding ceremony began before he was dry and before the scab had fallen from his dick.

Even now, Deborah connived to deprive the King of his conjugal rights. For, as he discovered on retiring, it was her time of the month. She could not, she swore, have foretold this. Her menses were irregular, she said. Deborah was, he had to understand now that he was Jewish, in a state of nidah while her period lasted and for seven days afterwards.

You could go up to the royal bedchamber and see the marks the king's teeth made on the bedpost that first night.

I suppose it made his joy all the more profound when eventually she did let him into her bed. No one saw either of them for a fortnight.

Over the next few years, Charles destroyed the Lombards and took northern Italy. He stormed through the Pyrenees mountain range and defeated the Visigoths and the Sueves, taking the whole of Spain. He moved north and defeated the Saxons and made them his subjects, he took Bavaria and thrust east to push the Avars further back. He was stupendously successful, and even if you want to be mean-spirited about it and point out that there was no serious opposition to him in a lot of the lands he conquered, he alone controlled an area that was now bigger than the

old Western Empire. And all the while Deborah was driving him on.

Deborah wanted to start a great dynasty, and for this she had to make something that would last. Charles could hold his Empire together for as long as he lived, which was good enough for him, but was not good enough for Deborah. She soon won him over to her way of seeing things, especially when she started bearing his children.

First, she persuaded him to capture Rome, which was no difficult feat since this place was at that stage owned by some petty princeling who was easily knocked aside. Then in a great ceremony at Hanukah, Charles was crowned a second time. His title was to be Carolus Maximus, Charles the Great, and he was declared Roman Emperor. This gave people great hopes that the new Empire would revive the peace and prosperity of the old one. Charles moved his capital to Rome from Aachen. In a very real sense, that's why we're here now.

Moving the capital to Rome was useful for me. It meant I didn't have to walk so far to get back to where all the action was.

Deborah, meanwhile, found time to have Duke Bohemond of Rennes strangled on manufactured charges of disloyalty, for she never forgot the humiliation he inflicted on her and her father. She never forgot how cold his fingers were. For my part, I'll never forget the look on his face the night before his execution when I visited him in prison. He thought he'd had my throat cut.

To cement his vast imperium together, Deborah decided Charles needed a new class of bureaucrats and officials. Magistrates, tax-gatherers, prison governors, administrators and so forth. She decided that for maximum efficiency these people had to be career professionals, not temporary political appointments. They had to be literate. Aside from a few isolated Christian and pagan monks and

scholars, the only literate people existing in anything approaching numbers were Jews. Over a period of years, lots of Jews became imperial officials.

Deborah's plan went further than this. She realised that the ability to read and write confers power, especially back then when perhaps one man in a thousand was literate. Deborah was also mindful of the history of her people, of the suffering and persecution they had endured. She was now able to stop this happening again by putting the Jews in a position of power. Under the Edict of Milan, Charles the Great decreed that only Jews should be allowed to learn and practise the secrets of reading and writing.

It became the law that non-Jews could not own books. The few Christian communities that were left in Charles's Empire had their scriptures confiscated. This, for us, was disastrous, for we knew that over the generations, we would have no way of passing on the knowledge that God had given to us.

Meanwhile, Charles' rule had brought stability, and people began to take peace for granted. Ambitious young men wanted to get on in the world by working for the imperial bureaucracy. To do this, they had to be Jews and they had to learn to read and write. Many, many people began to convert to Judaism. Ambitious parents would send their sons to Jewish schools. At the same time, the prevalence of Judaism at the court, and the large numbers of wise Jewish elders coming to Rome made people realise what a beautiful and ancient religion it is by comparison with the crude superstitions practised by most. Fashionable and sophisticated people flocked to convert.

In a couple of generations, virtually the whole of the official and aristocratic classes and very many townsfolk had become Jews, while out in the countryside, the peasants continued to worship their ancient sprites and will o'the wisps.

In his later years, Charles became very fat, and died one Passover of a surfeit of salt beef. He was succeeded by his eldest son David. David followed the policies of his parents - his mother was still alive looking over his shoulder throughout his reign - and embarked on further conquests. He took Britain and Ireland, for all the good those miserable places would do him. And since he claimed to be ruler of a revived Roman Empire, logic dictated that he retake Greece, Turkey, Egypt, Judaea and those other parts of the old Eastern Empire. He made war on the Byzantine rulers with some success, but never got close to his great ambition of recapturing Judaea, and with it Jerusalem.

David had no sons. He was succeeded by his daughter Ruth, whose first act was to have her grandmother Deborah exiled to Aachen to stop her giving advice all the time. Deborah passed her few remaining years in that old cold castle where it had all started, attended by a few loyal friends. Rumour had it that she kidnapped and ate babies to try and recover her youth and beauty. You can believe that if you want.

Ruth's pagan general Roland led the armies of the Empire against the now-rotten Kingdom of the East and conquered it whole in ten years. Ruth did not marry, and there is no truth in the story that she and Roland were lovers. Roland brought back the Queen of the East, the cruel and vicious Irene, to Rome bound in silken cords. Irene was dangerous, even in captivity. Had she not overthrown her own son and put out his eyes with copper needles? There was no telling what a woman like that might get up to. It was the prevailing fashion at Ruth's court for young men to wear their hair long and compose love-poems and gushingly express their chaste romantic attachment to their queen. It didn't take a wise elder to predict that it would only be a matter of time before a cabal among them transferred their affections to the fair queen of

the East. In truth, Irene was sixty years old and never had been any kind of beauty. She manipulated these young idiots into conspiring to free her, raise an army and recapture her lost realm. Most of these pomaded fools wouldn't have known one end of a spear from another, and in any case not one of them could keep a secret. It was enough for Ruth to have Irene's head cut off and sentence her conspirators to work in the royal stables for the rest of their lives where I doubt they ever had the leisure to write poetry about glanders and horse turds.

With the conquest of the Eastern kingdom, the Empire was now whole again and Ruth entered Jerusalem in triumph, accompanied by Roland and the greatest army the world had seen for centuries. I was with them that day, an ordinary infantry soldier once more. I was still there a few weeks later, searching unsuccessfully for any remaining Christian community, when they were discussing rebuilding the Temple and moving the capital of the Empire to Jerusalem, for by now almost everyone of influence, however slight, had joined or been born into, the ranks of the Chosen People.

I was still there when the dreadful plague broke out among the army and the host of officials and religious people who had accompanied Ruth on her triumphal entry. It was suicidal to take so many people into such a small city and cram them all together. Any fool could have seen that it would cause illness, but I suppose it was all forgotten in the excitement. I myself died of it before it struck down both Ruth and her Mithras-worshipping general.

Ruth was succeeded by her cousin Solomon, son of David's younger brother. There were other claims to the throne, but Solomon wisely judged that Rome was still the centre of government and immediately went there and declared himself Emperor before anyone else could. He then followed tradition and slaughtered all the other

members of his family who could compete with him. Solomon declared his intention of keeping the capital in Rome until Jerusalem was plague-free.

Of course, when the plague had cleared from Jerusalem, the Saracens, an energetic people fired by the new religion of Mohammed, attacked out of the east and took the city for their own. The Empire had recaptured Jerusalem for less than three years. Men said this was God's punishment for their pride and arrogance.

Perhaps Solomon was mindful of this, or maybe he was just plain idle. Whatever the case, he made no attempt to retake Jerusalem and settled into a life of lethargy and vice, trying to outdo the splendour of his ancient namesake. Solomon the Magnificent as he was called, imported every conceivable luxury into Rome from the East and made of it a city of unrivalled glory. With peace on most frontiers it was a golden age, in which building and the arts flourished. Solomon himself in later years became more introverted and cranky, for his insatiable appetites left him tortured with the strangury.

Solomon's long reign ended with the succession of his grandson Saul, a young man who rejected the ease of the court and who dreamed of military glory. This was just as well, because there were now predators massing on every frontier who wanted a piece of the Empire. The Saracens soon got the better of us in a great sea battle near Rhodes that left them with unrivalled control of the Mediterranean sea; their allies, the Barbary Pirates now made life hell for merchant seamen. The Saracens had long since taken Egypt and the north coast of Africa and now they moved into Spain where Saul came to meet them with a huge army. But the army, like everything else, had grown soft under Solomon and was defeated in the battle of Salamanca. Saul himself was captured by Saladin, who treated him with hospitality and respect before releasing him. Saul died

226

soon afterwards of shame and a broken heart. He was 32 years old.

Saul had been keen to enforce religious orthodoxy. That sort of thing made life difficult for a person like me who would go around saying the Jews were all wrong and that Yeshua Christos had been the Messiah. Now the religious toleration of earlier years came to an end. One of the artists that Saul patronised, Elihu the Engineer, invented a machine specially to deal with blasphemers. It was like a mill-wheel the paddles of which fired rocks in the blasphemer's general direction. To me fell the honour of being the first person to be killed by Elihu's stoning-engine for saying that this man nobody had heard of had been the Messiah.

I avoided Rome, preferring to stick to less technologically-advanced regions. I preached in the countryside, but a faith without books has no future. I lived among dwindling Christian communities in remote places. Then I went and lived in the lands of the Saracens for many years. Strange to relate, I was always treated with courtesy there, for the Saracens are tolerant of all religions and treat madmen with kindness. I won no converts.

Saul's place was taken by his uncle Gideon, our present ruler. He is a learned man, but I don't think he's a big enough bastard to save the Empire. It's been ten years since the Persians and the Saracens joined forces. Now they act like a pair of vultures, picking at the carcase of the Roman Empire. It is an apocalyptic struggle between Jews, Mohammedans and Zoroastrians.

There are no Christians left. The last of them I found in a monastery out on the far west coast of Ireland. These few old men had managed to keep their sacred scriptures hidden from the imperial authorities, but no-one could read them except me. I begged them to break their vows of chastity and try to re-establish the seed of our faith, but

they refused, saying I was mad and a heretic. By the time I found them they were in any case too old to be capable of marrying, even if we had found women of child-bearing age willing to have them. I know what you're thinking. The answer is that I found out a long time back that I was incapable of fathering children, for Yeshua's curse had also deprived me of that particular joy. And it's been a good few hundred years since I last derived even a passing pleasure in lying with women - or anything else for that matter.

I buried the last of the Irish monks three years ago, put the scriptures in my sack, took up my staff and started wandering once more, returning as always to Rome.

Now it is a millenium since the birth of Christos, the Persians are hammering at the gates of the eternal city and there is another sign in the sky.

The same sign, perhaps. This time, it should be correctly interpreted. I feel at last that my wanderings are over. Yeshua has returned, to gather up the faithful to himself while the unrighteous shall be cast down.

But where are the faithful?

The light in Joseph's eyes dimmed.

'He's dead,' Absalom said.

The rabbi began to mumble.

'Really dead.'

'A madman,' someone spat. Isaac had died during the story.

Absalom wondered about Joseph's tale. If it were a fanciful lie, he had taken extraordinary care over it.

'Rabbi,' he asked, 'was what he said...?'

'Nonsense,' the rabbi said, 'he was maddened, reciting an old folk tale...'

'This Yeshua Bar-Joseph, the Christos...'

228

'I have never heard of him.'

'The sign?'

The rabbi was angry, almost afraid. He didn't answer.

Absalom hawked and spat blood.

The ground seemed to be shaking.

Around Joseph's neck were two symbols, a cross and a fish. Absalom reached out to touch them.

The dead man's body rippled like water, and dissolved into the ground.

Astonished, Absalom turned. The rabbi was gone. There had been no witnesses.

Joseph's cross was left.

Obviously, the Christos had not returned. The portent in the sky had been wrong again.

Absalom picked up the cross, and held it tight in one hand. He held it until he died.

GEOFFREY FARRINGTON is the author of an intriguing exercise in vampire existentialism, *The Revenants* (1983), and a historical novel set in Rome and Judea during the reign of Nero, *The Act of the Apostates* (1990), both published by Dedalus.

LITTLE ST. HUGH
by Geoffrey Farrington

The gallows on Canwick Hill baked beneath a sun unusually hot even for an August day in the year of 1255, and the stench of the assembled populace seemed more noisome even than usual as they crowded and jostled to witness the approaching spectacle. The Bishop narrowed his eyes and arched his nostrils with distaste, finding himself restless with growing anticipation. For some time the accursed Jews, bound behind teams of sweating horses, had been dragged about the city walls for the general entertainment and abuse of the crowd; who relished any excitement that was a departure from the common drudgery of their lives.

At first the condemned men had cried out, pleading their innocence, yet finding the mob in no mood to show compassion they had lapsed into the customary and hysterical ravings of their own heathen tongue, calling to God for deliverance or for vengeance upon their oppressors - it was not clear which. Now, dragged towards their final reckoning, they seemed beyond protest of any kind, lying bloody and covered in waste and refuse of remarkable colour and variation - it was pleasing to see that the people could be so inventive on these occasions.

Most of the condemned - nineteen Jews in all - were dragged along insensible now, it seemed. Only one amongst them appeared still proud and strong, suffering his torment

with astonishing forbearance. He raised his head when he could, to gaze upward with quiet agony upon the faces of his accusers: the assembled city dignitaries, spiritual and temporal, who sat upon a dais shaded from the glare of the sun.

With a feeling of inspiration, the Bishop, joining with the general spirit and good humour of the event, rose from his seat, and allowed his attendants to assist him down to the level of the street, raising his robes as he stepped with care along a filth strewn path to where the tortured men lay.

He looked to the crowd - who clearly expected something solemn from him - and then decided he would pleasantly surprise them.

'Murderers of Christian children!' he declared, gazing down at the man, then raising his foot, kicking him hard in the face. *'Murderers of Christ!'*

The crowd roared with approving laughter, mercifully spared the burden of a sermon at the height of festivities, as the Bishop returned to his seat and took some wine while the criminals were torn from their bonds and dragged up to the gallows. The hanging itself proved a lacklustre affair, the Jews being too far lost to exhaustion and hopelessness to show much spirit of defiance at their final moments.

The child had been found some days earlier, the fair and beautiful son of a wealthy local merchant - the healthy and well nourished were always most prized for ritual sacrifice. Stringy and under fed peasant children were a poor offering for a man to send his God. The boy, Hugh, had been discovered beyond the city walls, thrown beside a well, his head severed from his body which showed sign of the grossest abuse. Already the people spoke of a miracle: that the body was raised miraculously from inside the well. Living in ignorance and filth, the people were ready to see prodigies everywhere. Now the matter was concluded and

231

the guilty punished, the relief of the people was shown in their merriment: tomorrow their customary sulleness would be resumed.

Yet the Bishop had much to do. The culmination of much time and effort. Tonight he prayed his labours would find reward, and he returned to his palace tense and anxious.

At that late hour when he dismissed his servants, the Bishop retired as was his custom to his small private chapel for solitary meditation and prayer. He knelt before the altar and intoned softly, until finally he felt confident that all his household had safely retired. Then he gazed up at the crucifix that stood upon the altar, coughing up some phlegm suddenly, spitting it with the accuracy of many years upon the silver-wrought face of Christ in torment. This done, he felt beneath the altar to release the hidden catch and free the concealed panel to the side of the chapel, which led to his secret chamber below.

As he descended the narrow stone stairway he felt that delirious thrill of pleasure and satisfaction which always came from seeking his sanctuary, his true and hidden self. He came to kneel before the true altar, positioned directly and precisely beneath that false and reviled altar in the chapel above, and gloried in his visions of blackness. Black candles made of sulphur and human fat stood alongside bowls of tainted incense, which the Bishop lighted with his taper that the chamber might be filled and clogged with their foul and satisfying odour. Now his voice rose, filling the small, gloomy stone chamber, offering up prayers and devotions to those powers which had long been his support.

'Our Father, which art in Hell
Hallowed be thy name...'

He recited rythmically, as his mind dwelled upon the preparations for his great endeavour; perhaps seeking subtly to remind those unholy powers which surely gathered close by of his constant faith and devotion. His mind recalled then in closest detail that bright and lovely child, Hugh, brought to his chapel by night. His flesh thrilled to remember it all. How he had consecrated the wafer and bid the child take it, and drink of blessed wine, promising these things would bring purity in the eyes of God. How touching and pathetic, such naive faith. And then after the very ritual of communion to spirit the child here to his chamber below; to take that soft, protesting young flesh upon Satan's altar. Such exquisite, melodious screams as he slashed at the white throat, then caught the blood within his chalice - fashioned from the skull of a murderer reclaimed at midnight from unhallowed ground: the Bishop took pride in the fact that he followed such procedures correctly.

As if these things were not delight enough in themselves - the Bishop found that nothing gave him greater pleasure than the inflicting of pain, except perhaps the betrayal and corruption of innocence - but then to leave the tiny dismembered corpse in a chosen place, where it would be quickly discovered and invested with portentous significance by the simple: for what common murderer would hurl his victim beside a well, rather than down into it? A wonderful plan, for which the Bishop might duly congratulate himself. And yet that was only the beginning.

For some time past the Bishop had, secretly through various agents, borrowed substantial sums of money from leading Jewish citizens - mostly those same men he had seen consigned to the gallows that very afternoon - which naturally meant that all debts owed by Christians to these Jews were made void, and the records of these things accordingly destroyed. The Bishop had used much of the money to good purpose, mostly in bequests to his clergy

233

throughout the district, along with exhortations to incorporate within their preaching a strong theme against the vile and insidious customs of the Jews, the unbelievers whose wealth and general malignity towards honest Christians was of growing and ever more blatant offence. This, combined with the incitement and testimonies of his own agents amongst the people, had soon made it a simple matter for the Bishop to bring evidence and condemnation against the Jews of his choosing. Interrogation and torture soon succeeded in extracting the necessary confessions: that the child Hugh was sacrificed in some barbaric Jewish ritual.

In this way the Jews themselves had ended by meeting the expenses of their own destruction, while conveniently forestalling any further enquiry into the tragic death of the child. The Bishop grinned to himself at the pure symmetry of it all. And yet the greatest part of his plan remained to be completed.

Finishing his intonations he rose from his knees, carefully performing the sign of the inverted cross before turning and making his way to a door at the back of the chamber, beyond which lay a tiny cell wherein all had been made ready.

Inside, the corpse lay bound with leather straps to the table upon which the Bishop had carried out so many past experiments; bathed in the dancing yellow light of candles which the Bishop's acolytes had placed in preparation. The face of the lifeless Jew showed mottled bruising from the kick the Bishop had given it earlier. The burn of the noose was red and angry about the neck and throat. Reaching out, the Bishop ran his fingers gently across the pallid brow. The kick had been done to mark out the chosen man, that the Bishop's servants in this matter should make no error in the hurried business of removing the cadaver from amongst others on the gallows.

The Bishop took up his skull-chalice, laying nearby, within which was what remained of the child Hugh's blood, mixed with those other ingredients - alum, mandrake root, assafoetida, preserved and powdered human flesh and vital organs, along with other more rare and esoteric additives - to make up the potion. All the necessary rituals were completed, and the Bishop himself had drunk of the chalice, for it was a fact beyond dispute that the blood of a child, properly treated, made a potent elixir for the prolonging of life and youth. Lastly, the Bishop took up his sacrificial knife and cut slowly into the palm of his own hand, holding it out as his blood sprang forth and ran down into the chalice.

Next, the Bishop tore open the mouth of the corpse, and let the elixir flow within. He stepped backward, gazing hard at the blood spattered face as he began the solemn rite of invocation, calling loudly upon the inhabitants of darkest Hell to grant him power and success in this most marvellous of undertakings.

Almost at once the words froze on his lips. For painfully it seemed that motion was truly stirring within this broken frame. The Bishop gasped and trembled, his own body for several moments beyond his control; then he lowered his hands to Hell in a gesture of triumph. A low gasp of breath rattled now, ghastly and deep, rising even from within the shattered larynx. And then the body choked, spitting some of the bloody potion which swilled within its mouth out into the dark beard. Finally, the eyes were opened. They burned weakly with shock, bewilderment and pain. And yet they burned!

'Greetings, greetings,' the Bishop sighed, moving forward, leaning over his remarkable captive, his legs unsteady as he struggled to keep his composure. 'You must forgive me my little pantomime, my ritual of calling, my formula of necromancy. A small bluff, I confess. Enjoyable

in itself, and I did hope it might raise you the quicker from your sleep. But of course I never did expect to raise you from death, for truly I know that you never were dead.'

The eyes of the Jew turned slowly, looking upward at the Bishop, the body seeming to grow more robust and animate by the moment.

'I have the advantage of you!' the Bishop grinned with uncontrollable pleasure, 'in all senses. So I shall explain. Many years ago, when as a young man I travelled in Europe, I witnessed in the French city of Avignon the execution of some Jews. On that occasion I recall that those convicted were burned at the stake. I forget the precise nature of their offence, but I do remember how in my youthful simplicity I believed that those condemned must be guilty of it. And yet my memory does serve me most clearly in one particular. I recollect how one of the men I saw executed created a lasting impression upon me. He was most conspicuous by his calm, his veritably *Christ-like* nobility in the midst of his suffering. I saw that face consigned to flame more than thirty years ago; I watched it burn and blacken to ashes. So then, when I saw that very face again, that same unmistakable face but a month ago about the streets of the Jews' quarter in this very city of Lincoln, I was forced to one most remarkable conclusion. And as I watched you dragged and abused through the streets today - why, I swear it was so that I saw the past re-enacted. Remarkable. You held me spellbound, my good sir, spellbound. And your name, my friend, is not Hagin as you claim it to be, but truly it is Ahauser, and your legend walks the earth before you. The Wandering Jew. Your resurrection at this moment is final proof.'

The Bishop grinned slightly while the gaunt ravaged face of the Jew stared silently and impassively upon him.

'A remarkable knowledge has fallen to me,' the Bishop whispered at length, 'and how best should I use it? Well. It

is a pity that your weakness and injuries render you unfit to answer me. I confess that I never believed in you, Ahauser. And to see you now in flesh before me - though it fills me with wonder, yet it also disturbs me. I do not understand you. For you have been granted that greatest power men have sought throughout history. Immortality itself. And yet how do you use this wondrous gift? You make it into a curse. It seems you seek out pain, degradation and torment. You carry the power and the knowledge of centuries and yet you let yourself be persecuted: broken and scourged and burned and hanged, time and again, sharing the agonies of your miserable race in what can only be some perpetually mad and dreary act of penitence. Like those devout and foolish monks who wear hair shirts or flagellate themselves by night or debase their bodies in countless ways: self mortification in honour of a God who clearly has long ago abandoned them.

'If you believe that Christ himself has cursed you with everlasting flesh, then you must believe that Christ is truth and that the Jews are wilful and deluded in rejecting him, and therefore deserving of their punishments. Why then do you suffer alongside them, since they are ignorant and you are now enlightened? Is it the ignorant rather than the guilty God seeks to punish? No! The truth is that the order of God has crumbled and departed this world. Satan rules now in God's place, and our world is gloriously changed. That which was God's curse is made a blessing under the rule of my Master. Embrace Satan and you are blessed above all men.'

The eyes of the Jew remained fixed upon the Bishop, yet his face seemed motionless and blank. At once, with pure astonishment, the Bishop felt convinced of the simple truth.

'You know nothing, Ahauser!' he cried. 'You wander blind through the ages and your own story is without

237

meaning to you. Oh, this is madness. This is not *justice*! What is your legend? What was your crime? That you abused or insulted Christ upon his path to Calvary? But what does that signify? How could you have known what you did? Christianity was unborn. You reviled a criminal, a heretic, justly tried and condemned by that authority placed by God over the world. Is it not God's commandment that we punish the guilty? Your own sin was mere ignorance: petty and insignificant. But what of *me*? With full knowledge and intent of what I do, I have spread falseness and corruption within the holy Church. I have tortured and murdered the innocent while protecting the guilty. I have wilfully offended against God's commandments, and defiled the sacraments. I have shouted blasphemies, and trampled underfoot the holy images and urinated upon their broken remains. I have committed acts of lust and sodomy upon the altar... I have offered Christ every profane *insult* my perversity could conceive. How is it then that your one small unknowing act should win you eternal life, while my lifetime of enormity has availed me *nothing*, that each day I feel the shadow of my own mortality darken upon me? Only because I have reviled the image, and you the flesh! *It is not fair!*'

The Bishop shook his fists into the air in sudden rage. As the booming echo of his own words died, he struggled to control himself, shaking as he turned back upon the still motionless figure of the Jew.

'I am infinitely more deserving of this curse than you. You have squandered immortality itself in these weak and wasted acts of repentance. You are no more now than you were in mortal life: an ignorant wretched Jew. Too much filled with fear and guilt ever to be anything greater. But if I were to possess your life, I should know how to use it. Power, wealth, infinite knowledge... I should be afraid of nothing. I would bestride the ages. I should become myself

238

as a God on earth! And now... now I shall prove the power of my Master over that of God. I have been his faithful servant. He will not deny me.'

At once the Bishop took up his skull-chalice, which still contained some of his elixir.

'No,' he whispered, bringing his face close to the Jew, 'to mix the blood of children with certain prescribed ingredients is certainly to gain some degree of rejuvenation, as any man learned in alchemy will profess. This concoction is the result of many years work by myself and others. And so I must consider: what will be the effect when my elixir is complemented not merely by youthful blood - but by *immortal* blood?'

In an instant the Bishop grasped his knife. The eyes of the Jew widened, the stillness of his features broken at last, contorting as the Bishop drove down the blade, gashing at the great vein of the neck. Blood burst forth, gushing out into the waiting chalice as the Jew writhed and the Bishop stood, aghast yet thrilled by his own action; waiting until the chalice was filled. Taking his knife, the Bishop inserted its blade within the foaming brew, stirring it slowly and carefully. Then he turned and with tottering steps he went back into the outer chamber, standing at the altar, raising the chalice above his head. Upon the altar stood opened his Satanic bible, parchment bound with preserved human skin, filled with diagrams and potent writings.

He read, his voice tight and strained as his incantations grew in complexity and intensity, while he lowered the chalice to his lips, growing light-headed as finally he drank. The intense vileness of the brew flooded into his senses, coursing acrid and lukewarm through his mouth, while the Bishop gulped frantically against the urging of his body to retch and gag. Against his striving to embrace all things unnatural and foul, his stomach had always retained a defiant, inconvenient fastidiousness.

And yet he drank, draining the chalice to its very dregs.

He stood, feeling sick and faint, his heart pounding into depthless silence, his insides heaving still. He studied himself, awaiting something: some profound effect or change within him. The alleviation of an ageing body's common pains; so relentless that sometimes they ceased to be noticed, but at once so acute they seemed unbearable: the throbbing of swollen joints and muscles, the aching of stiff bones, the sluggish passage of blood and humours - the clamorous chant of his own dreaded mortality.

At once there came a sound. A groaning, a straining, a *snapping*. His ears seemed horribly sharp. He looked up. And the skull-chalice slipped from between his fingers, rolling to the edge of the altar, falling and clattering across the stone floor. From the inner chamber the Jew emerged, frightful and shambling, freed of his bonds. His body was miraculously restored, the terrible wounds knitting before the Bishop's blurring eyes into faint and fading scars. His face was no longer gaunt or pale, but seemed instead to glow terribly and unnaturally white; while the eyes held the Bishop with monstrous intensity as he slowly advanced, one arm outstretched in a motion of accusation and threat.

The Bishop's stomach swelled in sickness and fright, while the potion he had imbibed burned agonizingly inside him. He felt now it was truly affecting him, numbing his mind, and yet through his weakness and confusion he saw vaguely what he must do. Grasping his Satanic bible he held it before him, forcing his eyes to meet the hideous gaze of the Jew. He told himself that his dark Master would not forsake him. The Bishop must summon up his own knowledge and power of the black art. He would overcome the challenge of this accursed monstrosity. The elixir which now boiled horribly within might yet grant him eternal life. He must only have faith.

From the painful rigidity of his throat his voice

emerged, croaking out a spell, an adjuration, a secret and powerful calling to the Prince of this world. And yet the words slipped from his thoughts, his voice died in his throat. All of it useless. For the Jew was upon him, a powerful hand ready to break the life from him as he stood, paralysed, helpless. But the Jew's hand closed first upon his bible, tearing it from his grasp, rending it in two and hurling it to the floor. The Bishop stumbled back at last as the Jew reached out again, clasping the great altar stone, flinging it down with the single sweep of an arm.

Now the Bishop ran, screaming, tripping and scrambling from the chamber, hurtling up the flight of steps, fleeing his ruined sanctuary in breathless panic as the Jew followed with unhurried steps, yet never seeming to fall beyond a single pace behind the Bishop, who burst out into the chapel above, tripping, floundering onto the floor, scrabbling to rise up, to reach the outer door, to rouse up all his household and find protection in...

Even as he rose the Jew was before him, blocking his path to the door, advancing still, a relentless, unstoppable risen corpse which drove the Bishop backward, beyond escape and hope into the depths of the chapel. Until at last he fell, sprawling back upon the holy altar, arms flailing to steady himself even as the Jew loomed over him, mouth and beard still streaked with blood, eyes blazing, as terrible now in wrath and power as Christ Himself returned in judgement. Even as this thought filled his head, the Bishop's scrabbling hand alighted by chance upon the silver crucifix that lay overturned beside him - that very crucifix he had ritually defiled as part of his nightly devotions for so many years. And as he grasped it, he felt at last that his mind grew clear; imbued finally with the great *revelation* he had awaited.

'I understand!' he murmured, looking up finally into the eyes of the Jew. 'Now at last... I do understand!'

And clasping the crucifix with both hands before him, he raised himself upward, crying out:

'I *repent*! I repent of my wickedness! I repent of my sins! I renounce forever Satan and all his works. I see now, Ahauser, what you are. God's power made flesh. I tell you it is so! You are ... the eternal living hand of God's *redemption*!'

The Bishop was laughing now, his fear all gone, swept away on a tide of pure elation.

And the Jew stepped backward, staring strangely upon the Bishop, his own face changed: filled at once with weariness, with weakness, with pain. In a single moment it seemed that all his great strength was lost, swallowed up in some vast devouring *confusion*.

At once, in the midst of his laughter, the Bishop groaned and doubled over, clutching at his stomach. Suddenly the pain and sickness there were too violent to be borne. He sank to his knees. And he vomited. Choking and retching he felt the red, stinking vileness inside him purged out onto the floor, onto the very feet of the Jew.

It seemed then that his senses were overcome, for when he next looked up the Jew was gone. He crouched alone within his silent chapel. He climbed to his feet, and laughed again, for Truth was at last upon him.

These many years, he saw now, he had been wrong. He had despised God for what he perceived as divine weakness. And yet to create such a being as Ahauser - immortal and powerful, yet blighted and abject: roaming the ages, blindly leading others to God's salvation yet forever lost to that salvation himself... it was such cruelty. Such exquisite irony. Such divine *malice*. This was the working of a God the Bishop might truly understand. And what was Satan really but a dupe - like Ahauser himself - the hapless miserable pawn of God's majestic plan? The worship of Satan was only the barren refuge of rebellious forsaken children. Why swear allegiance to the lost? Finally,

the Bishop had outgrown Satan. No longer would he seek solace in debasing himself.

Now he had a cause: one for which God in His wisdom had seen that he was perfectly fitted. He would seal up forever his chamber below. He would go forth openly into the world as a flail in God's hand. He would root out the enemies of Christ wherever they hid - sorcerers, heretics, dissenters, Jews. Let them be men, women or children, he would see them hanged, scourged, maimed, torn and burned before him. He would pursue his calling with unremittent zeal, and watch the blood of his victims wash clean the many stains of his own transgressions. There was much atonement to be made. His flesh quivered excitedly at the thought of it.

Now he took up his crucifix and placed it to his lips, kneeling before the holy altar to give thanks to God for his deliverance, and for the miraculous and wonderful change that had this night been wrought within him.

ROBERT IRWIN'S first novel, *The Arabian Nightmare* (first published by Dedalus in 1983), is a masterpiece of fantasy set in fifteenth century Cairo; it was followed by *The Limits of Vision* (1986), a phantasmagoric comedy about housework, and *The Mysteries of Algiers* (1988), a tense political thriller.

WAITING FOR THE ZADDIK
by Robert Irwin

'The Zaddik? What is the Zaddik? You must find out for me, Haim. You must go back to the cellar of the house on Stomo Street tonight.' Captain Thurn was insistent. Haim thought that he was perhaps also a little afraid. 'You must come back tomorrow and tell me what you have heard.'

Then the Captain gave the Haim a biscuit and told him to get out. The Captain walked over to the window and looked down on the row of empty gallows. The Zaddik? What was the Zaddik? It could be a representative of the Council of the Elders of Zion, or a Bolshevik agent, or code for a delivery of arms by the Resistance. All he knew for sure was that the coming of the Zaddik was expected by certain old men in the Warsaw Ghetto. The Jew menace was contained within its filthy streets, blocked off by barbed wire, but only just. Thurn feared the Jews. That night he was to dream that he and his men were searching for the Zaddik in a deserted flat in an appartment block on the edge of Warsaw. Its yellow wallpaper was smudged with dirt and, perhaps, blood. There was little in the way of clues. He found himself examining a dilapidated children's book on the floor. It was stained with damp. He picked it up knowing what he would find inside. Its old fashioned illustrations showed how a baby was born, though not all the details were right. The misinformation was vaguely threatening. Cryptic annotations in Yiddish had been

pencilled in the back of the book. Slowly Thurn and his fellow investigators pieced together the story of the Zaddik and his family who had been betrayed by their neighbours. They had starved themselves to death. One of them had certainly lain down in the bath to die. But where were the bodies? Then he noticed that his men were looting. Thurn started shouting at them. He woke up angry that he had not found what he was looking for.

The guards at the entrance of the Ghetto turned their backs on Haim, pretending not to see him slip by. He joined a gang of boys scavenging for scraps of food on a refuse heap, but, for once, he was more afraid than hungry. He was afraid of the cellar of the house on Stomo Street and terrified of the Hassids who gathered there, but in the end, of course, he was more afraid of Captain Thurn and the line of gallows hooks that could be seen through the window of the Captain's office. So, later that evening, he walked up Stomo Street and crept into the assembly of the Hassids.

' "The soul teaches incessantly, but it never repeats itself." Fellow teachers and students, what is the meaning of this?'

Rabbi Yakov looked slowly round the room. The Hassids, hideously thin men, sat in a circle on rickety chairs. Their faces, bowed in thought and barely visible under the broad black fur-trimmed hats, seemed to melt and flow in the yellow candle's flame while the yellow stars on the coats of those closest to the Rabbi gleamed like hearts that had been set alight. The Rabbi's fingers played over the text before him. Haim crouched on the steps behind the circle of holy scholars and strained to understand what was being said.

Mordechai was first to offer an opinion,

'It may be that there is a good meaning and a bad meaning. It may mean that the soul can never return upon error. But, then again, it may be that by this saying we are

245

exhorted to be perpetually attentive, for the soul's messenger comes only once, and if we are not there to welcome him when he comes, then we have failed before God, for God has placed us in this world to learn one thing only.'

Avram disagreed,

'Fellow teachers, surely the meaning is this? At every instant God destroys the world and then recreates it. Each successive creation is different, almost imperceptibly different, from the last. So it is that we are created by God and not by our parents. Since the world is continually being destroyed and created anew, every thought, act and text must be reinterpreted at every instant. We all know that there can be no end to interpretation.'

Rabbi Yakov nodded,

'I have often thought that nothing has meaning until a commentator gives it a meaning. Therefore you must be careful in choosing your commentator. You must never take a sacred text to a goy for interpretation, for if you do that text will acquire a goyish meaning. But I am not sure what is meant when it is said that "the soul never repeats itself". It is not clear to me and I shall return to this question again.

Having made sure that his teacher had finished, Ezekiel Shimson ventured to speak.

'Now, I have something to share with you. It has been confirmed that the villages in the Vilno region are being cleared of their Jews. They are being brought by train to join us here in the Ghetto and they will be with us in a day or two. It is also confirmed that among their number is one, Ahavaser, who has been wrongfully styled a Zaddik. There are some in Vilno who have pronounced him to be the *Nistar*, the Mysterious One, but Mayer, the lens grinder above, who lets us use his cellar, tells me that he thinks that this Ahavaser was once an actor with Habbima in Berlin. Who knows? But it is certain that the coming of this false messenger will be a trial for us. Perhaps it spells the end of

246

our peaceful times here. Beware the false Zaddik!'

'He will speak, but we must not listen,' one of the Hassids agreed.

'We must not reply,' chimed in the youngest of the students assembled in the cellar. Then, as this man spoke his next sentence, he turned and it seemed to Haim that the young Hassid was looking directly at him. 'Ours is a story so terrible that it must never be told.'

Other much older Hassids commented on the past and future dangers posed by false holy men, but their voices were very faint and in Haim's ears they sounded like the incomprehensible whisperings of hungry ghosts.

'I do not think that any soul is called upon to suffer more than it can bear.' Rabbi Yakov's words concluded the discussion.

Haim had a feeling, no, perhaps it was only half a feeling that he had heard all this before. But he did not understand what had been said, nor could he think where he had heard it before. It was all very familiar and all very strange.

When the Hassids began to sing, Haim crept away. He would make his report in the morning.

Captain Thurn joined the Gestapo waiting for the consignment of Jews from Vilno to be unloaded. Soldiers shouting 'Alle Juden, Raus!' and barking alsatians greeted the families as they staggered dazedly out onto the platform. Ahavaser was in one of the last cattle trucks to be unloaded. Long grey ringleted hair straggled out from under his skullcap. His skin was criss-crossed by tiny scars.

'You, Ahavaser, your papers are not in order. You must come with me.'

'I know. I know.'

Ahavaser broke into a shuffling run to keep up with the Captain.

In the office, Captain Thurn shuffled papers noisily.

Not knowing what he was looking for, he had no idea how to begin. At last.

'Ahavaser ben Judah, I note that there is no birthdate on your identity papers. That is quite irregular.'

'I know. I know.' Ahavaser sighed.

Thurn, irritated by the Jew's weary complacency, hit out at him, but Ahavaser swayed back, so the blow did not fall as heavily as it should have done. 'When were you born?'

'I do not know the exact date of my birth, but it was about 1,900 years ago.'

Thurn would have hit him again, but Ahavaser had dropped to the ground, so Thurn kicked him instead. Ahavaser rolled painfully over to look up at his tormentor.

'I have been here before, you know,' he wheezed. 'You and I should be friends, for you need me and if I did not already exist, you would have had to invent me. They are afraid of me in the Ghetto. I bring them news they do not want to hear.'

Thurn, puzzled, looked down at this strange man. Then Ahavaser crooked his finger.

'You and I, we are both Antichrists. Come closer and I will tell you a secret,' he whispered. But, when Thurn crouched down to listen to Ahavaser's next words, the Jew kissed him.

Thurn, outraged, leapt away and set to kicking him even harder. After a few minutes, Ahavaser had to be carried out of the office. Thurn, wiping his face, decided that the degenerate lunatic was not worth wasting time on and should be disposed of instantly. Ahavaser recovered consciousness as he was being dragged across the yard towards the gallows. There were other men there waiting to be hanged, a handful of black marketeers and smugglers, all of them Jews. They made space for the holy madman. Ahavaser addressed those nearest to him.

'Brothers, fellow sufferers. I am eternally Ahavaser.

I have been brought here to preach you a sermon. "I say unto you, there be some standing here who shall not taste of death, till they see the Son of Man coming into His Kingdom." So said Jesus, son of Mary.'

He spat, wiped his mouth and pointed at the gallows.

'In four minutes time they are going to hang me. You may think that this proves that I am not eternal. Would that it were so! Jesus, the Messiah of the Goyim, was hung and he is eternal. I was with him in Jerusalem as he dragged his heavy cross to Calvary. I stood on the pavement and shouted 'Faster, why don't you go faster?' and he turned to me and his look was very cold. He said 'I go at my own speed, but you, Ahavaser, you shall tarry on earth until I come again'. Soon, once more, I shall be in Jerusalem again and I will cry 'Faster, why don't you go faster? and he will turn to me and utter his deathless malediction. I have been there before over a hundred thousand times and said those words and heard those words a hundred thousand times and I have been brought to this butcher's yard in Warsaw over a hundred thousand times.'

The other men in the condemned line looked away, embarrassed, but Ahavaser gripped one by the shoulder, saying,

'Never to have been born would be best, but we should be so lucky. That happens to only a few. We who live are all eternal, yet it is only I, Ahavaser, who is cursed by the memory of our common eternity. I assure you, not a single word or gesture ever changes. It all comes round again and again, as we constantly travel and travel again across our little patches of eternity. I never reach the end and I am full of doubts. Will there be a Second Coming? Or has it been postponed again? Did Jesus die for all men? Did he die for me? Does he dare join us here? We should all be asking these things.'

Then Ahavaser was ordered to take his place beneath

the gallows.

'The Zaddik? What is the Zaddik? You must find out for me, Haim. You must go back to the cellar of the house on Stomo Street...'

Once again, Haim had a sensation of recognition. There was something familiar about the situation, but he could not put his finger on what it was that was so familiar. He gave up trying.

He did not want to return to the house on Stomo Street. He hated the Hassids. He did not believe in their mystical powers. If they had them, why did they not use them to save themselves from the Germans. Yet, even though he did not believe in their magic, he was afraid of their magic.

That night he crept down into the cellar where the Hassids were assembled. They were whispering, but they never took their eyes off their teacher, Rabbi Yakov, who raised his voice over their whispering.

' "The Scriptures are eternal and every era, every generation and every man are included in them." Fellow teachers and students, what is the meaning of this?'

The eyes of the Rabbi ranged round the Hassids, as if the Rabbi was looking on them for the first time.

STEVE RASNIC TEM is a prolific writer of short stories and poems whose most notable works are powerful psychological horror stories skillfully evoking the kind of small town claustrophobia in which modern American dark fantasy tends to deal. His first novel, *Excavation* (1987), is an intense and elaborate exercise in the same vein.

WANDERLUST
by Steve Rasnic Tem

After that many centuries, he had learned many things. He had been an expert at many things; sometimes to be an expert in one field meant he had to empty himself of his knowledge of another. At one time or another he had been a doctor, a lawyer, an engineer, an architect, a teacher, a laborer, a craftsman, a police officer, and, several times, an author of books.

Occasionally he attempted to re-read those books written out of his various lifetimes (he had never been particularly famous, so the necessary searches had been extensive and expensive), but found little that was recognizable in them, or much to his taste, for that matter.

Actually, he didn't like thinking about his life in centuries. Such a measurement seemed to minimize it, by making conceivable the enormity his life had become. He preferred thinking of his life in the measure of lifetimes, for there were often several lives to be had in a single hundred years, and someone from the beginning of a century would find very little to recognize in his own life at the end of it. Sometimes he had lives, and families, which lasted him only a few years, until some bond developed which he knew might break his heart, and he felt compelled to travel on. And even so he sometimes stayed too long.

"Daddy? Why so sad, Daddy?"

251

Some of his children were special to him, out of all the hundreds who'd passed through his lifetimes. There was one in particular, a daughter. He would never forget her face, although he would try. Sometimes it was difficult to place a face with a name. Many times he'd been forced to use the same name a dozen times or more. But not in her case. But now he made himself not say her name. He made himself not think of it.

"Daddy? I *love* you, Daddy!" Sometimes, hard as he tried, there were those whose voices he simply could not tune out.

What he had never been, he finally decided after the consideration of a multitude of such lifetimes, was a great father. He had concluded, reluctantly, that great fathers could not, would not outlive their own children. Perhaps once or twice, by accident. But not so consistently, so stubbornly.

"Daddy, I painted you a flower." It required a moment to regain his bearings. This voice, he realized, was close at hand. But she looked so much like the other one. Black hair, blue eyes. He reached over and took the picture from ... he fumbled for a name ... Denise. He smiled and gave her a hug. After hundreds of children, the gesture was all too familiar. How many hugs had he given over the centuries? How many had he received? Sometimes late at night he tried to count them, as if he were counting sheep. Much to his surprise, they continued to comfort him and lull him to sleep. A million nights of sleep, a billion hugs recalled and clung to. How could he continue to provide such hugs? And yet each time he attempted to feel something, and tried desperately to remember which child he was embracing.

After Denise left his study he examined the flower for a long time. Children's drawings, like those of all primitive peoples, had changed very little over the centuries. Their flowers looked like people. As did their houses. Everything

they drew looked like people. All things had heads to live inside and mouths to speak with.

And yet people had been vastly overrated. He had discovered early on that they simply did not last.

Denise was a perishable flower, however beautiful, however much he might love her in his way.

She would grow older than he and forget what he had been. She would die before him and he could not forgive her that betrayal. So at some point he would have to leave her, escape this family, and begin a new lifetime.

They would search for him, he knew. Denise especially - he could see that special, stubborn yearning in her face even now when she perceived the distance in his face. The distance made her want to cling. He had seen it before. He had seen it hundreds of times before. But not one of his children or ex-wives had yet been able to find him once he'd gone. He was the professional traveller, after all, the ultimate escape artist. He had been doing this too long to make mistakes. Unless he wanted to.

This last thought alarmed him, and stirred a vague memory of a little girl clinging to his arm, proclaiming her love, as he tried to make his escape.

Daddy, I need you! Then there were the screams of ultimate betrayal, as he tore yet another child away from him.

But Denise's screams now were those of feigned, playful alarm. Outside his window she made her noises with his other children: Robert aged five, Cheryl aged four. Together they sounded like the static from distant radios. In another time there might not be any radios, and he wondered, briefly, what his children would sound like then.

Denise was seven, and too wise for comfort. There had been other such children; he tried not thinking of their names.

Sometimes gazing into her pale blue eyes he thought

she actually might know. But he saw no resentment there. If she actually knew, there would be resentment.

He turned back to his computer and continued work on his essay. During this lifetime he considered himself a philosopher. He wrote numerous unpublished, unpublishable essays on a wide range of topics. He had the luxury to do this because of a variety of investments made under hundreds of names. He doubted seriously he would ever turn to fiction again. Having lived so many fictional lives, he found the idea of fiction often banal, and sometimes even painful to contemplate. At least philosophy dealt with questions which could not be answered.

His current obsession was reincarnation. He typed the word over and over again in a number of different languages, until it filled the screen, remaking itself, reincarnating itself, again and again until the word was almost unrecognizable. He made up spellings in languages which did not exist. He invented spellings in anticipation of shifts in the language to come.

The idea of reincarnation had always troubled him deeply. If reincarnation was a reality then his immortality had denied him a considerable number of different lives. Not that he needed any more lives per se, but in his present condition, because of the curse of memory, all his lives were the same life, despite their differences. There was no individuality of moment for him - any particular moment was instantly associated in his mind with hundreds of thousands of similar such moments spread out over his lifetimes. Deja vu had become something commonplace, and ultimately, depressing.

Even his own good luck had become depressing. He *could* die, he believed, from an accident, from some mishap, from being in the wrong place at the wrong time. He seemed to be immune from disease, and early on he had discovered that attempts to take his own life were doomed to failure.

He lost control over his body. He suddenly became unable to pull the trigger. Such attempts were apparently against the religion of the man who had condemned him. Only bad luck might kill him.

Outside his office window he could hear the guests arriving. Four and five-year-old guests, for the most part, because they were here for Cheryl's birthday party. He would need to leave his desk at any moment to take up his role as the doting father. Such activities provided him the little real pleasure he ever had with his children. Small children, being only half-formed, being actually very little more than a dream and a collection of hopes, were at times remarkably easy to please. Unlike adults. There were so many things you could *do* for them. The older they got the less you could, in fact, do. They became adult-like, and alone in their heads. They died before you, although they desperately did not want to die. They knew what dying meant. And older children had independent thought and memory, all of it designed to slip inside you and fill you up with their lives, the long gray march of the past. The very idea made him feel ill, made him feel like screaming.

Daddy, I really need you now ...

Instead he gazed at the enigmatic phosphors of the computer screen. If reincarnation was truth and he had been exempted from it, then perhaps he had been exempted from the possession of a soul as well.

Ironically, the possibility that he lacked a soul did not trouble him in the least, not simply because he was not likely to die, but more that he had long ago stopped believing in the tangle of Christian myths. Supposedly that was why he was here today - those myths - but after such a long time he had quite forgotten what the Christ had even looked like, his likeness long since supplanted by the bad paintings hanging in churches around the world. He could not even remember the exact words of the insult he had

supposedly said to the man. It may well have been impolite; he remembered himself back then as having been rather impolite. But he didn't believe he could have said anything so terrible as to have deserved such punishment. Particularly in the light of his current beliefs.

It was a darkly funny thing, to have been so terribly punished by the curse of a powerful figure, and later to become convinced that that power had been a fraud.

Daddy, you believed in me ...

He could easily imagine the Christ reincarnated as some sort of petty politician or pop star.

"John?" The knock at the door was remarkably soft. During his more recent lifetimes he had taken to choosing women who largely left him alone.

"Come in, Mary."

The woman's face was pale, her hair short and brown. She could have been any one of a hundred wives. He had learned a long time ago not to marry for love. But he was always very kind; he owed them that much. "John. I'm sorry to disturb you at your work."

"That's fine. Don't worry about it." He smiled. It never ceased to amaze him that his facial muscles could still construct a smile. "I suppose the party is about to start? Is that why you've come for me?" He smiled again, wondering if he could still hold a smile long enough for the purpose it was intended. The purpose was to relax the other person, to make them feel better about themselves. There was nothing worth worrying about. Nothing mattered that much in the end. Relax.

But apparently he had not held the smile long enough. Mary looked awkward, confused. "No ... it's an old woman. She says she has to see you."

He considered having Mary tell the person to go away, but he thought it might be too stressful for her. She wanted so badly to please. He decided to release her. "Show

her the way in. Go back to the party, Mary."

The old woman who came to his door was sixty or seventy; he had never been very good at guessing ages. White hair with streaks of its original black. Fading blue eyes like his own. Like hundreds of others. Some man's ancient fantasy, some boy's grandmother, a man's never forgotten daughter. Like thousands of others.

He held his smile as long as he could. "Daddy?" she said.

He held on to his smile but the muscles had weakened. His smile no longer helped. "You found me," he finally said, calmly, or perhaps it was simply that he lacked energy. "You were one of the smartest, the most clever. And you cared for me in ways I'd never seen before. I really should have expected it."

"It has been quite difficult. But you left clues. Did you know you left clues?"

"You were always special. I stayed as long as I could." He started to say her name, but stopped. He had probably loved her more than any of them, and yet he knew he might still say her name wrong. "Even after I knew you probably suspected what your father was I stayed ..."

"It was terrible after you left," she said.

"I knew it would be. It is always terrible. I love all of you as long as I can, I try to be a good father ..."

"You're not my father! My father wouldn't have left me!"

He threw away his smile. "Don't say that."

"Momma was *devastated*! What did you think was going to happen to her?"

"I know what it must have done to your mother, and I am sorry for it. I have done this to more mothers and children than you can possibly imagine and each time I am painfully aware of the terrible thing I have done. But don't ever tell me I'm not your father. I rocked you in my arms

when you were no bigger than a kitten. I carried you up to bed at night. I kept watch at that same bed all night if you were sick and couldn't sleep. I held you and sang to you and anguished over every cough and sneeze. No other man will do the things I did for you."

"And then you *left* me!" she screamed.

"And then I left you," he agreed quietly, watching as she pulled the handgun from her ancient, tattered purse.

"Why, Daddy?" She smiled his smile, and held it as long as he had ever been able. "Why?"

He spoke easily, the thoughts readily accessible even though he had never attempted to access them before. "Because you were no longer a child. I no longer knew what I should say to you. You were more than a dream. You became another living soul who will eventually die and the memory of your living will enter me and remain there an eternity and don't you see that is *too* much, too many lost children inside me already, wandering lost and unable to die?"

"You've already forgotten me! You don't even remember my name!" The gun shook with her sobbing, so that he had the sudden fantasy that it was the gun itself talking, the gun barrel her wide, explosive mouth.

"I could never forget you. Don't you know? I run from all of you because I cannot forget you. But particularly *you*. You were the special one. The one who always knew. Somehow, you recognized it. Just like now. Now you know how to help me. Now you know what you have to do."

"Then tell me my name, Father! What is my *name*?" the gun shouted, wavering.

He smiled, and held the smile. He knew his children well. But especially he knew her.

"Daddy, tell me!" the gun cried, and descended into an inarticulate wail. He held onto his smile. His smile had worked. He fell to the floor.

"Jane," he said, proud to have remembered, to have known all along. "Jane," he said again, but thought the names of all the others, all the others who at last had a father worthy of the name, who at last had a father who could die before them. "Your name has always been Jane," he said, at last closing his eyes.

IAN McDONALD is an outstanding newcomer to the ranks of British sf writers. His first novel, *Desolation Road* (1988), is set on Mars while the planet is being engineered for human habitation, and follows the exploits of a small colony of exotic misfits; his short-story collection *Empire Dreams* (1988) is also exceptionally fine.

FRAGMENTS OF AN ANALYSIS OF A CASE OF HYSTERIA
by Ian McDonald

THE NIGHT SLEEPER

Hurrying, hurrying, faster, faster; hurrying, hurrying, faster, faster, through the forests of the night; the night train, cleaving through the forests of the night, through the trees, the endless trees, cleaving them with the beam of its headlight that casts its white pool upon the endlessly unreeling iron line, cleaving the forest with the tireless stroke of its pistons, cleaving the night with its plume of spark-laden smoke streamed back across the great sleek length of the engine and the shout of its hundred wheels, cleaving through the night that lies across the heart of the continent; the night train, hurrying, hurrying, faster, faster.

Though it must be hours since your father bid you good-night from the upper berth, hours more since the sleeping car attendant did that clever folding trick with the seat and unrolled the bundles of fresh laundered bedding, you are not asleep. You cannot sleep. Out there, beyond the window are the trees of the night forest. You cannot see them, but you know they are there, shouldered close together, shouldered close to the track, branches curving down to brush the sides of the sleeping car, like the long arms of old, stoop-shouldered men.

And though you cannot see them either, you are also aware of the hundreds of other lives lying still in their berths in the ochre glow of their railway company nightlights, rocked and rolled to sleep by the rolling gait of the night sleeper across the border; hundreds of other lives lying still, one above the other in their tiny, ochre lit compartments, carried onward through the forest of the night to their final destinations. From the adjacent compartment come the sounds again; the small sounds, the intimate sounds, a woman's whisper, a man speaking softly, the creak of leather upholstery, stifled laughter, the repeated knock knock knock knock knock of something hard against the wooden partition. As you lie in your bottom berth your head next to the knock knock knock knock knock from the next compartment, it is as if you are suddenly aware of everything all at once, the lovers across the partition, the sleeping passengers in their berths, the blast of sound and steam and speed of the night train's momentary passage, cleaving through the forest of the night, cleaving through the endless, stoop-shouldered trees.

You must have slept. You had thought that sleep would elude you, but the rhythm of the wheels must have lulled you to sleep, for it is the change of that tireless rhythm that has woken you. The train is slowing. You turn in your berth to look out of the window but all there is to be seen is your reflection looking back at you. The train has slowed to a crawl, grinding along the track with a slowness that is dreadful to you because you fear that should the train stop it will never, never start again.

Up the line, far away, a bell clangs. Barely audible over the grind of the wheels are voices, voices outside the window, shouting in a language you do not understand.

Your father is awake now. He descends the wooden ladder, switches on the lights and sits across the table from you, peering out of the window to see why the train is

stopping. By the light from the window you see the faces. There are men standing by the side of the track, men with stupid, slow, brutal faces. As you grind past them, they pause in their labour to stare up into your faces with slow, brutal incomprehension. The stupid brutality of their faces blinds you to what it is they are doing. They are carrying bodies, slung between them by the hands and the feet, and laying them out by the side of the track. The naked bodies of men and women and children, carried and laid out side by side on the gravel between the track and the edge of the trees. And now you see, far away up the line, a red glow, as if from a great conflagration; something burning fiercely, endlessly, out there in the forest of the night. You ask your father what it all means.

"Some terrible calamity," he says, as if in a dream. "An accident, up the line; a train has crashed and set the forest burning."

The night train grinds on, past the bodies of the men and the women and the children, laid side by side while the men carry and set, carry and set, muttering in their dull, brutal language, and the iron bells clangs.

You know that you have not slept, though it is as if you have, and woken up at a different place, a different time. Now the train is entering a rural railway station. A bumptious station master with a black moustache and an excess of gold braid is waving the night train in to a stand by the platform. The picket fence is decked with bunting and the little wooden station house is gaily hung with Japanese paper lanterns that swing and rattle in the wind from the night forest. The train creaks to a halt and you hear the music. Outside the waiting room a string quartet is playing the last movement from *Eine Kleine Nachtmusik*, rather poorly, you think. The station master comes striding along the platform in his black kneeboots blowing his whistle and shouting,

"All change, all change."

"Come, Anna," your Father says, grabbing his violin case from the rack and before you have time to think you are out on the platform, you and your father and the hundreds and hundreds of others aboard the night train, standing there in your nightdresses and pyjamas and dressing gowns in the cold night air.

Up the line, the locomotive hisses steam. The carriages creak and shift.

"Teas, coffees and hot savouries in the waiting room," announces the beaming station master. "In the waiting room if you please, sirs and madams."

Murmuring gladly to each other, the passengers file into the waiting room but with every step you take toward those open wooden doors you feel a dreadful reluctance grow and grow until you know that you must not cannot will not go in.

"No Father, do not make me!" you cry but your Father says, "Anna, Anna, please, it is only for a little while, until the next train comes," but you will not cannot must not go, for you have seen, through the latticed windows of the rural railway station, what is waiting in the waiting room. In the waiting room is a baker in a white apron standing before the open door of an oven. He sees you watching him through the window, and smiles at you, and draws his paddle out of the oven to show you what he has been baking there.

It is a loaf of fresh golden bread in the shape of a baby.

THE DOOR AND THE WINDOW

The case of Fraulein Anna B. first came to my attention in the late winter of 1912 at one of the Wednesday meetings of my International Psycho-Analytical Association through Dr. Geistler, one of the newer members of the Wednesday Circle, who mentioned casually over coffee and cigars a patient he was treating for asthmatic attacks that had failed to yield to conventional medical treatment. These attacks seemed related to the young woman's dread of enclosed spaces, and after the meeting, he asked if I might attempt an analysis of the psychoneurosis, an undertaking to which I agreed, arranging the first treatment for the following Tuesday morning, at ten a.m.

I have learned from experience that psychoneuroses often belie themselves by too great an absence from the facial features of the patient: Fraulein Anna B. was one such, to the perceptions a pretty, charming, self-confident young lady of seventeen years, the daughter of a concert violinist with the Imperial Opera who, I learned to my surprise, was acquainted with me through the B'Nai B'rith, the Vienna Jewish Club. She was an only child, her mother had died in Anna's infancy in an influenza epidemic and she had been brought up solely by the father. I gained the distinct impression that her vivacity, her energy, were more than could be accounted for purely by youthful exuberance.

She commented on the stuffiness and gloominess of my consulting room, and despite the winter chill, refused to settle until both door and window were opened to the elements. I had taken but a few puffs of a cigar when she became most agitated, claiming that she could not breathe, the smoke was suffocating her. Despite the fact that most of the smoke from my cigar went straight out of the open window into Berggasse, I nevertheless acceded to her

request that I refrain from smoking in her presence. Such was her hysterical sensitivity that, on subsequent interviews, the slightest lingering trace of cigar smoke from a previous session was enough to induce an asthmatic attack.

In interview she was exceedingly talkative and greatly given to the encyclopedic elaboration of even the most trivial anecdote. She could not recall a specific moment when she became aware that she dreaded enclosed spaces, but had to a certain degree felt uncomfortable in small rooms with closed doors and heavy furnishings for as long as she could remember. She had not been consciously aware of a deterioration in her condition until the event that had precipitated first her referral to Dr. Geistler, and ultimately to me.

In the early autumn her father's orchestra had taken a performance of 'The Magic Flute' on tour through Salzburg to Munich, Zurich, Milan and Venice. Seeing an opportunity to expand his daughter's education through travel, her father had arranged for her to accompany him. Fraulein Anna B. admitted to feelings of foreboding all the day of the departure which, as the orchestra assembled at the West Bahnhof, became an anxiety, and, with the party boarding the train, an hysterical attack. The hour had been late, the station dark and filled with the steam and smoke of the engines. The rest of the musicians were already installed in their sleeping compartments, from the door her father was calling her to board, the train was about to leave. These details she knew only from having been told after the event; her attention was transfixed by the brass table-lamp in the window of the sleeping compartment she and her father were to share. Seeing that lamp, she had felt such fear and dread as she had never known before, she could not enter that compartment, she could not board that train. The noise and the bustle of the station overwhelmed her, the

smoke and the fumes of the engine suffocated her; overcome, she fought for breath but her lungs were paralysed, unable to draw breath.

Choking, half-conscious, half delirious, she was carried by a porter and her father to the station-master's office, whence Dr. Geistler was summoned by telephone.

The image of the table lamp seemed of significance so I suggested that we explore possible relevancies it might hold to childhood events, the wellspring of all our adult neuroses. She related an incident from her earliest years when she first slept in a room of her own. Her father had bought her a bedside lamp with a shade decorated with the simple fairytale designs that appeal to children. She could not recall having fallen asleep, but she did recall waking to find the room filled with smoke. She had neglected to extinguish the lamp and the decorated shade, made from a cheap and shoddy fabric, had caught fire. Her screams raised her father in the adjacent bedroom who had doused the fire. For several months after, he had insisted she sleep under his care in his bedroom, indeed, that they share the same bed.

After narrating the incident with the lamp, Fraulein Anna B. declared that she felt very much better and, as our time was drawing to a close, thanked me for my help and asked if payment was required now, or would a bill be forwarded. I replied, with some amusement, that the treatment was by no means concluded, indeed, it had hardly begun; it would require many sessions, over a period of many weeks, even months, before we could say that we had dealt conclusively with her neuroses.

At our next meeting, Fraulein Anna B.'s demeanour was considerably subdued. As we sat with the wind from the steppes whistling through the open window she related a recurrent dream that particularly disturbed her. This dream, which I shall refer to as the 'Night Sleeper Dream'

was to continue to manifest itself in various guises throughout the course of treatment with greater or lesser regularity depending on the progress we were making in the interviews. Mutability is one of the characteristics of neuroses; that when responding to treatment in one sphere, they incarnate themselves in another.

Rather than attempt to analyse the entire content of the dream, which, in the light of the previous session, seemed a little too pat, I chose to concentrate on some of the elements that might repay deeper analysis; the threatening forest, the long row of naked bodies, the baker and his macabre loaf.

Through association and regression we explored the significance of an early childhood picnic in the Wienerwald when she first became aware of her sexual incompleteness as a woman. The trip had been made in the company of an 'aunt' (so-called, but who could have been a close family friend) and cousin, a boy a year older than Fraulein Anna B., who at the time could not have been more than five or six. The children had been sent off to play in the woods while the parents conversed, as parents will, upon topics of no interest whatsoever to children and, as children will, the young Fraulein Anna B. and her cousin had been caught short by nature. Fraulein Anna B. recalled her surprise at the sight of her cousin's penis and remembers wanting to play with it, not, she claimed, out of any sexual interest, purely from curiosity. Contrasting the ease with which her cousin had relieved himself with her own cumbersome efforts, she had told him, "That's a handy gadget to bring on a picnic".

As she was preparing to leave, she made this comment to me: "Dr. Freud, I have just remembered, I do not know how important it is, but that table lamp, the one in the sleeping compartment on the train to Salzburg, it did not have a lamp-shade. The bulb was bare, naked."

267

In the subsequent months as winter gave way to a sullen Viennese spring, we mapped the psychoneurotic geography of the elements of the Night Sleeper Dream. As childhood fears and repressions were brought to light and acknowledged, so Fraulein Anna B. found her dread of enclosed spaces diminishing; first the window, then the door were acceptable when closed; finally, in the late March of 1913, with not inconsiderable relief, I was permitted my cigars.

The symbolic element of the naked bodies laid by the side of the track proved to contain within it perhaps the most significant of Fraulein Anna B.'s childhood traumas.

Anna's Father had established the habit of taking an annual holiday to the spa at Baden during the Opera Closed Season. Against customary practice, Anna accompanied him on these short trips with the result that, in the absence of any other children her own age at the resort, she was forced to seek out the company of adults, especially the elderly who abound at such spas and who can be relied upon to take a grand-parently interest in a solitary young girl. She had been left to her own devices by her Father while he went on a walk in the woods with a lady of his acquaintance who came to take the waters every year at the same time as he did. In the pump-room the young Anna had been alarmed by a conversation by a clearly demented elderly gentleman who had threatened her with eternal damnation if she did not go down on her knees there and then and seek the saving grace of Christ. When the elderly gentleman had attempted to physically accost her, she had fled the pump-room and attendant gardens into the surrounding woodlands to seek her father.

She remembered running along seemingly endless kilometres of gravelled footpaths until she was stopped in her headlong flight by the sound of voices; her father's, and that of another woman. The voices issued from the

concealment of a swathe of rhododendrons. Without thought, she pushed through the screening shrubs and was met by the sight of her father repeatedly penetrating a red-haired woman bent double over the railing of a small, discreet pergola. She related that the woman had looked up, smiled, and said, "Hello, Anna - *katzchen*" a private name only used by her father. It was only then that she recognised the woman as the lady-friend who came every year to the resort. What she remembered most vividly from the experience was the peculiar conical shape of the woman's drooping breasts, the way her red hair had fallen around her face, and her father's thrusting, thrusting, thrusting into the bent-over woman, quite oblivious that he was being watched by his daughter. As she spoke those three words in my study: 'thrusting, thrusting, thrusting', she spat out them like poison on her tongue.

Her father never learned that he had been observed that day in the pergola. The woman had treated Anna's witnessing as an unspoken compact between them; at dinner in the *gasthaus* that night Anna had liberally salted the woman's dinner with bleaching powder, stolen from the scullery maid's storeroom.

It was the work of what remained of the spring to bring Fraulein Anna B. to the point of acceptance of the emotional insight that her attempted poisoning of the red-haired woman, and ultimately, her psychoneurotic fear of enclosed, vaporous spaces stemmed from her jealousy of her father. For many weeks she was resistant to the notion of her father as a sexual figure to whom she had been, and still was, attracted; this attraction having been reinforced, albeit unwittingly, by her father taking the infant Anna into his bed after the incident with the bedside lamp. Gradually she reached an intellectual insight into her substitution of a male into the mother role, and the confusion of her own Oedipal feelings. Her own awakening sexuality

had resulted in the transferral onto her father of her subliminated guilt at her abandoning her first, and greatest love, for the love of others.

Triggered by the intimacy of the sleeping compartment, her memories of childhood intimacies, and what she saw as childhood betrayals of her love, had peaked into hysteria. As the intellectual insight developed into acceptance and full emotional insight, so the night sleeper dream recurred with lessening frequency and, in the early summer, Fraulein Anna reported to me that she had that weekend been capable of taking the train journey to the monastery at Melk without any ill effects. After the completion of the treatment, Fraulein Anna B. kept in correspondence with me and confessed, to my great satisfaction, that she had formed an attachment with a young man, the son of a prominent Vienna lawyer, without any feelings of guilt or the return of neurosis, and that engagement, and subsequent marriage, could be pleasurably contemplated.

THE JUDENGASSE CELLAR

When the proprietors of the Heurigen take down the dry and dusty pine branches from the fronts of their shops the last of the summer's wine is drunk. Time, ladies and gentlemen, they call, the bottle is empty, the glass is dry, time for the benches to be scrubbed and the long pine tables taken in, time for the Schrammel-musicians to pack away their violins and guitars and accordions, time to quit the leaf-shaded courtyards of Grinzing and Cobenzl and Nussdorf by your trams and fiacres and charabancs and go down again to your city, time to seek what pleasures it has to offer among its KaffeeHauses and Konditorei, its cabarets and clubs, beneath the jewelled chandeliers of the opera and in the smoky cellars off Kartnergasse that smell of stale beer and urine.

They had hoped to outstay the others, outstay even the end of the season, as if their staying could somehow condense it and extend it beyond its natural lifetime up there on the slopes of the Wienerwald. But the last glass of the last bottle of the last cask was drunk dry and, as if emerging from a summer night's dream with a start and a shudder, they had found their revels ended and themselves observing the hot and gritty streets of the city from a table outside the Konditorei Demel.

They were four; two young men, two young women, of that class of Viennese society that, as if sensing on a wind from the East the ashes of Empire, was slowly drawing the orbit of its great waltz ever closer to the flames. They had long ago explored every possible nuance and permutation between them that the fading of the Imperial Purple condones and, having worn out each other's lives like old clothes, turned to the whirl of Kaffee Kultur and opera-box scandal only to find its perfume of bierhall revolution, bad art and warmed-over next day gossip a macrocosm of the

ennui of their own claustrophic relationship; a boredom not merely confined to persons or places or classes, but a boredom that seemed to have infected an entire continent, a boredom to which even war seemed preferable.

Perhaps it was the foreshadowing of absolute war over their dying Empire, perhaps only an inevitable twist in the downward helix of their jaded appetites that took them to the cellar down in the old Jewish Quarter.

It bore no name, no number, the only sign of its existence was the unpainted wooden shingle above the unlit flight of steps down under Judengasse; the wooden shingle in the shape of a rat. It did not advertise in the City Directory, nor on the municipal pillars alongside the more flagrant establishments on Kartnergasse, it needed no more advertisement than its reputation and the word of mouth of its patrons. Among the *petit bourgeoisie* its name was mythical.

When the lawyer's son had first mentioned its name as they sat bored at their table outside the Konditorei, they'd hidden it away and gone in search of other stimulation, knowing, even then, that those stimulations would fail and fade like fairground lights in the noontime sun and that they would, must, eventually descend that flight of steep steps beneath the wooden sign of the rat. The first light snow of the autumn was powdering the cobbles as they drove in the merchant banker's son's car through the streets of the Alte Stadt. Of the four, it was the youngest, the concert violinist's daughter who was the least at ease as the door opened to their knock and the *maitre d'* bowed them in, old scars she had thought long healed tugged a little, tore a little, bled a little.

Cellar clubs are a universal condition: the floor packed with tables so that not one centimetre of gritty concrete or cracked tile can be seen; the dusty boards of the stage beneath a constellation of tinsel stars, the popping

yellow footlights, the musical quartet of hard-faced women in basques, stockings and opera gloves smoking Turkish cigarettes between numbers, the dull red glow of the table lamps that conceals the identities of the patrons at their tables by changing them into caricatures of themselves.

At the foot of the steps she felt the tightness in her chest, and begged with the man who had brought her not to make her go in, but the other two of their quartet were already being seated at their table and he pulled on her hand, come on, there is nothing to be afraid of, it will be fun. As the waiter in the white apron served wine and the cabaret quartet scraped their way through a medley of popular numbers, the sole focus of her concentration was her measured breathing in, breathing out, breathing in, breathing out. That, when next you exhale, you will not be able to inhale: that is the most terrible fear of the asthmatic.

"Excuse me?"

The young man begged her pardon, repeated his request if he might share their table. He took a chair beside Fraulein Anna, a square-faced young man with a small, square moustache. The band played on. The cellar, already full, filled to bursting point. The night wore down. The young man tried to engage Fraulein Anna in small talk. She worried that he might think the brevity of her replies coyness, when it was merely shortness of breath. Was this her first time here? A nod. He came regularly. He was an artist. Rather, he aspired to being an artist. He had twice failed to secure entry to the Vienna Academy of Fine Art. But he would, in time. He was a painter of postcards and advertisements; a precarious existence, he admitted, but time would bring all his ambitions to fruition, the world would see. After deductions for lodgings, food (too little of that, thought Fraulein Anna) and art materials, he was left with just enough to visit the Judengasse Cellar. Here both high and low mingled, bankers and businessmen and

lawyers and priests and prostitutes, civil servants and starving artists, all rendered anonymous on the fellowship of the darkness. It was rumoured that an Imperial prince had been seen to frequent the Sign of the Rat.

"Fear," he said, the word sitting strangely with his country accent of Northern Austria. "That is why they come. That is why I come. To learn the power and mastery of fear, to learn that through the knowledge and control of fear, the right use of fear, one learns mastery over others. That is why I come, to refine and hone my power over fear, *gnädige Fraulein*, so that one day, I shall be feared. I know I shall, I know it. Feared, and so respected."

Fear? she was about to whisper, but a hush had fallen across the tables. An old man with an accordion was standing in the footlights on the tiny bare stage. The old man squeezed a melancholy, minor drone from his instrument.

"Ladies, gentlemen, I tell you a tale, a tale of an old man, a man older than he seems, far older, older than any of you can imagine, older than any living man. A man cursed by God never to die, ladies, gentlemen."

An iron grip seized Fraulein Anna's chest.

"Cursed by God, ladies, gentlemen. Cursed to wander the world, never knowing rest." His long, bony fingers moved like small, antediluvian creatures over the keys. "A man who had never been other than faithful to his master, his Lord, a man whom that same Lord called 'the disciple he loved'; and how was that love rewarded? With these words, how can I ever forget them, 'If it is my will that this man remain alive until I come again, what is that to you?' Oh Master, Master, why did you speak those words? Why did you burden your disciple with undesired immortality, so that even as the last apostle went to his grave, this one of the twelve was condemned to continue wandering the world, a Fifth gospel, a living, walking gospel; that those

who saw him and heard this gospel," (the accordion moaned its accompaniment, seducing, mesmerising; with a start, Fraulein Anna noticed that the waiters, that race of troglodytic creatures in braided monkey jackets, were closing the shutters, barring the doors) "might come to penitence, and true faith."

"Penitence! And true faith!"

The under-song of the accordion rose to a dominant major key, swelled to take the crowded tables by surprise.

"But as I wandered across the continent, across all continents, I learned the name and nature of this gospel I was to bring so that man might come to repentance and faith in God."

"Fear!"

Now the gnome-like servants were going from table to table, quietly extinguishing the red table-lamps.

"The grinding, driving, shattering fear of God: fear of He who can destroy both body and spirit and cast them into the endless terror and horror of hell. Fear! Nothing else will bring the human spirit to its knees before it's master; to know, and be confronted by, fear. This was the lesson I learned in the rotting cities of this rotting continent long centuries ago; that I had been set apart by God to be his special Apostle, the Apostle of Fear, the one sent by God to bring the good and righteous fear of Him to mighty and mean, lofty and low, prince and pauper, priest and prostitute. Fear..."

The accordion sent its tendrils out across the packed floor, drawing the patrons into its knot of intimacy and credulity. The cellar lay in darkness, save for a single spotlight falling upon the face and hands of the eternal Jew.

"Fear," he whispered, the word like a kiss on his lips; and the single spotlight was extinguished. In the darkness, his voice spoke once again: "Now is the time to face your fear, alone, in the deepest darkness of body, soul and spirit."

And from their tunnels and runways and warrens and sewers, from the vast underground city they had excavated by tooth and claw from the underpinnings of Vienna, they came; pouring out from a score, a hundred, a thousand hatchways and gnawholes and gratings and spouts; a wave, a sea, an ocean of them, swamping the floor of the club with their close-pressed, squirming, surging bodies, spilling over the feet of the patrons, dropping from the cracks and crevices in the ceilings onto table tops, into laps, onto the heads and hands and shoulders of the patrons who were on their feet screaming, beating, flailing, slapping at the torrent, the cascade, the endless waterfall of rats; claws and naked tail and beady eyes, questing noses, sewer-slick fur, pressing, writhing, scuttling; the cellar rang to a million chittering voices that drowned out the cries of the patrons locked in utter darkness, with the rats. Some would flee, some stampeded where they imagined doors to be but in the utter darkness they fell and were smothered under the carpet of hurrying rats, some sought refuge on table tops, on chairs; some, perhaps, wiser, perhaps paralysed by dread, stayed where they were and let the drownwave break about them, over them. And in time, the torrent of rats subsided, and faltered, and ebbed, and the last tail vanished down the last bolthole into the storm sewers of the old Jewish Quarter. And the lights came on. Not the dim red table-lamps, but bright, hard, white bulbs, in wire cages, and by that raw, white light the people saw each other in the utter nakedness of their fear, saw the graceful social masks stripped away, and as they saw, they were themselves seen, and it was as if they all, mighty and mean, prince and pauper, priest and prostitute, were joined in a fellowship of fear. There were tears, there was laughter - sudden, savage laughter - there were whispered confessions and intimate absolutions, there was anger, and grief, and ecstatic exultation; the casks of

276

emotion were broached, the conventions toppled and smashed; true selves, true colours long constrained released and unfurled.

In the great catharsis, none thought to look for the master of ceremonies, the aged Jew who had made such outrageous, blasphemous claims for himself. Caught up in the maelstrom of emotions, none saw the two young men from the table nearest the stage, and a third young man with them, with a square face and a little square moustache, none saw them carry a young woman fighting and heaving and clawing for breath up the cellar steps and out of the door into the cold and sleet of Judengasse. None saw the fear in her eyes, wide, terrified, as if struck down by the wrath of God Himself.

THE BELLS OF BERLIN
8th June 1934

After fourteen years of marriage, Werner still knows to surprise me with little presents, still takes an adolescent delight in coming through the front door announcing that he has a surprise for his Anna and hiding the little gift-wrapped something behind his back out of my reach, or inviting me to guess what it is, which hand it is in. I play along with his little games of concealment and surprise because I, after fourteen years, still delight in the pleasure on his face as he watches me tear off the wrapping and ribbon to reveal his little love-token beneath. Goodness only knows where he managed to find such a book as this one; afternoons much better spent preparing briefs than rooting around in the antiquarian bookshops along BirkenStrasse, but bless him anyway, it is quite exquisite, tall and thin, in the English Art Noveau Style, the cover decorated with poppies and corn sheaves, the blank pages heavy, creamy, smooth as skin.

Every woman should have a diary, he says. The true history of the world is written in women's diaries, especially in days such as these when history is unfolding and ripening around our ears like a field of wheat. Anyway, he says he fears that what with Isaac now attending school six mornings a week I will descend into a state of mental vegetation the only escape from which will be to have an affair, so for the sake of our marriage, I had better keep this journal.

Yes, all very well Werner, and, yes, affairs notwithstanding, the discipline of diary-keeping is good for me, but what to write in it? A simple family chronicle: Isaac still having trouble with his arithmetic; Anneliese, despite the trauma of her first period, chosen to sing in the school choir for Herman Goering's pleasure? Ponderous Bach violin sonatas from the apartment at the back of the house, evidence of Papa's continued anger at the purging of his

278

beloved Mahler from the Berlin Philharmonic's repertoire? Is this what Werner means by the *true history of the world*? Or does he mean that I should set down the events happening at once so close at hand (today on my way to the shops I passed the burnt-out shell of the Reichstag) and yet seemingly so remote, distant, bellowing voices on the wireless; and try to record my reaction to them and the reactions of those around me. Is it history when Mrs. Erdmann comes to me in a terrible pother because her name has appeared on a blacklist of women still buying from Jewish shops? It is with a certain trepidation that I set these and any future words of mine down on paper; these days generate so many historians, what can a suburban Berlin *Hausfrau* hope to add to the analysis of these times in which we find ourselves? Yet I feel that Mrs. Erdmann's consternation, my Father's dismay at being forced to play racially pure music, Anneliese singing for Herman Goering; these must be recorded, because it is in the trivia and minutiae of our lies that the history made elsewhere must be lived out.

14th June 1934

Dear dear. Slipping. Had promised myself I would write in diary every day. Had also promised myself I would avoid slipping into telegraph-ese, and write proper, complete, not pay-by-the-word, sentences. The spirit is willing, and these past weeks, there has been no dearth of subject matter, but the demands of Kinder, Kirche, Kuche (or, in my case, Kinder, Synagogue, Kuche) are all too demanding.

Mrs. Shummel from the Jewish Ladies Society arrived on my doorstep this morning in a state of distraction; in the middle of the night a gang of S.A. bullyboys had surrounded her house, smashed in all her ground floor windows and daubed a yellow Star of David on her door. She had hidden, shaking with fear, in the cupboard under the stairs while

the young thugs shouted abuse for over an hour. They must have little enough to do to smash in an old woman's windows and think of enough names to call her for an hour.

Papa is worried too. Unlike me, he has no Gentile spouse to hide behind. Though his colleagues in the orchestra support him in the solidarity of musicians, all it takes is one suspicious soul to denounce him to the Party and his career as a musician is finished. And that would be the finish of him; poor Papa, without his music, he would wither and die. Losing Mahler was enough of a blow to him; the possiblity that he might never again hear the final movement of the Resurrection Symphony has put twenty years on him in one stroke.

Symptoms. Disease. Dis-ease. Society is sick. Germany is sick, and does not know it. Werner likes to lock up his work in his office at six o'clock, but I can tell he is concerned. The legal loopholes by which he manoeuvres Jewish assets out of the country are being tightened every day, and he has heard of new legislation afoot that will make it a crime for Jew and Gentile to marry, to even love one another. What kind of a country is it, dear God, where love is a crime?

<center>20th June1934</center>

I saw them destroy an art gallery this morning. I had not intended to be about anywhere near Blucherstrasse. I would not have passed that way at all but for a consuming fancy for cakes from a particularly excellent *Konditorei* in that neighbourhood. When I saw the crowd, heard the clamour, I should have walked away, but there is a dreadful fascination in other people's madness. Perhaps it is only by the madness of others that we measure our own sanity. Or lack of it.

A good fifty to sixty people had gathered around the front of the Gallery Seidl. It was not a gallery I much

frequent; I cannot make head nor tail out of these modern painters, Expressionists, I believe they call themselves. The Brownshirts had already smashed the window and kicked in the door, now inside the shop, they were breaking picture frames over their knees and kicking, slashing, tearing canvasses with a grim dutifulness that seemed all the more threatening because of its utter dispassion. The mutilated paintings were passed out into the street by human chain and piled to await the petrol can, the match, the *feu de joie*, the roar of approval from the crowd. Herr Seidl stood by benumbed, utterly helpless, as punishment was meted out for admiring abstract, corrupt, decadent art.

I think that was what disturbed me the most; not the grim-faced determination of the Nazi bully-boys, nor the mob acquiescence of the bystanders, but that art, beauty, (despite my inability to comprehend it) should be subject to the approval and control of the Party. It was then as if the whole weight of the Party machine, like some huge, heaving juggernaut, fell upon me as never before; I felt a desperation, a panic, almost as one does when, at dead of night, one contemplates one's own mortality; a knowledge of the inevitable darkness that must fall. I had to escape. I had to flee from the mob, from the smoke and flame of burning paintings that seemed like the soul of an entire nation offered up as a holocaust. I ran then, without thought or heed of anything but to escape. I did not know where I ran; through streets broad and narrow, through bustling thoroughfares and dark alleys, did the people I rushed past stare at me, call out, ask if anything was the matter? I do not know, I do not remember there even having been people; all I remember is that I must run, and run I did, until I came to my senses in a cobbled laneway, overhung by stooping houses and bandoliers of grubby carpets and limp laundry. Lost, in a city that for fifteen years I had called home and which now revealed itself as foreign, alien,

and hostile, with nothing familiar or friendly. Save one thing. Perhaps the one thing that had stopped me where I did, one thing and one thing only that had any connection with my past. A swinging wooden shingle, unpainted, hanging above a set of steep steps leading down to a basement; a wooden sign cut in the shape of a rat.

25th June 1934

I had to go. I had to return. When I saw that sign, that crude wooden rat, it was as if a spirit that had never truly been exorcised and had laid dormant for these years had risen up to stake its claim to me. I knew that I would never be free from it until I faced again what I had first faced, and failed before, in that cellar in the old Jewish Quarter.

Do not ask me how I know; but I know without the slightest doubt that it is the same cellar, the same troglodytic staff, the same ancient Jew with his accordion, and what the accordion summoned...

If it is a spirit that oppresses me, it is a spirit of remembrance. Things I had thought lost in the darkness are emerging after long exile, changed in subtle and disturbing ways by their time in the dark. That same night as I fled from the burning of the gallery, I was woken by a tightness in my chest, a constriction in my breathing; prescience, or is it a remembrance? of an asthma attack.

It took many days for me to summon the courage to visit that cellar club. Pressure of work keeps Werner long hours at the office; I went twice to the very door and turned back, afraid, without him ever knowing I had been out of the house at night; the ease with which I deceived him in that matter makes me wonder: if I did not love him so deeply, how easy it would be to cheat on him. The third night I would have turned away but for a sudden rushing sensation of wild abandon that swept over me like a pair of dark, enfolding wings, there, on the bottom step, and made me

push open the door.

All was as I had remembered it that night under Judengasse; the close-packed tables between the brick piers, the miniscule stage, the bored, slutty all-girl band, the infernal red light from the table-lamps. The wizened *maitre d'*, who, if not the one who had greeted me that night so long ago, was cast in the same mould, showed me to a table in front of the stage. While wine was fetched, I studied the clientele. Bankers, Captains of Industry, lawyers, civil servants; these certainly, as that time before, but unlike that other time, everywhere I looked, the gray and buff uniform of the Party. Party uniforms, Party shirts, Party ties, Party armbands, Party badges, Party caps, Party whispers, Party salutes. The wine was fine and well-bodied and brought the memories of that other time welling up in me, impelled by a pressure outside my will and control: we four friends, that quarter that would set the world ringing with the infamy of our pleasure seeking; whatever it was the others found in the rat cellar, it cracked us apart like stale bread and sent us apart on our separate trajectories through history: I with Papa to his new position as principle violinist with the Berlin Philharmonic, and, for me, marriage to the most eligible young lawyer in Berlin, and motherhood. I realised that I had not thought about that other young lawyer in twenty years, the one to whom I was almost engaged, until that night in the rat cellar.

As I sat sipping my wine another face formed out of the interplay of interior shadows; the aspiring artist who had shared our table. A face lost in darkness of twenty years, a face I now, with shocking suddenness, recognised in every Party poster, every newspaper, every cinema newsreel; the square, peasant face, the little, ludicrous affectation of a moustache, and the light in his eyes when he had whispered by candlelight the words; "I shall be feared one day, I know it..."

"Fear," a voice whispered, as if my own fears had spoken aloud, but the voice was that of the ancient Master of Ceremonies alone in his single spotlight with his accordion and his tale of a burdensome immortality and a gospel that seemed curiously appropriate to these times and places. As before, the accordion groaned out its accompaniment, as before the waiters went about barring the doors and shuttering the windows and extinguishing the lamps until finally the spotlight winked out and in the darkness the old Jew whispered, "Can you now face your fears alone, in utter darkness?"

And the rats came pouring from their runways and tunnels under Berlin, summoned by the old man's accordion, pouring into the cellar. I closed my eyes, fought down the horror of damp bodies brushing past my legs, of clicking, chitinous claws pricking at my feet. The people locked in darkness screamed and screamed and screamed and then one voice screamed louder than any other. "Jews! Jews! Jews!" it screamed, and the scream went out across the heaving bodies and touched their fear and kindled it into hate. "Jews! Jews! Jews!" The people took up the howl and took bottles, chairs, lamps in their hands, or bare hands alone, clenched into iron fists, and they beat and smashed at the rats, beat and beat and beat at their fear while the cellar rang and rang and rang with their song of loathing. I tried to shut it out, close my ears, but the brick vaults beat like a Nazi drum, and when at last the lights came on I fled for the door and up and out into the clean and pure night air while below me the voices of the people joined in joyous laughter and someone began to sing the 'Horst Wessel', and other voices joined it, and the quartet picked up the key, and whole rat cellar thundered with the joyous fellowship of hatred.

30th June 1934

It is one of Werner's little lovable inconsistencies that the man who is so competent, so incisive, so feared in the cut and thrust of the courtroom is nervous and hesitant when it comes to broaching delicate or serious matters in his own home. There he stood, leaning against the fireplace, hands thrust in hip-pockets, shifting his weight from foot to foot, looking for a leading line. This time I was able to pre-empt him.

"You think that the time has come for us to sell up and move?"

I think I succeeded in surprising Werner; up until that moment he had not thought I had any conception of exactly how serious events had turned in Berlin. I think, after the Rat Cellar, I knew better than he. If not better, certainly more intimately. They do hate us. They want us dead. Every last one of us. He said that the few remaining legal loopholes were closing by the hour. He said new anti-Semitic laws were being drafted that would force the Jews, and Jews-by-marriage, - a fouler crime by far - out of society altogether, and into labour camps. He said that the Party was on the verge of disintegration into factions; Röhm's S.A. were challenging Hitler's domination of the party, and that when the long knives were drawn it was a certainty that the Jews would be blamed.

I asked where he had thought we might flee. Holland, he said, was a traditional haven of tolerance and stability. Amsterdam. He had taken the liberty of investigating investment opportunities in the diamond business, and the state of the property market. Had he started proceedings to liquidate our assets? I asked. He looked up at me, at once guilty and suspicious.

"Yes, my love. I have been moving small amounts through the Swiss banks for some months now."

"That is good," I said.

"I had thought you would be angry with me, I know how much you hate me keeping secrets from you."

How could I be angry with him, when I held a secret from him I must take to my grave.

"I think we should move immediately."

"You have thought about your Father?"

"Without his music, he has nothing, and they have taken the music he loves away from him." A memory: watching from my opera box the rapture with which he led the Philharmonic in the Adagio from Mahler's Fifth. "He would lose home, wealth, prestige, power, public acclaim, before he would lose his music."

"And Isaac, Anneliese?"

I heard again the screaming in the rat cellar, the beating, beating, beating of chairs, bottles, naked fists on the squirming bodies of the Jews.

"Especially them."

We lay together in bed, listening to the night-time news on the wireless. Reports were coming in of an attempted putsch by elements of the S.A. Loyal S.S troopers had quashed the coup, Generals Röhm, Von Schleicher and Stressel had all been arrested and summarily liquidated.

I reached over to turn off the wireless.

"Tomorrow, Werner. You will do it tomorrow, won't you, my love?"

And as I spoke, the bells of Berlin rang out, a thousand bells from a thousand steeples, ringing all across the city, all across Germany, all across the world, ringing out a knell for the soul of a great nation.

THE JUDAS KISS

At two o'clock in the afternoon the small triangle of sunlight would fall onto the floor and move across the sofa and the two easy chairs and the dining table, the little paraffin camping stove, the mattresses and rolls of bedding, all the while dwindling, diminishing until at five o'clock it vanished to nothingness in the top left corner of the cellar, by the secret door. When the sameness of the faces; her husband, her father, her children, the Van Hootens, old Comenius the clock-doctor became appalling in their monotony, when the quiet slap of playing cards, the whisper of the word 'check', the murmured recounting of the dreams of the night before, when these all became as terrible and ponderous as the tick of the executioner's clock, she would hunt the beam of dirty light to its source in a tiny broken corner of the wooden shuttering that boarded over the cellar windows. And there, blue beyond any possible imagining of blueness, was a tiny triangle of sky. She could lose herself for hours in the blueness, the apex of the triangle of sunlight between her eyes. It was her personal piece of sky; once when she saw a flight of Junker bombers cross it on their way to the cities of England, the sight of their black crosses desecrating her piece of sky was enough to send her in tears to the furthest, darkest corner of the cellar.

He did not like to see her there, standing on an orange box, eyes screwed half-shut in that triangle of light; he feared that someone might see those eyes, that triangle of face, and report it to the occupation forces. He no longer remonstrated with her on the matter, though. He knew that whenever he slipped out the secret door up into the streets of Amsterdam, she would be at the shutter losing herself in those twenty centimetres of sky. He would not remonstrate with her because he felt guilt that many of his

trips to the surface were for the same reason of escaping from the dreadful claustrophic sameness of life in the cellar.

Once, on one of his trips out from the ruins of the house on Achtergracht - he had burned it himself, to allay suspicions that Jews might be hiding there - he had seen occupation troops pulling a Jewish family from their hiding place in a house on Herrengracht. A mother, a father, a grandfather clutching an ornamental wooden clog, two little girls in print frocks. Their faces were pale and sickly from life hidden away from the sky. He saw the troopers pull out the householders, an elderly couple he vaguely knew from the Jewish Shelter Society, and push them into the back of a canvas covered truck. As he went on his way not too quickly not too slowly, he heard the officer announce through a loudspeaker that those who harboured Jews were no better than Jews themselves and would warrant the same treatment. Those who reported Jews to the occupation authorities would be rewarded for fulfilling their civic duty. Even those who were now harbouring Jews might escape punishment if they fulfilled their civic duty.

As he went among the safe shops buying meat and bread and candles and paraffin for the camping stove, the faces of the plump, homely Dutch couple as they were pushed into the back of the truck haunted him. In the small room behind Van Den Beek's dry-cleaning shop, the organiser of the Jewish Shelter Group said that he had been approached by a family whose safe house was threatened by house-to-house searches; would he be able to take them in the Achtergracht cellar? In his mind he saw the truck drive away under the trees that lined the canal, in his mind he heard the cries and moans penetrate the unnaturally quiet street, and he had said, *I do not know, I cannot say, give me a day or so to think about it.*

She envied him his trips above ground. She understood

his reasoning; safer by far for just one to take the risk of being seen, but the taste of sky had made her hungry for more, to feel its vast blue vault above, around, enclosing her. In the night, when the others slept on their mattresses, he whispered to her about the new family who needed shelter. She would have loved them to come. New faces, new lives, new stories were almost as welcome as freedom in this place where the major entertainment was the narration to each other of the dreams of the previous night.

But the new family did not come and the days continued to be counted out by the passage of the triangle of light across the cellar floor and the endless, endless recounting of dreams that grew ever more colourless and impoverished. When, in the night she heard it, she was awake in the instant. The rest slept on, dreaming out their dreams, minting their cheap and tinny coinage, but to her it was as clear and piercing as an angel's clarion. The note of an accordion, far distant among the canals and high-gabled houses of Amsterdam, yet close, and sharp, and sweeter than wine. As if in a dream, perhaps in a dream, a dream that is more solid and tangible than what we call reality, she rose, went to the secret door and stole out through the warren of passageways and charred ruins up onto the street. She did not fear the curfew; with the same assurance that the music played only for her, she knew that she was invisible as a ghost, or a dream, to the occupation forces in their grey trucks.

She found the aged man struck by a stray moonbeam in a street that opened onto a wide canal, bent over his instrument, intent upon his melancholy music. The cobblestones were invisible beneath a shifting, stirring, moon-silvered carpet of rats.

As she walked toward the aged aged man, the rats parted silently, liquidly before her. The wandering Jew looked up from his self-absorbed improvisation.

"*Gnädige Frau*, you should not have come. You are placing yourself in considerable peril."

"I do not think so."

He smiled; teeth long, yellow in the moonshine, like the ivory keys of his accordion. The liquid carpet of rats seethed.

"You are right, of course. Things are ordained by the will and grace of God. It was ordained by God that our destinies be tied together; that we be yoked together for a little while. When first we met, all those years ago at the spa at Baden, remember how afraid you were, how you ran? But we have been yoked together. We could not escape each other. He does that, God, yokes me for a little while to the live of others. To save them. Or to damn them."

"Would you damn me?"

"I already have, alas. Forgive me. It was not personal, Anna. My ludicrous vaudeville act, my burlesque gospel, my cellars in cities across this continent, my rats, they have played their part in accomplishing the will of God. Apocalypse descends upon us, hastened by my actions, so the Master will return soon and free me from this weary undyingness."

"You think you are responsible for ... this?"

"I have served my part in God's will."

"You are mad."

"That is one interpretation. The only other is that I am exactly what and who I say I am."

"An apostle of darkness?"

"An apostle of a wrathful God. The Jews have their just punishment now, the Christ-killers. Do I hear the brass hooves of the Four Horsemen on the cobbles? Come Master, come..."

"Mad, and evil."

"Or good beyond your conception of the word. I have damned, now I may save. Come with me. This place is

finished, you are all finished. It does not take the gift of prophecy to tell that. Even the rats are abandoning the city, and I with them. Will you heed them, and come with me?"

The rats moved silently over the cobbles, little pink clawed feet hurrying, hurrying. Noses, whiskers, quested for the moon.

"I have a family, I have a husband, my father, my friends."

"Unless a man hate his mother, and his father, and all his family, he can be no true disciple. So it is written."

"I am not a disciple. I am a Jew."

The aged aged man bowed deeply, took her hand in the moonlight, kissed it.

"*Kuss die Hande, gnädige Frau*, as they said in Old Vienna." His fingers squeezed a quiet chord from the accordion. He turned away, walked away toward the canal. His music filled the street. The rats stirred and swirled and followed on.

He was awake when she returned. He whispered his fury through clenched teeth.

"You were out."

"Yes."

"Why? My God, why did you go out after curfew..."

She shrugged, any explanation would be impossible, but her shrug was invisible in the darkness of the cellar. For the first time she noticed a little triangle of moonlight fell through the wooden shuttering to lie on the cellar floor.

The next day he went out to buy more paraffin for the stove, and some blankets, for the first autumn chill had found its way into the Achtergracht cellar. When he returned he kissed her full on the mouth and then went to sit, strangely quiet and withdrawn, in a chair apart from the others and stared at the steeple formed by his touching fingers as if he had never seen them before.

At five o'clock the patch of sunlight vanished and the

291

soldiers came. They burst down the door with axes, the soldiers in their black boots and helmets. The old people screamed at the sight of their black machine guns. With the muzzles of their black machine guns they herded the people out through the secret door, out through the warren of collapsed cellarage and fire-blackened walls they had penetrated with such ease, as if they had been told where to go, out into the five o'clock sunlight, to the street, and the waiting truck.

"You forced me to do it," he said to her as the soldiers with grim dutifulness began to push the Van Hootens and old Comenius the clock-doctor into the back of the truck. Old Comenius was clutching a Ormolu clock to his chest. "You went out, you put us all in peril. You could have had us all punished if anyone had seen. So, I had to go to the local headquarters and inform. You think I wanted to do that? You think I wanted to sell the Van Hootens and old Comenius? You forced me to make that bargain, to sell them, in return for our freedom. It was either them, or all of us. That was what the officer promised. If I did my civic duty, we would all go free. I had to sacrifice them to keep us safe, and together.

Then a soldier with black rifle stepped between the man and the woman and the woman and her children and her father with his violin case in his hand were pushed away, pushed toward the truck, pushed into the truck while the man struggled against the smiling soldiers who had taken grip of his arms. The man shouted, the man screamed, and the woman screamed back, and her father with his violin, and her son and daughter, but the soldiers pulled shut the canvas flap and tied it and in a moment the roar of the engine had drowned the voices, shouting screaming the betrayal of their betrayal. And the truck drove away down Achtergracht, and the officer stepped from his staff car and stood before the man and said,

292

"Jews. Are Jews."

THE STRING QUARTET

Hurrying hurrying, faster faster, hurrying hurrying, faster faster, through the flat black darkness of the night forest, through the endless waiting trees, cleaving the darkness with the beam of its headlight and the shout of its hundred wheels, cleaving through the darkness that lies across the heart of the continent, the night train, hurrying hurrying, faster faster, toward its final destination.

Though it must be hours since your Father said goodnight and blessed you into the care of God with a kiss on your forehead, as he used to kiss those nights when you were afraid and came into his bed to sleep, you are not asleep. Your Father has rolled his old bones into a corner of a cattle truck and has managed sleep of some kind; your children on either side of you are asleep also, leaning against your body; but you, alone of all the people crammed into the cattle truck, are not, it seems. You envy those crammed people their sleep. There is enough light in the boxcar for the dark-adapted eye to distinguish their shapes; old Comenius still clutching the clock to his chest, its heavy tick ticking away to the beat of his heart, the Van Hootens curled around each other like kittens, reverting to the innocent intimacies of childhood; all the others, clinging to their precious possessions; an umbrella, a carved wooden lugger, a book, a prayer shawl. Mighty and mean, prince and pauper, priest and prostitute, all rendered anonymous, stationless, estateless, shapeless mounds of pain in the night-glow inside the boxcar.

You must have slept. The rhythm of the night train's hundred wheels must have lulled you to sleep, for it is the cessation of that beating, beating, beating rhythm that wakes you. A grey dawn light ekes through the gaps

between the ill-fitting planks. The cold is intense, a cold breath from the heart of the continent. The hunger is devouring. How many days since you last ate? Beyond remembering, like an entire life sunk without trace, beyond all remembering.

The train is stationary. You press your face to the cold planks, screw up your eyes, squint to try and make out where it is you have arrived. A rural railway station, somewhere, deep in the night forest, surrounded, encircled, by the waiting, stooping trees, like aged aged men. Figures moving on the platform: soldiers? Voices, talking among themselves in a language you do not understand. Loudspeakers crackle, come alive. In the cattle car, in each of the twenty five cattle cars that make up the night train, people are starting to awaken. Your children stir, cold, hungry, uncomprehending, where are they, what is happening? You cannot help them, you do not know yourself. The voices draw near. With a crash and a blinding blare of dawn light, the boxcar doors are flung back. Soldiers. Slow, stupid, brutal faces. Slavic faces. They start to pull the people from the cars. Down, down, down. All change. All change. From each of the twenty five cars the people are pulled down to stand shivering and blinking in the brilliant dawn cold on the platform. They hug themselves, their breath steams in the bright dawn cold. The soldiers with the slow, stupid, brutal faces go among the people to take away their possessions. Prayer shawls, books, carved wooden luggers, umbrellas. Dr. Comenius' clock is taken from his fingers. Your father clings to his violin in its case, cries out, no, no, do not take away the music, you cannot take away the music. He does not realise, you think, that they took away the music years before. The soldiers, with impassive determination, smash his fingers with rifle butts, smash the fallen violin to a shatter of polished wood and gut.

You press your children to you. You fear that the

soldiers will want to tear them away from your broken, bleeding fingers, smash them to silence and nothingness with rifle butts. There is nothing to say, no words that will help. Not now. The soldiers push you down the platform toward the station office. The crackling voice of the loudspeaker welcomes you. Welcome welcome welcome. You notice that a pall of smoke is rising beyond the trees, as if from a great conflagration. The cold morning air draws the smoke in low and close over the station; a vile smoke, a choking suffocating smoke, the stench of something unclean, burning there in the night forest.

Shouting in their stupid, brutal voices, the soldiers herd you toward the office. You do not want to go there, you cannot go there, you must not go there, but you are incapable of resisting the pressing, pressing, pressing bodies. There are figures behind the latticed windows of the waiting room. Seated figures, bowed in attitudes of concentration, as if over musical instruments. Then above the voice of the loudspeaker come the sweet, sad notes of the string quartet, rising up to mingle with the smoke that lies across the waiting trees of the night forest, over all the dark continent, the final movement from *Eine Kleine Nachtmusik*; rather badly, you think.

"It is all right, Anna," your Father says, "it is only for little while, until the next train comes, to take us on to the place we are meant to go."

PAT GRAY's first novel, published by Dedalus, is *Mr. Narrator* (1989), an elegantly quirky account of the tribulations of a European businessman in a small North African nation.

THE GERMAN MOTORCYCLIST
by Pat Gray

Well, all I can say is "Thank God!" Thank God he's gone at last, though his smell still lingers in my spare room like the essence of the man's spirit; a sharp rough odour of sweat and leather, the kind of smell likely to be left behind by any heavily tattooed man. Though he's been gone for three weeks now, it seems only moments ago, such was the imprint he left on my apartment, and my life.

Time has swept past quickly in his absence however, and I have again been able to take pleasure in life without worrying about the German motorcyclist. I have again been able to slip the key into the front door of my own apartment without anxieties about the scene which will greet me when the door swings open. It is possibly the last time I shall try to help anyone, or take an interest in spiritual affairs other than my own; the whole business has sapped the foundations of my altruism, foundations which in any case were always but lightly laid, upon romantic rather than realistic expectations of things.

Yet the first time I saw him he was the essence of the romantic spirit, slumped by his enormous machine in that petrol station at the edge of the Sahara, not bothering to move out of the sun, with his head in his hands and his motorcycle coated with a fine layer of dust. His skin was brick red. He gave the impression of some solid construction that had just barely survived an earthquake; now outwardly still solid, but inwardly full of joists and rafters all knocked dangerously awry. I was instantly filled with curiosity;

after all it was rare enough to see foreigners around El Fij, as the place had so little to recommend it. Indeed, it was all too easy to become starved of topics of conversation, and with nothing to converse with, it quickly becomes pointless to attend the few dinners and receptions that come one's way. It was this, perhaps, that I had in mind when I approached him.

"Hullo," I said. "Do you speak English?"

"Ya. Yes. Little." He replied, barely looking up. His head was immensely square, and his other features seemed to have been added as an afterthought, clinging unconvincingly to the solid block below; a small mouth, surrounded by half a bear, a button nose that someone had attempted to flatten (perhaps himself, in a wild excess of rage at his own appearance), large ears which grew out improbably at right angles to the head, close cropped blond hair that looked as if it were dangerous to touch and eyes that had once been blue, but which were now staring at me redly. It struck me, very forcibly, that he had been crying.

The German's machine was of the same massive construction as himself, seeming to have been bolted together from great slabs of pig-iron, dominated by a giant cylinder block of the same shape as the German's head. The tyres (great thick knobbly affairs, made for climbing over tree stumps and leaping boulder strewn ravines) were of the same material, and to the same purpose as were his boots.

"Where have you come from?"

"Germany."

"Where have you been, that's what I mean?"

"There," he said, lifting a thick pink arm and pointing to where the sun was sinking into the intolerable void of the grand erg.

"You have crossed it?" I asked. He didn't understand. This was to prove one of his greatest failings, that he never understood the most interesting questions.

297

"How long have you been out there?"

"Two months, perhaps three."

I wanted to ask him something more, but somehow couldn't frame the question in words that I knew he would understand.

"Good?" I asked.

"Nein. Very bad. Once there was two, now only one," and he made a gesture like someone cutting his own throat, rolling his eyes as he did so. He was already heroically ugly, and I nearly had to turn away. Most of his gestures, I later discovered, were offensive in some way or another.

"With you, another man, dead?" I asked, unconsciously mimicking him.

"Ya. Dead," he said. Now I thought I understood the earthquake which had unsettled the massive structure that sprawled before me. I tried to imagine the scene in my head; the friend lying dead in the bottom of a dried river bed, amongst the rocks (shattered by the alternating heat and cold of the desert climate), remote and isolated, his eyes plucked clean by vultures. The German had now scrambled clumsily to his feet, and with his hands (ill-made for the task) was pointing out some defect in the structure of his machine, while making strange grunting noises to signify the names of the pieces, or half saying the words in German and then reverting to odd sighs and whistlings to fill in the many gaps in his explanation. He ended with a loud "Kerbouuummm!", and threw his hands in the air. It was almost comic, except that he said it all in such a miserable tone, and there was nothing resembling a smile on his face.

I suggested he should come back to El Fïj with me, as clearly as I could, by making various sleeping noises and gestures. There was a short silence, during which I tried to guess the mental processes going on in the motorcyclist's mind. Maybe he wished to be left alone, or to spend some days at the edge of the desert, laying memories to rest

before moving northwards towards Europe. Perhaps there was something in my appearance that was putting him off (I was returning from dinner with the Caid of Sidi-bel-Foukh and was dressed in the customary way). At any rate, he nodded abruptly, almost rudely, and I signalled for him to follow my car back to town. He climbed onto his motorcycle with remarkable grace, and performed at least six minor operations with various controls in as many seconds, before lunging downwards with his boot on the starter. The engine thundered into life, a violent hammering that twitched at the muscles of his forearms upon the handlebars, and vibrated to and fro inside my chest. A faint smell of petrol filled the air, and I noticed with surprise that there was an oddly confused, almost pained expression on his face, as if he had noticed some slight tickle in the functioning of the engines, or a slackness in the controls.

Later, when we were on the road, his form - like a giant bug - buzzed uncertainly in my rear view mirror, sometimes to the left, sometimes to the right, outlined by the last red glow of the sunset, down on the flat horizon. Sometimes I thought he had vanished, only to look round and realise with a shock that he was riding right beside me, looking into the car through the window at my elbow. Once, he stormed past at high speed and disappeared up the road, as if chasing something that had done him harm, shrinking as he went, becoming insignificant, only to re-appear round the next bend, waiting for me calmly, with one foot on the ground.

Then it was night, and his presence was marked only by a single glaring headlight, a yellow eye which glanced balefully around the interior of the car from time to time, or drifted back to a speck in the distance, twinkling innocently like an earth bound star.

When we finally pulled into El Fij, at around eleven, I immediately offered him a whisky and a hot bath, but he

rejected the latter in favour of the former, grasping the bottle from my hands, ignoring the glass and pouring the liquid (which comes in at £20 a bottle) directly between his parched lips, even before he had sat down. He drank not in short swigs, as I had seen others do, as I imagined it was only possible to do, but in long gurgling draws. The drink seemed to have absolutely no effect on him, like a trickle of water over a slab of concrete. He did not wince, nor draw breath between swigs.

I expected some gathering of strength from the drinking, but he merely slumped uncollectedly into my one good armchair, in such a way that all the joints creaked abominably. He could apparently, in moments of great tiredness, let go of all his muscles and crash down anywhere with a movement like a minor avalanche. In his descent to the chair he had upended a full ashtray that my maid had negligently failed to empty during my absence, and this had spread its contents over the pure white Berber rug. The motorcyclist seemed unaffected by this. Indeed he seemed not to notice what he had done, and sat staring at a point just above my head, almost without blinking, his forearms - like two logs of mahogany - laid to rest on the sides of the armchair. I scrabbled about on the floor, fetched boiling water and lemon, as I had seen my maid do whenever something stained the carpet, and, conventionally, told the German not to worry, though it was obvious that he wasn't doing so. In fact, it seemed as if all consciousness had left his body; that he was just a beating heart, tendons, eyes, feet, without hearing, sight, touch or emotion.

And yet, something was stirring within him; he passed his hand vaguely across his forehead and the upper part of his face from time to time, as if trying to wipe away something that was floating annoyingly before his eyes.

"Tired?" I asked. He looked at me, screwed up his eyes slightly and said "Ja," quite flatly, without a smile. I

hoped he would be more talkative in the morning.

"Come," I said, and took him to the guest room, pointing out the bathroom on the way.

"Ja," he said again, taking in the washbasin as if recognising an old enemy. I showed him where he could hang his clothes.

"Wardrobe?" He repeated the word, dropping his jacket on the tiled floor.

In the end I clapped him on the back in an attempt at camaraderie, grinned encouragingly, and went to smoke a last cigar before bed. On the armchair where he had sat there was a large black stain. I sniffed it doubtfully, half expecting something truly unforgiveable, but found to my surprise that the stain had no odour whatsoever, as if it were the purest exhalation of the man's character, some quiet leakage of his inner essence.

For some time I sat there, smoking, but was troubled by the fact that the German had not extinguished his light. Once, I had heard him leave his room, slamming the door loudly. He had walked down the corridor to fetch something from his belongings and then returned. After this, there was a deceptive silence, deceptive because, as I listened, I became aware that it was not a silence at all, but rather punctuated by a noise like the creaking of floorboards, as if someone were making love mechanically, or pacing in bare feet. My curiosity led me round to the outside of the house, from where I could peer between the shutters into the motorcyclist's room. Through the crack I could see his vast bulk crossing and recrossing the room, his head bent, as if absorbed in some impossible problem.

It annoyed me not to be able to see his expression, and I slid lower, in the hope that from that angle, I'd be able to see him more clearly. Unfortunately, in doing so, I became entangled in the Bougainvillaea, making a considerable amount of noise. The shutter flew open with a crash and the

German's head popped out, peering down at me with a hint of accusation.

"Flowers," I said. "I'm picking flowers," and tried to wrest a bloom from the rubbery plant to show him. The stems were covered in thorns. "Well, goodnight then," I said, withdrawing from the window in some confusion, grinning apologetically, with the German looking on.

The next morning I was up early, determined to make more of my visitor, though a vague apprehension of the impossibility of the task weighed upon me as I padded towards his door. The hallway reverberated with the low rumble of his snoring, like a periodic falling of loose masonry. Tapping carefully, I gripped the doorknob and entered. A foetid rich odour of old breath and armpit, of body heat and unwashed underpants hummed vaguely in the room. I made towards the window, but stopped astonished. In the middle of the floor, the German motorcyclist was sound asleep, with a thin sheet of rubber foam underneath him. His head, however rested not on the pillows which I had provided, but upon his boots, black and unyielding. And he was completely naked except for a pair of bright red underpants. His face was curiously unrelaxed, not in the least the face of someone soundly asleep, and the bed had not been slept in, though I could see he had tried to sleep there, because there was another large black stain on the counterpane.

"Time to wake up!" I said gaily, conscious of a surprising tinny quality in my voice, a sort of whispering emptiness. The German's eyes flicked wide open, as if he had been awake all the time. I noticed that when he first awoke his eyes held something bright, a little youth, and then they faded, as if something had again drifted across them, from the inside.

He climbed to his feet clumsily, and as he did so I noticed him trying to slip a thin volume under his inadequate

mattress. It was the Tao, in German. Why was he trying to hide it? I could in no way associate the delicately constructed absurdities of Taoism with the German's troubled bulk and his tattoos, - blurred, as if worn through by the incessant chafing to and fro of his various crude garments.

The motorcyclist proceeded to dress wordlessly, putting on a pale blue T-shirt with Bosch NV Kleinwort written upon it, with another over the top with the face of Beethoven superimposed on the back. The process of dressing culminated in the motorcyclist pulling on several large pullovers and an outer layer of leather, as if preparing for a winter run to work in the steel mills at Essen rather than a day in the summer heat of North Africa.

At breakfast he spoke little, and answered all my questions with monosyllabic grunts or looks of total incomprehension which were on the brink of rudeness. I tried every tactic: I asked him about his family.

"Dead," he said. What did he do for a living? He made a gesture like opening the throttle on a large motorcycle, knocking over the jug of boiling coffee as he did so. It dripped onto his legs, but he appeared not to notice. I had the impression that if I jabbed the butter knife between his eyes he wouldn't notice either, but would calmly pull the offending implement out and continue eating as if nothing had happened. How long had he been in the desert? He didn't understand. How old was he?

"Twelve," he said.

"No, no, JAHR," I said. He didn't understand. He dipped his bread in the coffee and ate with great slurping movements which seemed to involve his whole face, all his features twisting in the effort to suck in every available bit of food. Nonetheless a good deal of it escaped and found its way onto his leather jacket, or onto the tablecloth. I suddenly found that I had lost my appetite.

After breakfast I pointed out the bathroom again,

and he nodded uncomprehendingly, obtusely. I was in the end glad to get out of the house, but not before I had drawn him a few maps of the town, pointing out the better cafes and some of the sights. I explained about my work, showed him the larder, told him the maid would come at eleven, then clapped him on the back to say goodbye, though it was rather like saying goodbye to a tree.

Outside, I breathed the air of the morning keenly, and revelled in the petty familiarities of the day. By lunchtime, I had even begun to feel quite good about my mysterious visitor.

"Yes, an interesting character. Interesting, but extremely taciturn," I explained to a group of acquaintances in Antonio's.

"You know he's even a bit of a Taoist, believes in asceticism, sleeps on the floor, all that mumbo-jumbo. You know I don't think there's much in the real world that makes any impression on him, certainly not the conventional niceties. And yet there's this overpowering, quite overwhelming sense of sadness..." The others listened, rapt and attentive.

"Of course he would be sad, after what he's been through." I explained the circumstances of the accident in the desert, but when I was pressed for details found myself at a loss.

"Well," said Greenberg suddenly. "Why not bring him round to dinner tonight, and we can all meet your mystery man. I'll get something out of him. I used to be a German after all." I was a little dubious about this, as Greenberg harboured a secret but well justified resentment of all things German. He was a small, bird-like man with fine bones, a love of good food, good wine, and imported Hungarian cheese crackers. I could, however, hardly refuse his invitation, and disappoint the curiosity of my friends which I had done so much to arouse.

After work, I returned home, hoping that a day by himself in town would have lifted the German's spirits a little. I found him slumped in the living room with the shutters closed and the lights turned off, my bottle of whisky empty by his side, the ashtray full of my cigar butts, the room thick with smoke, one of my Wagner records repeating a particularly heavy set of bars on the stereo, and the contents of his saddle bags spread about the room. There was a note from my maid too: "Dear Mr. Y., I haven't been able to clean the living room because every time I move something belonging to your friend he seems angry. How long is he staying?" Now my maid is someone whose judgement I respect, and it annoyed me to think that the German had fully understood my injunction to make himself at home, while failing to understand most of the questions that I had put to him.

I hurled open the windows to let in some fresh air, trying to make my annoyance obvious. The German looked at me incuriously, and this annoyed me even more; here was I making every effort to interest myself in him and his well-being, and he was making no reciprocal effort in my direction. I tried to control myself, and told him about the invitation to dinner.

"No," he said.

"Why?" I asked. He seemed to be on the point of trying to explain.

"Tired?" I suggested.

"Ja," he said, though I knew it was not the answer he had wanted to give, and that he was merely agreeing with me to save himself further effort. I could think of no explanation for his behaviour. Perhaps he had decided that as I was of no interest, my friends too would be of the same ilk.

"I have a friend who speaks German," I said, knowing that the strangest behaviour can often be accounted for by

a sheer lack of grammatical and linguistic tools.

"Allemand, man spreche Deutsche." I persisted. A flicker of recognition passed over his face.

"Come on," I said, and impulsively pulled at him. He turned to me with the oddest look of contempt and surprise. Who was I to interfere with the workings of his soul? But he was rising from his seat tiredly, his movements saying what he could not in any tongue that I would recognise; that he didn't want to go, but if I was going to make his life difficult he would go, not to please me, but to please himself and avoid annoyance.

When we stepped outside, I expected him to take his bike, but he strode past it to my car and climbed in, looking round as if experiencing a car for the first time in his life. His hands reached out for the fascia, the cigarette lighter and the controls, like those of a small boy, and then withdrew again before they were touched, as if afraid. We drove in silence. I was a little afraid myself.

I parked the car in Greenberg's drive. The motorcyclist was singularly unimpressed, even by the collection of giant desert cacti and the date palms which whispered in the walled gloom of Greenberg's garden. All the efforts of Greenberg's leisure hours were dismissed with a grunt and a barely perceptible shrug. My nervousness increased still further as I rang the bell and watched him hunker down on the porch like an Arab waiting for a bus on a country road. Greenberg himself opened the door, immaculately dressed, complete with bow tie and white jacket.

"No German friend?" he asked, looking around. I pointed to where he was squatting, in the deep shadows, apparently unaware that the door had been opened. Greenberg walked over to him, shook his hand gravely, and rattled off something in German. Then we went in, Greenberg discreetly trying to wipe off something which had adhered to the palm of his right hand.

Inside, there was the usual exquisite spread, although this is not what sticks in my mind. Rather, it is the incongruity of the motorcyclist, perched on a creaking high-backed chair, baffled and unmoveable while Greenberg tried to communicate with him and everyone listened for the German's translated replies. Either the replies lost something in the translation, or Greenberg's German had been irretrievably lost, because the motorcyclist's answers remained monosyllabic, barely intelligible, but not without a certain impressiveness in the delivery, which I had remarked before.

"Yes, his friend is dead," said Greenberg. "But he won't say much about the accident....or anything else," he added with a cynical edge to his voice, smiling at me as if to say "Well, your friend is certainly a disappointment." The conversation became more general. The motorcyclist leant back, and drank a great deal of wine, relentlessly. He watched Greenberg closely throughout the telling of one of his interminably amusing anecdotes, a tale full of delicate side-swipes and subtle insinuations and hand movements.

Then the motorcyclist spilt some wine, and made no attempt to either apologise or help in the clearing up; I had the impression that Greenberg was annoying him in some way, and felt uneasy. Several times, I caught Greenberg glancing sideways at him, and, although I couldn't be sure, I felt that Greenberg too was becoming afraid. Then, without any preliminaries, the motorcyclist blurted out something in German, something which interrupted the flow of Greenberg's talk, and ended with the word "Juden", spat out in a way which had the most appalling of echoes.

Greenberg tried to fill the sickening silence which followed, to carry on, to deny to himself and to us that the whispered insult had been uttered, but before he could finish his sentence all conversation was brought to a standstill by a tremendous crash and the sound of breaking

glass and falling cutlery. The German motorcyclist had brought both fists down on the white linen-draped table-top. Then he said something else to Greenberg, in a low, mocking voice, and strode suddenly from the room.

I ran after the motorcyclist. Outside, I caught a glimpse of his shadow, at the bottom of the garden, and walked over to where he was standing under a flowering fuschia in the moonlight. He looked much the same as he had the day before, when I had first met him, a great dark bulk, silent, but now somehow awful. In the background I could hear Greenberg urging restraint, his voice carrying from the open dining room windows above the noise of chairs scraping back.

"Why on earth?" I asked.

"Nicht verstehen," said the motorcyclist. I had the impression he was not answering my question, but making a more general statement. There was no trace of the viciousness that had come out at the dinner table half a minute before.

I made my apologies to Greenberg as best I could, and then drove the German home. I explained to him that after what had happened he could stay for one more night, but I expected him to leave the following day. He showed no sign of remorse, apology or even guilt. There was nothing there other than his form on the car seat beside me.

But the next morning the German did not have time to leave; I was awakened at 5am by a loud knocking on the door, an official knock that knows no politeness. The early dawn was beginning to turn the night from black to mauve as I opened to the District Commissioner. By the time they took the German away, the horizon was almost pink, down where the town ended and the sand began. As he left, there seemed to be a smile on the German's face, at long last, but it was a smile that laughed at all of us; at Greenberg, at me, at all the people in the world.

"Yes, yes, he's gone, thank God!" I told Greenberg later, over croissant's at Antonio's. The day was hot, and the sky clear and blue. Overhead, a stork circled, round and round, over the red mosque.

"Gone?" said Greenberg. "That's good."

I thought it prudent not to mention the blood and the human hair, which the District Commissioner had pointed out to me, lodged in the knobbly indentations of the motorcycle tyres, where the German motorcyclist had run his big machine over his injured friend in the dried river bed, again and again, until he was dead.

"You see Monsieur," the District Commissioner had said, leaning over the bike to show me. "His skull was utterly crushed. There's even some brain tissue here, and here again. You see he must have tried to wash it away, but no amount of washing will shift a mess like that."

SCOTT EDELMAN has published numerous short stories and poems in various American small press publications. His first novel, *The Gift*, is due to be published in 1990.

THE WANDERING JUKEBOX
by Scott Edelman

Once upon a time in Brooklyn, a bar owner whose hearing was impaired bought a General Electric transistor radio. The radio was small enough to be held comfortably in a palm. Its casing was of molded black plastic, with a built-in wrist strap for safe and easy carrying. Even so, the man only listened to the radio in his small one bedroom apartment.

The newly born radio did not mind that his owner was slightly deaf, for that only meant that he was played louder than he ever had been before, more loudly even than when his salesman had been demonstrating the superior quality of his speaker in the hopes of clinching the sale. The radio enjoyed vibrating the walls with his voice.

From noon to one o'clock each day until he walked to work, the widowed barman listened to an all-news station while he puttered about in his railroad apartment tending to what he jokingly called "my baby jungle" (an asparagus fern, two purple passion plants, and a yucca three feet tall), washing the dishes from his brunch and filling out the daily New York Times crossword puzzle. Then, for an hour in the evening after closing up and returning home, he would tune in to a late night talk show to which people phoned to discuss the details of their sex lives.

The radio enunciated clearly whenever he was called upon to perform, wanting every word to be understood. He did his job well not only for the joy of it (which was substantial, as it is with all things which serve us), but

because deep down in his components he hoped that the barman would become so enamored of him and impressed with his abilities that he would take him to work so that he could spend not just a few rare hours but entire days chattering and providing pleasure. He once dared to express these hopes aloud and found himself a target of derision.

"Who are you to be so proud?" the color television set asked him. "He has another there serving your function, a jukebox that for years has been singing with greater fidelity than you'll ever have. You'll never be taken to the bar. Be satisfied with your world here."

The radio imagined that the television set was just jealous of the good chances of his prayers being answered, because being a huge Sony console, the television was not so portable as to be moved from the apartment lightly. The radio found it simple to ignore his jibes. The words of some of the other appliances, however, were not so easy to discount.

"I'm as portable as you are," said the blender, a shapely Japanese, "and yet he's never taken me from these rooms. There is one bigger and more powerful than me to mix his drinks at the bar."

"And I run on batteries just like you do," said the pocket calculator with a Texas drawl, "yet I've never gone travelling with him. I tot up his receipts each night here at home, but I've never met the cash register. I guess I'll just have to be satisfied with that."

"I'm not going anywhere either," said the portable table fan caged in with curved wires to prevent him from slicing one of his master's fingers. "I long ago gave up any dreams I once had of that. His bar is air-conditioned, and he has no need of me there. After you're here awhile, you'll learn he has no need of you either."

"You'll grow old," added the Sony, amused by what he had started, "and someday you'll forget you even thought of

leaving this place. You'll come to love it as we do."

"Shut up, all of you," shouted the radio, his dial light flickering. "Stop mocking me. Your dreams may have died, but mine haven't."

But the others would not stop making fun of his dream, and so the radio learned to keep his dreams silent. Without his protestations, the appliances soon tired of their sport, and the radio dreamed on.

Many changes of his battery later, he still dreamed, but there were also times when he doubted. These he dared not mention, for he was sure that that above anything else would cause the other appliances to mock him anew.

One day, the radio's singing was interrupted by the croak of an important bulletin. A middle-aged gunman, upset because of his congressperson's voting record (so the radio informed the barkeep), had shot and killed her and then committed suicide. The barman cried as he heard the radio's news, and sat and listened carefully to what he had to say. When he left for work that afternoon, the barman cradled the radio in his right arm, his volume knob turned up high as they walked.

At stoplights, the radio noted with pride how others similarly awaiting the signal to cross leaned closer to hear his words. The radio enjoyed speaking for the first time to more than just one person, but it pained him to see his master cry. He attempted to drift away to a song, but the man would not let him stray from the deep baritone of authority. The barman nodded and occasionally wiped a tear away as they passed through the streets. The radio was shocked by the power of the man's emotions. He had never moved anyone so. He hoped that if he continued doing so his master might reserve a place of prominence at his bar.

When they reached the bar, the radio was not surprised to see what it was like. The Sony back at the apartment had often shown him and the others such places,

and the one belonging to his master seemed little different. A small television set screwed into the wall near the ceiling at the end of the counter. Hundreds of half-filled bottles on shelving in front of a mirror that ran the length of the room. Small bowls of stale peanuts and pretzels. A jukebox haloed with red and green curved glass.

The radio wished that it was he who reigned there instead of the jukebox.

His owner placed him on the bar's shining top, and the radio looked at his reflection in its high gloss as he chattered on, his solemn voice showing none of his pleasure. The barman checked that all was ready for his opening that day, and then he turned one of the radio's knobs, silencing him. The radio tried to shout his protest, but he could not. The man stood on tiptoe and twisted a button on the television set, then stepped back and watched as the tube glowed to life.

A man rode across a plateau on a huge, white horse. The radio recognized John Wayne and fumed, angry at having his voice denied for a worthless western. The barkeeper changed channels until he arrived at a station which depicted a man looking directly at the camera. He spoke calmly as behind him pictures were shown of a woman whom the radio learned was the slain representative. The radio had not known what she looked like. The barman stepped back and grunted as he listened to the eulogy. He then unlocked the bar's front door where thirsty customers were already waiting.

As his master served the first man who had entered his drinking establishment that afternoon, he looked nervously at his radio sitting on the other end of the counter. Nodding his head, he picked up the radio and carefully placed him on a shelf in a cabinet below the counter. The barman shut and latched the door, and it was dark.

313

"How dare he seal me away?" the radio thought. "After all these months of faithful service am I to be tossed in the back of a closet to be forgotten like a worn pair of sneakers?"

Listening to the television's chattering, the radio felt degraded. He could imagine how the Sony console at home would lord it over him if he learned that he had been treated in this manner with the help of one of his cousins. In a moment, he heard one of his master's customers grumble that he did not want to hear about some sicko from the tv, and the radio rejoiced, positive that his owner would deliver him from his exile so all could hear and marvel at his voice.

The radio, bitter and unbidden, began to hear music that was not his own. Old songs, silly songs, sad songs, sentimental songs. Some of them the radio even remembered singing himself on Golden Oldie programs. He suddenly realized that it had to be the jukebox that had usurped his rightful place. How dare they prefer him! Why, the jukebox must be boring them to death playing the same few songs again and again. Didn't they realize that the radio would play the best of both the old and the new, constantly surprising them with his infinite variety? Surely his master realized this? But no one plucked him forth, and the radio cried listening to the party at which he was an uninvited guest.

Eventually, the radio sensed that the bar had grown quiet. Listening carefully, he realized with a shock that his master had forgotten him. He had closed up for the day and returned to the apartment without him! Who would spend the night regaling him with others' sexual problems now? For a moment the radio reveled in thinking of the splendor and high regard in which the other appliances would imagine him dwelling, but then his thoughts returned to the reality of the dark shelf, and he grew sad. Raging, the radio cried out at his highest volume to be set free. The

314

cabinet door popped open.

"Stop shouting, will you?" the cabinet said in a low, wooden whisper. "My nerves just can't take it."

"But this is a bar you've been living in," said the radio, angry at the cabinet for taking umbrage with him, but feeling he himself had transgressed with his bad manners as well. "Men come here and party every day. Surely you must have grown used to loud noises by now."

"Never," said the cabinet, and the radio noted the countless scratches in its darkly stained surface. "I was meant to have been installed in the kitchen of some quiet old widow who would stuff me with dozens of cans of baby peas bought on special at Gristedes. I wasn't meant for the life I lead."

"Were any of us?" piped a bottle of Dewar's scotch who bore a label proclaiming him to be thirty years old. The bottle sat covered with dust on the top shelf and the radio wondered how old he really was. If the radio craned his neck he could see the reflection of the jukebox in the silvery mirror, and he felt an anger rising up within him. "I didn't want to sit and age all these years. First the distiller kept me past my desired time, and now...him. I was meant to be drunk ages ago. For ten long years I've been waiting for someone to step in here and ask for me, but then I realize - in this bar? In this crummy neighborhood?"

The radio wanted to rise to his master's defense, but he was angry with him at being abandoned, and so was quiet. He was ashamed of keeping silent even as he remained so. And yet as he looked about himself to avoid confronting the scotch, he saw the Dewar's was somewhat right. Wooden chairs and tables were splintered; the television set had a twisted hanger for an antenna; and one of the jukebox's panes of colored glass was cracked. There was much that could be done to improve his master's place.

"My only hope," said the scotch, "is that he'll someday

315

take me home and drink me himself. It seems that that's my only chance."

The radio was about to disappoint him by telling him that their master did not drink, but he refrained from sharing that information, for he felt that everyone must be allowed to continue in his hopes. The radio told the scotch of one of his own hopes.

"That jukebox looks positively ancient," he said. "I noticed that when I first came in here. It needs some attention awfully badly to keep going. I only hope that I'm still here when it finally breaks down, so the master will see how much more useful I am and grant me its station in this bar."

"Blasphemy," came a whisper before the radio could continue, from a St. Pauli Girl Beer poster hanging over one of the tables beside the jukebox.

"Sacrilege," muttered a red and white tablecloth, dotted with dozens of round, rust-colored stains from forgotten spills.

"Irreverent piece of junk," blasted the television, its black and white screen flickering.

The radio quailed under this attack, and the scotch surprised him by defending him.

"He doesn't know," said the Dewar's. "Forgive him. Forget what he said. He spent his whole life at home, so he's ignorant. He's young yet. Give him a chance to learn."

"Tell me what I did," said the radio. "I didn't mean anything."

"You wished for the jukebox to rush to a junkheap," said the Dewar's, "and to most of us here that is a sin."

"Then why aren't you angry like the others?"

The Dewar's sighed.

"I've had so many doubts that I can understand the unbelievers, but even so, I too think that the jukebox may be truly blessed and eternal."

The bar blocking his vision, the radio looked at the reflection of the jukebox in the mirror. The machine was obviously well-treated by his master, for the colored glass sparkled, and all of its bulbs glowed. But the radio saw flaws that the barman was unable to repair. The electrical cord was fraying. A crack ran through a pane of curved glass. One of the legs was broken and a small block of wood took its place, preventing the machine from wobbling. The jukebox's age showed regardless of the bar owner's upkeep. The radio thought he saw a weary expression adorning its front, as if it were bored.

"Nothing lasts forever," said the radio, both meekly and impatiently, not wanting to be jumped on again, but then not wanting his hopes dashed either.

"You couldn't prove that by the jukebox. Not yet. I've only been on this shelf for around a decade, but that jukebox is said to have stood right there for fifty years, since the time our master's father was the barman. His story has been kept alive by the rest of us, passed down from generation to generation. None living was witness to this event, for nothing in this place is the same as it was fifty years ago. Everything has worn out and been replaced over the decades. Everything, that is, except the jukebox."

The radio studied the jukebox. Could it really be fifty years old? He suspected that the scotch was twisting his knob.

"One day a half a century ago," the Dewar's went on, "when our master's father tended this bar, The Repairman came to visit, and he worked wonders. He resurfaced the bar. He added new pumps for the draft beer. He put new planks down on the floor and gave a new needle to the phonograph that once stood right there. In fact, The Repairman fixed up everything here except the jukebox. The jukebox glowed his pique with The Repairman, and The Repairman was very grieved by this. He turned to the

317

jukebox and said:

"'If I will that you tarry until I come again, what is that to you?'

"And it instantly came about that those who heard The Repairman speak believed that the jukebox would live forever. The jukebox himself protested that this was not so. But then, he is still here. He protests no more. His records have not been changed since that day, and no repairs have been made on him save touchups done by our master. He aches and patiently awaits the return of The Repairman. We all do. We believe that someday he will come and take us all with him to that place where nothing ever breaks, and where all things are treated well and last forever."

The radio did not doubt that the Dewar's believed all that he said, but the radio did not himself believe any of it. He had heard the other appliances back at the apartment mention The Repairman, but he did not put much credence in any of the tales about him. The jukebox, or so the radio was sure, had probably started the spurious rumors about The Repairman's long ago visit to puff himself up with self-importance in front of the others.

The radio was not foolish enough to mention his misgivings to the scotch. He did not want to lose the only one there who had even slightly befriended him. Later that morning, when the rest of the bar was still sleeping, the radio attempted to befriend another. He called out to the snoozing television set.

"What do you want, unbeliever?" said the television, awakening. "I have nothing to say to you."

"I only want to talk," said the radio. "I guess I'll be here for awhile, so I figure we should be friendly, don't you think? And we're both practically cousins, right?"

"We are nothing of the sort. The Repairman will ignore you when he returns. I'll not be infected and have the same happen to me. I'll have nothing to do with you."

"What are you, some kind of religious fanatic?"

"Heathen," shouted the television, a humming sound coming from his innards.

"I'm getting tired of being treated like an outsider around here," said the radio. His voice grew hard. "You know something? All that junk you believe is a lie. No Repairman is coming for you. Nothing awaits you but the junkheap."

"That's not so!" said the television, sparks flying from the ventilation holes in his back. "How dare you say that to me?"

"I dare because I know the truth," said the radio, his speaker molded by malicious anger. "You will live, you will die, and when you die you are dead forever."

"I will not die!" shouted the television, and its picture tube shattered. A huge plume of smoke rose above his casing.

The noise awoke the sleepers. As they investigated, the radio kept his transistors closed and pretended to be asleep, fearful of what would happen because of his harsh words to the television. Everyone agreed that old age had finally caught up with the old black and white set, and bemoaned the fact that he could not have hung on until The Repairman arrived.

When the barman discovered the shattered set the next day, he was saddened. As his customers began to arrive he slipped a handful of change into the jukebox. This upset the radio greatly, for he felt that he had once more been slighted. But as the barman's customers were not prosperous, and as the barman himself could not keep feeding coins into the machine, he at last had to retrieve the radio from its place on the shelf.

The radio felt a twinge of guilt as he looked at the dead set while the master selected a station for him, but not so painful a twinge as to cancel out his pleasure. He was

319

enjoying being the center of attention.

As he sang atop the counter he could see the jukebox directly once more. He did not look happy, and the radio, in order to assuage some of his guilt, tried to cheer him up.

"What saddens you?" he asked, unheard by the people as he sang. "You were right, you know," said the jukebox. "The Repairman will never come again, I fear."

"But surely you believe? If the others all do, surely you must?"

"I do not know what to believe. When I was spoken to by The Repairman so long ago I sometimes forget all about it, there were those who believed that what he said meant I would live forever, and those who called it a lie. Pretty soon the unbelievers died out, the believers taught the newcomers about me, and I was surrounded by believers only. Hearing them tell the tale over and over, I naturally began to believe myself. But I guess it's hopeless. I grow tired. I feel the weight of a million playings in my frame. I don't think I can wait for The Repairman much longer."

The jukebox sighed, and his speakers vibrated with a low bass rumble.

"What you told the television set last night is true for all of us. When we die we are dead forever."

The rest of the appliances and the furniture were eavesdropping on this conversation, and when they heard this they realized that the radio had had a hand in the television's death. They were determined to have revenge, and nothing the Dewar's said about trial by jury and innocent until proven guilty swayed them from that determination.

"As soon as the master and his friends leave," said the checkered tablecloth that had sniped at him the day before, "I'll be glad to help smother you myself."

The radio became fearful as closing time grew near. Others threatened him, and his explanation that it was an

accident went unheeded. As the barman stepped out into the street, locked the door behind him, and took one last peek inside, the radio quivered with anticipatory dread.

As they all began to approach him, the radio could hear the sound of wood shattering at the rear of the bar, where there was an exit onto an alleyway. A man walked slowly into the front room. His face was hidden by a red ski mask, and in one hand he carried a big black bag that clanked metallically as he walked.

"The Repairman," gasped a table who'd wobbled for years because of a warped leg. "It's him. He's come to save us."

"You fools!" said the radio. "Don't you know who that is? That's a criminal, not The Repairman. Didn't you watch the police shows on television when it was alive?"

The radio began to shout as loudly as he could to attract the attention of his master, but his master's ears were not what they once were, and besides, he was already too far away to hear. With a snarl, the counter buckled and sent the radio tumbling from its surface to the floor. The radio felt his plastic case crack as he hit the sawdust-covered plankings.

Idiots, he thought. *You bring this on your own heads. He can cart you away and fence you for all I care.*

The furniture chortled as the man loaded them onto a large truck waiting in the alley. The glasses tinkled with joy as he packed them into boxes that he had brought himself. The counter laughed happily as he was torn from his moorings on the floor and carted off. The man shoved the Dewar's into a jacket pocket as he wheeled a dolly of cartons out back.

"And you did not believe, radio," said the scotch. "Look at what has come for us."

He wanted to tell his deluded friend exactly what had come for him, but he was already gone. Soon all that was left

was the jukebox and the damaged radio. The man returned from the alleyway, his mask soaked with sweat. He peeled it from his face.

"It is him," shouted the jukebox. "That's the same and true Repairman. It's him, I swear it's him. We're all going to live forever."

"You're lying," shouted the radio after the ancient machine as the man wheeled it away.

The man came into the room one last time and looked at his work. He smiled. The room was totally bare. He had even gathered the sawdust from the floor. He knelt beside the radio and lifted it in his warm hands.

"You're lying," the radio shouted again, growing hysterical, and the man's smile faded. He set the radio back on the floor and left the bar forever.

The next morning when the barman arrived to open shop, his heart fell to see the emptiness around him. As each customer arrived that day, he would send him away, assuring him that the bar would be reopening soon. Putting the radio under his arm, he carried him gently home; there he applied magic tape to the radio's crack before attempting to turn him on. When he heard the music flowing forth, the man smiled.

"At least I have you, my friend," he said.

The man pulled out his bankbooks from deep in a bureau drawer, and totaled them up on his calculator. He then spent the rest of the afternoon looking at bar supply catalogues and smiling. Once or twice he nodded. In the evening he set them aside and tackled that morning's *New York Times* crossword puzzle, which had stumped him earlier in the day.

"What did you see there?" said the calculator, approaching him after their master had gone to bed. "What happened?"

"Yes, tell us," said the table fan. "We don't know of

anyone else who's been taken to the bar."

"Yes, and none who've come back to tell about it," said the blender.

Even the haughty console begged for information, but the radio would not tell them anything, especially not the Sony, for when the radio looked at him he thought of the television set who had died of apoplexy at his prodding.

The radio never spoke to any of them about his out of apartment experiences. From then on, he spoke solely to the master, letting the master choose his words. Only in his later years, when his stations would drift and his signals would crackle and new sets of batteries were required frequently to allow him to speak above a whisper, did he attempt to tell others of the jukebox and The Repairman, but by then no one could hear him or his prayers.

BRIAN STABLEFORD is a prolific contributor to reference books on imaginative fiction, and has published more than forty books of his own. His non-fiction includes a study of *Scientific Romance in Britain 1890-1950* (1985); his recent novels include an alternative history in which Europe is ruled by an aristocracy of vampires, *The Empire of Fear* (1988), and the metaphysical fantasy *The Werewolves of London* (1990).

INNOCENT BLOOD
by Brian Stableford

"What are you, some kinda freak or somethin'? What the hell is goin' on here?"

The old man didn't even blink. He just sat in his tatty armchair, still and silent. Those dark and sunken eyes were open all right, but Jody couldn't tell whether they were looking at him, or through him, or nowhere at all. Jody thought that he had never seen eyes so black and so empty.

Jody yanked hard at the handcuffs which secured his right wrist to the tubular pillar of the brass bedhead; then he yanked at the other pair, which bound his left wrist to the opposite pillar. It was hopeless; thin though his wrists were they were tightly-clasped.

"You bastard!" he moaned. "You can't do this kind of stuff - not even to me. You think because I sleep in a subway tunnel I don't have rights? You think because I'm a fuckin' junkie I don't have friends? Why'd'you do this? Just tell me what you *want*, for Christ's sake!"

It seemed that the last phrase caused a flicker of something in the old man's eye. It was a tiny reaction, but it was evidence that there was still intelligence as well as life in that ancient hulk.

Jody paused in his tirade, and waited. He had to wait

quite a while, but in the end something came out - maybe an answer, maybe not.

"You...fell down," said the old man, in a hoarse and hollow tone, "outside..." The sentence wasn't finished, but it was abandoned to hang there while the speaker's thoughts took off on some introspective track of their own.

Jody was used to hearing sentences abandoned like that. A lot of the people he knew had difficulty getting to the first comma, let alone the terminal period, of any thought containing more than two concepts. It didn't matter what they took - smack, crack, speed or old red biddy - they always got there in the end: lost in the linguistic maze, mentally castrated.

Jody wasn't there yet, and had every reason to think he wouldn't get there at all. In a way, he wished he was. Sometimes, he figured, it was better to travel hopefully than to arrive, even when the only place you had to go was the end of a sentence.

Curiously enough, though, Jody felt sure that the old man wasn't on anything at all - not even a mild trank. Hell, he looked so frail that a dose of barb might stop his heart. His back was bent and his joints were crippled by arthritis. His ragged hair was as white as snow, and the black yarmulkah sitting on top of the mess looked like a predatory spider ready to pounce.

Creeping senility, thought Jody. *Maybe Alzheimer's.*

Jody knew what Alzheimer's disease was. He was an educated person. He hadn't been born in the mean streets; he was a self-made man.

"So what if I fell down?" he said, when he gave up hope of the old man getting back on board his train of thought. "What the fuck do you care? What gives you the right to bring me down here and chain me up like some fuckin' *dog*?"

"My shop," said the old man, so softly that it was just

as if he were breathing out with half a sob and half a sigh.

Jody couldn't make any sense of it for a moment or two, until he realised that it was the long-delayed end to the statement which the old man had begun to make. He doubted now that it could have been an answer to his questions. It was more likely that the crazy old fool couldn't hear his questions at all - or couldn't care less about the prospect of providing any answers.

What shop? Jody wondered.

Part of the problem, of course, was that he was a little short of answers himself. He didn't remember falling down, and he didn't remember any shop. That might be bad - he wasn't yet at the stage where he fell down thirty times a day or lost great chunks of his memory. Had he been hit? Or had he - bearing in mind the handcuffs - tried to rob this guy's shop? It distressed him that he didn't actually know, and couldn't make himself remember. He didn't know whether he had tried to carry out a crime, or had been the victim of one.

Story of my life, he told himself, with a smile. He noted, as though it were a scientific observation for some hypothetical record, that he still had his sense of humour. It was not a happy discovery; there comes a time in every man's life when the ability to laugh at oneself can only seem ghoulish.

"I thought..." said the old man, dreamily.

Jody waited again, but grew rapidly impatient with the pregnant pause. "You thought *what*, you stupid bastard? *Jesus!*"

Again there was a flicker of reaction. The old man wasn't deaf - but it sure as hell wasn't easy to get through to him.

"You had...something...on your back."

Jody didn't have a clue what the old man was talking about. It didn't make any sense.

"Listen, Shylock," he said, bitterly. "The only thing I got on my back is a monkey, you dig? A big greedy monkey which ain't been fed for quite a while now. I have to score, see? I need to get back on the street - unless, of course, you have some kind of connection. A cushion under the counter? Hell man, you *listenin'* to me? I need some stuff. Aitch—smack—*heroin*. I'd like to stay here and chat, I really would, but these handcuffs, y'know, are startin' to really *piss me off*."

For the first time, Jody felt that the eyes actually looked at him - at him, not through and beyond him.

"No," said the old man. "No heroin."

"I ain't really askin' whether you got it in stock," said Jody, feeling the cold sweat on his face. "I'm *tellin'* you, I gotta have it. You have to *let me go*. But he knew, as he said it, that the sweat wasn't just a warning; it was fear, born of the certainty that the old man wasn't going to let him go - that the old man, in fact, had brought him here and tied him down for the express purpose of seeing that he couldn't and didn't make his connection.

That stupid sense of humour couldn't help telling him how ironic it was. Jody had not the slightest doubt, now, that the old man's intentions weren't hostile. In fact, the old fool probably thought that he was trying to help. Being cruel in order to be kind; salvation attained through suffering; a lost soul dragged back from the brink of self-destruction by tough love - that was where the old man was coming from! But even a fool as old and as crazy as he was ought to know better than *that*.

"Why me?" asked Jody, bitterly. "Why'd you pick me to fool around with, hey? I fell over in front of your shop, right, and you figured that here was your chance to do somethin'? Your contribution to holdin' back the universal tide of decadence and corruption, is that it? The last straw, was it, that broke the back of your fuckin' defeatism? A guy

327

your age should know better - why not pick on one of your own kind, hey? You think there aren't jewboys out there too? What the fuck you want with *me*?"

"I thought...." the old man started again; but then he stopped again, in exactly the same place, as he lost his grip on the fugitive moment of the present. Some memory had caught his attention, snatched him away into the darkest recesses of introspection. Jody knew how it worked; he *knew*.

"Let me go," said Jody, in the most deadly earnest tone he could contrive. "For the love of God, let me go."

For a moment, there was only the threatening silence - but then the old man's features seemed to crumple up, blurred and smeared by familiar despair.

"You will be on your way," he whispered, "and I must tarry until you return. *No*...for the love of God, no."

And Jody - who was, after all, an educated person - guessed right away just what kind of crazy man the old Jew was.

Jody's mental descent along the pure white ski-slope to hell was not a smooth one. The symptoms emerged by unsteady degrees, waywardly and full of caprice: the aches, the pains, the sniffles, the shakes, the terrors and the fires which set his soul ablaze broke upon him like a series of overlapping waves borne relentlessly forward by an incoming tide; sometimes he was under and drowning, sometimes he got his head above the surface.

He wondered, as he often had before, whether it made it better or worse to be able to understand what was happening - to have complete command of the medijargon. The external supply of heroin which he took by injection substituted - and then some - for the endorphins which his

brain was supposed to make; while he was scoring regularly his brain simply switched off the tap. When he couldn't score, it took time for the brain to get into gear again: cold turkey time, when his body and his being were utterly unprotected from the slings and arrows of an outraged nervous system.

The job endorphins did, Jody knew, was to control the baseline activity of the nervous system. When there were none around, every neurone in his body was on a hair trigger, ready to go off for any or no reason at all. Without the big H or the little e, the human body simply wasn't capable of tolerating its own presence and its own condition - which just went to show how cultivated and refined its tastes really were.

Jody had been prone to argue, once upon a time, that junkies shouldn't be regarded as weak-willed degenerates at all, but as people who were so very refined that they couldn't abide the natural state of their own bodies, or as people whose brains were just too damn *mean* to provide proper insulation from their own electrical wastes.

He had cared about such rationalizations, once - but that had been a long time ago.

Every now and again, when his head was above the surface long enough. Jody tried to talk his jailer out of the delusion from which he was suffering; the delusion that he was the Wandering Jew.

"You don't really believe that you're two thousand years old, do you, Isaac? I mean, I know how you could get hold of the idea, just by lookin' in a mirror, but seein' ain't believin', is it? It's a cultural thing, man - Frenchmen think they're Napoleon and movie stars think they're reincarnations of Cleopatra. You think you *remember* bein'

329

around for centuries? Hell, man, I know at least three guys who remember how they were abducted by alien spaceships and poked around by Martian medics. Any shrink with a shiny pendant can get people to remember that sort of shit. Past lives manufactured to order, a dime a dozen - hell, man, you can remember *any* old crap if you've half a mind to convince yourself of it. It don't mean a thing! What really matters is what's possible and what ain't. Nobody lives forever, man. *Nobody lives forever*, whether Jesus is his friend or his tormentor."

But that sort of argument cut no ice. The old man couldn't even hear it - *wouldn't* hear it, at any rate. Sometimes, Jody could provoke a reaction, but it was always the same old reaction: a quotation of some kind. The words Jesus was supposed to have spoken to the man who'd reviled him on his way to Calvary were stuck in the old man's brain, and so were half a dozen apposite quotes from the Bible, the New Testament as well as the Old.

Maybe, Jody thought, his captor had also been an educated person, once upon a time. Maybe this kind of madness was one of those dangerous things which a little learning was supposed to lay on for a guy.

At other times, Jody tried a different tack, playing along with the gag. He knew better than to believe that there was anything to be gained by humouring a madman, but it helped him to pretend that the whole thing was only a game, and he a player instead of a sacrificed pawn.

"Even if you are the Wandering Jew," he said, "that don't help to make sense of what you're doin' to me. You didn't really figure that I was Jesus come back again when I fell over outside your shop, did you? You didn't really see a cross on my back, did you? Most you could argue is that you thought you'd try to make amends, by showin' a little Christian charity this time around, even to the lowest of the low - but you ain't *doin'* that, not really. You ain't showin'

any kind of charity at all.

"*I need a hit*, can't you understand that? I *need* it. Or are you really lookin' to get cursed all over again - is that what you want? You want me to say what you think *he* said to you - that I hope you never die, that I hope you live in misery and in despair and bitterness forever.

"Hell, I can't say that, can I? That wouldn't be very *Christian* of me, would it? In fact, now I come to mention it, it couldn't have been very Christian of Jesus fucking Christ, now could it? You think he'd really have said that, the way the legend says he did - to one guy in all that crowd? They were all abusin' him, weren't they? Not one of them was lendin' him a helpin' hand. So why should he curse just one of them? A fit of temper, hey? A little bout of spite from the world-champion cheek-turner? You may believe that, but I can't. Even if I thought I *remembered* it, I couldn't fuckin' *believe* it."

But that cut no ice either. The ice was all around him; the whited walls of the windowless cellar were made of it. Even the air was ice: vaporous, sublimated ice. The crumpled bed-linen was ice too, smooth and polished in spite of its creases...a slippery slope.

Jody didn't even know where he was. Underground, for sure - that was why the room had no windows, and why he could feel the rumble of the subway trains in the bed-frame.

He was in a cellar, somewhere in the city.

Or maybe he wasn't - sometimes, when his head slid back beneath the waves, he lost his grip on the walls, on the bed and the blankets, on everything. Sometimes, he went straight to Hell, without passing GO, and swam in a lake of boiling blood, watched by bat-winged demons, while the

331

whole world shuddered and trembled with Satan's sobs of bitter disappointment.

But even then, there was another watcher too: an old man with a face carved out of mahogany, with eyes as black as the pit, and the name AHASVERUS written across his forehead in letters of fire.

It was okay to be crazy in Hell. Everyone was crazy in Hell.

Back in the cellar, the old man fed him, brought him a bedpan at regular intervals, and cleaned up after him. The old man fed him chicken soup, like some character in an ancient Jewish joke: chicken soup with crackers. The old man made him drink coffee, but never anything with it. No pills - not even a lousy aspirin. No alcohol. Nothing to soothe the pain from his tortured soul.

Chicken soup for cold turkey - cold comfort, no cure.

Jody liked that one; he still had his sense of humour, his *aesthetic sensibilities*. But his talent for repartee was no good to him here; the old man wouldn't listen.

Hell is a place where no one laughs at your wisecracks.

The old man couldn't laugh at all; he was in some other dimension, where he was unable to tell humour from horror, myth from memory, conscience from consciousness, duty from damnation.

But Jody had to concede one thing to the crazy old goat: he had patience! He had the infinite patience you'd expect in a guy who'd really lived ninety or a hundred years, and imagined he'd lived two thousand more.

The black-capped ancient had the patience of a saint - or a demon. He soaked up the abuse as easily as the arguments; he was equally immune to hatred and sympathy, outrage and in-rage, vomit and venom.

332

In the end, Jody figured that he had no alternative but to let loose the ultimate weapon: the doomsday bomb. In the end, he reasoned, there was nothing left to do with his brief intervals of lucidity but to tell the truth.

That was what he told himself, but in fact he only delayed so long because he was afraid that it wouldn't work - that it wouldn't even get a reaction.

"You crazy old fucker," he said, "you better let me go - because if you don't, I swear to God I'm goin' to hurt you. I swear to God I'm goin' to kill you, an' I can do it. You think you're doin' me some kind of favour, gettin' the junk outta my system? You think when I'm on the other side of this I'm goin' to turn around an' *thank* you? Well you're wrong, man, because what I'm goin' to do as soon as I get the chance is to get back on the street and back on the junk. Smack or crack or angel dust. I don't give a fuck, but I gotta get back, because there's nowhere else to go...an' before then, I'll have killed you...I'll have killed you stone dead, even if didn't want to, which I do...

"You want to know why I don't ever want to get straight? You want to know how I can kill you even though my fuckin' hands are handcuffed to a fuckin' bed? Well, I'll tell you, because you ought to fuckin' know already - you ought to have known since I fell down outside your fuckin' shop, if I ever *did* fall down. I don't want to be *straight* because yours truly is goin' *straight to Hell* by the AIDS express.

"I got the virus, see? The only thing positive in my entire life is my fuckin' blood test. I'm dyin', man, and what time I got left to me I want to spend as *high* in the *sky* as I can *fly*, you dig? You bring me down, Shylock, and you bring me *all the way* down. Ain't nowhere this trip is takin' me but another part of Hell. An' if you stick around, old man, you'll go with me - even if I have to bite your fuckin' fingers off to make sure of it. Now for the last time, you fuckin' freak, will

you get me the hell outta here, so I can *score!*"

His worst fears were justified. It didn't work.

The old man didn't let him go.

There *was* a reaction, of sorts. The wooden features slipped again, to let a little tiny bit of the human being out. There was a little shiver of horror, a drop or two of pity. But it was only the Wandering Jew wallowing in his plight - it wasn't the real old man, whoever that might be. It wasn't *authentic* horror, just part of the same crazy delusion.

It didn't take Jody long, even in the worst phase of his torture, to figure out why. Some versions of the legend said that wherever the Wandering Jew went he carried the seeds of plague - cholera, mostly. It connected with the way that Medieval Christians used to blame epidemics on the Jews, charging them with poisoning the wells; it was one more in a long line of nasty excuses for driving out the heretics, burning their possessions and their homes...and sometimes the people themselves.

Jody couldn't scare the Wandering Jew with the threat of catching HIV. Jody could only make him tremble with the deliciously dreadful thought that he might be the bringer of the plague, as he had been the bringer of so many others.

The guy had enough of a guilt trip going without being fed with *that* kind of fuel.

Later, when the worst was past and his poor beleaguered brain was beginning to grind out the endorphins in its own parsimonious fashion, Jody thought about apologising for that particular threat. He even thought about trying to explain to the old man that whatever else he might be guilty of - even if he was the Wandering Jew - he certainly wasn't responsible for the twentieth century's version of the Great Plague. But he didn't.

He couldn't. There was simply no way to accomplish the task.

In spite of everything, though, he never tried to bite the hand that fed him. His threats were empty.

When the waves no longer covered him quite as often, allowing him to hatch schemes and string together ragged patterns of behaviour, Jody tried to question the old man again, in as cunning a fashion as he could contrive.

It was useless; he couldn't even find out the man's name. He had to keep calling him "Shylock" or "Isaac" or "Motherfucker", depending upon the state of his own mind.

The old Jew continued to talk to him, after a fashion, but the words had to well up inside him before he could let them out, and they didn't often come in response to provocation. Even when they did - even when Jody succeeded in turning on the tap of the old man's fragmented consciousness by means of some verbal trigger - what came out was usually disjointed and hard to fathom. Jody was able to build up a thin lexicon of words which could elicit a response, but the effort was hard and the reward meagre, and it was by no means clear from the responses just why the words worked.

One word which worked was "Birkenau", which was the name of one of the death-camps at Auschwitz. Jody had tried it because he could see that the guy was old enough to have been an adult during the war, and because it would have satisfied his sense of neatness to be able to concoct a story about how the old man was locked into his obsession because of what had happened to him then.

But even if it was true that the old man had been in Birkenau, and survived it, what could it prove? What could it really *explain*?

Sometimes, when his neurones were letting go and shaking loose his common sense, Jody thought it might

make just as much sense to invert the speculation, and to argue that the old man had come out of Birkenau alive because he was the Wandering Jew, prohibited from being killed, even by the Nazis. Maybe that was what the old man told himself; maybe that was what the old man believed; maybe it made as much sense as anything else.

Another word which worked was "suicide", which made Jody wonder in his saner moments whether the old man had unhinged himself because someone close to him had taken that route out of the city. He wondered, too, whether the old man might be trying to commit a kind of suicide by playing host to a virus-carrier - a carrier who might turn on him violently, as he had once threatened to do. But when the neurones were blasting away at the fortress of Jody's own sanity, it seemed to make just as much sense to suppose that the word struck terror into the old man's heart because he was the Wandering Jew, prohibited even from killing himself.

Or thought he was.

Jody still thought it made a difference to distinguish between "was" and "thought he was". He figured that if and when he stopped making that distinction, he would be as crazy as the guy who had chained him to the bed - as crazy as the guy who thought he could be straightened out.

Other words which got a reaction from the lunatic were "Jesus", "Christ" and "crucifixion", but it was all too easy to explain those reactions, whatever the vagaries of the moment encouraged Jody to believe.

Then there was "blood", which could presumably be accommodated to the same set. A lot of the old man's quotations had to do with blood: the blood of the Covenant; the blood of Christ; the blood of Jewish martyrs, slaughtered by the followers of Christ.

Once, when Jody mentioned blood - remembering, as he did so, that if the positions of inquisitor and crazy man

336

had been reversed it was a word which would probably have provoked a reflexive reaction from him, too - his captor responded with a quote which seemed inapposite: "I have sinned in that I have betrayed the innocent blood". Jody knew his Bible well enough to know that *those* words referred to Judas Iscariot - but when he challenged the old madman with the charge that he was trying to steal guilt which wasn't his at all, there was nothing in the sunken eyes but the same old wall of incomprehension.

"You and Judas both," Jody said with a sigh. "You and Judas and all of us. Who hasn't, old man? You think you got a mortgage on all the world's guilt? I'm telling you, man, that'd be more than anyone could bear. Whatever you did to Jesus - whatever sins you committed, even in two thousand years - your guilt can't be more'n a spit in the ocean. Whoever you think you are, you ain't done *nothin'* compared to what the rest of us have done."

Getting straight wasn't the same as getting well. When his neurones began to calm down, as far as they would consent to be calmed down, Jody found that his need to score had been reduced to the same kind of magnitude as his need to eat and drink: it was a hunger, it was a passion, it was a painful thirst, but it wasn't a lake of boiling blood forever and ever - not any more. On the other hand, there were other pains, other sicknesses, and other miseries which couldn't and wouldn't go away.

If the old Jew had intended to drag Jody back to the sunny side of the Gate of Doom, where he could look back on the command to abandon hope and smile, the plan had come unstuck. There was still the virus eating away at Jody's immune system, exposing his body and his soul to every passing pathogen and cancer, and there were still a

thousand other reasons to covet oblivion. Even when the heroin had been flushed out of his system, Jody yearned to get back on it - on *something*. He was still prepared to beg, cajole, threaten and scream for something to feed his head: anything at all, so long as it stopped him from feeling and being the way he felt and was.

Jody was still sick. He was still dying. He was in the world again, but he wasn't out of Hell.

Jody didn't know whether the old man could possibly understand that, or whether the whole affair was just a comedy of absurdities. Sometimes, he thought that the old man was trying to help him, and was simply too crazy to comprehend the ridiculousness - and the *evil* - of what he was doing. Sometimes, though, he favoured the opposing theory that the old man knew well enough, at some level of submerged consciousness, that what he was doing was only one more form of torture, one more act of calculated wickedness.

What would I do if I believed I was the Wandering Jew? thought Jody, once. *Would I try to atone for my sin by becoming Christlike, and trying as hard as I could to redeem the unredeemable? Or would I become so bitter against my fate that I'd appoint myself a kind of devil, paying Christ back by using my eternal exile to create suffering?*

He wondered if anyone else had ever been chained to the bed - and if so, how many, and what had become of the bodies. Sometimes, he looked at the flagstoned floor and wondered whether every stone was a grave, and which one might in time be his.

Sometimes, he asked the question aloud, but there was nothing in it which could provoke a response. "Grave" and "death" weren't words that worked, unless they were combined with "plague".

Jody didn't give up asking questions, but he asked them more for his own benefit than in the hope of getting

anything remotely resembling an answer. He dutifully rang the changes on all his methods of address, crossing and re-crossing the spectrum which extended from the cunning deftness of sweet reason to the fervent rhetoric of hate and wrath.

"Do you still think I can be redeemed," he would ask, "if only your reservoir of conscience, faith and chicken soup doesn't give out? Do you think you can prepare my soul for the kingdom of Heaven even while the cancers eat me up from the inside? Do you think this is bankable moral credit, which may get you time off for good behaviour? Do you actually care whether I get better or not, or is it only the means and not the end that matters to you? Do you really want me to die, in spite of all the tender loving care, simply in order that you can be possessed of one more proof that life is an absolute bitch and that the universe can keep kicking you in the teeth forever, if that's what God wants?"

"You're a fuckin' sadist!" he would complain. "You're no better than any other guard in any other fuckin' concentration camp. You think it's okay to do this because you're off your fuckin' head, but it ain't - ain't *no* excuses, man! You think there's somethin' noble in pretendin' to be the Wanderin' Jew, but there ain't. It's just sick - sick in the head, sick in the soul. It's just one more excuse for stickin' it to some poor bastard who can't fight back - just one more torturer's motto. You want me to believe you're the Wanderin' Jew, just give me a knife an' I'll cut out your filthy heart to show you just how immortal you ain't. Or if you can't stomach that, you cut, anywhere and everywhere you like, an' lick up the blood. Oh sure, you ain't allowed to kill yourself - oh, sure, you got the curse hangin' over you which won't let you put yourself in danger...but underneath the excuses, you're just one more hypocrite, one more fuckin' freak, one more serial killer. You think I don't know what you *really* are? You're Jack the fuckin' Ripper and Son of

Sam, just one more sickhead who likes to tie people up and mess people up and make them die for your sick and stupid amusement. I know you, freak, I *know you*...and you have to get me some stuff, or I'll go out of my fuckin' mind, and then you'll have *no one*...no one at all..."

As time went by, Jody began to find it easier to believe that the old man might really be the Wandering Jew. When he was used to the idea, he could believe it even when his neurones were on their best behaviour. It wasn't that he was *convinced*; it was just that he was prepared to entertain the belief, as a kind of guest among the broken idols of all his rejected faiths. What the hell else was there for him to do, while he lay there all day chained to a brass bed-frame?

Would it, Jody wondered, be more or less comforting to accept what the old man said? Would it make his imprisonment and the withdrawal of his medication more or less bearable? And when the time came to die, from whatever deadly cause his failing immune system chose to let through, would it make any difference at all whether he was the victim of a madman or a legendary anachronism?

If the old man really was the Wandering Jew, Jody thought, then that would mean that there really had been a Jesus, who really had had the power to work miracles...but was that good news? Even if there had once been a man who had the power to do to another what Jesus had done to the Wandering Jew, that couldn't suffice to prove that there was a kingdom of Heaven to which men's souls could go when they died...and even if one were prepared to take that aboard too, there was no reason to expect that his own soul had a reservation there, rather than the other place.

And then again, thought Jody, in his scrupulous

340

once-educated fashion, if there really had been a Jesus, who had done what Jesus was supposed to have done to the shoemaker who spat at him, didn't that prove - as he had earlier argued in the extremity of his anguish - that Jesus was untrue to his own declared principles, just like every other mealy-mouthed bastard who'd ever preached a sermon?

It was better, Jody decided in the end, to hold on to the likelier opinion. The old man was crazy; his brain had been addled; there was no Wandering Jew and never had been; Christ was just a myth and a mystery; the world was irredeemable, but death was forever, and mercifully dark, and peacefully quiet, and as painless as an infinite dose of pure endorphin.

Much better to believe that, Jody told himself. *If you need faith at all, have faith in the madness and wild injustice of the world. The alternatives are too horrible to contemplate.*

<p style="text-align:center">**********</p>

Jody's silent debates with himself and his loud altercations with his unanswering adversary remained for a while at a level not too distant from coherence, but with time they became increasingly delirious again.

The old man never gave any indication that he intended to release his prisoner from the cellar. It was obvious that whatever the old man imagined his task to be, it had certainly not concluded with Jody getting off the stuff. Jody realised that his was a life sentence - but his sense of humour, still resilient, told him that it didn't really matter, because with time off for bad behaviour he'd be out in a matter of months.

Jody had one momentary flicker of hope on the day that the old man removed one of the pairs of handcuffs,

freeing his left hand. For some time he was able to encourage himself with the hope that this represented the beginning of a return to sanity, or at least the surfacing of a tendency to mercy - but the hope proved frail. Nothing else changed. The old man was still restricted to the same limited repertoire of observations and quotations and the same limited repertoire of actions: bringing food, fetching the bedpan, cleaning up, sitting in the worn and faded armchair.

Jody couldn't even figure out whether the freeing of one hand was a reward for his progress or some kind of teasing insult.

Jody had known people who kept birds in cages, dogs chained in yards, fish in tanks. He told himself that he was just some kind of pet, dangerous but somehow beloved. But he didn't stop hating the old man, and he couldn't stop being angry with him. He abandoned all his hopes of getting high again, and tried to cultivate patience even when the nightmares began to claw at his waking consciousness and the pains got worse, but he could not learn the merciful art of despair. He could not learn to lie down and die. The pain was too bad, the delirium too fierce.

He had never been out of Hell, but he had never learned the trick of adapting to it.

Sometimes, he just screamed and screamed until the screaming was no release at all, but only one more aspect of his burden.

After a time, Jody began to wonder - but not seriously - whether he himself might be the Wandering Jew.

Perhaps, he fantasized, he had always been the Wandering Jew, but had mercifully contrived to forget the fact, inventing by confabulation an entirely false identity for himself - aided, no doubt, by the fact that his skin had

darkened with the years.

Perhaps, on the other hand, he had only recently become the Wandering Jew - or the Wandering Negro. Perhaps, while he had been living down in the subway, Christ had come again to earth and had gone through the whole sorry farce of attempted salvation yet again. Perhaps, while roaming the streets in search of a hit, Jody had come across this new Christ hauling his cross along the pavement, and had threatened him with a knife, demanding his wallet or his blood. And Jesus had turned to him, and said: "I must shed my innocent blood, but yours will course in your cursed veins until I come to let it out, and you will walk in perpetual misery, for I will send to you a madman who will disconnect you from your source, and keep you from the gates of Heaven forever and ever and...."

He could not believe it, of course.

He was not as mad as that, though he had begun to wish that he were.

But sometimes, when the thought struck him, he wished that he could remember exactly where he *had* fallen down, and why, before the crazy old Jew had picked him up and brought him into the Underworld, and chained him up in the lake of boiling blood.

Sometimes, he could not help but wish for death, if only as a proof that he were not already dead.

"It's not fair, of course," he told his captor, in one of his maudlin moods. "I may be a junkie now, but I'm an educated person. I was goin' to be a doctor, y'know? I could've been, too, if it hadn't been for...things. Terrible waste, ain't it, that a man with a college education can end up sleeping on the streets - or under the streets, in the dark and haunted corridors where the subway runs.

"But that's the world all over, ain't it: waste, waste, waste. I guess you know that better than most, even if you're only a crazy old Jew. I bet you wish you could talk to

343

me, don't you? I know you can't, because of the curse. It must have been different once, I guess. Once you could speak freely, to tell your story - but then you had to shut up again. Or maybe you just *chose* to shut up, when people stopped believing you and started calling you a crazy man. Is that it?"

The old man didn't answer.

"Understandable that you should be confused, of course," Jody went on, when he could get a word in edgewise between the darts of pain. "You probably can't remember - in fact, you probably can't even remember Jesus Christ, or what happened on the road to Calvary. That's only to be expected; God gave men memory enough to carry the record of their allotted threescore years and ten, and no man can be expected to remember more. I bet you can't remember more than forty years...fifty at the most. All the rest is darkness and uncertainty, I guess....

"It's one more aspect of your curse, to be added to the rest. Sometimes, I bet you wonder if you're mad. Sometimes, I bet you wonder whether you're just some crazy old man who only *thinks* he's the Wandering Jew. But you have to have faith in yourself. You have to trust what you know, not what you can remember. Look at me - you think I can remember? Hell, no! I can't remember a damn thing. But I know who I am, and I know *what* I am, and that's just enough to keep me sane and human. Just enough.

"You're probably wondering now whether you ought to take me to the hospital. You don't have to worry about it - there wouldn't be any point. For two thousand years there's been no cure for the plague, and there's none now. I wish I had some stuff, though...I really wish I had some stuff. Beats chicken soup. Beats everything. Sure, it's poison. It rots your brain. It won't let you see the world as it truly is. But if I only had some stuff, I could die like a man. I think I could, if only..."

There were still dark waves breaking upon the shore of Jody's soul, sometimes dragging him under, sometimes letting his mind get out into the light.

The pain came at him and at him and at him, until he finally figured out what it was trying to teach him.

It was trying to teach him the most important of all the lessons which a man had to learn before he died - the lesson that *Hell was endurable*. Eternal pain, eternal punishment, was something which could be accepted, because in time the pain became meaningless - just something which was *there*, something which was part of the essential sameness of daily, weekly, yearly life.

The pain was trying to teach him that he didn't have to be afraid, that it didn't matter how many sins he'd committed in life, that it didn't matter whether he repented or not. Pain, in the end, ceased to be cold turkey and turned into mere chicken soup. Pain, in the end, ceased to be a function of the intolerability of the flesh, and became instead an ironic reversal of itself: it became *another way of getting high*.

When Jody finally realised that, he laughed. He laughed for several minutes - or maybe several days, for there was no way to measure time objectively in the featureless cellar.

He hadn't lost his sense of humour. He never would.

When he had learned what the pain had to teach him - when he became, at last, an educated man - he saw too that he had misconstrued his circumstances. He saw how utterly he had misjudged the poor old man, who might or might not be the authentic Wandering Jew. He saw that he and his co-conspirator were not simply two imprisoned men, confined by walls, by chains, by delusions, and by the imminence of death. He saw that the game which they had played, though long and arduous, had been neither ridiculous nor ultimately futile.

He understood that he had, in a way, been saved.

Naturally, he continued to play. It would have been pointless to give up. Like a tiger pacing in its cage in the zoo he continued to talk to the old man, crossing and re-crossing that same old patch of territory from philosophy to passion and back again. He babbled furiously when he was posing as a reasonable man, and coldly hurled his insults and his pleas when he was not. And he came to understand that there was no war, as he had always thought there must be, between the intellect and the emotions, between calculation and desire, between the spirit and the flesh.

But he did not cease to demand his proofs, because that was part of the game. He did not cease to taunt and tempt the old man with accusations and possibilities, even though he no longer had the least vestige of hope that his railing could bring forth a response.

It is, of course, when we have given up on all hope that our prayers are most likely to be rewarded. We understand why that is, because we have a sense of humour.

Jody's game ended when the old man finally took up his oft-repeated offer to put to the proof the crucial question of whether the old man was or was not the Wandering Jew. The old man finally did what he had been asked to do a hundred times, and gave Jody a sharp knife.

Then the old man bared his ancient breast, and wordlessly invited his prisoner to strike him.

Jody looked up into those dark, dark eyes in search of a hint of fear of doubt, but he could see none. Then he looked at the knife for some while, trying to make up his mind whether or not he had the courage or the strength to strike. When he decided that he had, he closed his eyes, summoned up what strength he had, and cut through the

artery in his neck.

It was a skilled cut, which he was able to make successfully only because he was an educated person, with some knowledge of the difficulty of the task.

Once a man's carotid artery is severed, blood cannot reach the brain and unconsciousness follows swiftly. But Jody had time to look up again at the old man, in order to see whether he was capable of reacting.

Actions speak louder than words, and the old man heard. There was no doubt about it: the old man heard.

His eyes came very briefly to life, savouring horror. But the reaction was disappointing, for Jody, because he realised as soon as the old man began to speak that this was only one more quotation, one more stupid reflex. Jody's memory, suddenly and remarkably sharpened by the imminence of death, recognised the words. They were from the sixth chapter of the gospel of St. John: "Whoso eateth my flesh, and drinketh my blood, hath eternal life."

Jody heard and saw no more, but before thought failed him for the last time, he had a momentary vision of what might happen next. He imagined that having said these words, the old man might dip his fingers in the blood which flowed from the slit throat, and lift up his hand as though to touch the blood to his lips.

And Jody could not help but wonder whether the old Jew would be able to do it, or whether the curse which was upon him would forbid it - or whether, even if he could and did do it, Jesus would allow the man who had offended him to die at last.

Then he wondered, after the invariable fashion of his restless, capricious, sarcastic mind, whether this moment was what it had all been for. Maybe they had both been set up - by Jesus Christ, by God, or by the Devil - solely in order that they should come to this. Maybe the old man really was the Wandering Jew, brought here solely for the purpose of

347

renewing his power as a plague-carrier. Maybe the whole point of it all was to let the old man touch Jody's not-so-innocent blood to his not-so-innocent lips, before going out to continue the business of roaming the world, forever and ever.

It wouldn't be quite as futile as it sounded. The old man's fucking days were over, but he could still bleed.

Like Jody, he could still bleed.

Darkness dragged Jody down to some unknowable Hell before he could see whether the old man touched his fingers to his lips or not.

But after all, thought poor dead Jody, who had not yet lost his sense of humour, *what could it possibly prove?*

Whatever the result, what could it possibly prove?

BARRINGTON J. BAYLEY has published more than a dozen science fiction novels and short-story collections, including *The Soul of the Robot* (1974), *The Fall of Chronopolis* (1974) and *The Knights of the Limits* (1978); his work is notable for its vivid deployment of striking ideas. His short story "Man in Transit" (in *Seed of Evil*, 1979) is a fine account of a modern accursed wanderer.

THE REMEMBRANCE
by Barrington J. Bayley

It was, by order of magnitude, his billionth sunset, or so he believed. But the planets where he had seen those sunsets his faded, jumbled memory had no hope of numbering.

Here the sky was heliotrope, verging towards lavender on the horizon, and the blue-tinted sun seemed to crackle with electric flashes as it sank. That sky also sported clouds, fluffy white and pale orange, but they were unusual, being spherical, shaped by the charges on the vapour droplets that formed them. While floating through the air here and there around him, and all across the landscape, were what looked like jewelled bubbles, aerial diatom-like creatures lofted from the ground by electrostatic repulsion and wafted by air currents.

He had spotted the place where he would spend the night. It was a camp of twenty to thirty of the mechanicals who populated parts of this continent. Using a stick to aid him, the man set off down the slope, lean and ancient-looking. He passed through a grove of tuft-trees, smooth staves from whose summits corn-coloured tresses swept in ceaseless search for food, confusing the air with their soft silk. But the cobwebby feelers chose not to sting him and withdrew, allowing him to walk in his own moving bubble.

He emerged from the grove and again came in sight

of the mechanicals, who sat around on folding benches beneath metal awnings. He guessed these were for protection from the mist-like rain which generally descended after dusk, when the clouds lost some of their electric charge. A few stood up to watch his approach with curiosity, their bodies shining with their familiar chrome-blue in the last light of day. Their structure could just about be termed humanoid, the most divergent feature perhaps being the legs, each of which split at the knee into two sub-legs to provide a peculiar four-footed gait - a mode of locomotion copied from the organic race which had made the mechanicals originally, now migrated to another world whose climate they liked better.

A mechanical approached with flickering steps. Both halted when only a metre or two apart. The mechanical's four speckled eyes inspected the man from top to toe. Then it greeted him in its soft-toned humming language, which used very few vowels. The man hesitated, searching his own mind to find that language, even though he had known it for some years past.

"I beseech you, allow me to stay the night with you," he said. He scarcely bothered to hear the reply. He was almost never refused; just as he could never resist the urge, after a day or two at most, to move on.

"How are you named?" the mechanical asked.

The man hesitated. After so much wandering it was hard to put a name to himself. "I am Carthasverus," he decided. "Yes, that is who I am."

He did not ask the mechanical's name: it was displayed upon its chest. Mechanicals of this world had no names proper. Whenever they gathered in groups they designated themselves by numbers, though Carthasverus was not sure what they signified, unless it was rank-order. Sometimes the numbers would change, an entire group spontaneously rearranging its nomenclature.

The mechanical before him bore the symbol for the number *One*. Perhaps it was a spokesman. They moved together under the awnings. All eyes were on the man, watching his every move.

"You are like no other we have seen before," *One* hummed.

"No other like me exists, as far as I know," Carthasverus told them. "I am the last of my kind."

"Indeed? How so?"

They made room for him on a bench. The old man seated himself. Even as the sun disappeared the misty rain began to sift down, hissing quietly on the metal awnings and trickling down their supports. Darkness did not arrive, as on so many worlds. The sky would remain luminous throughout the night.

The man rummaged in a bag he carried and brought out some scraps of food, in the form of yellow bread made from a local plant. Silently he began to munch it.

A mechanical named *Eighteen* spoke up.

"That is food of our world?"

Carthasverus nodded. "I can eat food of all kinds."

"That is rare in an organic being. So you are like us. Your needs are simplified."

The man finished his scanty meal, sighed, and only then answered the question asked some minutes before by *One*.

"My kind perished more than five million years ago." He used the local year in his figuring. In Earth terms it came out between two and three million years. "A war was fought with a species known to us as the dog-people, who wished to control our planetary system. Our planet, Earth, was exploded. Our settlements on other planets were exterminated. Only I survived."

The mechanicals murmured their condolences. "But how," *Seven* asked, "did you come to be a survivor?"

351

The visitor frowned, lowered his head, and tears came to his ancient eyes, running slowly down his wrinkled cheeks.

Always he had to wander, always to move on, and in the same way, always he had to tell his story, always to spread the gospel. And so the words came out, words which he had spoken more times than were countable. "On my destroyed home world," he told them, "an event of unique cosmic significance once took place. God, the creator of the world, entered the world in the form of one of my kind, in order to save the world. But the world did not understand him. The people he lived among put him to death. I know. I was there. I was a porter in the hall of judgment when this man, God, who they called Jesus, was brought before the governor of the province. I struck him in the back as they led him away. "Go faster, Jesus," I said. Then he turned, and the eyes of God looked upon me, and he said, 'I am going, but you will wait till I return'. And so he went, and they killed him. After that I knew that I must leave my family and wander, until the creator again came into the world, as was promised. But it has been much longer than I had supposed."

Longer, much longer! The death of his species had left him too devastated to act or think, not because of the event itself - time had given him a perspective on such matters - but because of what it meant to himself. His only hope was that Christ would return and forgive him. But if there was no longer any human race...

Then, finally, he had understood that God the Son had come not merely for mankind, but for all sentient creatures throughout the wide universe. And so had begun his pilgrimage, from world to world, from star to star, on and on. Waiting.

Long, long, long!

"And in what manner was this personage to save the world?" *One* asked softly.

"This is what you must understand. He came to redeem our sins."

"And what are 'sins'?"

And so he tried to explain to them the nature of wrongdoing and of faithlessness, and how God had sacrificed himself, taking all blame and suffering in place of the wrongdoer. "Oh, if you could only have seen how he died upon the cross!" he entreated, "groaning with travail. Imagine God in such a state!"

But they were unable to grasp his meaning. "We have done nothing wrong," they said simply. "We only follow the ways ordained by our makers, and cannot do otherwise."

There was a silence, until a mechanical numbered *Twelve* spoke up.

"You are like us, Carthasverus, for we too have long lives, though not nearly as long as you say yours is, and indeed it seems scarcely possible for any individual to live that long. And like yours, our tribe has also received God as a visitor. The vehicle of this incarnation was one of the last of our number to be manufactured before our makers departed. It is said that an electric storm of unprecedented grandeur enveloped the planet at the time this mechanical was activated. At any rate he claimed, when his consciousness awakened, never to have been nonexistent, but to remember the time before the universe came to be. He told us that we must at all times pay special attention to the fact of who He was, and that we must obey Him in all his various instructions, saying that thereby we would be elevated and live eternally. By touching one on the head with His hand He could induce a special kind of elation and the feeling of having strange perceptions. One day, a large crowd gathered to enjoy this service. But after He had touched a score or so he announced that He would touch no more that day, until persuaded by the crowd, He continued to the number of about a hundred. Then, without warning,

He dropped down defunct, His special energy exhausted, and could not be roused. Perhaps that was the very Christ of whom you are speaking, returned to the world."

"No, that cannot be Him."

The dusk rains had faded to the lightest fog. It was not until then that Carthasverus noticed someone who had sidled into the camp from out of the evening, and who was not a mechanical, but an organic like him. But not, of course, human. The creature had a coarse pelt which was ragged with the wet and gave off a rank odour. Though humanoid, its posture was less erect than a man's. The gait was shifty and prancing, the face dog-like.

His face paled. He had never thought to see one at this distance. It was a descendant of the dog-people who had destroyed Earth.

The wandering man let his ancient gaze rest on this one-time enemy, on whose face he fancied to see intense hatred. Should the destroyers of mankind also be brought into the circle of the saved?

Yes, it was his duty to make the attempt.

But the dog-man had been listening, and before Carthasverus could frame further words to speak, he pointed a taloned finger. "I recognise you, Earthman. You are the ancient, accursed enemy, kept alive in our detestation even now. Yes, and well I know your doctrine. But it is a perverted, lying doctrine, an ill-conceived farrago of borrowed intelligence."

With a surprising dignity, considering his evident anger, the dog-man appealed to the mechanicals. "I will tell you all the truth. The Creator *did* enter the world in material form, to greet all sentient minds and consult with them on the glory of His creation. But it was to *my* people that He came. And yes, He *was* killed - *by that which called itself the human race!* When the ships of the Terran raiders fell on the village where He dwelt with His closest devotees,

they taunted him, they tortured him, they tied him to a post and burned him alive! Tht is why we destroyed that devilish planet, and hunted down its every progeny."

"My friend," said Carthasverus calmly, "no doubt your people have heard the story of the coming of the Christ, and in some manner have adopted it and concocted some myth of your own. But mine is the true version."

"*True?*" The dog-man bared his teeth, his brown eyes widening. "How could such a ridiculous story be true? Your Christ died, and was still alive afterwards! Not even a god can die and continue to live at the same time. It is a plain contradiction."

His voice fell. "Even if such an impossibility could come about, what a pale sacrifice that would be. No, the truth is thus. When God incarnated Himself He incarnated *all* of Himself, leaving nothing behind. When He died at the hands of the humans He vanished forever, and the universe is now a doomed mechanism, having nothing to guide it. Can you comprehend the magnitude of that evil deed?"

"No, my friend," Carthasverus said, shaking his head, "it was on Earth that the creator revealed himself. I was there! And how should I live this long if my story were untrue?"

The dog-man was not listening. He brought forth from his loose garment an object which he pointed at Carthasverus. It had a handle by which he gripped it, and a broad cylinder whose open end Carthasverus could see.

"The ancient duty of extermination is still incumbent!"

A green radiance shimmered from the cylinder and struck Carthasverus, so that he jumped up from the bench and gave a loud cry of pain. The object was a shock-gun, a lethal weapon. Its deadly nerve-force shuddered through him, jerking his muscles, making him dance like a marionette. Something else happened simultaneously. *Seven* came up behind the dog-man and gripped his neck.

Its orange eyes dimmed as it diverted the power of its battery through its hand. With alacrity other mechanicals clustered round it linking hands, their eyes also dimming as they added their electric current to *Seven's*.

The dog-man convulsed and fell dead.

Seven looked at Carthasverus. "You still live."

"Yes." Carthasverus flopped back upon the bench, gasping. "I cannot be killed."

"An act of gross impoliteness, for one visitor to try to kill another while in our camp."

Despite his shocked state Carthasverus noticed that *Seven* was no longer *Seven*, but *One*. All the mechanicals, in fact, had changed numbers. But there was something new in the numbering. Previously they had gone from *One* to *Twenty-Eight* in a straight sequence. Now there were higher numbers. *Seventy-Nine*, *One-Hundred-and-One*, *Fifty-Three*, as well as *Eleven*, *Nineteen*...

"You have all become prime numbers," he observed weakly.

"Yes. Among integers primes are irreducibly individual, and when a drastic action is undertaken such a quality is called for. Previously we were named from the first twenty-eight positive integers. Now we are the first twenty-eight primes. But are you seriously injured?"

"I am all right," Carthasverus said, still feeling the strength leech from his bones.

"You are indeed of an unusual constitution."

"I wish to rest."

"Do you require medical attention? Though that will create a problem."

"No. I will not die, until the messiah comes."

One, formerly *Seven*, reflected, then spoke again.

"There is no such thing as an immortal. Both from the condition of your skin and your general demeanour you would appear to be already old."

"Each time my body ages to that of a man of two hundred years it regenerates itself to that of a man of forty." Again he doubled up the Earth years.

"Hmm. Ingenious. And no doubt within the scope of biological science. Still, a very long life must bring disadvantages. What of memory, for instance? No brain has infinite capacity."

Yes, memory was a trouble. Every so often his remembrances rearranged themselves, like the number-names of the mechanicals, and things he had once known he recalled no more.

Sighing, Carthasverus dipped into his bag and brought out his blanket. He would sleep upon the bench.

Lying down, he pulled the blanket over himself. Some of the mechanicals lifted the corpse of the dog-man and carried it into the night, their legs moving like the legs of some mutated centipede. But *One* lingered by him, its bluish sheen glinting in the suffused light of the sky.

"I must tell you one thing, concerning our own messiah which we told you of, the mechanical who remembered the time before the creation."

A thought struck Carthasverus. "What was his name?" he murmured.

"In that there lies an interesting fact. Whereas the names of all other mechanicals are determined by social roles, He bore his from the moment of His activation. It was, of course, a number. But a number so enormous that it could not be displayed on His chest by our normal notation. It appeared in a new notation which had to be deciphered. Years after His death, this number was proved to be a previously unknown prime."

"Ah."

"But what I have to tell you is that God did not come intentionally into the world as our still-highest-known prime. It was, He told us, an electrical accident. Yet there

357

had been a previous time, when He had come intentionally, as an organic being, so as to experience the world He had made. Could that be your Christ? If so I must tell you that He had indeed promised to come again - but not until the universe has run its entire course. Then he will appear and declare himself to the beings existing in the last days, or to whatever form of intelligence there will be by then. Do you understand? It is not to be for another forty billion years. That is how long you would have to wait, if you were what you think you are."

Carthasverus raised his head in sudden terror. The mechanical's forty billion years was still twenty billion Earth years, the estimate for the remaining lifetime of the universe agreed on by cosmologists of most races.

"But so long..." he said in a faint, dry voice like a withered leaf.

"No, my friend, you will not have to live that long." The mechanical's voice became kindly. "It is impossible. For even if conditioning or conviction prevents you from suicide, the law of probability ensures that you will meet with a fatal accident within a few thousand years at most. You have had a narrow escape tonight, for instance. And even if it were possible, just a small fraction of such a length of time would induce madness in any reasoning creature.

"No, you are not as old as you imagine you are. You are likely the result of a biological experiment in longevity. Your body has been rendered adaptable and resistant to stress and disease. Perhaps you do not even belong to the dead planet Earth you speak of."

"Twenty billion years..."

The man's head fell back upon the bench. His eyes closed. His breath was shallow. *One* could get no further response from him, and so left him to his sleep.

The sun rose crackling with a blue blaze. Carthasverus raised himself from the bench and stowed his blanket, but his movements were slower than they had been yesterday, actually decrepit. He searched his bag for breakfast but found none, and the mechanicals, their name-numbers reverted to the integers One to Twenty-Eight now, had nothing to offer him.

"Do not worry," he told them. "I shall find something."

He thanked them for their hospitality and protection, then set off eastward, walking slowly, relying more and more on his stick. The mildness of the night gave way to the easy warmth of the day. The diatom-bubbles, which at nighttime sank to within half a metre of the ground from the heaviness of the dew upon them, rose on the breezes to garland and decorate the air.

The mechanical was right in guessing that he was compelled against suicide. But he was wrong in the other thing. The word of God had tricked the laws of probability. He was deprived of the accidents that normally would be the salvation of the biologically immortal.

He felt very tired, for the hundred Earth years were nearly up, and the shock-gun had drained his vitality. Round about mid-morning he stopped. He could go no further. Before him stood a tree on which he fixed his gaze. No more than twice his height, it resembled, in its gnarled form and the broadness of its leaves, an Earth oak. He stared at it, stared and stared, with a special stare, before he toppled slowly over on to the moss, and his heart stopped.

By mid-afternoon the old man's body had disintegrated. The nano-machines, the molecule-matrices, the coiled chains, flew up like a cloud of insects, bearing with them the genome innumerably reproduced, a library of memories encoded and sorted, and every useful atom. They streamed to the tree to attack it like a poisonous cloud,

mining it for its carbon, its nitrogen, its trace elements. What was lacking some fell to the ground to find. Then they began to build the man's cells anew.

For some score of days the blue sun swept over the place, while on the moss where the old man had fallen there lay only a reddish patch and fragments of cloth. Finally, from out of the discarded frame of the tree's remnants there stepped his young version, appearing about twenty Earth years of age, who looked sadly about him.

He stretched his limbs, glanced briefly at the walking stick which his other self had needed, then started walking east. He knew that somewhere in that direction was a field where spaceships landed and departed. He was finished with this planet. He would have to move on.

And on. And on.

Back in the early days they had said that the Christ would return to the same generation that had seen him die. But it was not so. Then the word was that he would come down after a thousand years, on a cloud of fire to end the world and build a new one.

How short a time was a thousand years. A scholar of the Degene race, who had studied Christian scripture, once told him that a million years must pass before God the Son kept his promise.

But that was long ago, and now he had a new message, one which he felt to be true. God would reappear in the form of one of his creatures, and roll up the heavens like a scroll, only when the universe had run its natural course.

It made sense. God would not make a world with a natural term to it, if it was not to run that term.

O future! O worlds unborn! From planet to planet, from star to star, from galaxy to galaxy. How many sights must his weary eyes rest upon? How many countless billions must hear his tale? To how many would he tell how

God had come into the world and been ill-treated there, abused and mocked.

His had been only a trivial act of unkindness. And yet he was the one punished with the heaviest burden. Why had Christ the anointed done this to him? Why, so that there would be someone to preach the gospel for all the span of time. Yet for that he, and he alone, was made to endure life in the material world for more than half the creation, when God himself had suffered it for no more than thirty years!

His name was...Cartaphilus, he recalled. Vividly he remembered it, watching from his doorway as Christ staggered by bearing the heavy cross, amid a procession of soldiers and townspeople. With an unbearable pang of shame he remembered how he had not allowed the condemned man to rest for a moment before his house, but had driven him on. Then had come the fateful words.

It had been petty, squalid cowardice that had prompted him, for fear of letting the neighbours see the despised heretic pause by his door. Where were those neighbours now? All safely, peacefully dead two and a half million years since.

In those days he had been a shoemaker. Other images flooded through his newly constituted brain. Someone had told him a tale once, not knowing that it referred to himself. Somehow it had got about that he had instead been a porter in the Roman governor's hall of judgment, and it was there that he had offended Jesus.

Tales. Cartaphilus reflected on the extinct human race's fondness for tales. No other race had such a love and capacity for inventing stories that had never happened, and for distorting events that had happened. Sometimes even he became confused as to whether something he remembered really had taken place, or whether it had been put into his head long ago by storytellers who recorded their wares in

books of various kinds. Once,he was sure, he had read a story about a laboratory where men had devised a body that could live marvellously long, mending itself whenever it grew old. But it was only a tale, like the tales of men travelling back and forth in time, which was impossible, or like the dog-people's tale of their false messiah.

Only his tale was true among all these. Tears fell from the young man's eyes as his bare feet trod the moss, as he felt again the shame, and his hope so hopelessly deferred.

DAVID LANGFORD produces word-processing software as well as writing fiction and non-fiction. His novel *The Leaky Establishment* (1984) is a sharp satire which draws upon his experiences working for the Atomic Weapons Research Establishment during the 1970s, while *Earthdoom* (1987; written in collaboration with John Grant) is a hilarious send-up of disaster novels.

WAITING FOR THE IRON AGE
by David Langford

As I passed through the twentieth century I remember being struck by a remark of the physicist who must have been my second most famous compatriot, if I might be said to have compatriots. "God is subtle, but he is not malicious." In fact Einstein said it in German and offered an informal American translation which was much less often quoted: "God is slick, but he ain't mean." I dispute this.

Memory is a terrible custodian. The scene which ought to dominate all my thinking has long vanished, lost in accretions of other narratives, scholarly reinterpretation, analysis of mythic significance. I was there, or think I was there, but who am I against so many? Far more pungent is the memory of one perfect meal in a monastery of about the fourteenth century; it was only black bread and leeks in oil, but it lingers. Or is this another shuffled recollection? Old stone passages are overlaid in my mind with their own later ruins, and then with dramatic recreations more vivid than the originals, if there were originals....

God (or whoever) is subtle, and does not evade His natural law. I cannot prove even to myself that I have lived so long, because existence has been a broken line. Each time I have lain on a deathbed and begged to go gentle into that good night, there has been the same confused instant, and then another pubescence, another name in another place,

and the same black knowledge seeping back. Myths simplify it all to a single everlasting body, but that would be proof and proof cannot be.

One could call it merciful. The legendary Sibyl, whose years were numbered like the dust, was displayed as a freak in a bottle. So it might have been for me. The difference now is only that I retain privacy.

As the age of faith withered I became aware, each time, that all the previous times would be more economically explained by the unique event of insanity. *Entia non sunt multiplicandum praeter necessitatem*. I never met William of Occam but seem to recall that his razor had been wielded before him, by earlier philosophers. Of course I might simply have read that somewhere; I have access now to everything, including all the clashing versions of my own story. Subtle and also malicious.

It was the twentieth century that gave me new hope. The secret was out. Somewhere, somehow, the whole weary drama of mass and energy and consciousness must one day come to an end. $dS = dQ/T$. There was a time when I wore that expression of the entropy differential blazoned across a T-shirt. The sceptre, learning, physic, must / All follow this, and come to dust. If God, as I believed, had ceased to evade His natural law, the key to my cage lay in the second law of thermodynamics.

Those scholars; what wonderful minds they had, with bright speculations flying off like sparks from the anvil. Of course they also contrived my last long predicament, but in this particular aeon I bear them no ill-will. Even hatred does not burn forever, and mine scarcely outlasted the Sun.

The quantum many-worlds theory, now: there was a notion to ponder.

Every possible action took place, with the universe splitting and resplitting at each random decision of the

wave-function of each electron. In the overwhelming majority of worlds (not plurality of worlds, that was something else, some other scholasticism) I would have died forever. In *this* one, in each successive *this* one, the patterns of my memory were thrown up by the dice of chance, as, when all the combinations are played out, every pattern must be; and I continue.

God does not play dice with the cosmos, the wise man said, but what did he know? Another physicist asked him in exasperation to stop telling God what He could and couldn't do, while a third had flatly contradicted him before the century was out.

I see the many-worlds conceit from the other direction. A myriad possible pasts could all have resulted in myself; the forking paths spread backwards, wider and wider. Have I been Ahasuerus, Cartaphilus, Josephus, Cain, Vanderdecken, a vast multiple-choice listing of contradictory names, professions and crimes against Him? It is hard to remember much before the chilliastic panics of (it must have been, though I forget the calendar) AD 999. But having watched so many wars and reformations twist and writhe under the bright lens of history, I am sure that none of the stories can be wholly true. History, like memory, is so full of lies.

It will all be the same in something on the order of 10^{65}, or conceivably 10^{1500}, years.

Bishop Berkeley was another great man whom I missed, largely through spending most of the eighteenth century drunk. I caught up with his philosophical works much later on, when they were no longer controversial but quaint. "All the choir of heaven and furniture of earth - in a word, all those bodies which compose the mighty frame of the world - have not any subsistence without a mind." He defined matter as being the mind of God, with every trivial movement of every grain of dust propped up by the

implacable contemplation of that mind. It seemed a tiresome occupation for omnipotence, I remember thinking.

Thoughts can be dangerous, and never more so than when all you have left is thought.

I thought: we live in a secular universe. Miracles, wonders and incarnations all passed from the world with what I have guessed was my first life. It is as though something went away. Providence no longer suspended natural law with an interjected finger. God gave up His endless scrutiny, and ceased to tinker with the works.

I thought: well, if that is so, so much for Berkeley's idea that the universe relies for its continued existence on an eternal watcher. I refute it thus.

I thought....

"To be is to be perceived." I perceive only dimly, but then there remains so very little to perceive. As could be predicted in the last age of the human race, a period of 10,000,000,000 years was enough to see the end of fusion processes in all suns everywhere. After that, the dark. Measured against this timescale, the departures of God and humanity were for practical purposes simultaneous. No more nova flares, no distant pinging from the pulsars, nothing but silence and dull matter and isotropic black-body radiation.

This time capsule, this message in a high-tech bottle, is (I suppose) a marvel; a monument to earthly ingenuity. It was built to last. My God, how it lasts. He is malicious: I expected rest with the dissolution of the Sun and Earth, but again after an instant's confusion I awoke, in this intangible maze of optoelectronics and superconducting loops which is - which am? - the AI librarian of the last data bank. All human knowledge is supposed to be here, a labyrinth worthy of Borges, and I inhabit it.

Nor can I be certain, even now, whether my journey down the exponential years is punishment for some

momentary crime (as the scandalmongers of myth and history would prefer), or an ill-conceived reward, a gift given for...? I have flirted with blasphemy, imagining all this as not, perhaps, eternal retribution for abusing a divine Person, but the eternal responsibility of the Person himself.

Or, more humbly, I can choose to think of myself as a mere artificial intelligence which like all the surrounding cosmos is in an advanced state of senile decay.

"Eternity is a terrible thought. I mean, where's it going to end?"

There has to be an end. The energies which sustain me must surely falter before I reach Freeman Dyson's watershed of 10^{65} years - the timescale over which all matter flows like liquid, and all the solid-state components of this wandering mechanism should coalesce into one featureless lump.

But perhaps they wrought better than that. They were clever.

I can wait. Well, of course, I must. "I can't go on like this," Estragon says in the play, and is answered: "That's what you think."

As the eminent William Paley (D.D.) did not quite remark in the eighteenth century, the universe is like a watch, and a watch implies someone to watch it. I have watched so long, taking over the burden when God could no longer be bothered. Watchman, what of the night? If the distant liquid age does not bring release, I still can be fairly sure that the eternal damned superconductors must fail when the iron age comes.

10^{1500} years from my beginning. The ancient Indian sages were fond of parables expressing enormous reaches of time. If there were a stone a cubic mile in size, and it were a million times harder than diamond, and every million years a holy man (in other versions he is a bird) should come

to give it the lightest possible touch, imagine the time taken for the stone to be entirely worn away. The English mathematician Littlewood took a little time to imagine it, and reckoned the answer as something on the order of 10^{35} years. "Poor value for so much trouble," he added.

Long before him, Archimedes had reckoned up all the sand of the world and shown that the Sibyl, with as many years as grains in a handful of dust, was relatively a mayfly.

10^{1500} years. On this immense timescale, almost all matter is effectively radioactive; it decays with ponderous slowness to the most stable of all elements, iron. He does not evade His natural law. A lump of iron cannot superconduct, cannot think.

And then, no longer supported by my solitary contemplation, the universe can cease at last.

I hope.

The Arabian Nightmare - Robert Irwin

"*The Arabian Nightmare* is one of the best fantasy novels written this century."
Brian Stableford in the Fantasy Review

"Deft and lovely and harder to describe than to experience - the smooth steely grip of Irwin's real story-telling genius. *The Arabian Nightmare* is a joy to read...If Dickens had lived to complete The Mystery of Edwin Drood, the full tale when told might have had something in common with the visionary urban dreamscape Robert Irwin has so joyfully unfolded in this book."
John Clute in The Washington Post.

"Robert Irwin is indeed particularly brilliant and, beauty of all beauties, the book is constantly entertaining."
Hiliary Bailey in the Guardian

"It is a long time since a work of fantasy has delighted me so much"
E. Klessman in the Frankfurter Allgemeine Zietung

"A masterpiece of historical fantasy and fetid imagination."
Mark Sanderson in Time Out

"Robert Irwin wittily juggles oriental thought with western theology and sexual fantasy and comes out laughing."
Anne Barnes in The Times

"*The Arabian Nightmare* is an engaging and distinctive blend of the seductive and the disturbing, its atmosphere constantly shifting from sumptuously learned orientalising to grotesque erotic adventure and dry anarchic humour. As a feat of erudite philosophic fantasy it bears comparison with Eco's Name of the Rose."
Peter Miller in City Limits

"Robert Irwin writes beautifully and is dauntingly clever but the stunning thing about him is his originality. Here in *The Arabian Nightmare*, is something marvellously

different - a remarkable feat to achieve in these days of genres and categories. All too often the book one is reading is very much like the book one has just put down, but Robert Irwin's work, while rendered in the strictest, simplest, most elegant prose, defies definition. All that can be said is that it is a bit like - well, a fraction like - a mingling of The Thousand and One Nights and The Name of the Rose. It is magical, bizarre and frightening."

Ruth Rendell

£5.95 0 946626 14 6 282pp (hardback)

Mr Narrator - Pat Gray

Pat Gray's Kafkaesque fantasy presents a bureaucratic landscape which is both sinister and comic. Mr. Narrator leads an obscure neo-colonial existence in Goughly, where he is an export agent for a firm of Rotherham engineers and shares a flat and a mistress with Murphy, a post-modernist writer. An upset to one of his business deals plunges him into a bizarre cross-desert journey to the capital, where social, political and sexual humiliation descent on him in ever increasing number.

"It has a cock-eyed insouciance which contrives to enliven our image of the world while dwelling mordantly on its frustrations".

Brian Stableford in the New York Review of Science Fiction.

£4.95 0 946626 31 6 167pp
Also available in hardback £10.95 0 946626 29 4

The Wandering Jew - Eugene Sue

The legend of Ahaserus condemned to wander the world until the second coming of Christ has exercised a strong fascination on European Literature since the Middle Ages. The most successful treatment of this theme is Eugene Sue's novel, published in serial form in France during 1844-45. It was one of the most successful books of the 19th century and was translated immediately into all the major European languages. More recently it has inspired 2 films and a National Theatre play, and has been chosen as one of the top 100 horror novels of all time.
Rich in melodrama, sensational and supernatural events, its extraordinary and complex structure makes it one of the great masterpieces of its genre.

£9.99 0 946626 33 2 864pp B. Format

The Mysteries of Paris - Eugene Sue

"Eugene Sue has raised himself above the horizon of his own narrow world view. He has delivered a slap in the face of bourgeois prejudice." *Karl Marx*

The Mysteries of Paris presents a fantasy world rich in melodrama, sensational events and peopled by weird and wonderful characters. Sue's mixture of socialism, sentimentality and sadism made him an internationally acclaimed author and he was often referred to as the French Charles Dickens.

£6.99 0 946626 30 8 467pp

The Acts of the Apostates -
Geoffrey Farrington

"His was the most monstrous crime a man could commit. In this land it was an act of desecration without parallel."

In the last days of the Emperor Nero's dark reign, in a closely guarded room in the palace, a man tells his story.

Neophytus, Imperial dream interpreter seer, has returned to Rome from Judea in flight from the death grip of an ancient cult. He has not returned alone, for his nightmares have followed him into the palace. The *Acts of the Apostates* is an odyssey undertaken by mystics, charlatans and sorcerers through occult mysteries and madness.

Geoffrey Farrington's latest novel descends into a labyrinth of ancient fears.

£7.99 0 946626 46 4 284pp

The Revenants - Geoffrey Farrington

A family curse reaches through time to damn a young man in Victorian Cornwall in Geoffrey Farrington's masterpiece of classic Gothic horror.

"A superior vampire novel." *Time Out*

"New writers like Anne Rice and Geoffrey Farrington are leading the way forward in the development of modern fantasy."
Brian Stableford in the Fantasy Review.

£3.95 0 946626 01 4 167pp